Gardens in History

A Political Perspective

Louise Wickham

WIND*gather*
PRESS

Windgather Press
is an imprint of
Oxbow Books, Oxford

© L. Wickham 2012

ISBN 978-1-905119-43-1

A CIP record for this book is available from the British Library

This book is available direct from

Oxbow Books, Oxford, UK
(Phone: 01865-241249; Fax: 01865-794449)

and

The David Brown Book Company
PO Box 511, Oakville, CT 06779, USA
(Phone: 860-945-9329; Fax: 860-945-9468)

or from our website

www.oxbowbooks.com

Printed by Printworks International

Contents

List of Figures

Introduction

Over the past fifty years, the subject of garden history has been firmly established as an academic discipline. While many have explored *what* was created in gardens throughout history, the notions as to *why* they were created has naturally been more diverse. Depending on the background of the author, the reasons have ranged from aesthetic values deriving from art, philosophical thoughts and ideas, social and even economic forces. Occasionally some thought has been given to the influence of political ideology, which is quite surprising given one of the earliest histories of gardening, Horace Walpole's *History of the Modern Taste in Gardening*, published in 1780, was overtly political. He was the son of Sir Robert Walpole, the British Whig Prime Minister for twenty-one years to 1742. However at the time of writing about 1770,[1] the Whigs were divided with Walpole junior favouring the 'old guard', as represented naturally by his father and their supposed unadulterated form of Whig ideals. He used his history to advance the claim that the 'best' forms of gardens were the English style of Lancelot 'Capability' Brown and other professional improvers and that they only came about because of 'old' Whig principles. These were a non-absolutist monarchy, free trade and laissez-faire economics. While Walpole was not entirely right in his assertions, at least the development of the English landscape garden in the first half of the eighteenth century has been viewed from a political perspective in recent years.[2]

My intention with this book is to look at the creation of gardens elsewhere through a similar political 'lens'. I thus wish to move the debate away from merely portraying 'garden-making' as painting a picture with plants and garden buildings and explore the deeper meanings involved in their creation. What do I mean by 'political'? The *Oxford English Dictionary* defines it as 'of or relating to the government or public affairs of a country'. Specifically it 'relates to the ideas and strategies of a particular party or group in politics' and describes actions 'motivated by a person's beliefs … concerning politics'. In this context gardens are looked at in relation to not only how they are influenced by the political ideas of their creators but also how the gardens themselves provide support and legitimacy to those in government, either overtly or indirectly.

Much time and thought has been given to the meaning of the rock formations in the Ryoan-ji dry landscape garden[3] in Kyoto, Japan (Figure 9.8) that was laid out in the early sixteenth century. The guidebook to the garden merely says 'it is up to each visitor to find out for himself what this unique garden signifies'. Creating a garden to me is the ultimate in self-expression: ideas may be copied

(or more politely borrowed) but no two gardens are alike. This is the same about an individual's political views: there may be core themes that they, as part of a group, may support. So they can be labelled as holding a certain political stance, usually defined along a left–right axis but quite where they 'sit' on this line varies depending on the subject (the economy, law and order, social issues, the environment for example). This complex interaction means that no two individuals can hold entirely the same political views on all matters.

One of the criticisms levelled at Lancelot Brown[4] was that he created 'identikit' landscapes with the main house in a sea of turf, some water, albeit often an impressive feature, and trees in clumps or shelterbelts. The criticism lay not in the aesthetic values of such landscape parks but rather that the owner had lacked imagination and possibly 'taste', an even greater crime! There was also a whiff of uniformity equating to authoritarianism. This went against the British desire for individualism that had pervaded political ideology following the Glorious Revolution of 1688. Even today with our largely uniform domestic architecture, there is that streak of individualism in the green space outside even if it is neglected and full of weeds…

This is not a one-way process of politics only influencing the design of gardens. As Mukerji (1997, 35) points out 'gardens address … some fundamental ties between human action and the material 'natural' world, so they have surprisingly important tales to tell about human societies'. Studying gardens can therefore tell us something about the political processes of the society in which they were created. Architecture and art have long been seen to have this role but the rather transitory and often ephemeral nature of gardens, has led them to be largely ignored by cultural and political historians. The fact they were often the preserve of the rich, or indeed super-rich, in the society and regarded somewhat as a frivolous pleasure, has not helped their cause. The urge to create a garden (particularly among the British!) would appear to be 'hard-wired' into our psyche. As man developed political units in Egypt and Mesopotamia over five thousand years ago, then the first known gardens appear. These were areas where plants were grown mainly for their aesthetic value, rather than their productive abilities: a reflection both of the increasing 'leisure' time of the leadership and the specialisation of roles within the community. At this stage too, the garden becomes part of human mythology with the concepts of the Garden of Eden and paradise as a garden becoming recurring motifs.

The early earthly gardens were designed to demonstrate the political power of the owner either by its technical achievements, for example the Hanging Gardens of Babylon,[5] or by the plants they grew. Queen Hatshepsut in the fifteenth century BC sent an expedition to Punt (today's Somalia) to get incense trees to grow in Egypt. This was a sensible economic move, as it meant that the valuable resins from the trees did not have to be imported. It also re-enforced the notion that royalty's power derived from their link to the Gods, as incense was an important part of religious ritual. In the Greek city states however such overt displays of power amongst the top echelons were inappropriate for their

new political ideology of democracy. The only gardens in the Greek world were 'sacred groves', which were very natural and did not demonstrate man's power over nature. This reflected an important part of Greek philosophy, which believed that 'plants and men have a natural environment that shapes them' (Osborne 1992, 388). Political discourse and more importantly philosophy in the Greek academies developed not in buildings but in landscaped grounds outside, so perhaps gardens can also provide inspiration to political thought!

Gardens have long been used as a means of enforcing a political culture. In this way, garden styles have crossed borders and influenced the society that they are created in. One of the earliest examples are the Persian hunting parks (*pairidaeza*) being adopted by the Greeks (*paradeisos*), giving the English word *paradise* and its link to the Garden of Eden. The first to actively take their cultural styles to new lands were the Romans with their expanding Empire. As far apart as Britain and the Middle East, there are practically identical styles of architecture and more importantly gardens. The latter could prove to be something of a challenge given the variations in climate between the regions and it was not only the Roman soldier but also the Mediterranean plants (Campbell-Culver 2004, 21–35) that shivered in the British chill! However, added to the 'What Have The Romans Ever Done For Us' discussion from the film Monty Python's *Life of Brian* should be 'Apart from Gardens …' for Britain. The British national obsession for gardening probably started two thousand years ago, as there is no evidence of any recognised gardens in Ancient Britain prior to the Roman arrival.

The gardens of the Muslim world are an integral part of their culture and the Persian quadripartite or *chahar bagh* garden style that the Arab invaders adopted, can be seen with slight variations from Spain in the west to India in the east. The role of the garden as a cultural icon in Muslim society continues to this day. The local Islamic community enthusiastically embraced the creation of a Mughal style water garden, in the restoration of the previously solidly British nineteenth century Lister Park in Bradford in 2001. For the Muslims, it was not about stamping their authority on the conquered land with their style of gardening, as the Romans had done with their 'Pax Romana'.[6] It was about providing symbols of their religious (and *de facto* political) ideas. The paradise promised in the Koran is set in a garden. Therefore gardens built on earth were seen as a foretaste of those that they would encounter in the next world and a reminder for the population to be good and law abiding citizens. Christian doctrine carries a similar message but apart from the medieval period, the link between symbolic gardens and Christianity has not been strong. Even the great gardens of the Italian cardinals of the sixteenth century were created apparently more for pleasure here on earth, rather than a symbol for the Catholic Church's teachings.

Italian Renaissance gardens provide an interesting forum in which to look at how political thought changed from the narrow Christian ideas of the medieval world, where Rome and the Pope were the centre of European power, to the secular and humanist views of the Medici and others. As Comito observes

(1991, 37) 'the humanists provided an ideology that situated the villa garden within the whole project of Renaissance culture and at the same time was not without effect on the evolution of its design'. The Medici villa gardens around Florence were opened up to the surrounding countryside and the latter was celebrated. Prior to this all gardens had been enclosed either within castles or monasteries. The world outside had been deemed dangerous and out of the security both literally and metaphorically of the Church centred society. Certainly Renaissance writers understood the importance of the new style of gardens. Seemly independently, Bartolomeo Taegio in 1559 and Jacopo Bonfadio in 1541 both had the idea of a garden as being a 'third nature': wild areas being the first and cultivated (productive) areas being the second.

I also wish to explore *how* gardens were used as a political tool. An analysis of the sixteenth century park at Pratolino near Florence by Butters (2001, 64) shows that the Renaissance garden creators (in this case Francesco de' Medici) 'recognized that gardens could be programmatically shaped into metaphorical microcosms ... [reminding] visitors of the prince's power to tame the recalcitrant, both in nature and in human society'. There has been some interesting analysis of the use of the Versailles gardens[7] both as a statement by Louis XIV of his (and thereby French) power but also his relationship with the diplomatic world. Louis took power back into the hands of the monarchy in 1661, following a period where powerful commoners, as First Ministers, had run the state. This coincided almost exactly with his construction of the gardens at Versailles that Mukerji says was a demonstration not only of French military engineering and style but also Louis' control over the land and his people. Louis used the gardens as an indicator of the importance (or otherwise!) of his foreign visitors. The greatest honour was for the King himself to show you round, although many were with official guides but with directions from the king on the prescribed route. However if no tour at all was offered, as happened to the delegation from Moscow in 1687 (Berger and Hedin 2008, 71) this was seen as a snub.

The emergence of the landscape garden in Britain in the eighteenth century has probably had the most thorough research over the last half century and provides a microcosm of the debate over the rationale for a particular style. There is no doubt that many were created to make a political statement by the owner either overtly in the case of Stowe or Wentworth Castle or in more subtle ways such as Chiswick. The latter, together with its iconic Palladian house, have been described as 'a distinctive badge of Whig ideology' (Williamson 1995, 63). Following the restoration of the Whigs to power in 1714, the more radical among them wanted to model Britain on Republican Rome. Renaissance Italy was the nearest model they could use. When Lord Cobham started his 'political temples' at Stowe in the 1730s, the Whigs were divided depending on whether they supported Sir Robert Walpole's administration or not. The opposition was centred on Frederick, Prince of Wales whose garden at Carlton House by William Kent, was one of the first in the 'new style' famously described in a letter by Sir Thomas Robinson in 1734.

Kent worked at Chiswick, Stowe and Carlton and given his background as a painter, the association has been made between these more natural landscapes and the application of principles of pictorial composition as used in paintings. While the end result was no doubt as pleasing to the eye as say a landscape painting by Claude, this misses the point. Kent, like Charles Bridgeman before him, was in part executing the ideas of the owner, albeit in a new and interesting way. As the eighteenth century progressed, the landscape garden became associated with the opposition MPs who came from both the Whig and Tory parties. As they held no political office, they regarded themselves as uncorrupted by the money and patronage that Government ministers had at their disposal. With the rise of the increasingly 'natural' landscapes of Lancelot Brown and others from the 1760s onwards, the claim made by Horace Walpole that these were the true English style, was in essence correct. However many would disagree with him that it was his and father's brand of Whiggism that was responsible. With the threat of a Jacobite rebellion largely gone by 1770, landowners felt more secure and they were not averse to using their new landscape parks as an expression of their wealth and prestige. The expansion of their landowning through enclosure had the effect of shoring up their local party support in this very limited franchise.

The debate changes in the late eighteenth century and it is now that the aesthetics of landscape takes on a political dimension. Following the French Revolution of 1789, the burgeoning picturesque movement both in art and landscape, takes a more sinister turn. The Brownian landscape park with the neat Palladian mansion in the middle, according to Uvedale Price and Richard Payne Knight smacked of commercialism and despotism. They argued that these landscapes were being created for those without 'taste', often self-made men, who wanted to control their environment. Price and in particular Knight advocated a 'rustic' or wild picturesque where nature was untamed. To many observers, this view had parallels with the anarchy associated with the revolution across the Channel. In a time of increased patriotism, Brown's main supporter and successor as the leading landscape gardener, Humphry Repton argued for a 'middle way' between 'the wildness of nature and the stiffness of art' (Repton 1795, 70) and against the extreme views of Knight. While the debate between the two sides continued until well into the nineteenth century, it largely lost its political potency with the defeat of Napoleon in 1815. Repton though suffered and by the end of his career, had gone full circle back to more formal gardens.

The political impact of the American and French Revolutions meant that the ruling elite in Britain could not ignore the disenfranchised that still represented the majority of the population. An increasing number of the latter were becoming urbanised and unlike their country cousins were deprived of access to 'green spaces'. Politicians such as Robert Slaney and the garden writer, John Loudon, took up the ideas of the reformer, Jeremy Bentham, to use urban parks as a way of providing 'open spaces' for the common man to walk in. Such exercise

was thought to promote better standards of behaviour that in turn would have the 'powerful effect in promoting Civilisation and exciting Industry' (House of Commons 1833, 9), as well as the added benefit of suppressing demands for political change. The resulting public parks in Britain and elsewhere certainly did much to improve the life of the urban dweller, though the first that were built were often too far away from those who needed them the most.

Whether it had the desired effect of improving the moral fibre of the lower classes is debatable but in Britain at least, there was limited civil unrest and certainly no revolution prior to mass enfranchisement in 1918. This interest in the benefits of parks on urban society continues today as the historic public parks in Britain to date have received over half a billion pounds in grants, out of a total of four billion pounds distributed by the Heritage Lottery Fund.[8] Parks elsewhere came to be seen as a statement of civic pride but we also see the politics of conformity and suppression through their development. In Japan, following the Meiji restoration, the new government turned many of the former noble (or *daimyo*) gardens into public parks in 1871. While this could be seen as a gesture of democratisation, the fact that there were new police stations positioned near these parks suggested that the authorities thought the parks could be places for seditious activity.

One area where ornamental, political and commercial forces interacted was in botanic gardens. Here plants were grown for scientific purposes, although displayed in an attractive setting. They started in the sixteenth century in the universities of Padua and Pisa and by the eighteenth century, most of the leading European academic institutions had them. They were meant to be places for scientific experimentation. However they became highly politicised, as governments got more involved both strategically and financially. The Royal Botanic Gardens at Kew and its satellites in the colonies played a vital role in Britain's expansion of empire. Kew had been taken into state hands in 1841 and the India or Colonial Office funded other British colonial botanic gardens. Economically important plants such as tea, quinine and rubber were grown at these botanic gardens to test their viability in various parts of the world, after plant hunters sponsored by Kew and endorsed by the British government had taken the plants from their original country.

Gardens by the twentieth century were no longer the preserve of the better off, reflecting the changes in the wider society due to the impact of socialist ideas and the increasing affluence of the population as a whole. This was coupled with the rise of town and city planning and spurred on by the reformist garden city movement, thought was increasingly given to the wider environment. In contrast the large landscapes both of the private owner and the state suffered through lack of money and resources. By the 1960s many of these historic landscapes, particularly in Europe, were under severe threat and the first attempts to conserve them were made. In 1971 the IFLA (International Federation of Landscape Architects) and ICOMOS (International Council on Monuments and Sites) set up an International Committee on historic gardens.

Ten years later, they produced the Florence Charter which set out definitions of historic landscapes as well as strict regulations concerning 'the maintenance, conservation, restoration and reconstruction' of gardens.[9]

Some countries such as Britain started 'listing' gardens to protect them and today parks and gardens are part of the wider environmental and conservation movement that has now come into mainstream politics. However political tensions remain with the desire to conserve the past versus planning for the future. Whilst a building has to be actively destroyed, a garden needs a short period of neglect before it could be deemed past restoration: it depends on the funds and the long-term viability of such a scheme. For some this is a natural process and point out that many gardens have 'layers' where each new generation has put their mark on the landscape and so this process should be allowed to continue.

My 'tour' takes me to all parts of the world but it is not an exhaustive history of gardens worldwide. That has already been done very successfully elsewhere, as has detail on the design of gardens. What I will do is to draw parallels between the ideas influencing garden design and those shaping political thought. At times this may be subconsciously on the part of the garden creator but often it is quite deliberate. In each chapter I will explore in depth one particular garden that demonstrates the ideas that I am putting forward as a case study. By their very nature, they are usually both well known and researched and these case studies are not intended to repeat this previous research but rather they serve as a framework for analysis. I deliberately talk about gardens but at times will refer to 'landscapes'. However when I use the latter term, I use it in the sense of the 'landscape gardens' created in the eighteenth century, not the landscapes of the art world, which could be entirely natural. Although the ownership of land has a direct political relevance in terms of franchise for instance, I restrict my analysis to that which was entirely ornamental, rather than productive.

I will also talk about plants as, throughout history, they have been endowed with political identity from the earliest times. Central to gardens in Mesopotamia were trees: they offered shade in the harsh climate to humans, animals and plants alike. They were often cut down when a city was captured as a symbolic act. In Japan, the cherry tree in the garden has a long history dating back to the Chinese influence of the Nara period (AD 710–784). Together with the willow, it had been associated with the coming of spring and thereby the firm ruling of the Emperor. However by the early fourteenth century, the Emperor had effectively lost power to the warlords and to emphasise this, in 1357 the latter put a cherry tree native to their district of Kamakura in front of the main hall of the imperial palace in Kyoto (Kuitert 2007, 135). We have the modern symbols of today such as the red rose of the British (New) Labour Party in 1986. It was Neil Kinnock's idea, who admired the flower's use by Nordic socialist parties. The existing symbol of the red flag was seen as threatening and linked with 'old style socialism', while the rose was positive and patriotic.[10] It was also appropriate as the early socialists of the late nineteenth century

had been closely associated with the preservation of the natural environment, cultivated and wild.

Acknowledgements

My special thanks go to the many people who have helped make this book infinitely better through their comments and advice: Mavis Batey, Alison Brayshaw, Marilyn Elm, Patrick Eyres, Jon Finch, Peter Goodchild, Graham Hardman, Val Hepworth, Jenni Howard, Sarah Jackson, Sally Jeffery, David Lambert, Barbara Simms, Liz Simson, Paul and Rachael Stamper, Tom Turner and John Watkins. Finally this book is dedicated to my mother, Jill Bishop, who painted the wonderful illustrations on the covers and to Ella, my constant companion for twelve years and much missed.

Notes

1. There has been some debate when this was actually written with Chase (1943) speculating that it was written during the 1750s and 1760s but Quaintance (1979) believes that the date is the one Walpole affixed on it i.e. 'August 2, 1770'.
2. See Richardson (2008) and the excellent work by Patrick Eyres and others in various editions of the *New Arcadian Journal* from 1981.
3. For example Van Tonder, Lyons and Ejima (2002).
4. Criticism started soon after his death in 1783 from a variety of opponents such as Uvedale Price.
5. Many have disputed that these actually existed and pictures of terraced or vertical gardens are often misleading. However Dalley (1993) believes a mound planted with trees and watered by an Archimedean screw at Nineveh was probably the inspiration (see Figure 1.2).
6. A period of peace in the first and second centuries AD, following the colonisation and integration of many lands including Britain.
7. See Berger and Hedin (2008) and Mukerji (1997).
8. www.hlf.org.uk/English/MediaCentre/Archive/parksforpeople [consulted 28 October 2009].
9. www.international.icomos.org/charters/gardens_e.htm [consulted 4 November 2009].
10. www.icons.org.uk/theicons/collection/the-rose/biography/biography-of-the-rose [consulted 30 October 2009].

CHAPTER I

Ancient Gardens as Political
Expressions of Power

...

> For men of rank who, from holding offices and magistracies, have social obligations
> to their fellow-citizens, [and should have] lofty entrance courts in regal style, and
> most spacious atriums and peristyles, with plantations and walks of some extent in
> them, appropriate to their dignity. They need also libraries, picture galleries, and
> basilicas, finished in a style similar to that of great public buildings, since public
> councils as well as private law suits and hearings before arbitrators are very often
> held in the houses of such men. (Vitruvius 1914, 182)

Vitruvius' advice above, written in the first century BC, makes it clear that
having a fine garden was a status symbol in the Roman world. Gardens have
been cultivated, both as a source of food and medicine and for ornamentation,
from the time that man started creating cities over 5000 years ago. Just like
buildings, they came to represent the society in which they were created,
with the more ornamental garden being a sign of affluence and prestige. In
Mesopotamia and Egypt, they were large impressive constructions built by the
ruling elite. Whereas in Greece, where wealth was more widely distributed and
displays of luxury shunned, the gardens were more modest. In many of the early
civilisations, gardens and specific plants were associated with gods and their
divine power. Political legitimacy too was gained through association with the
gods and their representatives, so it is not surprising that gardens, the plants in
them and political power became inextricably linked in the ancient world.

While the cultivated area was important in terms of its design and size, it
was also individual plants especially trees that had political potency. Many
of the regions were harsh deserts and trees were vital for providing shade to
people and to other plants. The destruction therefore of an enemy's trees was
a highly symbolic act (Figure 1.1). The Egyptian Pharoah Thutmosis III, in his
campaigns in Syria, claimed to have cut down all his enemies' trees in 1458 BC,
as did the Assyrian kings Shalmaneser and Ashurbanipal in the first millennium
BC (Carroll 2003, 124–5). Later it was whole palaces and their associated gardens
that were destroyed, such as Alexander's sacking of Persepolis, which was the
grand symbol of his enemy, the Achaemenid Empire. Ancient gardens in Egypt
and Mesopotamia solely relied on the supply of water available from the rivers

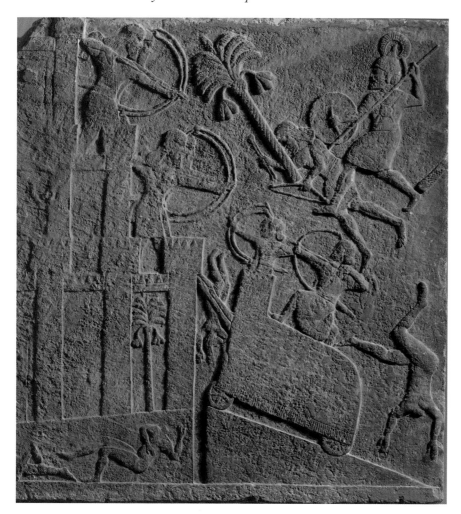

FIGURE 1.1. Trees being felled by an attacking army, Assyrian relief from Nimrud *c.*728 BC.

such as the Nile, Tigris and the Euphrates, as rainfall was unreliable. Political control therefore depended on access to this water both for the ruler's gardens and for his people. Increasingly complex systems of irrigation were thus needed to satisfy demand as the population grew. Rulers used the commissioning of waterworks as a political tool to keep the population supplied with water and to avoid any potential discontent that a lack of water would bring.

The idea of gardens and their design started to travel across the known world, as the ancient empires battled for control in the three millennia before the final dominance of the Romans. The expanding Roman Empire continued on this tradition and gave many new areas the culture of gardening, including probably Britain, now one of the most fanatical of gardening nations! Even during the so-called 'Dark Ages' in the second half of the first millennium AD, the Byzantines and then the Muslims preserved gardening traditions of the Romans (see Chapter 2). It was not just ideas that traversed lands. The ancient civilisations did not rely just on native plants for their gardens, as there is

evidence of plants being transported from one region to another as early as the second millennium BC. Some had political and economic value such as incense. Others, such as the many plants taken to Britain by Romans, were part of the process of 'Romanisation' of these lands.

Mesopotamia and the notion of paradise

It was in the plains of central Anatolia and the foothills in eastern Mesopotamia that the first cultivated crops were grown by eighth millennium BC, with the former hunter-gatherers becoming farmers. By the third millennium BC and the time of Sumerian Empire, these farmers had moved south to the delta area between the Tigris and Euphrates rivers in southern Mesopotamia, where crops relied on by the water provided by these two rivers. This water supply was quite variable and settlements often had to be abandoned when the rivers changed course. This more precarious life, compared to the north where the Sumerians had originated from, and the fact that irrigated water could literally turn the desert green, left a deep impression on these people. This came to be represented in an ornamental green space or garden. Often protected in a courtyard, they were seen as sanctuaries against the harsh surroundings outside, typically the desert. It gave rise to the powerful myth that Paradise is a garden and occurs in the first known writing of man, by the Sumerians around 2800 BC. In the poem, the Sumerian God of Water, Enki, ordered the Sun God, Utu, to create a divine garden on earth by providing water. In the Sumerian *Epic of Gilgamesh* of about 100 years later, there is a reference to a Garden of the Gods.

The Zoroastrians, the Jews with the Garden of Eden and the Ancient Greeks with their Elysian Fields, all took up this idea. The Christians and Muslims would later adopt it through their incorporation of the Old Testament into their respective holy books. The 'paradise garden' was usually described as a place where it was perpetually spring, that is, the climate was temperate, there was an abundance of plants, particularly fruit, and it was untroubled by animals (Prest 1981, 11). The word 'paradise' itself is a transliteration of the Old Persian pairidaeza meaning 'around wall' and was a regularly planted area of fruit trees surrounded by a wall. However earlier texts such as the Epic of Gilgamesh refer to a 'forest of pines or cedars, which stood on the mountain slopes of the Lebanon, [and] was a sacred place guarded by the giant Humbaba, appointed by the highest gods' (Dalley 1993, 11). Gilgamesh's destruction of this place, particularly the cutting down of the trees, was a highly symbolic act of who was in power.

Life in the Sumerian period had become more organised by the third millennium BC and cities were being built such as Uruk and Ur. In the Epic of Gilgamesh, Uruk is described as being one-third city, one-third gardens (or date palm groves) and one-third fields (Jellicoe and Jellicoe 1995, 11). While little remains of the Sumerian culture, it had a profound influence on those civilisations that followed in it, in placing the garden as a key part of its culture. Its most notable feature was stepped pyramids or 'ziggarats' that represented a sacred

mount: the link between heaven and earth. While these monumental structures were never planted,[1] there are later pictures of artificial hills that do have trees on them (Figure 1.2). Built by powerful kings, these planted hills demonstrated their prestige in being able to construct these technically difficult gardens. They also emphasised the ruler's link to the gods, as on the top of the hill, the king would be nearer to the deities and provide a legitimisation of their rule.

Trees also symbolised gods and were believed to contain a divine presence, for instance Nin-Gishzida guarded the gate of heaven and was personified as a tree. There were few native trees in central and southern Mesopotamia. The date palm, tamarisk and the Euphrates poplar were thus so important, affording shade, fuel, timber and in the case of date-palm, a valuable food source. To the north of the Sumerian Empire, in the centre of Mesopotamia, was the Akkadian empire that gradually took control from around 2300 BC. From the Akkadians comes the idea of four rivers of life and the division of the earth into quarters (later taken up by Persians, see Chapter 2). Akkadian kings were calling themselves the 'King of Four Quarters' from around the middle of the third millennium BC. By the time of the construction of the Persian garden at Pasargadae, by King Cyrus in the middle of the sixth century BC, not only does it appear to have a quadripartite layout but also Cyrus styled himself 'king of the four quarters' (Stronach 1994, 9), a direct reference to the Akkadian idea.

The fall of the last Akkadian dynasty at the end of the third millennium BC led to the rise of the Babylonians and the first mention of gardens, specifically a palace courtyard with palms at Mari, in their literature about 1800 BC (Dalley 1993, 2). Evidence of the earliest palace courtyard garden of around 1400 BC was found in Ugarit on the Syrian coast (Dalley 1993, 2). It was the Assyrian Empire, formed in the northern part of Mesopotamia in the second millennium BC that was the first to use gardens as a political statement (Stronach 1990). It became the dominant force in the region from 900 to 600 BC. Unlike its counterparts to the south, Assyria was a more benign place, being watered by mountain streams and having many native trees, enabling the creation of the first parks.[2] The Assyrian king, Assurnasirpal II, in the ninth century BC undertook enormous waterworks to bring water from the mountains to his capital Nimrud. These flowed into the lush gardens, which Assurnasirpal obviously delighted in, as he records that: 'fragrance pervades the walkways, streams of water as numerous as the stars of heaven flow in the pleasure garden … like a squirrel I pick fruit in the garden of delights' (Dalley 1993, 4).

In creating this garden, Assurnasirpal was not only showing his role in ensuring the fertility of his nation through the waterworks, he was also demonstrating his conquests through the cultivation of 'foreign' plants (Stronach 1990, 171–2). He records that he planted:

> 'seeds and plants that I had found in the countries through which I had marched and in the highlands which I had crossed: pines of different kinds, cypresses and junipers of different kinds, almonds, dates, ebony, rosewood, olive, oak, tamarisk, walnut … pear, pomegranate, fig, grapevine.' (Dalley 1993, 4)

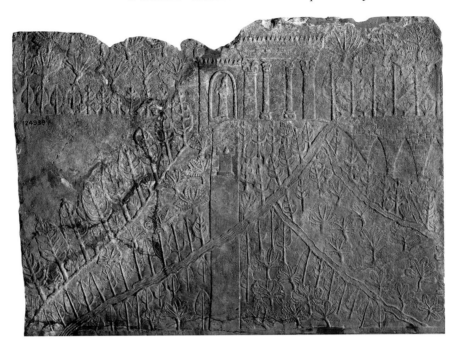

FIGURE I.2. Assyrian relief of a planted mound from the palace of Ashurbanipal, Niveveh *c.*650 BC.

What is interesting about this list is the variety: clearly his travels took him to many parts of the known world and could be regarded as one of the first botanic gardens. One of his successors, Sargon II, was much more ambitious and he made a park at the new capital Dur-Sharrukin (modern Khorsabad) from around 713 BC, creating one of the first 'designed landscapes'. Sargon used the first recorded planted mount, recorded in an inscription as 'a park like unto Mount Amanus' where all types of Hittite (ancient Syria) trees and the 'plants of every mountain' (Stronach 1990, 172) were placed. By mentioning the source of the trees and the evidence from a relief of the garden and its associated pavilion, it demonstrated Sargon's recent extensions of his empire (Stronach 1990, 172).

Sargon's son and successor, Sennacherib, although abandoning his father's new capital, also built a similar planted mount that is commemorated in a relief in the palace of the next king, Ashurbanipal, in Nineveh (Figure I.2). Sennacherib built waterworks to carry water to the capital and it would appear that a form of Archimedean screw probably watered the mount. This picture and the description by Sennacherib of this again being the image of Mount Amanus, re-enforces the political potency of this artificial planted hill. Nebuchadnezzar (604–562 BC) of Babylon took advantage of the weakness of the Assyrian empire to take control. The fabled 'Hanging Gardens of Babylon', one of the Seven Wonders of the World, have recently generated a lot of debate about whether they existed.[3] Some, like Dalley (1993) believe they were actually those referred to above at Nineveh, built by Sennacherib rather by Nebuchadnezzar in Babylon. 'Hanging' was thus a misnomer, as it did not have trailing plants but trees planted on an artificial slope.

Whether the gardens at Babylon existed or not, what is interesting is that the

Babylonian king wanted to link his city with the achievements of the previous rulers of lands that he had taken over. This is an echo of future Islamic rulers who sought legitimatisation through the symbol of a garden type (see Chapter 2). The building of similar extensive palace gardens also took place in the Achaemenid Empire in Persia such as Pasargadae by Cyrus the Great and one by his son, Cambyses II, at a site near the River Pulvar (Stronach 1990, 176). Another Persian king, Darius, built many palace and gardens at Persepolis, with the Greek author Xenophon detailing his love of gardens in 401 BC: 'in all districts he resides in and visits, he takes care that there are 'paradises', as they call them, full of all the good and beautiful things that the soil will produce' (Khansari, Moghtader and Yavari 2004, 40). The destruction of Persepolis by Alexander the Great in 330 BC clearly signalled that the Achaemenid Empire had ended.

Egypt and the power of the Pharoah

In Ancient Egypt, the Nile was critical to the country's development after 3000 BC, as the climate became drier, due to reduced rainfall. The river gave a regular supply of water, provided fertiliser in the form of silt left by the floodwaters and was a means of transport. The desert either side of the river acted as a natural barrier to invasion, leading to long periods of stability conducive to building a nation state. The river affected the development and the position of ornamental gardens. As the conditions for growing crops became more difficult, having a garden was a luxury and its size, an indicator of status (Wilkinson 1998, 13). Only those who could afford to grow plants for pleasure, rather than survival, could have a garden. In Egyptian society, this meant the royal family who had them, together with the court officials. The first documentary evidence of gardens highlights the power and prestige of the latter group. From a record in the tomb of the official Methen, about 2600 BC, there is a description of the creation of his garden where 'fine trees were set out, a very large lake was made therein [and] figs and vines were set out' (Wilkinson 1990, 204).

Creating a garden was not just about the power and wealth that the owner had here on earth, for the Egyptians, it also had deep symbolic and religious meaning as well. The garden was believed to represent the place of first creation. The widespread use of a pool (Figure 1.3) symbolised the water of Nun from which life originally sprang (Wilkinson 1994, 2). Tombs were the place from where the dead moved into the afterlife. They were modelled on the one for the god, Osiris, who was brought back to life and whose tomb chamber was enclosed in a mound of earth with trees around it (Wilkinson 1994, 3). The Egyptians believed that many plants symbolised gods and where these plants grew, deities resided. Osiris lived in a tamarisk tree and hence these were often found in funerary complexes. Critically, Pharoahs were considered as living gods, so any gardens associated with them, were therefore sacred (Wilkinson 1994, 2) and the most complex.

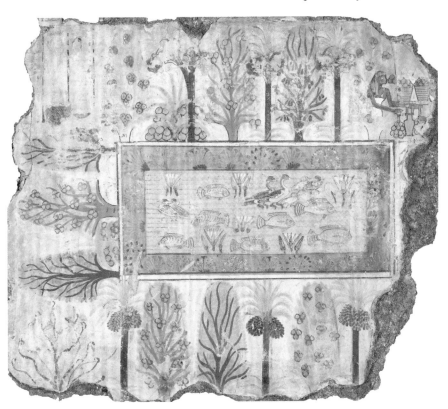

There were gardens attached to temples, tombs, royal palaces and the houses
of the wealthy officials in Ancient Egypt. Temple gardens' main purpose was to
provide offerings for it. While many of the plants used in the ceremonies were
native and therefore could be grown locally, the resin used for incense had to
be imported. Incense was such an important part of the religious ritual, as it
was thought to unite the Pharoah with the Gods (Wilkinson 1990, 202), that an
enterprising Queen Hatshepsut sent an expedition to Punt, around 1470 BC, to
collect trees for the resin. While there is some debate as to how well these trees
transplanted (Dixon 1969), it is one of the first examples of economic botany
that drove the later Empires (see Chapter 8). Sites used for both temples and
tombs were very carefully considered and chosen on the basis of where deities
were thought to reside. Pharoah Mentuhotep put his tomb and associated cult
temple in the mountain sacred to the goddess Hathor (Wilkinson 1998, 68).

Funerary temple and royal tomb gardens were placed in magnificent settings
with long avenues of trees serving as processional routes and symmetrical layouts
of twin pools and groves. Many were set in a series of terraces set against a
sacred hillside such as that of Queen Hatshepsut at Dier el-Bahari, next to the
Valley of the Kings and her ancestors. This was quite a political move as many
questioned her legitimacy to rule as a woman (Wilkinson 1998, 75). Like the
later Mughal Emperors, the Pharoahs wanted to retain their power and status
after death. Above all, these gardens had to be maintained, with water taken

from the river to irrigate the plants and to top up the pools. If they were allowed to be neglected that signalled a change of dynasty.

Large parks, as in Assyria, were largely absent in Egypt due to the climatic conditions. The one of the few built was Maru-Aten, a walled park constructed by the Pharoah, Akhenaten, around 1350 BC, as a dramatic statement of his power. Five kilometres south of his new city, Amarna, this was a sacred space, where the divine king's power was demonstrated in elaborate ceremonies for his subjects and foreign visitors (Wilkinson 1998, 154). Controversially Akhenaten had created a new monotheistic religion based on Aten, the sun god and the symbols of it were widespread through the gardens in Amarna. There has been much speculation as to why he moved from the traditional royal base at Thebes, but one view is that he wanted somewhere new to practise his religion away from the priests of Amun and the old faith (Wilkinson 1998, 146). At Maru-Aten itself, the centrepiece was a main lake, one hundred and twenty metres long and sixty metres wide. This landscape also had the first known garden pavilions that were to become popular elsewhere. The site was a difficult place for a garden with high summer temperatures and very labour intensive to maintain, further indications of the power of the Pharoah (Carroll 2003, 26). As one of the first 'pleasure gardens', Maru-Aten typifies what absolute power can do for a ruler. However its glory was short-lived as after Akhenaten's death both his religion and his capital were abandoned by his successors.

The Greek City States, democracy and 'natural gardening'

The Babylonians and the Ancient Egyptians had initially influenced the thinking of the early Greek society and they adopted the pantheon of Gods from Mesopotamia. However the development of the city-states, in particular Athens in the fifth century BC, led to a different type of politics where political power was distributed amongst the citizens rather than residing with a king and his entourage. Alongside the new ideas on democracy in Athens, any ostentatious displays by the better off were discouraged. Critically for the development of gardens, property belonging to these city-states was fairly evenly distributed both at home and in any lands that they colonised (Carroll-Spillecke 1992, 84–5). In the city, it was exclusively houses that took up these regular plots, with no room for any outside space. While there were some larger estates outside the city, these were mostly productive with fields, vineyards and orchards.

The earliest Greek gardens in the period between and eighth and sixth century BC, were those near to religious buildings or places. There are references to the sanctuary gardens of Apollo, Athena and Aphrodite planted with trees and meadows and watered by springs, in the work of Homer and Sappho (Carroll-Spillecke 1992, 85). Homer's description of the sacred garden of Alcinous in the *Odyssey* is of a walled area containing fruit trees, vines, herbs and vegetables, with a continual supply of water. In these sacred areas the natural spring represented the earth mother god, Gaia and the wooded

areas, the sky god, Uranus. This notion of the sanctity of nature was to have a profound effect on the ideas of its philosophers. Greek philosophy believed that plants and men have a natural environment that shapes them, in other words, you should work with nature not impose on it. This was another factor why in Greece, there were no large, regularly planned gardens as had been seen in Ancient Egypt and Mesopotamia. Greek art too reflected the ideals of its philosophers in trying to recreate the natural world, hence the realistic quality of their paintings and sculptures. No Greek building attempted to dominate the landscape, as the situation was more important than the building itself. The *genius loci* or pervading spirit of a place distinguished a sacred place, so it needed little in the way of man-made intervention.

By the fifth century BC, a significant proportion of the Greek population was now urbanised. The urban houses were unable to have gardens, as the water supply to their houses was limited, as they relied only on spring water. Archaeological evidence has shown that all courtyards were hard landscaped and they only grew plants in pots. Most popular was the 'Adonis garden' or fast growing plants in clay pots or broken amphorae where plants matured and died within days, symbolising the life and death of Adonis. The only access to green space therefore were the public areas such as the Agora in Athens and the 'green belt' that surrounded the cities. The Agora in the heart of the city was the main assembly place for the people or *polis* and the planting of trees here was intentional. Since it was where the important political business took place (Carroll-Spillecke 1992, 86), the numerous citizens needed to be shaded from the sun during the long debates and votes. The Athenian statesman Cimon is credited with the planting of the Agora, as part of the campaign to reinforce the new democracy.

Other *agorai* in the Greek Empire were similarly planted and these it could be argued were the first public parks. Later Roman leaders who wanted to gain favour with their population would embrace this idea enthusiastically. The Greek philosophers were keen to spread their ideas through schools or *gymnasia* and they chose the site of sacred groves for these in the outskirts of Athens (Carroll-Spillecke 1992, 91). These naturally wooded areas with the benefit of springs for irrigation were ideal. The first of these was Plato's Academy, which had a landscaped area for the teachers and students to discuss their ideas and the Lykeion, founded by Theophrastos. These 'philosopher gardens' were copied in the Roman period by Cicero and Hadrian and again in the Renaissance, as garden surroundings became linked with radical thinking, in all areas including politics.

The period of democracy in Greece came to an end following the rise of Alexander the Great in the fourth century BC. Xenophon, a Greek essayist and historian, visited Persia in 401 BC and took the idea of the Persian pleasure gardens or *paradeisos* back with him to Greece. He was clearly impressed saying that the Persian king Cyrus filled his gardens with 'all the good and beautiful things that the earth wishes to put forth' (Carroll 2003, 49) and the new Greek

rulers started to build pleasure gardens. The Greeks' previously natural parks became more elaborate with fountains, statues and grottoes. For most Greeks having a garden at this time, was still a luxury. The difference was now the rich could not only afford a garden space in the suburbs of Athens, there was no political pressure to avoid such displays of wealth. When the Greek king Ptolemy took over in Egypt, he and his dynasty built gardens in the new city of Alexandria but in doing so, they were following an ancient Egyptian idea, rather than a Greek one (Carroll 2003, 30). In doing so, they were making a statement more about their legitimacy to rule (as Pharoahs) than any aesthetic considerations.

The 'politicisation' of Roman gardens

Roman society was far removed from the idealistic democracy of ancient Athens. Though it was influenced by Greek philosophy and started as a republic, the wealth created by the expanding Roman empire allowed the upper classes a standard of living more akin to the ancient Egyptians. Through their poets such as Virgil, Ovid and Horace, the Romans had an idealised view of nature and the rural life was glorified, albeit for those wealthy enough to afford comfortable living in the countryside. The concept of the *villa urbana* or country villa and associated *horti* (garden) became popular in the first century BC and was the forerunner of the country estates of house and garden that the wealthy have built for themselves over the next 2000 years. These large estates and associated gardens had developed in the second century BC when smaller properties became uneconomic and their owners forced to sell out to the wealthy Equestrian order, the second rank after the Patricians in the social hierarchy (Stackelberg 2009, 74). As the dispossessed rural population moved to the towns, they became disenfranchised as only those owning property could vote and join the army, thus political power became increasingly concentrated by the first century BC.

The Roman gardens incorporated elements of Egyptian, Greek and Persian design, although for the first time even the more humble urban homes had a garden, often enclosed in a *peristyle* or courtyard (Figure 1.4). The earliest evidence of this style of garden at Pompeii dates from the second century BC but gardens were being put in Roman houses at least 100 years before that, possibly influenced by the Etruscans, their northern neighbours (Farrar 1998, 17). These early Roman gardens were typically an open piece of ground at the back of the property, where edible as well as ornamental plants were grown. From their early *hortus* (productive patch of land), the concept of the Roman 'pleasure garden' began to emerge. From the Greeks, they took the idea of putting sculpture in their private gardens, although the former had used the statues mainly in their public areas. The large number of gardens, together with their increasingly sophisticated waterworks, was only made possible by the improved water supplies that they now had available to them. Advances

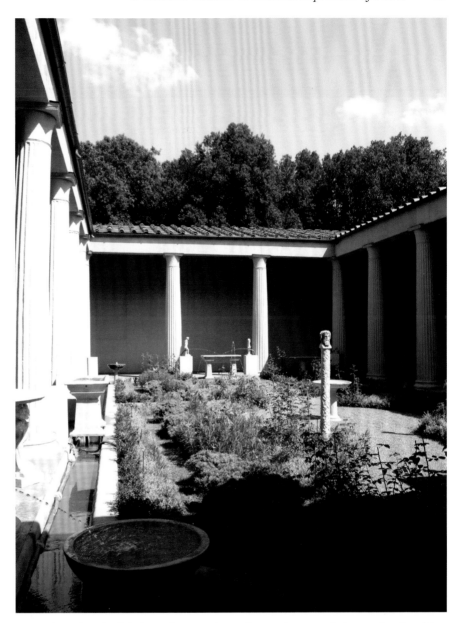

FIGURE 1.4. Recreation of the garden of the House of Vettii, Pompei in an exhibition at Boboli Gardens, Florence.

in engineering had led to the creation of aqueducts and domestic plumbing for their water supply, rather than relying on springs as the Greeks had done (Farrar 1998, 22).

Whilst their ideas on garden design had come from a myriad of sources, the Romans would be the first civilisation to actively 'export' their style, alongside their architecture, throughout their expanding empire. It was not only design ideas that moved round the Roman world, plant species also came into the empire from the surrounding area via trade. Many key edible plants such as the cherry, peach, damson, citron and melon were introduced to Italy. Romans

also took their plants with them to the extremes of the Empire including Britain, vastly increasing the stock of those islands, although some plants fared better than others in the British climate! Pliny the Elder notes that Lucullus brought the cherry to Italy in 74 BC from Pontus and that 'now, in the course of 120 years, it has travelled beyond the Ocean, and arrived in Britannia even' (Jennings 2006, 62–3).

It was in Rome itself though that the garden was used in the most overt political way. As the republican ideals, inherited from Athens, were slowly dying away during the power struggles of the mid first century BC, two garden types became the focus for political activity. The first was the *villa urbanae* of leaders such as Caesar and Pompey and the second was the public park or *porticus*. In the neighbourhood of Baiae, on one of the hills surrounding Rome, Gaius Marius became the first to actively use his villa for political purposes. Marius was a politician and military leader who had introduced the recruitment of landless citizens into the army in 107 BC. His power base came from these soldiers, who received land in return for military service, thus enabling them to vote. Stackelberg (2009, 74) observes that Marius 'consciously built his estate at Miseneum on the same principles as a military camp' not only as a reflection of his power base but also in a strategic location overlooking the city. The implication being that he was keeping on eye on the events in the city.

The villa and garden built by another statesman, Lucullus, a few years later between 68 and 63 BC, had a very different message. He was out of power at the time as Pompey had replaced him as head of the army. As a result, he was required to reside outside Rome. Instead of an austere, militaristic place, the gardens of his villa on the Pincian Hill more closely resembled the pleasure gardens of Persia. He had conducted many military campaigns in the East and was probably inspired by the gardens he had seen there. They were also an unsubtle way of demonstrating his military achievements. Lucullus used the villa primarily to entertain selected guests and show off his wealth. A forerunner of the 'Cardinal villas' of the sixteenth century (see Chapter 3), the garden was a series of terraces that ran down to an artificial lake at the bottom. Such engineering skill was bound to impress but it was just for his fellow politicians. He had no need to cultivate the loyalty of either the soldiers or the population as a whole, as he did not seek immediate re-election. As a testament to the garden's magnificence and desirability, a later owner, Valerius Asiaticus, was forced to commit suicide so that Messalina, wife of the Emperor Claudius, could take possession (Farrar 1998, 49).

However it was the two bitter rivals, Julius Caesar and Pompey who were to use their respective villa gardens, to try and gain political power. Due to the changes introduced by Marius, soldiers were loyal to their respective general rather than to the Roman army as a whole, so each man had a powerful political base. Both these men used their *horti* to seek favour, encouraging supporters and voters to visit them. In comparison to the small garden these people would have had themselves, this would have been a great privilege. By implication,

the owner was thus re-enforcing his power and prestige by the opulence of their garden. In his election campaign, Pompey even used his garden as a place for buying off voters (Stackelberg 2009, 76). Caesar used a different tactic by holding feasts for the people in his *horti*. The first of these was in 46 BC, which celebrated not only one of his military victories but also the defeat of Pompey two years previously. This was unusual as such public feasts were normally held in public areas, following the Greek tradition. To move it to Caesar's private space was therefore highly significant. Earlier that year, Caesar had reformed the system of welfare ('corn dole') and by having the feast in his garden, he was reminding the population who was literally putting food in their mouths (Stackelberg 2009, 76). Mark Antony went one step further and following Caesar's death, promised his followers *horti* as a reward for their loyalty.

Clearly Vitruvius' advice of

'for men of rank who, from holding offices and magistracies, have social obligations to their fellow-citizens, [and should have] lofty entrance courts in regal style, and most spacious atriums and peristyles, with plantations and walks of some extent in them, appropriate to their dignity.' (1914, 182)

was inspired by the villas of these politicians. By the end of the Republic in 27 BC, it was not uncommon for the wealthy to have a number of properties, which would be used according to the season, for example maritime villas in the winter. These were 'public spaces' and nobles vied with one another in terms of size and quantity of these estates. However the use of the *horti* as a political tool amongst the elite declined as power within the Imperial family increased. Many prized estates fell into the hands of the ruling Julio-Claudian dynasty, after their owners were forced to leave their properties as legacies to the Emperor (Carroll 2003, 58). The first Emperor, Augustus, an astute politician, recognised how divisive the grand estates had become and restricted himself to a very modest villa and garden. His successor, Tiberius, shown no such restraint and built himself a luxurious palace on the Palatine Hill, which became the Imperial residence.

A later Emperor, Nero, appropriated eighty hectares of land on the slopes of the Palatine and Esquiline hills, following a fire that destroyed large parts of Rome in AD 64. He built his *Domus Aurea* (Golden House) there with its associated landscape park and man-made lake, in a show of luxury and excess that was not appreciated by the propertied classes (Carroll 2003, 58). When Nero was murdered four years later, his successors Vespasian and Titus, gave much of the estate to the public, as a way of placating the masses, who had been particularly incensed that the estate had also blocked many arterial routes into the city (Farrar 1998, 52). Later Emperors however were undeterred and Vespasian's son, Domitian rebuilt the imperial palace on the Palatine Hill, known as *Domus Flavia* between AD 81 and 96. Its landscaped gardens had many features that would become popular elsewhere such as sunken gardens within a courtyard, a hippodrome garden and sophisticated waterworks. The

most magnificent and largest estates though were those outside Rome, where access could be restricted and therefore mitigate any resentment over the cost of them. One of the largest and the best preserved of these is Hadrian's Villa built in the second century AD.

The public park or *porticus*[4] in Rome had drawn inspiration from the Greek ideas of the sacred grove and the *agorai*. At first, these were natural spaces near the urban areas but as the cities grew, the first planned parks were made. Politicians increasingly saw the provision of public parks as a way of re-enforcing their legitimacy and so they were often built near to sacred sites (Kuttner 1999, 10). The first was Porticus Pompeiana, completed by Pompey in 55 BC. Situated in the less developed Campus Martius, it was already a place where crowds gathered and it was an attempt by Pompey to shift the focus away from the main Forum Romanum, where the population traditionally met (Gleason 1994, 13). In addition to a theatre, Pompey built a portico containing a garden planted with a symbolic avenue of plane trees that he had specially imported from Asia. These together with statues representing places he had conquered and the Temple of Venus Victrix (Pompey's divine protectress), they were an unsubtle message of his achievements (Stackelberg 2009, 81). In the space next to the *porticus*, Pompey completed his dominance of the area by building himself a villa, which was later owned by Mark Antony.

Not to be outdone, Caesar built the Forum Iulium in 54 BC, along very similar lines with a theatre and garden. However Pompey was to have the last word, albeit from the grave, as Caesar was murdered in the Porticus Pompeiana, collapsing next to his rival's statue (Gleason 1994, 13). Augustus, Caesar's adopted son, extensively remodelled the site probably to remove the political significance of the place. Certainly Pompey's statue suffered the ignominious fate of being boarded up and finally becoming a latrine (Gleason 1994, 24). Caesar had willed his horti to the Roman people as a way of ensuring that support for him, and by implication for his successor Octavian (Augustus) remained. Another who wanted to be immortalised through the provision of a public park was Agrippa, an official during Augustus' reign. His main achievement was the doubling of Rome's water supply between 33 and 12 BC. The Porticus Agrippae, in Campus Martius was a bath complex that he donated to the Roman public on his death. It included a large still pool and a canal of running water supplied with water from one of his aqueducts, the *Aqua Virgo*.

Emperor Augustus too built public parks to improve the lot of the urban dweller and to repair the damage done during the civil war following Caesar's death in 44 BC. He wanted to portray himself as the ideal citizen, which in Roman terms meant being a farmer and soldier. So by providing *horti* for the masses, Augustus was symbolically cultivating their well being (Stackelberg 2009, 89). Later Emperors, such as Vespasian in AD 71 and Trajan in AD 112, would also make their mark by building public parks in Rome. As well as being adjuncts to theatres, porticos also placed next to public baths, libraries and temples. This trend spread to the Empire with public garden complexes being

built in the major settlements. There are theatre garden complexes at Italica and Mérida in Spain, gardens associated with baths in Portugal, Turkey and Tunisia and in Athens, the Library of Hadrian had a portico next to it (Farrar 1998, 182–3). Those public parks that were placed near temples reflected their origins as a sacred space.

Roman gardens were ultimately about control and public display, by those who had designed them and the purpose they were used for. What had driven the increase in the number and size of gardens in the ancient world was the availability of water. Until the Romans, this meant that gardens were reserved mainly for the rich and powerful who could control the water supply. As part of the democratic ideals inherited from Athens and perhaps a cynical ploy to keep the masses happy, the Roman leaders engaged in massive public works that brought a regular water supply to the population. Both private and public gardens were introduced throughout the Roman Empire that put a stamp on their respective areas that showed that the Romans were here to stay. In time these colonial outposts became more important than Rome itself, particularly when Emperor Constantine formally moved the capital to Constantinople in AD 330. This was symbolised by important statues being removed from Hadrian's Villa and placed in Constantine's new palace in the new capital. Despite these attempts to shore it up, as the Roman Empire crumbled in the late fifth century AD, then so too did its estates and gardens (Farrar 1998, 191). Country villas increasingly had to be protected against the barbarian invaders and Rome finally ceased to be a centre of power. The garden once again became an enclosed private space that would only be 're-opened' by the Italian Renaissance 1000 years later.

Notes

1. Sir Leonard Woolley excavated one at Ur and in 1954, he mistakenly stated they were planted with trees (Dalley 1993, 45).
2. The Assyrian hunting parks probably originated around two thousand BC with the collection of exotic animals by kings through conquest.
3. See Dalley 1993; Wiseman 1983 and Reade 2000 for the debate.
4. Often called *porticus*, which although means colonnade, took on the general meaning of a public urban park (Gleason 1994, 13).

Hadrian's Villa, Rome

Built near the town of Tivoli (Tibur in Ancient Rome) between AD 118 and 134, Hadrian's Villa is one of the most complex of the *villa urbana*, which had become popular in Rome in the first century BC. This was a massive undertaking as the site was originally 300 hectares (Figure 1.5) and the nearby town of Tibur expanded rapidly due to the construction of the villa. Excavations done in the sixteenth century by Pirro Ligorio, on behalf of Cardinal Ippolito d'Este, indicated that there were ninety piazzas or distinct areas with many containing soil and, therefore, gardens (Jashemski and Ricotti 1992, 579). Modelled on the now lost villa and gardens of the *Domus Aurea* built by Emperor Nero, it showcased Roman architectural skills and engineering. It further highlighted Hadrian's consolidation of the Roman Empire, by naming parts of the complex after the places that he favoured such as Greece and Egypt.[1]

The Empire had reached its geographical limits under Hadrian's rule, as he made the decision to consolidate Roman territory rather than try and expand further. This villa was the largest ever construction by a Roman emperor and represents Ancient Rome at its height of power and influence. Hadrian was in some ways an outsider, having been born in Spain rather than Rome. Although he was not the first non-Roman born Emperor (his predecessor Trajan was also from Spain), Hadrian was not compelled to assert his authority by hiding his origins and being more 'Roman than the Romans'. Indeed the villa's many references to the Roman provinces reflect their importance to him. The villa was a very personal project and it is believed that Hadrian himself was the designer and the architect (Ehrlich 1989, 161). The site had originally been a modest villa dating from the Republican era but this was soon dwarfed by Hadrian's masterpiece. It was unlikely that such a place could have been constructed in the centre of Rome, as this would have been too politically sensitive. Away from the masses, Hadrian could indulge in this large project and create reality from his imagination (Bowe 2004, 62–3).

Water was key to the overall design and the main reason why the site was chosen was due to the nearby spring and aqueducts (Jashemski and Ricotti 1992, 579). The Greeks had attached much importance to water, with springs having sacred connotations and being associated with the gods such as the nymphs who looked after them. 'Nymphaeums', which could be a natural spring or a man-made fountain or artificial grotto, had become popular in the Greek world (Ehrlich 1989, 172) and the Romans adopted the idea, as they had done with so much other Greek culture. For the Romans though, water and its movement through a space was more about artistry and technical expertise, rather than having any sacred meaning (Ehrlich 1989, 161).

FIGURE 1.5. Model of Hadrian's Villa at Tivoli, showing the layout when first built.

There are many and varied water features at Hadrian's Villa, which range from small to large pools of still water, rills, single jet and complex fountains. Of the twenty-five distinct architectural areas that remain today, nineteen have some sort of water feature and a further four have a theatre where no water would be present. Ehrlich (1989, 165–6) has speculated that the type of water feature used was deliberate. In the public areas, there was often moving water, typically fountains, which were not only lively, thus encouraging social discourse, they were also there to make a grand statement about Hadrian and his ability to manipulate one of nature's forces. In the more private areas, the water is stiller, aiding contemplation but perhaps also it did not need to be so opulent in its display.

In the famous 'Canopus' area (Figure 1.6) dating from AD 133–138, water played a vital part in the iconography that Hadrian wanted to project about himself and the Roman Empire. The layout is a long pool of water, representing a branch of the River Nile with a covered area or 'exedra' at one end (Figure 1.7). Around the pool were a series of statues, some of which have been recovered (Figure 1.8). Judging by those that have survived,[2] which represent Rome, Greece and Egypt, Hadrian's interest in the wider Empire is once again evident. The name of the area 'Canopus' comes from an Egyptian settlement near Alexandria, celebrated at the time for its magnificence. It was not meant to replicate the latter in terms of using Egyptian style, it was just a symbol (Ehrlich 1989, 169). Originally this

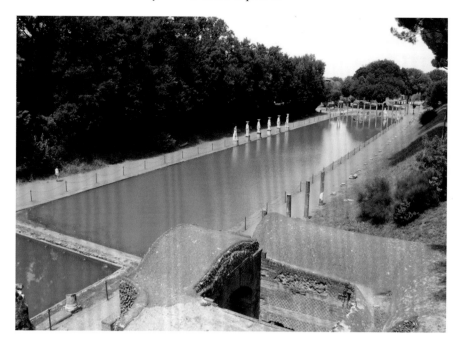

FIGURE 1.6. The Canopus
at Hadrian's Villa, Tivoli.

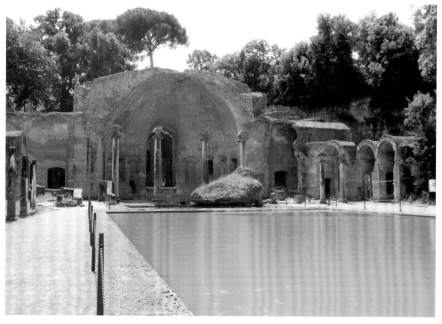

FIGURE 1.7. The Exedra
in the Canopus area,
Hadrian's Villa, Tivoli.

area was thought to be the setting for the tomb of Antinous, Hadrian's lover,
but despite major excavations, no tomb has been found and so this theory has
been disproved (Jashemski and Ricotti 1992, 580).

Instead, it was a dining area or *triclinium* that was used for parties and
banquets in the summer months. Hadrian would sit at one end at the back of
the exedra (Figure 1.7) apart from his guests. A foaming waterfall behind him
provided a focal point and made an obvious point about his position in the

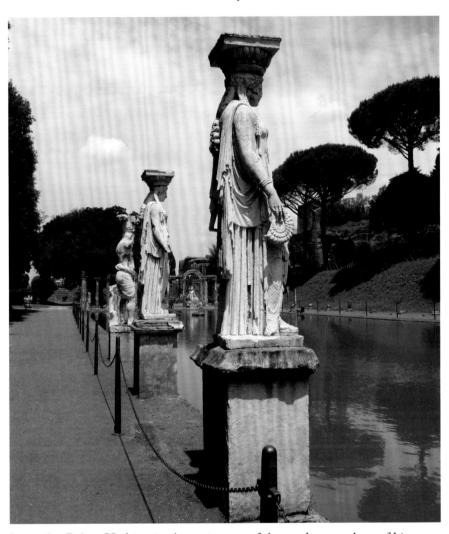

FIGURE 1.8. Statues
around the *nilus*,
Hadrian's Villa, Tivoli.

hierarchy. Below Hadrian in the main part of the exedra, members of his court and important visitors would have sat on a stone couch or *stibadium* where water flowed by in a channel from the fountain behind Hadrian. In the two adjoining pavilions would be the next rank of visitors, who although would be shaded would not have cooling water running next to them. The lowest ranks would be in the open air alongside the '*nilus*' or central pool (Ehrlich 1989, 171).

Another dining area or *triclinium* was the now named 'Piazza d'Oro' or Golden Square.[3] This was part of the main villa complex and a less public area than the Canopus. However this was still a place for public display as demonstrated by another 'exedra-nymphaea' or niche with fountains at one end. Here again Hadrian and selected guests would sit and view the proceedings in the main courtyard. Unlike the Canopus, this was a large peristyle garden enclosed with a double portico to afford shade. Down the middle was a shallow *euripus* or channel (Figure 1.9) and either side it would have been planted, possibly with clipped box (Jashemski and Ricotti 1992, 593–4). To the north of this area was a

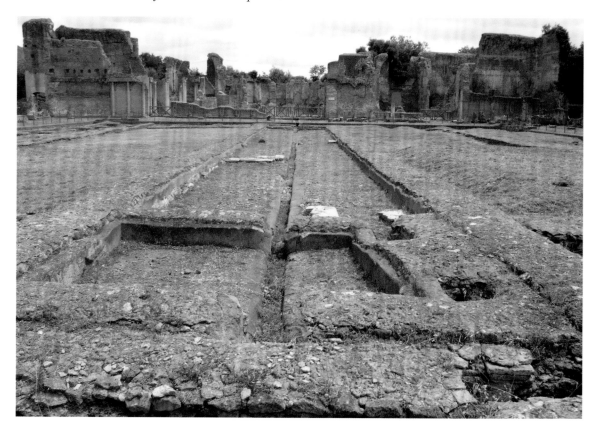

landscaped valley which was designed 'to recall the idyllic surroundings of the Vale of Tempe in Thessaly, in the foothills of Mount Olympus' (Farrar 1998, 53) in Greece.

FIGURE 1.9. Channel and planting areas in the Golden Square, Hadrian's Villa, Tivoli.

It was thus clear that Greece was the most important part of the Empire for Hadrian, perhaps to demonstrate his culture and learning. One of the largest structures is the *Poikile* and it was named after the famous *stoa* or covered walkway in Athens (Figure 1.10). A place for exercise, it could possibly have been a hippodrome garden, a style that was popular at the time and Pliny famously described the one at his Tuscan villa. Certainly the 'Garden-Stadium' near it was in this style of a long thin garden with a rounded end, although this was unusually divided into three sections. The Northern section was primarily for the Emperor's private use and the southern part was a public space.

The most intriguing area is the so-called 'Villa of the Island' (Figure 1.11). It is next to the Greek and Latin libraries and was previously known as the Maritime Theatre. Thought by the archaeologist, Ricotti, to be the first building on the site, at its construction around AD 118, it would have been surrounded by agricultural land and vineyards.[4] In this area, a moat encircles a small island that is only connected by two drawbridges. Hadrian could thus ensure his security by pulling this up at night, as the site would have an isolated place initially. In the centre of the island is a typical small atrium and around it, are small living and dining areas. This was a very private place just for Hadrian and a couple

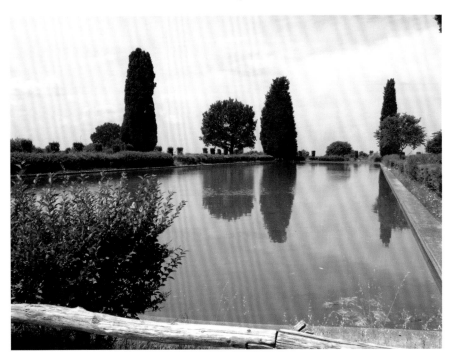

FIGURE 1.10. *Poikile* at Hadrian's Villa, Tivoli.

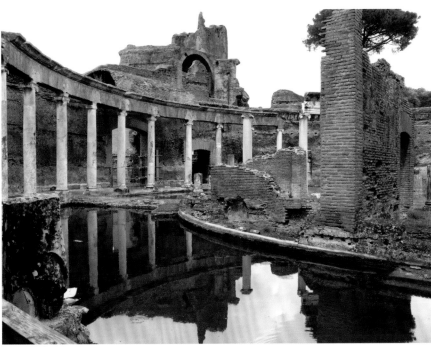

FIGURE 1.11. Villa of the Island, Hadrian's Villa, Tivoli.

of friends. It is said that he disliked Rome and while not away on campaign, sought refuge here. It also provided a base to keep an eye on the construction of the rest of the site.

Some historians have attached greater meaning to this space with it being

described as a pleasure pavilion or an aviary (by Gothein) and perhaps more bizarrely as a sanctuary to host the divine emperor in a cosmic theatre, with the central area having a roof and a planetarium-like ceiling (by Stierlin).[5] While these theories cannot be disproved, the fact that it was the first construction makes these unlikely. In particular the idea of a 'cosmic theatre' would not seem necessary, as there were plenty of other spaces where Hadrian could assert his public position such as the Canopus and the Piazza d'Oro.

Hadrian's immediate successors continued to use the villa as an imperial residence until the end of the second century AD. During the next century, with the rapid succession of Roman Emperors, the estate fell into disrepair, however the Emperor Diocletian restored it during his reign at the end of the third century. Its resurgence was brief as Constantine took many of its statues to his new capital in the East and alongside much of Imperial Rome, it was damaged by the invading barbarian armies preceding the final fall of the Roman Empire in the late fifth century AD. In the twelfth and thirteenth centuries, it was a source of building materials for the town of Tivoli and slowly its identity was lost. At the end of the fifteenth century, Biondo Flavio correctly identified it as Hadrian's Villa as described in the *Historia Augusta*. With the first 'excavations' and Pope Pius II's description of it in his *Commentarii*, the villa's fame began to spread. Pirro Ligorio despite being a renowned architect, contributed too to the decline of Hadrian's villa. He removed many of the valuable remaining statues and precious marbles during this 'excavations', which would be used later at Villa d'Este (see Chapter 3). At the end of the nineteenth century, Hadrian's Villa finally became the property of the Italian state and a concerted effort was made to protect the site.

Notes

1. This is commented on by his biographer in Historiae Augustae (Farrar 1998, 52).
2. A warrior (Ares or Theseus?). Hermes, Athena, copies of two Amazons from the Temple of Artemis at Ephesus, a crocodile, Tiber with the she-wolf and twins Romulus and Remus and a statue of the reclining Nile with a sphinx, Jashemski and Ricotti (1992, 580).
3. Possibly called Prytaneum (the Greek centre of government) from a list by Hadrian's biographer, Aelius Spartianus (Farrar 1998, 52).
4. www.espr-archeologia.it/articles/287/The-Maritime-Theatre-Hadrians-Pied-terre-at-VA [consulted 19 June 2011].
5. www.espr-archeologia.it/articles/286/Theories-and-datation-of-the-Maritime-Theatre [consulted 19 June 2011].

The Garden in the Islamic Empire's Expansion

..

'The world is a garden for the state to master
The state is power supported by the law
The law is policy administered by the king
The king is a shepherd supported by the army'

This statement of kingship comes from a 1425 copy of the *Nasayih-i Iskandar* (The counsels of Alexander), an essay giving the principles of statecraft for Islamic rulers (Lentz and Lowry 1989, 12) and demonstrates the central role of gardens not only in Islamic culture but also politics. It is no co-incidence that the seat of power for a Muslim ruler is often placed in the centre of a garden, either for a living king or for his tomb: the most famous example of the latter being the Taj Mahal (Figure 2.1). Indeed the first mosque was in a garden. While many conquerors have stamped their authority on their newly acquired lands by extensive building programmes, Muslim invaders have used a geometric style of garden first developed in the sixth century BC in Persia. Often referred to as the *chahar bagh* or quadripartite garden (Figure 2.2), it appears in various forms across the Muslim world.[1] It shares the common characteristics of regular layouts, the use of water in channels and fountains and a central feature.

The first Mughal Emperor, Babur, records the many gardens he created during his conquest of Afghanistan and India in his memoirs. He noted that the latter was in particular need of his creations, saying 'the cities and provinces of Hindustan [India] are all unpleasant. All cities, all locales are alike. The gardens have no walls, and most places are flat as boards' (Thackston 2002, 335). Why did Muslim rulers use the garden in this way and what was its role in the expansion and cementing of the Muslim world? Romans took their model of gardens, as well as architecture, as a blueprint for their conquered lands, in order to 'Romanise' them. For Muslim rulers, the building of their style of gardens was less of an overt political statement and more a case of creating something that gave a focus to their identity and more importantly, their legitimacy. The garden served firstly as a symbol of territorial and social control and secondly as a place of social access and interaction. In doing so, 'gardens gave shape to

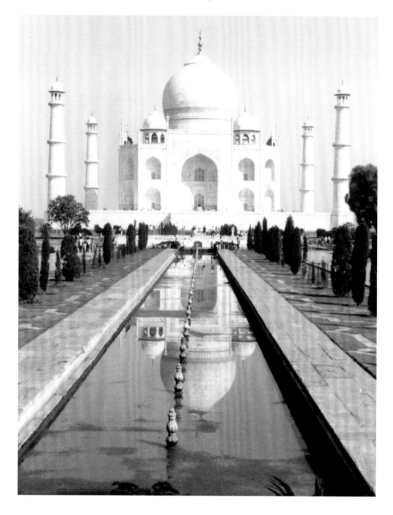

FIGURE 2.1. Taj Mahal, Agra.

both the aesthetic experience and functional organization of ... urban centres' (Wescoat 1986, 12) such as Samarkand, Cordoba and Isfahan.

Why were gardens so important to them? Part of the answer lies in the origins of the first Muslims who came from the arid Arabian Desert where water was critical for survival, not for making gardens. It was not until they conquered Persia in the seventh century AD that these followers of the Prophet Muhammad saw the 'desert flowering' and made the link between earthly gardens and promised paradise that awaited them. These gardens were self-contained and did not use the surrounding landscape as a backdrop. Indeed the outside was either desert or a crowded city street, so the garden was literally an oasis of calm and shade and a place of retreat. Their belief that a garden represents paradise on earth, is not uniquely an Islamic notion because this idea goes back to the Sumerian culture of the third millennium BC. All Abrahamic religions share the idea of entry to heaven being conditional on a worthy life on earth.

Islamic gardens though are invariably sacred as there is no separation in

FIGURE 2.2. *Chahar bagh* and gatehouse at Taj Mahal, Agra.
PAINTING BY JILL BISHOP.

Islam between the secular and the non-secular. From the Koran, two elements are important: water and greenery. Water was the source of life for all living creatures and the gardens in paradise always had flowing water (Gelani 1996, 182). The first mosque of the Prophet in Medina was built on a site called *hadiqa* as it had a palm tree plantation (Gohary 1986, 32). Images of gardens were shown on the panels of the Great Mosque at Damascus and other early Islamic buildings. To see Islamic gardens however, as merely recreations of paradise is to obscure the more fundamental reasons for their construction, which were more concerned with matters on earth rather than heaven.

The political nature of the Islamic state was influenced firstly by the complex relationships surrounding the prophet Muhammad and his extended family and secondly by their Arabian background. While the Middle East at the time was controlled by two large empires: the Byzantine (or Later Roman Empire) and the Sassanian, the first Muslims were nomads who traditionally were outside of the political control of such empires that were based in the larger settlements. For these nomadic people ties of kinship were far more important than a distant ruler. When the Prophet died in 632, his successors or *caliph* were part of his extended family. In two years, through an aggressive military campaign, Abu Bakr, Muhammad's father in law, had secured all of Arabia. It was the next two *caliph*, Umar ibn al-Khattab and Uthman ibn Affan who took over most of the Sassanian Empire (including Persia) and substantial parts of the Byzantine Empire by 656. This conquering zeal was driven by the fact that these Muslims 'saw their mission as *jihad*, or militant effort to combat evil and to

spread Muhammad's message of monotheism and righteousness far and wide' (Donner 1999, 13).

The fourth *caliph*, Ali, was the first direct relation of Muhammad. His assassination in 661 led to the first major division in Islam between Sunnis and Shias: the latter being supporters of Ali and his descendants. The Sunnis supported Muawiyah, a kinsman of Uthman from the Umayyad clan and under his leadership and his successors, the Islamic empire continued to expand to include Samarkand, parts of northern India and most of Spain by 713. Family links were to intervene again when the Abbasids (descendants of another of Muhammad's cousins) took power from 750. One of the Umayyad dynasty, Abd ar-Rahman, escaped to Spain and established the Cordoba caliphate.

The Abbasid caliphate lasted until 1258, when the Mongols executed the last ruler. Their real power had started to dissipate around 950 when secular rivals, principally the military commanders, took control in the disparate empire. Islamic rule was now firmly established from Spain to India and created one of the most sophisticated cultures of the time. All the arts and sciences were studied at centres such as Baghdad and they embraced the work of the Greeks, Romans and Persians, including botany and gardening. What united the Islamic world by the thirteenth century was not 'political boundaries and hegemony … it was a common set of religious beliefs…and other elements of Islamic culture, and this identity was firmly enough established to survive even rule by non-Muslims such as the Mongols' (Donner 1999, 61). In this context of a common Muslim culture, the gardens created by Islamic rulers were part of the political legitimacy that these rulers sought, by emphasising a link back to the past, be it to Muhammad himself or other great rulers such as Timur.

Early Islamic gardens and their influences

The Arab Muslims were influenced by the gardens they found in Persia and the Roman ones in the Byzantine areas they conquered, such as Syria and Palestine. The Persians had a long history of garden building, dating from the sixth century BC when Cyrus the Great built his famous palace at Pasargadae. In Persia, the Arabs encountered the *chahar bagh* or quadripartite garden design for the first time. This design with a building situated in the central axis of a garden was as Stronach (1994, 3) points out: 'an unequivocal demonstration of the way in which … a recognizable symbol of power at the apex of a garden design could be used to imbue a visual, axial avenue with potent indications of authority'. This idea clearly appealed to the new Muslim rulers, which they would have encountered in the Taq-e Kasra palace at Ctesphion. It was located in a walled hunting park that had the palace at the intersection of the main axes. To the Arabs who conquered the city in 637, this was paradise and according to the historian, Ibn Khaldun, they were 'won over by the taste for a life of pleasure (and) they learned the arts of architecture from the Persians' (Khansari, Moghtader and Yavari 2004, 12).

The new Islamic rulers of Persia took this idea of a royal pleasure garden and spread it throughout their conquered lands. The first of these, the Umayyad dynasty, ruled from Baghdad but controlled the Middle East and ultimately Southern Spain from mid-seventh century. Although little evidence of gardens exists from that early period, later members of the dynasty in Spain show the influence of the Roman style of courtyard garden that was favoured in Byzantium. Umayyad gardens in Syria and Palestine copied the local Roman rural villas in the desert where 'caliph and princes went to escape the uneasiness of Syrian cities to find something closer to their origins' (Strika 1986, 72). With the Umayyads, garden design began to develop into a fixed set of ideas, based on the *chahar bagh* and the use of water (Ruggles 2008, 26). This had political potency for two reasons. Firstly the provision of water was something a ruler could give his people and secondly the conspicuous use of it in non-essential areas like gardens, had always been a symbol of wealth and power.

More evidence of the *chahar bagh* model being adopted[2] comes from the Abbasid dynasty, *caliph* of Baghdad from the eighth century AD. The *caliph* al-Mutasim, for political reasons, built a new city at Samarra from 835. He had built up an army consisting mainly of mercenaries in the belief that they would only be loyal to him and the new capital was a way of reducing tension between the Arabic speaking population of Baghdad and the soldiers. The Balkuwara Palace, built there between 849 and 859, has been excavated to reveal a series of courtyards that may have contained water channels leading from a central fountain. The throne room was not only at the highest point, so that there was an extensive view of the surrounding plains, it was also in direct axial alignment to the three courtyards. In the Dar al-Khilafa palace, there is the same arrangement of gardens in courtyards leading up to the throne room and beyond.[3] These are the first evidence of an important building at or near the centre of an axial garden layout, putting the ruler at the centre both literally and metaphorically.

The Arabs had conquered Spain as early as 711 but it only became an independent Muslim state in the latter part of the century under the Umayyad prince, Abd al-Rahman. He and his successors cemented their rule by restoring the infrastructure of the former Roman colony and allowed the agricultural economy once more to flourish. Cordoba became the capital and the Munyat al-Rusafa was the first new palace to be built. It was located outside the centre where there was a better supply of water. Although no evidence of any gardens remain, they were praised and considered important by contemporaries. Certainly the name, if not the layout, was a reminder for the Umayyad dynasty of their roots in Syria, territories that they had now lost to the Abbasids amid much bloodshed. Thus the priority of gardens was established for all subsequent Hispano-Umayyad palaces (Yeomans 1999, 88–9).

In 936, the palace-city of Madinat al-Zahra (Figure 2.3) was built outside Cordoba by Abd al-Rahman III. Seven years previously, he had declared himself *caliph*. This move enforced his rule not only over al-Andulus but also staked a

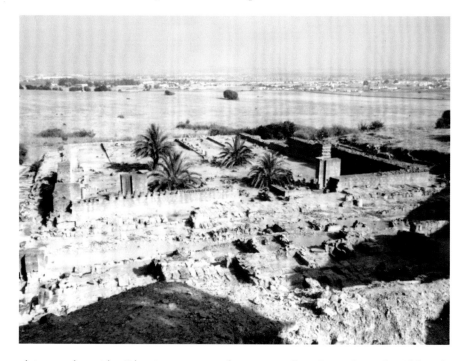

FIGURE 2.3. Madinat
al-Zahra, Cordoba.

claim to the wider Islamic empire as the power of rivals, such as the Abbasids
and Fatimids, was waning. He needed a suitable setting for a court to vie with
his rivals and so Madinat al-Zahra, modelled upon the spectacular palaces of his
rivals such as Samarra, (Ruggles 2000, 56) was the result. It had three terraces
with the palace on the top one, the middle one with gardens and lowest with
the mosque and servant quarters. The ruler was again in a central location
overlooking elaborate gardens, in the same way as a landowner supervised the
cultivated fields (Ruggles 2008, 48), demonstrating the source of wealth for the
ruler. For the Hispano-Umayyads, 'the cross-axial garden was a powerful symbol
of territory, possession and sovereign rule' (Ruggles 2008, 48).

When Abd al-Rahman's grandson became *caliph* in 976 at the age of eleven,
power transferred to a regent. Al-Andalus began to fragment into regional
kingdoms, driven by civil war. This changed the gardens from a purely secular
place for enjoyment to one that embodied elements of the sacred in the form of
a paradise garden. The reason was the increasingly tenuous grip that Islam was
having on the Iberian Peninsula. From 1055, with the threat of the Christian
Reconquest, the regional kings sought the help of Almoravids from Morocco,
only for the latter to take over Seville and other cities in the late eleventh
century. The Almohads, again from Morocco, in turn replaced them but by
1212, they too had been defeated by the Christians. The fall of Cordoba in 1236
meant that only the Nasrid dynasty that ruled Granada was left of the once
great Islamic al-Andalus. Many Muslim historians at the time saw the sacking
of Madinat al-Zahra in 1010 as the start of the state's downfall and it became
the symbol for the golden age of this Muslim state.

In their native Morocco, the Almohads developed an interesting new garden type, the *agdal*. It had elements of the Persian hunting parks in terms of scale but design ideas that developed the basic *chahar bagh* concept. This model was repeated when the Almohads took over Seville. The *agdal* garden in Marrakech was a walled enclosure of 500 hectares next to the city and its main feature was its two large tanks of water in the southern part of the garden. Begun in 1157, it relied on a complex hydraulic system that brought water from the Atlas Mountains via a system of *khettaras*[4] and a significant organisation to create and maintain it. These were made possible by the political changes that both centralised power and required its leaders to demonstrate it (El Faïz 2007, 103). The interior used a series of enclosures that either were a quadripartite layout or formed a larger axial layout. Those areas nearest the tanks were planted with crops such as oranges that needed the most water. Although there were many productive trees, it was a garden not merely an orchard because the pathways were bordered by flowering plants such as roses and jasmines.

The last Islamic dynasty in Spain, who took over from the Almohads in 1232, decided to use an older garden style. The Nasrids chose the styles of Umayyad Cordoba, making a link to their Arab past to differentiate themselves from the North African Almohads. They believed that this helped in their struggle against Christian Castile and the Merinids of Morocco (Ruggles 2000, 167). The Nasrids survived for nearly three centuries by becoming a tributary to Castile and by developing the economy as their predecessors, the Umayyads, had done. Their success led to fine palaces and arguably the best Islamic courtyard gardens at the Alhambra palace and the Generalife. These are on a hill overlooking the main city of Granada, following a long tradition of having a seat of power away from the main populace. It is not clear when the Nasrids started actively building on the site, which may have had a fortress there dating back to the end of the ninth century. Throughout this period, they were constantly fighting their two enemies to the north and south and only periods of peace allowed for major construction.

Towards the end of the thirteenth century, the Alhambra was fortified and about 1310, Muhammad III built the Generalife, a palace and garden complex. This was purely a place for the king to relax as no official business was conducted there. Acequia Court (Figure 2.4), one of the original areas still in existence, follows the typical *chahar bagh* format with the central axis formed by a canal. At the Alhambra palace itself, two courtyard gardens survive. One, the Court of the Lions (Figure 2.5) built by Muhammad V between 1370 and 1390, again has the quadripartite layout with a central pool and water channels leading off it. However the Court of the Myrtles (Figure 2.6), completed in 1370, has a single axis, its design the same as an older garden that it was built on top of (Ruggles 2008, 154). It was thus not only a reminder of the past but also it focussed on the large and decorated Hall of the Ambassadors. This was the state reception hall where the king conducted official business, mainly of a diplomatic nature and is a testament to the fact that the Nasrids stayed in power by negotiation rather than by military victories (Ruggles 2000, 187).

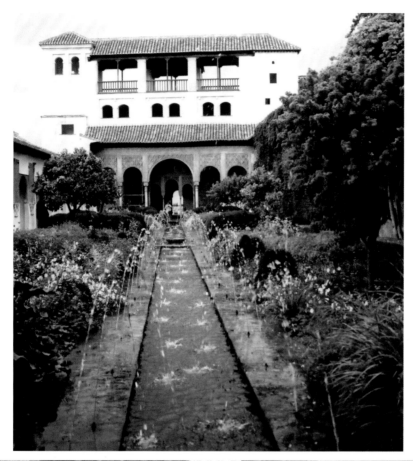

FIGURE 2.4. Acequia Court, Generalife gardens, Granada.

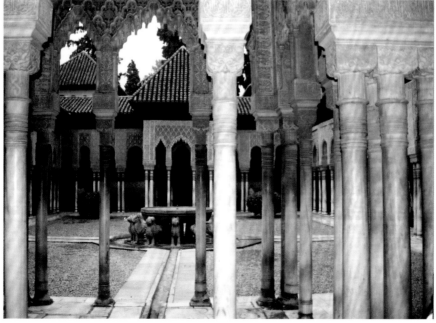

FIGURE 2.5. Court of the Lions, Alhambra, Granada.

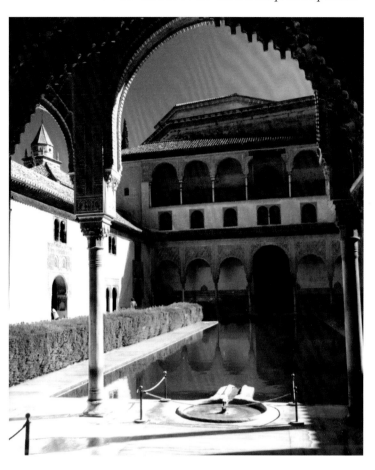

FIGURE 2.6. Court of the Myrtles, Alhambra, Granada.

Gardens as citadels in the Timurid Empire

With the downfall of the Abbasid caliphate in the tenth century and the subsequent regional power struggles, many nomadic invaders of Turkish and Mongolian origin began to convert to Islam. The Seljuks took over most of the former Abbasid Empire by the middle of the eleventh century. These invaders added their political system of nomadic chieftaincy, which relied on descent from famous past rulers. In doing so, they 'cultivated a parallel non-Muslim concept of authority … [in which] they made themselves patrons of religion and necessary to the success of Islam' (Lapidus 1999, 355). Their nomadic and conquering tradition though led to an unstable political environment as the conquerors tried to settle in their new lands.

As a way of marking their authority and their legitimacy, the new ruler would establish a court, which he would make *the* centre of culture. Thus came the 'standardisation' of many Islamic features such as architecture, art and gardens: with Persian ideas as the driving force. One of the most successful of these new leaders was Timur, who came from the minor Barlas tribe. While the latter had adopted Turkish customs and languages, they were descended from the Mongols who had travelled with Genghis Khan. This was important for Timur

to establish his power base. More critically was his faith, as his success was seen as the will of God. In 1370, he defeated his main rival as *khan* or leader and set up his capital at Samarkand. For the next 30 years, he was constantly on the move, expanding his empire. He brought back many artisans to his capital from the defeated lands and so new styles of architecture and gardens developed.

The gardens built by Muslims in the Middle East, North Africa and Southern Spain had been in relatively hostile environments. Central Asia (and also Afghanistan and Kashmir) was a much more conducive environment for garden making, in particular the lush valleys in the Ferghana province. The tradition of creating gardens with tents to live in, rather than large buildings, became popular echoing their nomad heritage. Timur was a great garden builder and built them in the lands he conquered as a means of asserting his authority. Timur took the Persian *chahar bagh* model as the garden could reflect his status as a world conqueror. He decorated his pavilions with treasures from the nations he had conquered. Having his throne on the platform above the watercourses, which represented the four rivers of life, showed he ruled the four quarters (Moynihan 1980, 71–2).

Whilst the gardens in his capital, Samarkand, have disappeared, there are descriptions from the time. The main elements were 'the enclosure within high walls, the division of the enclosed area into quarters, the use of a main water axis, [and] the location of a palace or pavilion at the centre of the area' (Wilber 1979, 29). The location of these gardens is interesting as many were in a ring encircling Samarqand and each was named after the major centres of the Islamic world: Cairo, Damascus, Baghdad, Sultaniyah, and Shiraz. Many were cities Timur had conquered so 'this verdant orbit was a material projection of nascent Timurid imperial ideology and appears to have functioned something like a symbolic display of war trophies' (Lentz 1996, 36). The creation of the gardens were also a celebration of Timur's and other royal marriages because he had gained his legitimacy of descent from Genghis Khan through marriage (Golombek 1995).

In 1404, Timur held a great feast and assembly (*qurultay*) of the Chaghatai nation. Beforehand he and his entourage moved between eight separate gardens around Samarkand, in order to celebrate his successes. With this, he ensured that for 'his descendants (Figure 2.7) a defining expression of their identity that was tied to the garden' (Lentz 1996, 37–8). When Timur died in 1405, he left a large power vacuum as strong, charismatic leaders often do. The network of princes who controlled various provinces vied for power and it took his son, Shahrukh five years to assert his authority. He transferred the capital to Herat (now in Afghanistan). Like his father, he moved the imperial residences to gardens outside the city walls. By doing so, he emphasised that local bureaucrats ran the city, while he was concerned with wider affairs of state.

Iskander-Sultan, Shahrukh's nephew and early political rival, built or renewed numerous gardens at Yazd, Shiraz and Isfahan. Muhammad-Jaki, Shahrukh's son, despite representing his father in Kabul and Balkh, built two gardens

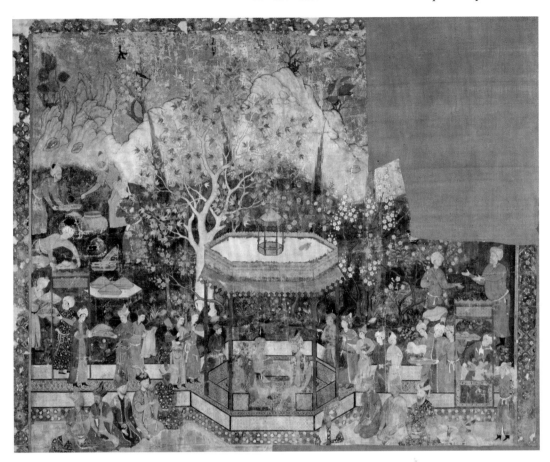

FIGURE 2.7. The Princes of the House of Timur by Mír Sayyid 'Alí *c.*1550–5.

outside Herat, to signal his political aspirations to succeed his father (Lentz 1996, 43). Slowly the empire that Timur had built began to shrink and by the end of the fifteenth century, it only covered Khurasan (Central Asia and parts of Iran and Afghanistan). Its rulers sought to prop up their regime by building gardens, none more so than the *Bagh-i Jahan* (World Adorning Garden) by Sultan-Husayn Mirza, the last Timurid ruler. It was developed over 25 years and its walled enclosure covered 173 acres (70 ha). The gardens in Herat were of great importance, as they provided the inspiration for Babur, prior to his conquest of India.

Grand gardens and territorial power in Mughal India

Muslims had invaded India and established themselves long before the first Mughal Emperor, Babur, made his conquest in 1526. The Delhi Sultanates and others established their own architectural style, drawing on Hindu temples and they also had built gardens, next to these buildings. Firuz Shah, whose capital was Delhi, is credited with having built a hundred gardens in the fourteenth century (Crowe *et al.* 1972, 42). While these gardens had similar functions to the

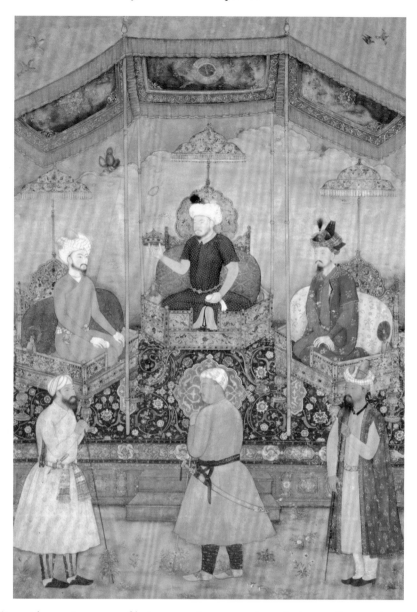

FIGURE 2.8. Timur handing the imperial crown to Babur by Govardhan *c*.1630.

Timurid ones in terms of being camping grounds and places of entertainment, they were never intended to represent the power of the rulers (Welch 1996). This was achieved by their architecture instead.

Babur was not impressed by their efforts though. He had seen the gardens of his ancestors at Samarkand and Herat and these were the ones he wanted to recreate. Reflecting his Timurid roots, these gardens were outside the major buildings, almost in deliberate opposition to the forts built by the pre-Mughal rulers. Babur could claim descent from both Timur (on his father's side) and Genghis Khan (on his mother's) but right from the age of 11, when he inherited the small principality of Ferghana, he had to struggle to assert his authority.

Considering himself the rightful heir to the Timurid Empire (Figure 2.8), he briefly took control of Samarkand in 1497. By 1501, he had not only lost control there but also of his home state, so he turned his attentions to Kabul, which he did succeed in holding. Ten years later, he again recaptured Samarkand but having lost it the following year, he left his homeland for good to conquer Northern India or 'Hindustan'. This had been part of the territory that Timur had secured 100 years before, so Babur believed he had a credible claim to it.

Babur stamped his authority on the places he conquered in Afghanistan and India by building gardens in the Timurid *chahar bagh* style (Asher 1991). The first was in Kabul[5] as he recalls in his memoirs: 'in 914 [1508–9], I had constructed a *charbagh* garden called Bagh-i-Wafa ['Garden of Fidelity'] on a rise to the south of the Adinapur fortress [in Kabul]. It overlooks the river, which flows between the fortress and the garden' (Thackston 2002, 156). Perhaps his most political garden was the one he ordered to be built on a site by the Ghaggar River (in the Punjab) in February 1526, his first garden in India. This was two months before his decisive victory over the Lodi Sultans and an indication of his confidence in securing Hindustan. It was completed by 1529 and as he advanced towards Delhi and Agra, he built gardens in Panipat, the site of his main victory, Agra, his new capital, Gwalior, Fatehpur Sikri and Dolphur. Babur ordered in addition *chahar bagh* gardens and orchards were to be laid out in all large cities (Asher 1991, 53).

His nobles duly obliged, as he notes:

'Khalifa, Shaykh Zayn, Yunus Ali, and all who had acquired lands on the river [at Agra] also built geometric and beautifully planned gardens and ponds. As is done in Lahore and Dipalpur, they made running water with waterwheels. Since the people of India had never seen such planned or regular spaces, they nicknamed the side of the Jumna on which these structures stood, "Kabul".' (Thackston 2002, 364)

Babur felt that he was not only bringing order to the gardens he created but also to the country over which he was now ruler. His comment about a garden he renovated in Istalif (near Kabul) makes this clear: 'the stream used to run higgledy-piggledy until I ordered it to be straightened. Now it is a beautiful place' (Thackston 2002, 162). A famous picture (Figure 2.9) from a copy of his memoirs commissioned by his grandson, Akbar, shows Babur directing work on the Garden of Fidelity in Kabul, demonstrating his mastery of the garden and, by implication, of the state.

Humayun, Babur's son, came to the throne just four years after the Mughal conquest and he struggled to assert his authority, even losing his kingdom for 11 years between 1544 and 1555. He 'differed from his predecessors because he lost sight of the connection between gardens and territorial control' (Wescoat 1990, 106) and for him gardens at times became places of refuge and humiliation. During his retreat to ultimate exile to Persia, it was ironic that he first stayed at Babur's victory garden at Fatehpur Sikri. Later he met two of his brothers, Kamran and Askari in their respective gardens at Lahore and Kandahar but both his brothers refused to help him and demanded that he left. In the early

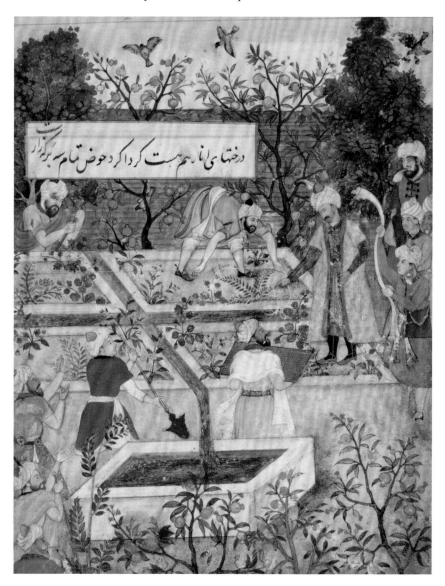

درختهای ا ، هم هست کردا کر د حوض تمام س برخزار

FIGURE 2.9. *Babur Supervising the Laying Out of the Garden of Fidelity* by Bishndas *c.*1590.

PHOTO © VICTORIA AND ALBERT MUSEUM, LONDON.

part of his reign, he had sought to consolidate his reign by building projects in Agra and the former capital, Delhi. These were either in existing gardens or gardens were incorporated into the design:[6] an important shift which would be the model for future Mughal gardens.

Humayun regained his kingdom a year before his death and it is appropriate that his tomb marks the transition between the Timurid *chahar bagh* that Babur introduced and the Mughal version that his successors would use to great effect. Begun around 1560, four years after his death, and completed 13 years later, it is the first example of putting a tomb in the centre of a *chahar bagh* garden (Figure 2.10), instead of the usual tent or pavilion. However 'Mughal tombs were of much grander dimensions than ordinary garden pavilions and did not

fit easily into the middle of a *chahar bagh* ... [so] to remain in proportion, the surrounding *chahar bagh* was laid out at a matching monumental scale' (Moore *et al.* 1988, 179–180). His son, Akbar, built Humayun's tomb (Figure 2.11), so it says more about his political vision than his father's. The Islamic garden was about sovereignty and the mausoleum about dynasty, so here the two are powerfully combined (Ruggles 1997, 178). Its revolutionary nature and architecture reflected Akbar's policy of seeking alliances with the local Hindu Rajput rulers as a means of control, rather than his predecessors' policy of continual war (Lowry 1987).

Akbar's different style of government and his increasing wealth were reflected in the fact he built fortified palaces and as a result gardens were now largely placed inside these buildings complexes. Akbar moved the capital back to Agra

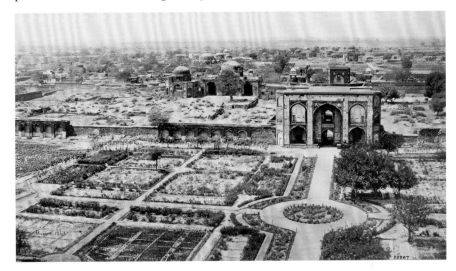

FIGURE 2.10. View from the top of Humayun's Tomb of its garden, photograph by Samuel Bourne 1860s.
PHOTO © VICTORIA AND ALBERT MUSEUM, LONDON.

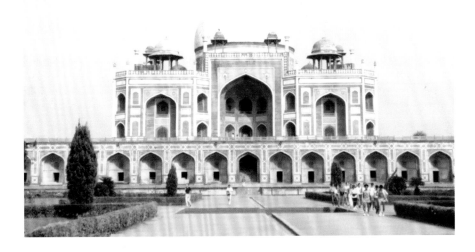

FIGURE 2.11. Humayun's Tomb, Delhi.

in 1558 and rebuilt the Red Fort on the banks of the Yamuna River, however the courtyards appeared to have only been paved there (Koch 1997, 144). The new city of Fatehpur Sikri, built between 1571 and 1585, was a political move by Akbar to assert his authority.[7] Of the two gardens there, the Diwan-i-'Amm (court of public audiences) is a classic *chahar bagh*. The gardens of the *zenana* (women's quarters) though are two terraces with each divided into two by a water channel that flowed through a kiosk (Koch 1997, 146). It was this style of garden that was used in Kashmir, the summer capital where the Mughal emperors went to escape the heat and dust of the plains. A reminder for them of their Timurid roots in the Ferghana valley, these gardens were purely for visiting as they had no living quarters but court affairs were carried out there. Shalamar Bagh, Kashmir, built by Jahangir, Akbar's son, in 1619–20, is typical of the simple design with a main canal rising slowly through two stepped *chahar baghs* with pavilions. At the lowest part, the Emperor gave public audiences, the middle part (and first *chahar bagh*) was for invited guests only and the top part reserved for the *zenana*.

In an interesting reflection of the balance of power in the Mughal court, there are two river front gardens in Agra attributed to two influential imperial wives. Ram Bagh was started by Babur but rebuilt by Jahangir's wife, Nur Jahan[8] in 1621. Although it has a *chahar bagh*, it has no central pavilion, instead there is a terrace overlooking the Yamuna River with two pavilions (Ruggles 2008, 201–2). Mumtaz Mahal constructed the Zahara Bagh in late 1620s: she was Shah Jahan's wife and for whom the Taj Mahal was built. Its design (Koch 1986) is more radical than Ram Bagh as it has no *chahar bagh*, just a central canal with a pavilion on a terrace next to the river. During this period many nobles, including Hindu Rajputs (Joffee and Ruggles 2007) also built lavish gardens (Figure 2.12) for two reasons. First, wealth was gained by success at court, which in turn depended on retaining the emperor's pleasure. The latter encouraged spending on things such as gardens to impress the Emperor. Secondly, a noble's possessions and wealth went to the Crown, not to their heirs, so the money was spent rather than saved (Moynihan 1980, 118).

Under Shah Jahan, the fifth Emperor, the Mughal Empire reached its height stylistically with great monuments such as the forts in Delhi, Agra and Lahore and of course the Taj Mahal. His success as an administrator meant huge wealth was accumulated and this was channelled into the arts including gardens (Figure 2.13). His most ambitious project was the fortified palace (now known as the Red Fort) at Shahjahanabad, an area of Delhi, built between 1639 and 1648. Like his predecessors, he wanted to asset his authority by building a new capital but by choosing the 'old' i.e. pre-Mughal capital, he was also erasing the memory of Humayun's failure. This palace differed from its counterparts at Agra and Lahore, in that the whole complex was conceived as if it were a garden (Koch 1997, 153). The interior was a series of *chahar baghs*, pavilions and halls, linked by a canal that ran parallel to the riverbank. The architecture too reflected nature's themes with columns in the pavilions carved to represent

FIGURE 2.12. Gardens at Amber Palace, Jaipur.

FIGURE 2.13. Shalimar Gardens pavilion, Lahore.

cypress trees,[9] particularly those around the Hayat Bakhsh garden and inlaid floral motifs. This artificial interpretation of nature here reflected 'the imperial garden, permanent and above the laws of nature … it symbolized the good government of Shah Jahan who brought everlasting bloom in Hindustan' (Koch 2007, 171). These floral motifs (Figure 2.14) would become a standard part of Mughal architecture.

Shah Jahan's heir was his eldest son, Dara Shikoh, who was trained to continue his father's style of government and patronage of the arts. However he lost out to his younger brother, Aurangzeb, who seized power during a civil war between the brothers, while his father was still alive. Aurangzeb's reign marked a turning point, as gave up on his father's ambition in the historic homelands in Central Asia, emphasising a break with his Timurid past. Instead he turned his attentions to the south and spent a large part of his long reign

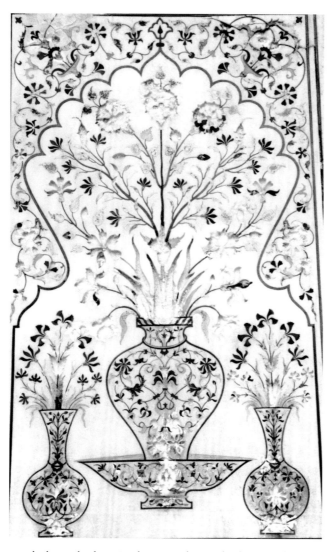

FIGURE 2.14. Detail of *pietra dura* from Lahore Fort, Pakistan.

at war, particularly with the Hindu Marathas, which caused a large drain on resources. Aurangzeb differed from his predecessors by his stricter adoption of Islamic principles, including sharia law, with the official patronage of arts severely curtailed and his only building projects being mosques.

While he regarded his father's construction of the Taj Mahal as an extravagance (despite the fact that it was for his mother), he built a similar tomb for his wife, Rabia Daurani. It is only half the size of the Taj, with just the dome and parts of the building in marble, the rest is plaster. However, it is placed in a *chahar bagh*. For all Aurangzeb's piety, he still believed that 'palaces and gardens were necessary for kings, the first for accommodating the huge retinue and the second for reviving energies depleted by administration' (Vaughan 2000, 472) but he merely maintained them rather than creating new ones. By the time his son came to the throne in 1707, Mughal power was on the wane and it was

perhaps apt that the last Mughal Emperor was captured by the British, in the gardens of Humayun's tomb (Vaughan 2000, 482) in 1857.

The garden as a city in Iran

Since the Arab invasion of the seventh century, ancient Persia had been divided and by the early sixteenth century, Turcoman Sultans ruled in the west from Tabriz and Timur's direct heirs in the east from Herat. When Ismail, founder of the Safavid dynasty, defeated the former in 1501 and took over the latter in 1507, Persia was once again united, this time as Iran. The Safavids, although descended from a Sunni Sufi, Shakyh Safieddun, had changed to Shiism and proceeded to make it the state religion, despite the fact that most of the population were Sunnis. Following defeats by the Ottoman Empire, by 1516 Ismail only controlled the Iranian plateau and so he and his successors embarked on a strategy of making themselves heirs to the ancient Persian Empire. The aim was to strengthen their legitimacy and exert control over the population.

One of the ways they did this was by creating new 'garden cities' alongside the old centres of their capital cities and aligning these with their own palace gardens (Alemi 2007, 114). Gardens, as for so many other Islamic rulers, were an integral part of the Safavid culture, which was inherited from Timurid ideas and older Persian models. Ismail's grandfather, Uzun Hasan, had briefly occupied Tabriz between 1466 and 1478, building a palace-garden complex called Hasht Behesht (Hobhouse 2003, 92), which may have been the model for the one of the same name in Isfahan (Ruggles 2008, 8). Set in a walled enclosure, it had the palace at the centre, next to a public square or *maydān* (Alemi 1997, 73): a layout not dissimilar to the Bagh-e Fin at Kashan, where nobles were said to have entertained Shah Ismail in 1504 (Hobhouse 2003, 93). Tabriz though was too close to the Ottoman Empire and following an attack on it in 1544, Shah Tahmasp (Ismail's son), transferred the capital to Qazvin, a city founded in the Sassanian period. This was a Sunni centre and in order to establish himself there, he undertook a large urban development programme, secular as well as religious. To the north of the existing city, he built palaces and gardens for the court (one of these, the Chehel Sotun still remains) and to link these, two public garden areas: a tree-lined avenue next to a canal (*khīyābān*) and a large square[10] were built. The palace gardens follow the enclosed Timurid *chahar bagh* style but the use of the public garden areas, reflected earlier royal ceremonial areas, such as those at the ancient city of Persepolis (Alemi 1997, 73).

After Tahmasp's death in 1576, there was a period of infighting, which finally led to the accession of his grandson, Abbas Mirza in 1587. One of his first acts, after being crowned at the Chehel Sotun palace in the Sa'ādat garden in Qazvin, was to execute those who had opposed him and put their heads on spears in the *maydān*. Thus these two places became an unwelcome reminder of anyone who would want to challenge his might (Alemi 2007, 119). After Abbas had secured the rest of the country, he established his authority by building further garden

cities, using the model of Qavzin, at Sari, Rasht, Farahabad and Ashraf, with the latter considered the second capital. He also picked up on the old Persian idea of hunting parks, where he would 'display his power by inviting emirs and guests to take part in a hunting ritual' (Alemi 2007, 119). To establish his new identity as an 'Iranian', Abbas moved the capital to Isfahan on the Iranian plateau, in 1598. It had the added advantage of being further away from the Ottomans but it also had historical significance. Founded in the Achaemenian period and a city in the early caliphate, it was chosen as the capital of the Saljuks in the eleventh century. They had built palaces and gardens that had survived the onslaught of the Mongol invasion and Timur. Taking the established Safavid garden-city model, Abbas created a royal garden quarter and one of the largest public squares, next to the old city.[11]

The Maydān-e Shah (Imperial Square) was a critical part of Abbas' strategy of asserting this authority, not only by its sheer size (over 500 × 600 ft [*c.*150 × 180 m]) but also the 'four monumental entrances signifying the power and union of the community in all its facets' (Khansari, Moghtader and Yavari 2004, 87). The north gate led to the newly created Royal Bazaar, which formed the basis of his policy on increased trade, to build the nation's wealth. To the south and east, were the main city mosque and the family mosque of the Shah, demonstrating the importance of the Shia religion. Lastly to the west was the Ali Qapu gate that led to the royal quarter and then on to the public Chahar Bagh Avenue. This plane tree lined avenue with gardens on either side, continued down to the river and across a new bridge to further royal gardens and palaces.

The land in Chahar Bagh Avenue was sold to dignitaries of the Safavid court and they were ordered to build gardens (Brignoli 2007, 142). Much in the same way as patronage was given to the nobles in Versailles in terms of apartments in the palace, here they were rewarded with the use of one of the gardens. The *maydān* itself was improved in 1601 with the planting of plane and willow trees to provide shade, surrounded by a stream. Abbas' goal was to make this the focal point of the city and encouraged sports such as polo, archery and public celebration of festivals, some of which dated back to the pre-Islamic era. Even preaching by Sunnis and other non-mainstream factions was sanctioned and therefore contained with the boundaries of these public gardens. Such public green space:

> 'offered a symbol of the presence of the king as a great city benefactor, and a stage for rituals that served to remind all city dwellers of his legitimacy as heir of ... [ancient Persian] kings, and as leader of the Shiite community.' (Alemi 2007, 129)

Unlike Abbas, who actively travelled throughout his empire, his successors were largely sedentary and concentrated on building gardens in Isfahan.[12] By the mid-seventeenth century, Isfahan had become a cosmopolitan city and the layouts perhaps reflected influences from Western Europe, particularly France. In 1700, the last Safavid ruler, Shah Sultan Husayn created the largest garden complex of 500 acres (202.3 ha) to the west of the Hezar-Jarib. He linked it with Abbas' garden by a tree-line promenade, enforcing the link with his illustrious

ancestor but it was to be an unlucky place for Husayn. It was here that the Afghan forces of Mahmud stayed before they captured Isfahan in 1722, thus ending the over two centuries of rule of the city by the Safavid dynasty. Named 'Farahabad' or Abode of Joy, it came to represent the folly and extravagance of the later Shahs. Its distance from the city gave the impression too that Husayn had no particular interest in state affairs (Brignoli 2007, 139), unlike Abbas who deliberately placed the royal palace next to the very public main square. The tradition of building garden cities continued with the Zand dynasty at Shiraz in the eighteenth century and the Qajars in Tehran in the nineteenth century.

Insular gardens in the Ottoman Empire

The Ottomans were Turkic nomads who settled in a new land after the conquest of Byzantine Anatolia in the eleventh century by the Seljuks. They converted to Islam and taking advantage of the weakness of the Byzantine Empire, they slowly gained territory, culminating in the capture of the capital, Constantinople, in 1453. They had two major influences when it came to gardens: the ancient Roman traditions that had been kept alive by the Byzantines and also the Timurid ideas (Necipoglu 1997, 32). Like the Safavids in Iran, they fused together these ideas to legitimise their regime, with Mehmed, the conqueror of Constantinople seeing himself as both Roman emperor and *caliph*. His success achieved the 'age-old Turkish ideas of a destiny of world domination, the imperial ambitions of the Roman empire, and Muslim jihad and expansion of the domain of Islam' (Lapidus 1999, 374). The success of the Ottoman Empire was due to the high degree of centralisation of power centred on the ruler's court at the Topkapi Palace.

The gardens at the palace reflected the strict protocol and the way in which the Ottoman sultan ruled. The site had been a Byzantine hill fort but it was largely in ruins, along with most of the city, which had been abandoned by its population. The palace was built in the centre and it was surrounded on three sides by woods, flower gardens, orchards and meadows (Ergun and Iskender 2003, 62), a naturalistic style inherited from the Byzantines. While the Sultan could look out to the city from the Fifth Courtyard, the view of him was strictly limited. It was only in the First Courtyard where the public were allowed to enter and this was the plainest area with only a single avenue of trees. From then on, access was increasingly restricted, with the Second Courtyard used only by the Sultan and palace officials for infrequent ceremonies. It was more heavily landscaped with paths shaded by cypress trees. In contrast the Third, Fourth and Fifth Courtyards with access only for the Sultans are the most elaborate. It was here that the formal design with numerous pools and highly valued flowers such as tulips reflected its Timurid roots.

The importance of the gardens to the Ottomans was demonstrated by that fact that there were reportedly twelve thousand gardeners employed at the site out of a total population of forty thousand.[13] Being royal gardeners for a time had a special purpose. As enslaved Christians, these young men were forcibly

converted and then given prestigious jobs in the army and bureaucracy, after being 'naturalised' by their training as gardeners (Necipoglu 1997, 34). As in the Mughal and Safavid courts, patronage and power was restricted to individuals not to families, other than the imperial one. Most of the large estates in the capital therefore belonged to the royal family, who increased their landholding through confiscation from executed grandees. In the mid-sixteenth century, there were 40 palace gardens in Istanbul and the sultans and his family regularly visited them. Suleyman I was particularly fond of his gardens, visiting them nearly every day (Necipoglu 1997, 33). The larger ones were modelled on the Topkapi palace in terms of layout with semi-formal on the outside and more formal in the private areas. Many were situated on the banks of the Bosphorus, such as the Uskudar Saray, so that they were easily accessible and afforded a pleasant view. Most of these gardens were created purely for pleasure but one, the Karabali Garden, did have political overtones. It was built to commemorate the Ottoman victory over the Safavids in 1514 (Necipoglu 1997, 33) and the fact that it uses the Persian *chahar bagh* design is no coincidence.

The Ottoman Empire reached its height under Suleyman I in the mid-sixteenth century, both in terms of its extent and also culturally. However the very system that had ensured its success, also contributed to its slow decline. The concentration of power in the hands of the sultan and his immediate entourage led to a series of weak sultans, dominated by palace officials and members of the harem. More time was spent enjoying the increasing number of gardens, rather than to attending to affairs of state: indeed the sultans had left Istanbul in the mid-seventeenth century to live in the first capital, Edirne. By the early eighteenth century, the Empire was losing not only territory but also much needed tax revenue.

A revolt by the Janissaries (Sultan's personal troops) in 1703 brought Ahmed III to the throne and a change in the way gardens were used. Ahmed was forced to return to a declining Istanbul and to make his presence visible, he renewed the city and engaged in public displays (Çaliş 2007, 240). Together with the introduction of Western ideas (especially French), a new style of garden was created: one that was intended for public rather than private enjoyment. It also led a burgeoning consumerism where rare items, such as tulips, began to change hands at inflated prices. A backlash from conservative elements within the establishment led in 1730 to a revolution, ending the so-called Tulip Period. Kağithane, a royal palace and the mansions of the Ottoman elite, together with their gardens, were placed next to a public promenade. The conservatives destroyed them, as symbols of this supposedly decadent era (Çaliş 2007, 245). Clearly for them, the garden was meant to represent paradise on earth, not an excuse to flaunt worldly wealth.

The world is a garden for the state to master …

There has been much debate as to whether there is something that can be defined as an Islamic garden,[14] based mainly on whether the strict symmetrical *chahar bagh* (or quadripartite) design is used. However if Islamic gardens are seen as versions of a Persian symmetrically planned water garden within a political context, it has more relevance. These gardens were not meant to be exact carbon copies of an original that the newly converted Muslim Arabs found in Persia, but rather an image of an identity that they could use to legitimise their claim to power. Muslim leaders relied not only on descent from a previous ruler but also had to lay claim to being the *caliph* or successor to Muhammad. Names of gardens are therefore repeated, with the later version usually taking the design of its predecessors, just as its creator was recreating an idealised past. In the case of the Safavids and the Ottomans, they took over territory that had a prominent pre-Islamic culture. Here gardens were developed using older styles, in order to demonstrate the new rulers' somewhat spurious link to this previous culture.

In terms of the design, there are two recurring themes. The first is the fact that most of these gardens had 'controlled' water, indicating the control these rulers had over a precious resource in many parts of the Muslim world.[15] The other is the importance of the centre of these gardens, at the junction of the north–south and east–west axis, where a throne or a tomb is found. Many of the Muslim rulers, as *caliph*, have considered themselves as the ruler of the world. Given part of the Islamic ideology is the mission to convert the whole world, they would naturally regard themselves as being at the centre. The building of large garden complexes has often signified the demise of an Islamic dynasty. So while the construction of gardens became a metaphor for power and sovereignty over a land, it also represented the excesses of a complacent ruler. However the desire to continue to build 'Islamic' gardens remains strong. When the British moved their imperial capital from Calcutta to New Delhi in 1931, Lutyens designed a 'Mughal' Garden next to the Viceroy's House.[16] In doing so, he was following a long tradition of using the imagery of the garden style to assert the authority of the new (British) Emperor.

Notes

1. See Turner (2011, 62) for a discussion of the various forms that the *chahar bagh* has taken in the Muslim world.
2. There is a dispute about the findings of the original excavation by Herzfeld in 1911–13 which identified water channels in the courtyards, see Ruggles (2008, 183).
3. For a full description see Ruggles (2008, 183–4).
4. A subterranean gallery for irrigation similar to that used in Persia, there known as a *qanat*.
5. Further discussion of this garden see Wescoat (1989).
6. See Wescoat (1990, 106–16) for descriptions of these.

7. The site had a special significance, as it was the home of Salim ad-Din Chisti, a Sufi who Akbar had consulted over a lack of a male heir. When the latter duly arrived in 1569, the city was built as a celebration. The Emperor also wanted to tap into the Sufi's spiritual power to promote his claims of legitimacy.

8. Nur Jahan, a wealthy widow, married Jahangir in 1611 and effectively took power in the 1620s from the ineffectual emperor. She was also the aunt of Mumtaz Mahal.

9. For the Mughals, the cypress represented eternity.

10. See Alemi (2007, 114–5), see also Khansari, Moghtader and Yavari (2004, 74) for layout.

11. See Khansari, Moghtader and Yavari (2004, 88) for layout.

12. Examples are the garden next to the Chetel Sotun reception hall finished in 1647 by Abbas II. It is situated between the royal quarters next to the *maydān* and the Chahar Bagh Avenue. Next to this was built the Bagh-i Bulbul (Garden of the Nightingale) in 1670 by Suleiman I, surrounding the Hasht Behesht palace. This stands at the intersection of the two main axes of watercourses but not at the centre as in previous symmetrical *chahar bagh* layouts, such as the Hezar-Jarib garden built by Abbas I at the end of the Chahar Bagh avenue.

13. Atasoy (2007, 206). Reports elsewhere say the figure was nearer to 2000–4000 for all royal gardens.

14. See Conan (2007), Ruggles (2008, 3–11) and Turner (2011, 61–3).

15. For a discussion on these ideas see Wescoat (2007).

16. For layout see Ruggles (2008, 209–10).

Taj Mahal, Agra

The Taj Mahal (Figure 2.1) brings together two Mughal traditions: that of the riverfront garden and of the dynastic tomb complex. The banks of the Yamuna river in Agra have been a site for many Mughal gardens,[1] from the time when the first Mughal Emperor, Babur, conquered this land in 1526. He built several extensive gardens and encouraged his nobles to follow suit (Thackston 2002, 364). Babur's successors and their families, including two queens, continued this tradition of garden building at Agra, refurbishing existing ones such as the Ram Bagh (probably begun by Babur) or creating new ones. The Mughals were descendants of Timur and so took the Timurid idea of tomb building from Central Asia. At Samarkand, Timur and his successors were placed in one dynastic tomb complex, which became a place of pilgrimage. The Mughal Emperors ended up with separate tombs.[2] Babur's wish was that he should be buried simply in a garden and he was interred first in Agra[3] and later moved to Kabul.

Akbar erected the first Mughal tomb garden (Figure 2.11) at Delhi for his father, Humayun. The layout of the garden surrounding the tomb is a *chahar bagh* with each quadrant further subdivided into eight squares by water channels[4] and the mausoleum is in the middle. This design layout was followed for the tombs of Akbar in Sikandra (near Agra) and Jahangir, his son, in Lahore. All these became sites of pilgrimage,[5] as a 'focus for an emerging royal cult in which the living ruler and his court prayed for his deceased predecessors' (Richards 1996, 263). Between 1622 and 1628, Empress Nur Jahan (wife of Jahangir) built a tomb garden for her parents at Agra. It is regarded as one of the main influences on the Taj's design. Situated by the waterfront, it is a simple *chahar bagh* layout with the tomb in the middle. There are two gates, one from the land and the other from the river.[6]

The Taj Mahal was built for the wife of Emperor Shah Jahan, Mumtaz Mahal, between 1632 and 1648.[7] She had died while on campaign with her husband in Burhanpur, where her body remained until it was taken to Agra, to a temporary grave, six months later. The site that was chosen for her tomb, was a garden owned by Raja Jai Singh of Jaipur,[8] which he exchanged for imperial land elsewhere. Aesthetic reasons influenced Shah Jahan's choice of site, as it was the last in a series of gardens along the riverbank from Agra Fort and the one that could be viewed best from there (Lall and Dube 1987, 102). As Mumtaz had died in childbirth, she was considered to be a martyr and therefore her tomb would become a place of pilgrimage (Lall and Dube 1987, 102), not only for the royal family but ordinary people as well. Hence the inner grounds unusually include not only a mosque, but also a guesthouse and meeting place. These two

buildings are in the same architectural style facing one another, along the axis of the tomb.

The mausoleum was placed next to the river, more in the style of other waterfront gardens in Agra, not in the centre of the *chahar bagh* as with other tomb gardens. This seems strange given 'the plan [of the Taj] is governed by absolute symmetry in both its broader measure and detail. The symmetries seem multi-dimensional as they are inverted and mirrored in the water or repeated in the rhythmic intervals staked out by shrubs and cypresses, echoing less formally the vertical alignments' (Yeomans 1999, 217). Across the river however new evidence has shown that 'the Mahtab Bagh ('Moonlight Garden') was part of the original plan of the Taj complex and, though long overlooked, its inclusion demonstrates such a crossing of the Four Rivers (Figure 2.15). The water channels in Shahjahan's two gardens are aligned and provide one long north–south axis' (Moynihan 2000, 32 and 38). This garden would seem to be the source of the oft-quoted myth that a black 'Taj' was to be built on the opposite side of the river for Shah Jahan himself.[9] The garden layout in front of the tomb is a classic *chahar bagh* (Figure 2.2) with each quadrant further divided into four, giving sixteen areas for planting. In the middle is a raised pool and it, together with the channels, reflects the main tomb building.

The original planting would have had cypresses and flowers along the water channels (Figure 2.16), rising in height to the outer walls with flowering shrubs

FIGURE 2.15. An aerial view of the Taj Mahal and gardens 1800.

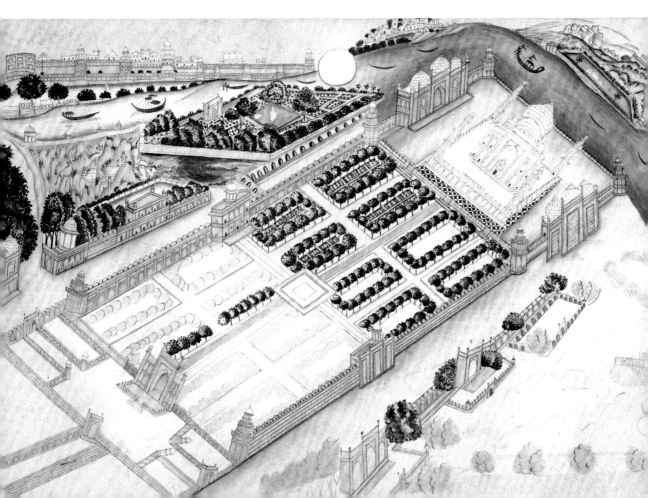

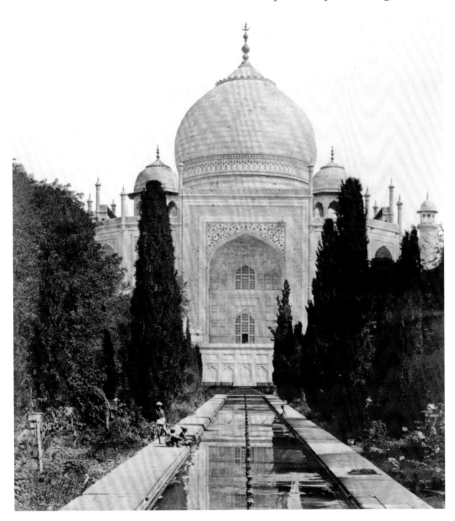

FIGURE 2.16. Central pool
and garden in front of
Taj Mahal, photograph by
Beato *c.*1858.
PHOTO © VICTORIA AND ALBERT
MUSEUM, LONDON.

and trees such as mangoes and tamarind trees. François Bernier, a visitor in 1663, describes the garden thus:

'Opposite to the entrance from the street is a large open arch, by which you enter a walk which divides nearly the whole of the garden into two equal parts. This walk or terrace is wide enough to admit six coaches abreast; it is paved with large and hard square stones, raised about eight French feet above the garden; and divided the whole length by a canal faced with hewn stone and ornamented with fountains placed at certain intervals ... and to the right and left of that dome on a lower surface you observe several garden walks covered with trees and many parterres full of flowers.' (Bernier 1891, 295–6)

The total cost of the complex has been put at anywhere between 5 and 50 million million rupees, although no official accounts remain. This was funded by the annual income from the bazaars and caravanserais in the forecourt that formed part of the endowment (waqf) and thirty villages, giving a yearly total of 300,000 rupees (Vaughan 2000, 480). The sale of fruit from the garden also provided income (Lall and Dube 1987, 108).

The Taj has been described as the 'most perfect visual metaphor for the Garden of Paradise ... The Persian couplets inscribed on the entrance gateway make the imagery explicit: "Hail, blessed space happier than the garden of Paradise! / Hail, lofty building higher than the divine Throne!"' (Vaughan 2000, 479). Begley (1996) has argued that this in fact is the garden of paradise on the Day of the Judgement with the tomb representing the throne of God. He bases his arguments on cosmological diagrams, which he says are the basis for the design of the Taj. The raised marble tank in the centre of the *chahar bagh* (instead of the usual tomb) represented the celestial tank of abundance, called *Hawd al-Kausar*, where Muhammad will stand before God on the Day of Judgment, to ask for the faithful to enter paradise. Many have disagreed with his argument,[10] as the design is consistent with other Agra riverfront gardens and also as the Mahtab Bagh is part of the overall design, then the tomb is in the middle of the complex. The Yamuna river 'becomes part of this bold concept joining – rather than separating – the two gardens ... Only someone with Shahjahan's vainglorious sense of himself could conceive such an audacious plan' (Moynihan 2000, 38–9).

The design has to be seen as part of the wider demonstration of power, authority and most importantly the legacy, of the Mughals, in particular Shah Jahan. His historian describes it thus: 'they laid the plan for a magnificent building and a dome of high foundation which for its loftiness will until the Day of Resurrection remain a memorial to the sky-reaching ambition of His Majesty, the Sahib Qiran-Thani (Second Lord of the Auspicious Conjunction of the Planets Jupiter and Venus), and its strength will represent the firmness of the intentions of its builder'.[11] As Koch points out: 'the Taj Mahal was built with posterity in mind, and we the viewers are part of its concept'. Tavernier says that Shah Jahan 'purposely made it [the Taj] near the TASIMACAN [possibly *táj-i-mukán* or camp of the Taj], where all foreigners come, so that the whole world should see and admire its magnificence. The TASIMACAN is a large bazaar ... and an enormous quantity of cottons is sold there' (Ball 1889, 109–110). Shah Jehan himself visited it once a week when he was in Agra and on the anniversary of Mumtaz's death each year, there was a large feast and the distribution of alms.[12] This continued throughout his reign and in addition, 'the poor are admitted three times a week during the rainy season to receive the alms founded in perpetuity by Chah-Jehan' (Bernier 1891, 295).

In the eighteenth century, the Marathas and the Jats occupied Agra, before the British took the city in 1803. A guide from 1904 describes the garden 'now as a jungle, planted by a European overseer without any understanding or feeling for the ideas of the Mogul artists' (Havell 1904, 80). Its current form, with the changes made in the early twentieth century to turn the grounds into an English style park, has robbed the Taj of its full magnificence and highlights the close relationship between the building and its designed landscape. Part of the beauty of the Taj is the wonderful *pietra dura* floral motifs (Figure 2.17) and the flowering plants picked out in relief on the dado that runs both inside and outside the building. This matched the flowering plants that once were part of the surrounding garden. The man responsible for the alterations was Lord

FIGURE 2.17. *Pietra dura* from the main building of Taj Mahal, Agra.

Curzon, Viceroy of India from 1899 to 1905. He declared himself to be passionate about preserving the Mughal architectural heritage (Herbert 2005, 250) and the buildings were restored to their original state. However the Taj's garden was so radically altered that it lost its essential Islamic nature. It could be argued that Curzon did not appreciate what the original garden looked like, although there were contemporary accounts. Perhaps he understood instead that the Islamic garden was a statement of political legitimacy for the previous Mughal Empire and so a garden in the style of the British rulers would be more appropriate.

Notes

1. Koch says that there were forty-four garden complexes shown on a map from the 1720s (2005, 131).
2. For a discussion of the different burial places of the first six Mughal Emperors see Brand (1993).
3. There is some dispute over which garden in Agra it is. The Gulafshan or Ram Bagh is now described as Babur's garden but others believe it to be a garden called Charbagh near the mosque built by Humayun.
4. For plan see Ruggles (1997, 181).
5. The first was Humayun's tomb, where his descendants would visit every time they went to Delhi.
6. For plan see Ruggles (2008, 200).
7. There is some debate as to when the whole complex was actually finished. Jean Baptiste Tavernier, who visited Agra in 1640–1 and in 1665, wrote that it had taken twenty-two years to complete. So the end date would therefore be 1654, however an inscription on the gateway would indicate a date of 1648. The completion of the tomb itself was celebrated in 1643.
8. Inherited from his grandfather, Raja Man Singh, a friend of Akbar's and one of the first Rajput officials in the Mughal court: Moynihan (2000, 26).

9. He is in fact buried next to his wife in the mausoleum at the Taj. This story appears to have started with Tavernier, who states that 'Shah Jahan began to build his own tomb on the other side of the river but the war with his sons interrupted the plan and Aurangzeb, who reigns at present, is not disposed to complete it': Ball (1889, 188).

10. See Koch, E. (2005, 144–5).

11. Abd al-Hamid Lahawri, *The Badshahnamah* (Persian text), ed. M. Kabir al-Din Ahmad and M. Abd al-Rahim (Calcutta: Asiatic Society of Bengal, 1865–72) vol. 1, pt 1, p. 403 in Koch, E. (2005, 128)).

12. 100,000 rupees were distributed at the first anniversary.

Italian Renaissance Gardens and Political Ideology

On gardens of kings and other illustrious and wealthy lords

1. Because such persons by reason of their riches and power are able to satisfy their own will in all earthly things and almost nothing is wanted by them, except the labour of setting workers to task, they should know they are able to make gardens having many delights in this manner. (Bauman 2002, 102)

The advice comes from Piero de' Crescenzi's *Liber ruralium commodorum*, which is thought to have been written around 1305 and first printed in 1495. Its twelve volumes dealt with the management of a rural estate and much of the material is derived from Classical treatises such as Pliny's *Naturalis Historia* of about AD 77 and practical medieval experience. Book Eight specifically discusses 'On making gardens and delightful things skilfully from trees, plants, and their fruit'. In it, de' Crescenzi refers to three types: herb gardens, which served both a practical and aesthetic purpose; gardens for those of moderate means and, last but not least, gardens for kings and lords. It is the latter two which shed most light on how gardens were, and came to be, viewed in Renaissance Italy. From the outset, gardens were to be statements of political ideology, power and, ultimately, wealth. In his section on 'gardens for persons of moderate means', de' Crescenzi declares that: 'let the space of earth set aside for the garden be measured according to the means and rank of the persons of moderate means, namely two or three or four or more *iugera*[1] or *bubulcae*. (Bauman 2002, 101)' This differentiation in the type and size of garden dependant on the owner's status came to represent the changing political system in Italy's many independent city states, including Rome (MacDougall 1994, 1).

In the proudly independent republic of Venice, the gardens both in the city itself and in the surrounding Veneto area were relatively modest. Although run by an oligarchy of a few powerful families, there was no hereditary right to power in the Venetian republic and none of their villas or gardens stood out as being more magnificent than any of the others. In states with hereditary rulers such as Ferrara[2] and (from the 1530s) Florence, there are increasingly lavish gardens and designed landscapes. In Rome, the powerful Popes, Cardinals

and their families were engaging in a process of 'one-upmanship' by creating even more elaborate gardens attached to their villas. Until 1484, the Cardinals were not able to own land to pass on to their families but, due to the political manoeuvring of the future Pope Innocent VIII, this changed. In order to get elected, Innocent promised the Cardinals that he would allocate them a rural residence. As each new Pope (bar two from the Medici family) was from a different Italian family, they brought with them their relatives and court officials, who in turn wanted a residence of their own. As the properties built by previous Popes' entourages often remained in the possession of the original owners (even though they were funded by church money), the only option was for new places to be found (MacDougall 1994, 3). Thus in the space of 100 years, over 80 of these grand villas and gardens were developed in and around Rome. Each new one attempted to outdo its predecessors in scale and complexity, particularly in the use of water, with the latter being a potent symbol of a landowner's control over nature and the population.

The factors that triggered this explosion of garden building in the sixteenth century had its roots in the Italian Renaissance and humanist thinking. The enclosed medieval gardens were 'opened up' by these new ideas inspired by Classical models. Although Imperial Rome had left its legacy through the Catholic Christian Church, it was the Byzantines and Muslims who had kept alive Greek and Roman ideas following the end of the Roman Empire in the fifth century AD. During the fourteenth century, a revival in Classical ideas in philosophy, art and architecture in Italy began, with gardens being seen as the interaction between art and nature. By the mid-sixteenth century, they were being described as the 'third nature' with the natural world being the first and agriculture the second.[3]

Petrarch, the first 'humanist' philosopher, was a keen gardener and helped popularise the importance of the garden for the aspiring Renaissance man. He used classical texts on gardening to guide him such as Pliny the Elder's *Naturalis Historia* and was inspired by the descriptions of Pliny the Younger's gardens surrounding the latter's villas. However despite the extensive open gardens described by Pliny, Petrarch's garden at Vaucluse was still laid out in the medieval fashion inside high walls with mainly functional rather than decorative plants. The humanist ideas of Petrarch did change the way gardens were thought about and created. As Comito (1991, 42) points out 'the harmony of the cloister garden [of the medieval world] directs the inquiring mind to God; the Renaissance garden testifies to the nobility of its lord, of its city, of humanity in general'. The garden became less about being a representation of paradise (as in the Garden of Eden) and more about what man could achieve here on earth. Humanists were proposing that man should explore the world for himself rather than accepting the pre-set ideas of the Church's teachings.

The humanist thinking brought new architectural ideas. Leon Battista Alberti, who was influenced by the Romans Vitruvius and both Plinys, published his *De Re Aedificatoria* in 1453. Known as the *Ten Books of Architecture*, in it he

recommends a hillside setting for a villa.[4] The garden, although possibly still walled, would thus overlook the countryside beyond. This was the first time that gardens had used such 'borrowed scenery' since Roman times. Gardens had remained firmly within the building's high walls with no view to the wider landscape in the medieval world, as the 'outside' was deemed wild and dangerous. Inevitably the layout of the gardens changed and became outward looking, with terraces used to suit the hillside position. Control was maintained in this more open green space through the revival of the use of topiary.[5]

Alberti's ideas were taken up most enthusiastically in Florence. It had become the leading economic centre of Italy in the late thirteenth century through trade and banking, overtaking its rival, Venice. By the early fifteenth century, the Medici bank (founded by Giovanni de' Medici) was pre-eminent and although Florence was nominally a democracy, in reality it was those with the money, such as the Medici, who held power. Cosimo de' Medici, Giovanni's son, became a patron of the arts and was one of the first to adopt the new ideas in architecture and gardening. In 1457, Cosimo remodelled an old castellated house at Careggi, in the hills outside Florence. While the garden at this 'villa' was still enclosed, he, and then his grandson Lorenzo, gathered here with favoured guests to discuss philosophy, imitating the ancient Greek Platonic academies. The garden at Villa Cafaggiolo, redesigned in 1452 for Cosimo from an earlier building, was more revolutionary. While the architecture of the building remained medieval, the garden was outside the defensive walls for the first time and also aligned in an axis away from the building. The garden was thus trying to break free, just as the new and radical ideas of the Renaissance elsewhere in time would start to challenge not only the prominence of the Catholic Church but also the role of a nation's leader.

First Renaissance gardens

It was at Villa Medici at Fiesole (Figure 3.1), designed possibly by Michelozzo between 1455 and 1461 for Giovanni de' Medici (Cosimo's son), that was one of the first to put into practice Alberti's ideas about position of a villa. Built on a hill overlooking Florence, its current top two terraces are original to the fifteenth century design with the lower one added in the twentieth century. Giovanni was a well-known humanist scholar and in the villa was his extensive library of classical texts. The villa and its garden was the first to consciously model itself on the Roman idea of the *villa urbana*. Just as at Careggi, the garden at Fiesole became an outdoor meeting place for his nephew, Lorenzo.

Palazzo Piccolomini became the model for gardens of the senior clergy of the Roman church. Aeneas Piccolomini (Pope Pius II) was a friend of Alberti and he was one of the first to inspect remains of Hadrian's Villa at Tivoli. The Renaissance had flourished in Rome from the reign of Pope Nicholas V (1449–1455) and he had grand plans for the gardens of the Papal palace but died before they could be put in place. After becoming Pope in 1458, Piccolomini

FIGURE 3.1. Villa Medici
at Fiesole, near Florence.

turned his attention away from Rome and instead rebuilt his village birthplace
of Pienza in Tuscany, with the Palazzo as its centrepiece. While the building is
relatively conventional in terms of architecture, what was different was the triple
loggia, one side of which looked out over a small garden and the view across
the Val d'Orcia. The garden originally was open on all sides and so could be
viewed by the local town as well as its owner, a clear demonstration that Pope
Pius wished his creation to be seen and appreciated by everyone. This was very
different from the enclosed *hortus conclusus* that was only for a selected few.

These radical ideas on garden design of the Medici in Florence and
Piccolomini took another 50 years before they were developed further. None of
the subsequent Popes until Julius II, showed any interest in creating gardens,
nor did the Cardinals who now had the right to acquire property in and
around Rome. Julius's plan was to increase the political importance of the
papacy by linking the Vatican to the might of Imperial Rome, in particular its
iconic buildings (MacDougall 1994, 7). The Villa Belvedere garden, which he
commissioned in 1504 (Figure 3.2), was designed to recreate a classical pleasure
garden. The villa itself was to display Julius's works of art and the garden was a
link between it and the main Papal palace in the Vatican. Designed by Bramante
and completed by 1513, the Belvedere revolutionised the way gardens would be
planned in future. In a deliberate statement, it remodelled the natural terrain
into three large terraces on an axis rather than the more traditional central
point. By doing so, it marked a shift not only in design but also showed the
Renaissance vision of man imposing on, rather than working with, nature
(Comito 1991, 43–44).

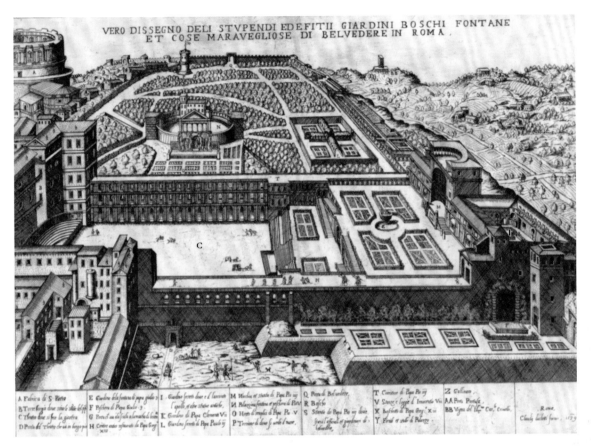

VERO DISSEGNO DELI STVPENDI EDEFITII GIARDINI BOSCHI FONTANE ET COSE MARAVEGLIOSE DI BELVEDERE IN ROMA.

FIGURE 3.2. *The Cortile of the Belvedere in the Vatican*, print by Brambilla 1579.

An another innovation was a public area for display (marked 'C' on Figure 3.2 as *cortile del teatro*) and as early as 1509, it was used for a bullfight (MacDougall 1994, 7). This idea of public display in a garden would be replicated at the Boboli Gardens in Florence with the amphitheatre (Figure 3.3) and in the French Renaissance palaces. Finally there was a private area (*giardino secreti*) for Julius and his favoured guests to go inside the Villa (marked 'I' on Figure 3.2), copying the idea used at the early Medici villas. The design aimed to display variety within an ordered structure, demonstrating man's control over nature and by implication the papacy's role in the politics of the Western world. Essentially geometric, it was divided into compartments that became more elaborate over time as each succeeding Pope added their own area.

The other key garden of this period was Villa Madama, owned by Cardinal Giulio de' Medici and started in 1516 for his cousin, Pope Leo X, by Raphael.[6] This was the first classical villa outside Rome and modelled on those in Florence as a place of retreat and discussion of humanist philosophy. Giulio had hoped to succeed his cousin when the latter died in 1521 but he had to wait for another two years before he became Clement VII, spending the intervening time back in Florence. His tenure as Pope, while it allowed for the resumption of building at Madama, in 1527 led to the sacking of Rome by the Habsburg Emperor Charles V. The Emperor's forces, many of who were Lutherans, took great delight in

FIGURE 3.3. Amphitheatre at Boboli Gardens, Florence.

destroying symbols of what they believed was the corrupt Catholic Church, including the half-built Villa Madama. This traumatic event stopped further work on expanding Clement's villa and garden and merely restored what had already been completed. It also meant that no further gardens were planned until Rome had recovered its confidence through the Counter Reformation of the 1540s.

In Florence the surprise election of Cosimo de' Medici as the head of the republic in 1537 led to a new wave of garden building there. Cosimo was only seventeen at the time and a member of the 'junior branch'[7] of the family as his predecessor, Alessandro[8] died without legitimate issue. From the start, Cosimo had to demonstrate his legitimacy to rule, which he did successfully by defeating those opposed to his election and making an important alliance with the Emperor Charles V. Cosimo's election ensured that the Medici family once again held the reins of power. Following the sack of Rome (and the Medici pope's humiliation), the Florentines had drawn up a new republican constitution. In appointing Cosimo, the senators hoped that they could control him but he soon proved them wrong by taking power firmly back into his own hands. It was in his creation of gardens that he sought to emphasise this power and the benefits that his rule brought to the Florentine people.

At Villa di Castello, laid out between 1536 and 1567, the designer, Tribolo's 'brief' was to develop an elaborate iconological programme worked out by one of Cosimo's court humanists, Benedetto Varchi. Lorenzo de' Medici had

FIGURE 3.4. Main garden at Villa di Castello, Florence.

bought Castello, at the base of Monte Morello outside Florence, in 1477. It had a building dating from the thirteenth century and an enclosed garden behind. The fact that it was the site of an ancient Roman reservoir or *castellum*, which supplied water to Florence via an aqueduct, gave it greater resonance. It demonstrated the Medici power and the importance of water to the Florentine state (Vasari 1851, 191–2). The main theme, using the improved water supply[9] was the 'calming of the troubled waters, the birth of Venus, and the return to spring to Florence' (Wright 1975, 314), which related to Cosimo's defeat of the rebels and the strong government and prosperity that he brought after the weak rule of the previous Medici. The new garden was created within the existing structure but unlike the villa at Fiesole, the gardens are all integrated. They rise above the house (Figure 3.4) along a central axis and spread out beyond the house. At the top of the garden is a pool with the statue of Appenino (Figure 3.5), representing the melting mountain snows and the subsequent torrent (the revolt against Cosimo). The waters then flow into the grotto (Figure 3.6) where Orpheus tames the wild beasts and stills the waters with his lyre (Wright 1975, 314). The water re-emerges into the two central fountains: the first is Venus (Florence) reborn from the waves[10] and the second is Hercules overcoming Antaeus: a metaphor for Cosimo (Lazzaro 1990, 174), as the symbol of strength.

In the central part of the garden along the garden walls, was the most complex part of the iconographic programme. Together with statues, see table

FIGURE 3.5. Statue of Appenino, Villa di Castello, Florence.

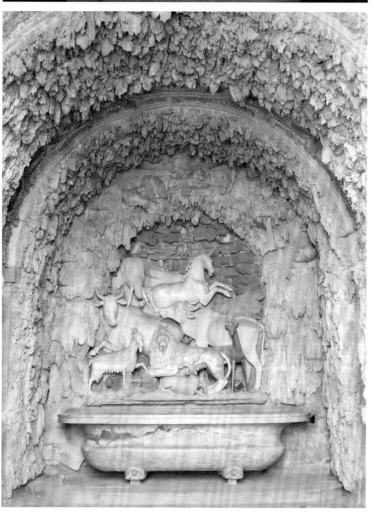

FIGURE 3.6. Grotto at Villa di Castello, Florence.

below (Vasari 1851, 202), his Medici predecessors would be represented by busts along the walls, symbolising both their fluctuating fortunes[11] and also Cosimo's legitimacy. A contemporary, Giorgio Vasari, noted that:

> 'at the entrance, and on the right hand, commencing from the statue of Winter, six figures were to be placed along the wall which descends to the lower part of the garden; all to denote and set forth the greatness and excellence of the house of Medici; signifying moreover, that all the virtues are to be found assembled in the person of the Duke Cosimo … which have ever dwelt in the house of Medici, and are now all to be found in the most excellent Signor Duke; seeing that he is of a truth most just and merciful, brave and generous, wise and liberal.' (Vasari 1851, 202–3)

On the opposite side were all the attributes of the Florentine people. At the time of writing,[12] Vasari commented that Tribolo intended to place a bust, which would be of one of the house of Medici, in the niches above the statues that they related to (see table for Vasari's suggestions). It is perhaps telling that Cosimo's immediate predecessor, Alessandro, is not mentioned as the latter's rule had caused so much division.

Summer	The river Mugnone	Portal	The river Arno	Spring
Arts				Liberality (Pope Leo X)
Tongues				Wisdom (Cosimo the Elder/Pope Clement VII)
Sciences				Generosity (Lorenzo the Elder)
Arms				Valour
Peace				Mercy (Giuliano)
Law				Justice (Cosimo)
Autumn	Portal	Loggia	Portal	Winter

Castello was the first place where the myth of the Golden Age,[13] which was particularly important for Medici propaganda (Comito 1991, 39), was used. Cosimo had been brought up at Castello and it was perhaps apt that it eventually was Cosimo's 'retirement' home after he gave his son the powers of state.

The Genoese republic in the sixteenth century was dominated by a number of families and the development of the villas and gardens there were a result of attempts by the Fieschi and Doria families to impose their pre-eminence in local politics during the first half of the century. Like the Medicis in Florence, they chose areas immediately neighbouring the city. The Fieschi family were on the eastern hill of Carignano, and the Doria family opposite them on the western part, arguably a more strategic location on the way to the city centre.[14] The size of the villas and the 'complexity of their gardens [made] a claim by their owner to the role of "lord" of the city, whether or not this was actually

true.' (Magnani 2008, 54). Andrea Doria's villa, started in 1528, was a grand statement in the Medici mould. It not only was a place of power where only the selected few were invited but its 'garden was a remarkable political and commemorative representation of its owner – and the project was continued by Andrea's heir, Giovanni Andrea Doria, to celebrate the glory of the dynasty' (Magnani 2002, 46). Comparisons with the Florentine republic ended there, as the rising Genoese financial class would not accept a dynastic head such as Doria and 'so [also] rejected as well the model of the symbolic/dynastic garden designed for a prince' (Magnani 2002, 46). The Fieschis took part in an ill-fated coup against the Dorias and the former's defeat in 1547 brought about not only the destruction of their power base but also symbolically the demolition of their palace and gardens by the Dorias (Magnani 2008, 54). In Genoa ultimately there were only modest villas and gardens, owned by the whole oligarchical class of the Republic, rather than one family making grand statements. This was, according to Magnani (2008, 54–5), 'an affirmation of the identity and political role of that class, and thus implicitly became a gesture of refusal of, and possibly defiance to, the supremacy of a unique "lord"'.

Gardens as grand statements

The defining gardens of the Italian Renaissance, the Papal villas around Rome, were built by an oligarchy but their status and money owed not to trade but to being servants of God. The former means of acquiring wealth was regarded with a slight degree of distaste, so the Genoese and the Venetian nobles in many ways downplayed their status and produced relatively modest villas and gardens. There was no such restraint for the Popes, Cardinals and their families, who could seemingly justify their extravagance by virtue of the position they held in the Church. Drawn from a select group of Italian families, they were suddenly thrown into prominence, wealth, and improved social status by the election of one of their number as Pope. This in turn led to the emergence of the new Roman villas and gardens and to changes to Roman aristocratic society.

From the mid-sixteenth century these families[15] began to form a particular group known as the papal aristocracy. The new type of villa invented by this group as been called the 'estate-villa' by Beneš (2001, 93) 'because structurally it presents the configuration of an estate – with palace, dependencies, formal gardens, parklands and agrarian lands'. They were an important statement about the power of the owner because they could afford to have a large estate near the city centre, imitating the Roman Emperor Nero's Golden House and one as well outside Rome. The inner city villa gardens 'were like a synthetic representation of these countryside properties … placed right at the exit point of the city, in the first ring of vineyards, where the journey to these properties began' (Beneš 2001, 106). Visitors to and from the Vatican would stop and visit these villas and gardens, contributing to the rivalry amongst the owners to outdo one another, with the features and overall magnificence of the gardens.

Renaissance garden iconography of the second half of the sixteenth century had two distinct features. One was linked to the aggrandisement of the garden owners' reputation through symbols and the other was the garden being portrayed as being beneficial to the local population, often through public works such as improved water supply. Garden sculpture was critical and represented the 'art' part of garden making, with the plants the 'nature'. Most sculptures were on a classical theme and often alluded to the garden's owner. Hercules was popular with the Este and Medici families as a symbol of strength and the ability to choose good over evil. The interrelated themes of Mount Parnassus, Apollo and the Muses, together with Mount Helicon, Pegasus and the Hippocrene spring was particularly popular as it associated the owner with patronage of arts and literature (Cellauro 2003).

It was not only in art that the owner could demonstrate their wealth and prestige. New plants were arriving throughout the Renaissance from the Near East and Americas. In important gardens of the Medici and others, the latest imported plants were grown, as well as in the newly formed botanic gardens. There were three main categories of plants used in the garden: large trees in the *bosco* or wooded areas away from house, fruit and nut trees in an orchard or main garden and herbs or flowers in beds in a smaller area near the house. Today much of the colour has gone from these Renaissance gardens, mainly due to long-term neglect and cost of maintaining flowers, leaving just the 'green structure'. We can however see from contemporary paintings such as the lunettes painted by Utens about 1599 (Figure 3.18) how these gardens originally looked. The trees used depended on the site but typically evergreens such as cypress and laurel and deciduous such as oak, maple and elm were grown. Evergreen shrubs were popular especially box and they were used for all types of hedging and of course for topiary.

The Villa d'Este and the Villa Lante were not only the most ambitious papal aristocratic gardens but also the first to have a defined itinerary. Perhaps this was to determine the movement of the public through the garden but it also emphasised control of the owner (MacDougall 1994, 19). Louis XIV would adopt this idea for Versailles, as the latter's garden neared completion in 1689. These two villas have come to define the Renaissance villa garden, full of technical expertise and symbolism. Villa d'Este is in the hill top town of Tivoli outside Rome, famous for Hadrian's Villa, which it set to rival. Originally an old monastery, the garden plans required a quarter of the neighbouring town to be pulled down! Begun by Cardinal Ippolito d'Este in 1550, it was developed further after his death in 1572 by his nephew, Luigi. The d'Este family had come from Ferrara where they had built many fine gardens. Ippolito also had spent time at the French court and must have been influenced by the developments in gardens there. The work on the gardens at Villa d'Este reflected the varying fortunes of its owner. It started when d'Este was made Governor of Tivoli in recognition of his support for the newly elected Pope Julius III. Five years later, his campaign to become Pope on Julius' death backfired spectacularly as not

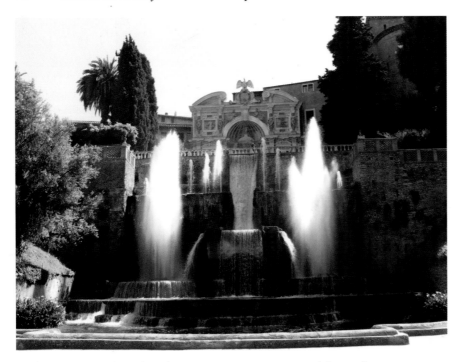

FIGURE 3.7. Fountain of Nepture with Fountain of the Organ behind, Villa d'Este, Tivoli.

only he did lose but also the winner, Pius IV, accused him of attempting to buy votes. Not surprisingly he was relieved of his governorship and sent into exile in Ferrara until Pius' death in 1559.

After the election of Pope Paul IV and the restoration of his position at Tivoli, d'Este probably wisely decided to concentrate on making his garden into the most spectacular yet seen, while still harbouring a desire to get the top job. Although the town had a good water supply, it was insufficient for the grand plans Ippolito had for his garden. The main fountains could only be constructed from 1565 after the water supply was established by diverting a local river and at the same time, improving the water supply to the town. In all, the garden originally had twenty fountains, fourteen of which remain (Figures 3.7 and 3.8). It is unusual that it has two main axes and no obvious route (Figure 3.9) hence the itinerary and critically all the garden cannot be seen from one point. The latter design 'trick' makes the garden seem larger than it really is and perhaps consolation for d'Este who ultimately failed in his main ambition to become Pope. The main themes of the Villa d'Este are firstly the mastery of the natural terrain by the creation of the terraces. Secondly the paths and fountains in the garden represent the story of Hercules and his visit to the Garden of Hesperides to retrieve the golden apples, for example the Fountain of the Dragons, guardian of the apples (Figure 3.10).

Cardinal Gianfrancesco Gambara began Villa Lante at Bagnaia in 1568 on the site of a hunting park that one of his predecessors, Cardinal Riario, had first developed in 1514. He had become bishop of nearby Viterbo in 1566 and with the position came the property. Cardinal Ridolfi had commissioned the building

FIGURE 3.8. The Hundred Fountains, Villa d'Este, Tivoli.

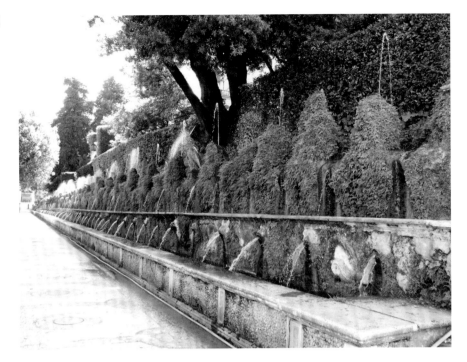

FIGURE 3.9. View of the gardens of the Villa d'Este in Tivoli, print by Cartaro 1575.

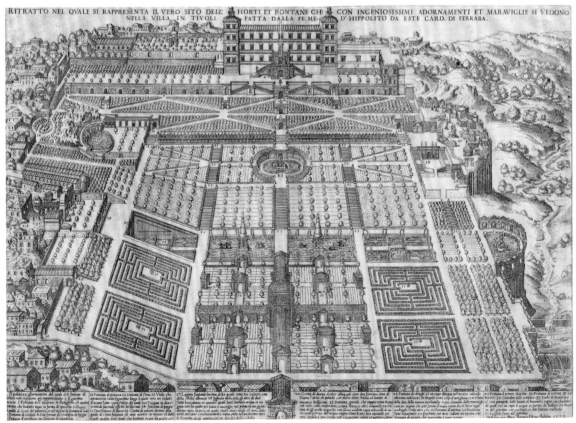

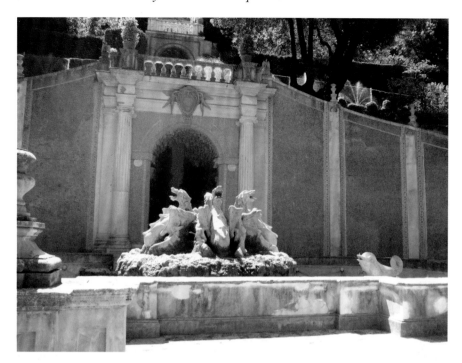

FIGURE 3.10. Fountain of the Dragons, Villa d'Este, Tivoli.

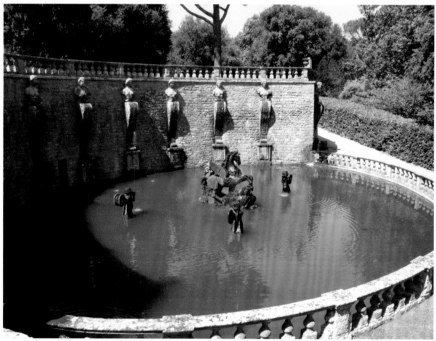

FIGURE 3.11. Fountain of Parnassus, Villa Lante, Bagnaia.

of an aqueduct in 1549 to bring water to Bagnaia and while there were mineral springs, it is unlikely that Gambara could have completed his project without this additional water supply. Unlike his near contemporary d'Este, Gambara seemed to prefer to be less involved with the highest level of Vatican politics.

He did however want to outdo d'Este in terms of an extravagant garden. This backfired when Pope Gregory XIII visited his new garden in 1578. Gambara had been receiving the special 'poor cardinal's allowance' and Gregory was so angry that the money had gone on such conspicuous consumption that he cancelled the allowance (Attlee 2006, 63). It was a sensitive time for the Catholic Church, as it was trying to defend itself against charges of corruption. The fact that Church's funds were being used by the senior clergy on lavish personal projects such as the gardens, rather than on supporting the poor priests, nuns and the Catholic population, did not help matters. Many in the Church viewed these grand gardens of the Cardinals as counterproductive in their fight against the creeping tide of Protestantism. This did not deter the gardens' builders, as they believed that being a patron of the arts was as important as their strictly religious duties. Gambara and his ilk truly believed that they had brought a second Golden Age.

Villa Lante was thought to have been designed by Vignola, who had been working on the nearby Villa Farnese (Caprarola) for Cardinal Alessandro Farnese. It has a formal garden and park side by side, representing the contrast between the paradise of the Golden Age and the subsequent civilising Age of Jupiter. The formal garden is a series of terraces on a main axis, culminating in a large water parterre. The itinerary, starting first in the park, reflects the time of the Golden Age when men lived in peace, did not have to work for a living and wild food was plentiful. Thus we see first the Fountain of Parnassus (Figure 3.11), signalling that this is a garden of the poet, followed by fountains of Acorns and Ducks, both of which were in plentiful supply in the Golden Age. The new era (the Age of Jupiter) starts at the top of the formal garden with Fountain of the Flood, the source of water for the garden. Next to it are the rooms of the Muses, which represent twin peaks of Mount Parnassus where survivors of flood landed. Further down the formal garden, the planting becomes more controlled as art is taking over from nature and the force of the water diminishes until you reach still pools (Figure 3.12) at the bottom. Halfway down is the water chain (Figure 3.13) with the crayfish symbols representing Gambara,[16] implying that nature is becoming art through the cardinal. The water flows into the Fountain of the River Gods (Tiber and Arno): two rivers that bring prosperity to northern Italy and finally to the water parterre. The garden spells out the virtues of Cardinal who made surrounding area more beautiful and was a patron of the arts enabling the human spirit to reach its potential. It is the use of water not only in terms of astounding displays but also as representation of a fertile life that mark out this garden 'as a token of princely magnificence' (Comito 1991, 42).

In central Florence, the Medici were creating their own grand central statement at the Pitti Palace and adjoining Boboli Gardens. Eleonora, wife of Cosimo de' Medici, had acquired the site in 1549 from Pitti family. Tribolo's design, completed just before his death in 1550, although simpler than the one at Castello, was on a much grander scale, reflecting its main purpose as a place

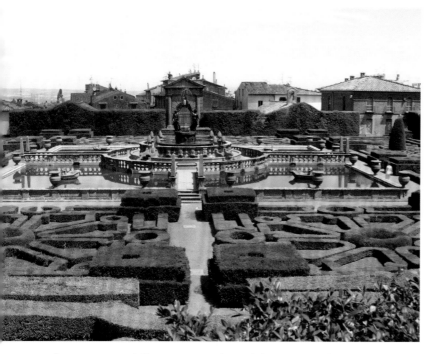

for visitors and for major Medici celebrations such as weddings. Cosimo and his family continued to live at one of his villas outside the city, in particular Castello. The Boboli gardens did not have to have a complex iconographic programme, as it demonstrated to its visitors the power of the Medici merely by the sheer scale of the place. As the new Pitti Palace was being constructed in the 1560s, the stone quarry at the foot of Belvedere hill was turned into a semi-elliptical open space, reminiscent of Roman hippodromes. In the centre of this amphitheatre (Figure 3.3) was the Oceanus Fountain erected in 1577. On his accession in 1587, Grand Duke Ferdinand made Pitti the main palace for the Medici, highlighting the new status of the family as Grand Dukes of Tuscany,[17] so it was inevitable that the garden should develop in size and complexity.

While Ferdinand's successor, Cosimo II, was responsible for the new layout from 1609, it was Ferdinand II who reworked the original garden. His accession in 1621 was marked by a difficult period in Florence with both an economic recession and the plague threatening the stability of the duchy and ultimately the power of the Medici. The water supply to the city was proving inadequate for the growing needs of the population, so the commissioning of a new aqueduct by Ferdinand, using unemployed textile workers, thus solved some of these issues. Like his Medici forebears, these achievements were commemorated in his garden. First he had the amphitheatre remodelled into a more permanent structure where grand events could be staged.[18] Secondly he altered the central *allée* of the Boboli to celebrate his role 'as a preserver of peace, restorer of prosperity, provider of water, and munificent benefactor of the Florentine people…by the installation of a colossal marble statue representing

FIGURE 3.12. Water parterre at Villa Lante, Bagnaia.

FIGURE 3.13. Water chain at Villa Lante, Bagnaia.

Dovizia (Abundance) at the uppermost point of the *allée*' (Campbell 1996, 173). It is made more overt by the inscription on the base of the statue, which 'declares that while all Europe was plunged in terrible warfare and Italy suffered from famine, Tuscany enjoyed the benevolent reign of Ferdinand II, most perfect prince of a felicitous people' (Campbell 1996, 173–4) The new basin below, whose waters came from the new aqueduct, had a statue of Neptune, representing the abundance of water just as the Oceanus Fountain had done.

The Italian garden expands and travels abroad

The traditional divide between park and garden as seen in Villa Lante became blurred in the late sixteenth century and paved the way for the 'landscape garden' both in Italy and abroad. This new style of gardens was planned on a completely different scale to previous ones. There is no single dominant axis, instead the garden spread away from the main building in many directions. The garden at the Medici villa, Pratolino, north of Florence, marks this change. Built between 1569 and 1581 for Francesco de' Medici, it was a statement not only of his power and prestige but also technically what now could be achieved in the garden. There were no separate areas for formal gardens: it is planned as an integrated area, however it was still imbued with much symbolism relating to the rule of Francesco.

It was an architect who truly opened up the garden into the landscape. Andrea Palladio worked in the Veneto region for many Venetian nobles in the mid-sixteenth century. Like Alberti before him, he was inspired by Classical architecture especially the works of Vitruvius. He produced the first Italian translation of the latter's *De Architectura* in 1556. Palladio was more of a purist than Alberti in terms of proportions used for the buildings and their overall style. His architecture influenced the design of the landscape around it, with his architectural treatise, *Quattro Libri dell'Architettura* (*The Four Books of Architecture*, 1570), becoming the blueprint for the 'Palladian architectural style'. The villas Palladio designed in Veneto hills most clearly demonstrated his skill at integrating buildings and the surrounding landscape, where the central building became more important than the adjacent garden. Villa Capra 'La Rotunda' (Figure 3.14), built in 1565, was inspired by the Pantheon in Rome. From each of the four porticos there is a different view of the landscape. To the north are the entrance carriageway and the city of Vicenza in the distance. To the west is a wooded area and to the south and east, the plains below. This is very different to other villa gardens of the same period in Florence and Rome. Venetian nobles did not want to flaunt their wealth, therefore they had to look for other ways to make use of their estates and the landscape surrounding them.

By end of sixteenth century, the concept of the garden had changed as Renaissance ideas became universal and the new styles of garden largely lost their symbolism. The idea of interaction of human and natural realms slowly disappeared and garden iconography relating specifically to the owner's

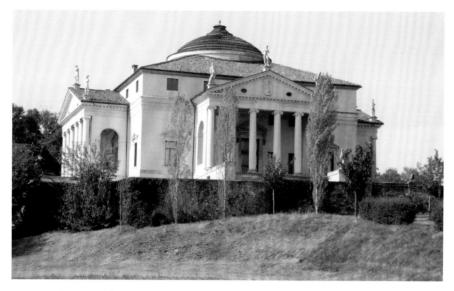

FIGURE 3.14. Villa Capra 'La Rotunda', Veneto.

perceived virtues became more overt. At the start of the seventeenth century, the papal aristocracy became more interested in amassing strategically located landholdings than developing gardens as grand statements. Following the same ideas of the barons of the medieval period, these 'papal families' wanted properties along the routes that they 'controlled' into Rome (Beneš 2001, 108). Gardens merely became displays of wealth and power allied to the new Baroque architecture, the symbol of the increasing confidence of the Catholic Church. These more elaborate and expensive architectural buildings directly affected the gardens, as the latter's costs of maintenance had to be trimmed. Over time, there was more simplified planting in the parterres and higher hedges, through less frequent pruning. Green structures such as pergolas were replaced with hard landscaping. There was a reversion to a single axis that aligned the baroque garden with the wider landscape, as the central building once more became the dominant feature. The overall effect of this style of garden was one of spectacle rather than contemplation.

The new style of baroque villa and garden developed particularly in Frascati, a town in the Alban Hills south-east of Rome and first developed in Roman times. Cardinal Pietro Aldobrandini was given a property at Frascati by his uncle, Pope Clement VIII in 1598, as a reward for his skilful negotiations with France.[19] He had the modest villa turned into a palace and created the first baroque garden (Figure 3.15) over a 20 year period. Typical of the changed motives of these later garden builders, Aldobrandini sent an artist, Guerra, to visit all the best gardens in Italy, so that he could surpass these. Thus there are elements from Villa Lante (the Casino garden), Villa d'Este (the water theatre) and even from Bomarzo, the strange garden of grotesque carvings created by Vicino Orsini. However he encountered the same problem as other garden builders: a lack of sufficient water. The problem was the increasing popularity of the town as a summer retreat for the papal aristocracy and the subsequent large numbers of

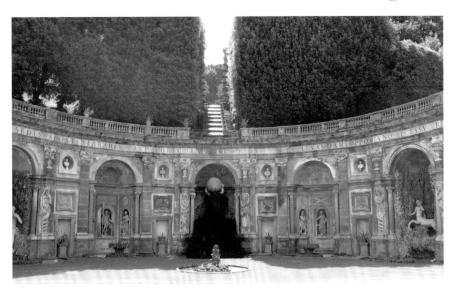

FIGURE 3.15. Loggia and water staircase at Villa Aldobrandini, Frascati.

villas and water hungry gardens that were built. Aldobrandini's solution was to build an aqueduct that would bring water from a spring 8 km away, financed by his uncle, Pope Clement.

Villa Aldobrandini is perhaps the best example of 'Cardinal-nephew'[20] villa, where the favoured relative of a Pope became his *de facto* heir and thus could benefit financially. These villas and their gardens were opulent essays in power politics, demonstrating not only the achievements of the villa's owner but also their papal patron. Villa Borghese in Rome itself typified the smaller inner city villa of the 'Cardinal-nephew' of the early seventeenth century. This hunting and pleasure park was built for Cardinal Scipione Borghese[21] between 1608 and 1613. Although the wider park was open to the public, Borghese clearly wanted areas that were private where only his invited guests could come. So he had two 'secret gardens' made around the main building that were filled with exotic plants. These were areas for either private contemplation or for selective gatherings where philosophy or more likely, Vatican politics, could be discussed. The Cardinal was carrying on a tradition started by the Medici nearly 150 years earlier in the villas outside Florence. While the main area was open to all, implying that such garden delights were for the masses, in reality the best parts were reserved, like political power, for a selected few.

While the creativity of the Italian garden slowly declined and started to be eclipsed in the latter half of the seventeenth century in France, the legacy of the radical Italian Renaissance garden continued. It inspired and continues to inspire countless generations of garden creators in the Western world, who adopted the ideas and used the resulting gardens to express their own political ideologies. The most obvious impact was in France, starting with Charles VIII who was so impressed by the Medici gardens and the villa at Naples, both the result of Florentine humanist ideas, during his invasion of Italy. The latter garden was a result of a visit to Naples by Lorenzo de' Medici to negotiate

a peace treaty between the two states in 1480. Afterwards Lorenzo sent his architect, Guiliano da Majano, to Naples to build a palace for the king of Naples (Comito 1971, 485–487). The two Medici queens, Catherine and Marie, brought first-hand Florentine garden design styles to France and used them to assert their positions as regents for their respective sons. In England, there was little direct impact of Italian garden style until the early seventeenth century as few English were able to visit Italy directly and only had ideas that had filtered through France (Strong 1998, 10).

The new Scottish Stuart kings, James I and Charles I, took up the 'Italian style' enthusiastically as they sought to establish their position in the English court after the Tudor era. While this was largely confined to temporary garden displays for court entertainments, it was the king's important subjects who were creating the real gardens (Hunt 1991, 21–22): a sign of garden building in the future. One of these, Wilton House (Figure 3.16) built in the 1630s by the Earl of Pembroke, shows its clear debt to Italian Renaissance ideas. Just as the Earl fought on the side of the Parliamentarians in the Civil War for the cause of civic humanism against the absolutism of Charles I, then this 'Italian' style would in future be closely identified with balanced and non-absolutist governments of future generations, particularly the Whig aristocracy (Hunt 1991, 24). Italian Renaissance gardens also played their part in the emerging respect for, and conservation of, historic gardens at the end of the nineteenth century. The revival of the style and ideas in the early twentieth century with 'recreations' such as Villa I Tatti (see Figure 10.1) and Le Balze, inspired by the Villa Gamberaia (Figure 10.2) shows the important role the Italian garden still has to play.

FIGURE 3.16. Bird's-eye view of the garden of Wilton House, as laid out by de Caus *c.*1645–9.

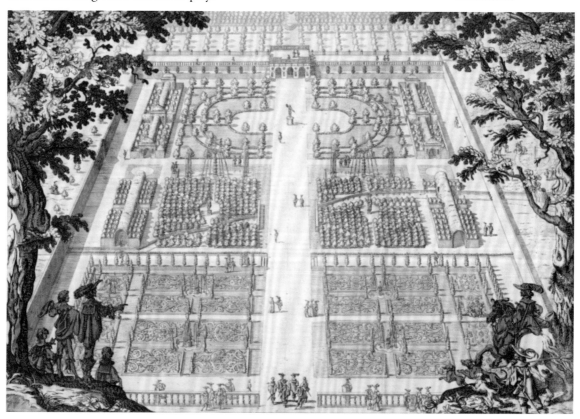

Notes

1. Roman measure of land, one *iugera* was approximately two-thirds of an acre (*c.*0.27 ha).

2. The d'Este family built a number of gardens around the city walls at Ferrara from the 1470s: these must have been influential on Ippolito d'Este, the creator of Villa d'Este in Tivoli.

3. Bartolomeo Taegio in 1559 and Jacopo Bonfadio in 1541 (Hunt 2000, 32).

4. The villa 'should be in view, and have itself a view of some city, town, stretch of coast, or plain, or it should have within sight the peaks of some notable hills or mountains, delightful gardens', Alberti (1988).

5. Pliny the Younger refers to these as 'box and shrubs cut into different shapes ... [and] figures of animals in box' in his letter to Domitus Apollinaris, translated by William Melmoth [revised by F. C. T. Bosanquet]. Harvard University Press, 1909. from http://catena.bgc.bard.edu/texts/pliny_tuscan.htm [accessed 2 May 2011].

6. His full design was never implemented due partly to his untimely death in 1520 but also to the fortunes of his patron, Guilio de Medici.

7. He was descended from Lorenzo the Elder (*c.*1395–1440), the younger son of Giovanni, the founder of the Medici bank.

8. He may have been Pope Clement's illegitimate son as the Pope backed his appointment.

9. One of the first things Cosimo did was to commission a new aqueduct to bring water from Castellina, quarter of a mile away. This was designed by Piero da San Casciano (Vasari 1851, 190).

10. '[The statue of the fountain of the Labyrinth is Venus] implies that Florence is fertile because of the rivers that flow past her. The association with the ... Medicean device [Capricorn] are a subtle reminder that she is so in the Capricorn sign, or under the rule of Cosimo' (Lazzaro 1990, 176).

11. Their cycle of exile and return to Florence is likened to the four seasons in the four corners of the garden (Wright 1975, 314).

12. The first edition of Vasari's work came out in 1550 with a second edition in 1568.

13. The Golden Age refers to the time when Saturn ruled Latium and ended when Jupiter overthrew Saturn. It was seen as a time of plenty and paradise on earth. The following period was marked with increasing wickedness on the part of humans and culminated in a flood that killed all humans apart from Deucalion and Pyrrha who survived on top of Mount Parnassus. It was only then that mankind learnt the art of civilisation but this came at a price of restrictions on some of the freedoms they had previously enjoyed.

14. It overlooked the entrance to the Western harbour and was on the route that Emperor Charles V took on his visit to the city in 1533 (Gorse 1986, 320).

15. Such as the Medici, Este, Aldobrandini and Borghese.

16. Crayfish in Italian is *gambero* and the symbol is found on the d'Este coat of arms.

17. In 1569, Emperor Charles V had crowned Cosimo as the first Grand Duke.

18. The first of these was on 15 July 1637 for his marriage to Vittoria della Rovere, Princess of Urbino.

19. This resulted in the peace treaty of 1595 and the annexation of Ferrara (home of the d'Estes) to the Papal states.

20. 'Cardinal-nephews' were relatives appointed by the Pope to senior positions in the Vatican from their immediate family – they were usually but not always the nephew. Another prominent one who built a famous garden was Alessandro Farnese (Villa Caprarola).

21. Borghese's uncle was Pope Paul V (1605–1621).

CASE STUDY THREE

Villa Pratolino, Florence

Situated about six miles north of Florence, just off the road to Bologna, Villa Pratolino was one of the last country villa and garden retreats built by the Medici family between 1450 and 1600. Of all the important Italian Renaissance gardens, it had the greatest impact on future gardens designed throughout Europe. It had a direct influence on Hellbrunn (Markus Sittikus von Hohenems, Prince-Archbishop of Salzburg), Neugebäude near Vienna (Holy Roman Emperor Maximilian II), Prague (Rudolf II of Bohemia), Richmond (Henry, Prince of Wales), St Germain-en-Laye and Fontainebleau (Henri IV of France) (Zangheri 1991, 62 and 64). It not only blurred the divide between garden and park, which led to the English landscape style, it also brought sophisticated engineering to create the first 'garden of marvels' (Zangheri 1991, 62).

Its builder, Francesco de Medici, eschewed the many other villas and gardens built by his forebears, including his powerful father, Cosimo, for two reasons. First he wanted to a place to escape to from court affairs and secondly, and perhaps more importantly, he wanted somewhere to put his mark on. By the time his father had been raised to Grand Duke in 1569, Francesco had already taken on some of the state duties as Prince Regent. Now that he had become the grand ducal heir, he needed a new building and garden to reflect his new status (Butters 2001, 79). His ambition for the villa and garden is summed up by the inscription in the vault of the original villa (now destroyed): 'Francesco de' Medici, second Grand Duke of Tuscany, adorned this house with fountains, ponds and tree-lined walkways, and dedicated it to the amusement and relaxation of himself and his friends, in the year of the Lord, 1575' (Butters 2001, 62). It was therefore a privilege to be invited to Pratolino by its owner, not only to view its marvels but also to be in the company of the most powerful man in Florence.

The previous September, Francesco had purchased the site at Pratolino, which comprised of eleven farms and their associated arable land and woods, so essentially this was a blank canvas. His inspiration for the garden is thought to have come from his visit in 1565 to the villas and gardens created by his brother-in-law, the Austrian Archduke Ferdinand, at Liboc, outside Prague and Schloss Ambras in Innsbruck (Zangheri 1991, 59). The Archduke was a noted collector and patron of the arts. Both properties reflected his interest in nature and man's representation of and relationship to it. As Zangheri (1991, 59) notes, Pratolino therefore 'explored the relationship between the open and closed spaces, between areas displaying the wonders of nature itself and those in which 'nature' was imitated or its characteristics reproduced. It was created with the express intention of reflecting the power and virtues of Francesco I de' Medici'. In other words, Francesco's ability to control nature in this garden

would reflect his ability to control the Florentine state, although it is debatable how successful he was doing the latter.

It was not so much what he put in the garden but how he achieved his creation that was the political issue. In 1586, Francesco de Vieri published *Delle Maravigliose Opere di Pratolino, & Amore* (Discourses on the Marvellous Works of Pratolino and of Love), in which the message of the garden was made explicit. The book, written with the help of Pratolino's main architect, Buontalenti and clearly approved by the Medici, made the link between the garden and good government. De Vieri states: 'Pratolino is a portrait first of a well-governed commonwealth here on earth and then of the divine commonwealth beyond the celestial spheres, insofar as it signifies to us the mind's beauty, which itself is a likeness of the beauties of heavenly Paradise and of those commonwealths which are regal and good, to which celestial commonwealth we should always aspire, with our thoughts, our words and our deeds' (Butters 2001, 64). He makes some specific examples such as the Appenine figure (Figure 3.17) is representative of one of the fallen Titans who tried to overthrow Jove, recognising that without God's help, one was bound to fail (Strong 1998, 82).

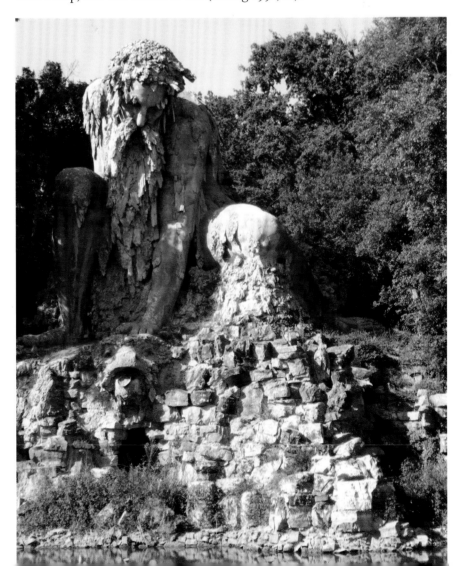

FIGURE 3.17. Statue of Appenine, Villa di Pratolino.

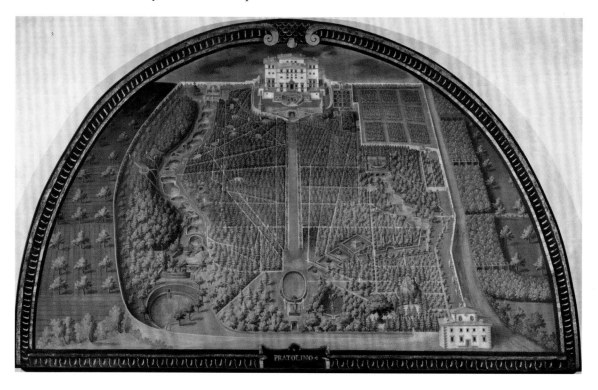

Work started in May 1569, following a design laid out by Bernardo Buontalenti and continued for another fifteen years. The picture (Figure 3.18) by Utens of around 1599 unfortunately only shows the southern half of the garden, which was completed first but a plan from 1742 (Figure 3.19) shows the full landscape, albeit with a few minor alterations, most notably fewer water features. The villa is placed in the centre of the designed landscape and both the north and south axes, leading from the house, are developed. This is in contrast to earlier properties where only the garden behind the property had significant work done on it. While the design was unusual for the time, it shared the copious use of water as seen in other Italian Renaissance gardens, such as the central Avenue of the Fountains (Figure 3.20). However, the site too suffered from a lack of a good supply (Smith 1961, 157) and as with other gardens, again great cost was incurred in bringing the required water to the garden, this time from the Mugnone River. The northern section (sometimes referred to as *barco nuovo* or new park) was started around 1578, together with its still extant statue of Appenine (Figure 3.17) by Giambologna and associated pool.

A lake was created near Fontanella, some two miles north-east of the main site from 1579 and this latter project put further strains on the water supply. There had been a long standing tradition to use what Butters (2001) has called 'pressed labour' or *comandati*, that is commandeered peasant, unskilled labour for these large scale Medici building projects. While the buildings and gardens used a greater proportion of skilled labour, the construction of these lakes required a significant unskilled workforce. At Fontanella, fifteen hundred

FIGURE 3.18. Villa di Pratolino, lunette by Utens *c.*1599. Florence, Museo di Firenze com'era.
© 2011. PHOTO SCALA, FLORENCE

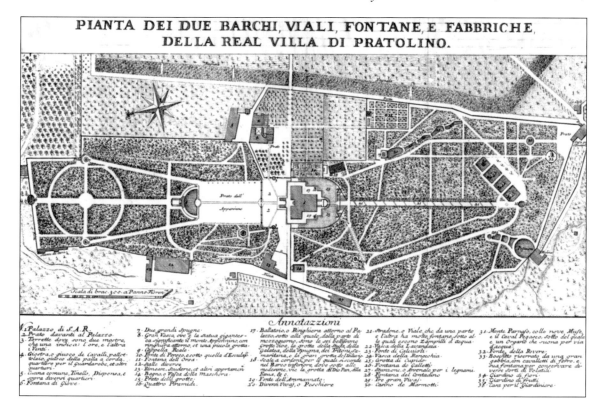

peasant labourers were employed at the peak of construction (Butters 2001, 72) and this led to increasing resentment amongst the local population. In 1582, general discontentment was made physical by the main garden at Pratolino being vandalised, with the noses cut off the statues, the pipes of fountains damaged, trees cut down and captive animals released (Butters 2001, 87). The Grand Duke Francesco was very shocked by this invasion of his privacy and implicit threat to his authority. It appears that he took note of it when he commissioned the second artificial lake at his villa, La Magia, three years later in consciously using less *comandati* (Butters 2001, 75). It did not stop him or his successors continuing to carry out large construction projects, such as the completion of Pratolino or the changes to the Boboli Gardens in Florence, although more volunteers were used. The Grand Dukes believed that such public works were beneficial for the local population, providing employment, thus reducing poverty and potential discontent.

Pratolino was compared to Villa d'Este at Tivoli, by contemporaries such as Montaigne who said it 'was made precisely in rivalry with this place [i.e. Villa d'Este]...although the Florentine [de' Medici] has a little more delicacy' (Smith 1961, 167). Perhaps Montaigne preferred the fact that the garden at Pratolino was subtler in its imagery. Instead of grand classical themes, it was more down to earth. As well as the usual statues of the Classical gods, there were automata, which acted out scenes from daily life and the walls of the grottoes had scenes showing the mining of precious metals, rather than mythical scenes present in

other gardens (Zangheri 1991, 59). As can be seen from the lunette painting (Figure 3.18), it is much more informal in terms of the planting and Francesco's love of botany meant that it was filled with many rare plants. Aldorvandi on a visit to the gardens in 1577 commented that Pratolino rivalled the botanic gardens of Pisa and Florence (Zangheri 1991, 64).

This Arcadia was in sharp contrast to the lives of the peasants around the estate and indeed to the nature that it was intended to portray. It is perhaps apt then that today the site is a public park, the Florence's Provincial Council having bought it in 1981 from the last private owners, the Demidoff family. It became the property of the House of Lorraine in 1737 after the last of the Medici died and was thought to be largely intact at that stage, although perhaps a shadow of its former self. The map (Figure 3.19) was from Sgrilli's *Descrizione della regia villa, fontane, e fabbriche de Pratolino* of 1742, which mentions some additions and alterations mainly from the late seventeenth century by Prince Ferdinando, son of Cosimo III. Sgrilli comments that 'many [things] have been taken away by time and diminished by the severe seasons' (Smith 1961, 166). Grand Duke Ferdinand III of Lorraine, in a seemingly misguided attempt to follow fashion, transformed the site into an 'English' style park in 1819. The Bohemian architect Josef Frichs was responsible for the design in which tragically the villa was demolished in 1822. In 1872 the park was then sold to the Russian Prince Paolo II Demidoff, who made some attempts to restore the remaining buildings within the property, and landscape features such as the Cupid's and Mugnone grottoes.

FIGURE 3.20. Central *allée* and fountains at Villa Pratolino, print by della Bella *c.*1653.
© TRUSTEES OF THE BRITISH MUSEUM.

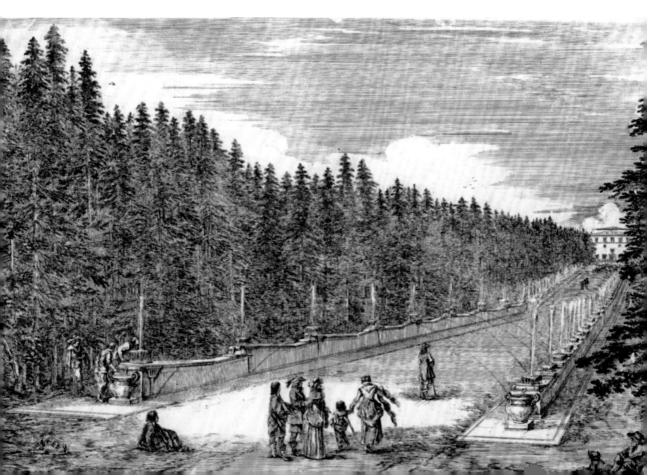

CHAPTER FOUR

Absolutism and Diplomacy
in the French Formal Garden

En sortant du chasteau par le vestibule de la Cour de marbre, on ira sur la terrasse; il faut s'arrester sur le haut des degrez pour considérer la situation des parterres des pièces d'eau et les fontaines des Cabinets.

Il faut ensuite aller droit sur le haut de Latonne et faire une pause pour considérer Latonne les lésars, les rampes, les statües, l'allée royale, l'Apollon, le canal, et puis se tourner pour voir le parterre et le Chasteau.[1]

This is the start to a version of the *Manière de montrer les jardins de Versailles* (Way of showing the gardens of Versailles), a guide written by Louis XIV first in 1689 and subsequently revised up to 1705 as the gardens were developed (Berger and Hedin 2008, 93). While this would not seem unusual today when visiting an eighteenth century English landscape garden such as Stowe, then it was a statement about the size and complexity of the garden that required a guide, not least to stop visitors getting lost! It demonstrated Louis' requirement for complete control over how his statement of power, that is Versailles and its environs, were viewed by the outside world. Although French nobles were required to spend the majority of their time at the palace, a ploy to stop them plotting revolution, these guides were not for them but for foreign visitors. The first one was written for recently exiled English Queen, Mary of Modena (wife of the deposed James II). Louis also personally escorted her on the tour of the garden, the highest honour and a gesture that must have been a riposte to the new English King, William III, his great rival (Berger and Hedin 2008, 56).

The gardens at Versailles became the model that other aspiring political leaders in Western Europe, including non-royals, would use when planning their estates, such as the English Whig grandees of the late seventeenth and early eighteenth centuries. The design layout of it and other grand French gardens of the era were down largely to the vision of one man, André Le Nôtre. He created these designed landscapes on the often uninspiring, flat sites that he had to work with France, rather than having a location with an interesting view, as in Italy. Versailles would not have been realised without the absolute power that Louis enjoyed. In this context, it is interesting to look at Louis' peers in England,

Prussia and Russia. Since the English Civil War and the Glorious Revolution in 1688, the powers of the monarchy in England had been restricted and so we see no English Versailles. However the Brandenburg rulers of Prussia and Tsar Peter the Great of Russia both increased their control of their respective states in the late seventeenth century.[2] It is no coincidence that following a visit to Paris in 1709, Peter built his version of Versailles, the Peterhof in St Petersburg, using French designers six years later.

It was not just about the sheer size and the overall design, it was *how* Louis used these gardens politically, which is interesting. In addition to the diplomatic tours, it is the use of the garden as a place of symbolism and spectacle that is also important. As Mukerji (1997, 2) points out: 'Versailles was a model of material domination of nature that fairly shouted its excessive claims about the strength of France … [and was] testimony to the greatness of the monarch who built [it]'. This was not a new idea, as the Medici had been using their gardens in Italy for these purposes for well over a century. It was the Medici queen, Catherine, who popularised events in the garden in France in the mid-sixteenth century. These needed space and it would have been inconceivable without the steady expansion outwards of the garden away from the main building.

France had been a series of independent kingdoms until 1500[3] and the Medieval French kings had spent most of their time either at war or travelling round their own castles or those belonging to vassals. The castle's *hortus conclusus* or enclosed gardens were firmly inside the castle walls at this time, these buildings still being defensive structures, therefore limiting their scope. This changed when Charles VIII invaded Italy in 1494. He was impressed by

FIGURE 4.1. Château d'Amboise, plan by Du Cerceau *c.*1570.

the new gardens of the Medici around Florence and in particular by the royal gardens in Naples, Poggio Reale. They were very different from the royal castles by the Loire with their enclosed medieval gardens, whose quadripartite design layout had not changed since the Roman times. Charles' first Renaissance garden at Amboise was constrained by the site (Figure 4.1), which had little to recommend it apart from its dramatic setting by the Loire River. The original garden had been the typical small, enclosed space, similar to those found in medieval cloisters of monasteries. Charles had brought back from Italy, Pacello de Mercogliano, a Neapolitan priest and the latter is thought to have designed the new garden. It was made on a high terrace within the château precincts, overlooked by the main rooms. Its design, of walks dividing the garden into square or rectangular areas, was clearly influenced by the Italians. So too was the main feature of a large wooden pavilion sheltering a fountain.

Charles' successor, Louis XII continued the trend for Italian influenced gardens and developed the grounds at the nearby château of Blois, the new royal base, from 1499. Unlike at Amboise, Louis sought to emulate the Medici villas and extended the garden outside the castle walls (Figure 4.2). The gardens were however disjointed and did not relate to the buildings. The site of the château gave splendid views over the Loire to the south, but no attempt was made to exploit these. Instead the gardens were made on the west, where the ground sloped down to a stream. Clearly for Louis, the new Italian idea of opening up to the world, did not appeal. The garden was more or less self-contained: a rectangle, divided into ten compartments, five on each side of the long axis. In 1505 land was bought to make an upper garden, which became known as

FIGURE 4.2. Château de Blois, plan by Du Cerceau *c.*1570.

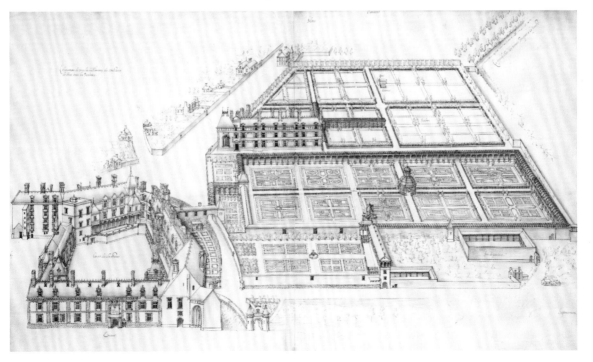

Le Grand Jardin, where fruit (particularly exotics) and vegetables were grown. In both Amboise and Blois, 'aside from a new sense of scale and a taste for Italian embellishments of sculpture and fountains, the French garden remained strikingly conservative' (Adams 1979, 13).

The two gardens of this period that were more ambitious in design, belonged to representatives of the other powerful groups, the church and the ministers. This marked a trend in the development of the French style, where gardens marked out territorial claims on power. Gaillon, thirty-five miles south west of Rouen, was begun in 1502 for Cardinal Georges d'Amboise. The gardens were again designed by de Mercogliano and were the most 'Italianate' of the period. They were separated from the main building on a series of terraces. The major achievement here though was the fountains, which not only equalled those at the time in Italy but also would set the standard for future French creations. Bury was built by Florimond Robertet, Louis XII's minister. He acquired the site in 1511 and the building and the integrated gardens were completed by 1524. The garden's main feature was a bronze replica of Michelangelo's David, showing not only his appreciation of contemporary Italian art but also his wealth and prestige.

Louis' successor, François I, decided to move to Paris for political reasons[4] and made his new base at the royal residences of the Tuileries inside the city and Fontainebleau, which was just outside. These gardens were the first to provide a background for political display and diplomacy and to act as a statement of the strength of French military engineering to reshape the landscape. Fontainebleau had been originally a royal hunting park and was not constrained in terms of space, as was the case for Amboise and Blois. The palace was rebuilt in the new Renaissance style and François developed the grounds from 1528. Like his predecessors, François employed Italian artists and architects, such as Sebastiano Serlio, to work on his building projects, who not only brought their technical skills but also spread the new humanist philosophy that challenged orthodox Catholic teaching. His son, Henri II perhaps due to having an Italian wife, Catherine de' Medici, broke with tradition by appointing a French designer, Philibert de l'Orme, as superintendent of all royal buildings on becoming king in 1547.

It was with de l'Orme in charge that the gardens started to develop more of a unique French style. Henri and Catherine further developed Fontainebleau after their accession, particularly its complex gardens centred around the lake (Figure 4.3). It reflected the 'growing cult of the garden and nature' (Adams 1979, 32) in the court of Henri and his father, where elaborate decorations of real and mythical nature inside the building were mirrored in the gardens outside. Combined with increasingly elaborate spectacles, the buildings and gardens were designed to 'awe and impress foreigners with the power of the court, to stir the loyalty of Frenchmen and, after the political and religious crisis deepened in the second half of the sixteenth century, to subtly express the political policy of the state' (Adams 1979, 33). Louis XIV was to take all these strands of the garden as theatre or spectacle, as territorial power, as symbol and as centre for diplomacy in his master creation at Versailles a hundred years later.

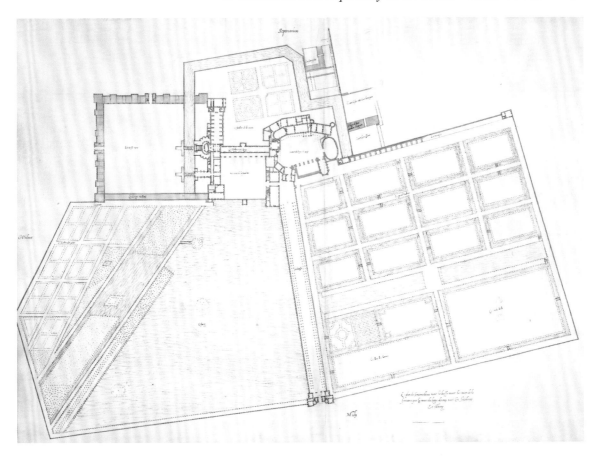

FIGURE 4.3. Château de Fontainebleau, plan by Du Cerceau *c.*1570.

Gardens as political theatre

Catherine was the daughter of Lorenzo II de' Medici. Although he died soon after her birth in 1519, she was brought up by her father's relatives and spent some years at the Medici palaces in and around Florence. There she would have seen the spectacular garden displays with special areas dedicated to them. As Woodbridge (1986, 81) notes 'the use to which Catherine put her gardens was part of a tradition of spectacular display which influenced the course of garden design'. On her marriage to Henri in 1533, she not only brought with her a love of Renaissance art but also the humanist philosophy espoused by her Medici relatives. However she had a major rival in the form of Henri's long-term mistress, Diane de Poitiers. While Henri was alive, it was Diane, not Catherine, who was able to demonstrate her power and influence over the king through two key sites: Anet, southwest of Paris and Chenonceaux in the Loire Valley. Anet had been the home of Diane's husband, Louis de Brézé, and her supposed aim in rebuilding it, was as a memorial to her late husband. The fact that she had been able to keep it after her husband's death, when it should have reverted to crown property, was a sign of her influence with the king.

When work began in 1547, the architect was Philibert de l'Orme who was

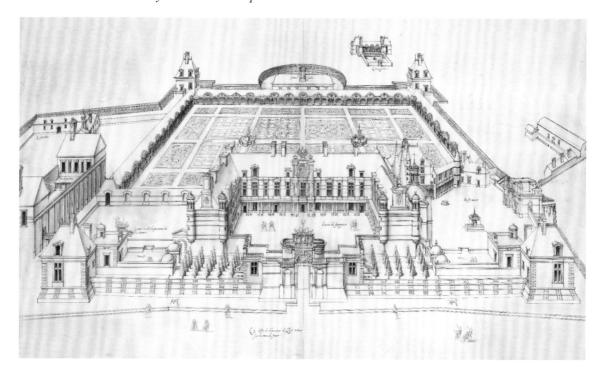

responsible for many royal buildings, so it was clear from the outset that this would be a statement about who was the power behind the throne. The garden at Anet was laid out on a central axis to the remodelled main building (Figure 4.4), following the Italian fashion but it was the imagery in it that was more revealing. In the courtyard to the left of the main entrance is the fountain *Diane d'Anet*, portraying her as the mythical Diana the goddess of hunting (and love). This allusion is replicated in other sculptures, paintings and tapestries inside and out. It gave out the none too subtle message that she had succeeded not only in capturing Henri's heart but also that her powers were akin to that of a goddess. At the end of the central axis is a semi-circular pool with a pavilion for theatrical spectacles, which would become a popular feature in French gardens.

Thomas Bohier, a financier, had built Chenonceaux after he acquired the estate in 1512. It was given to Diane in 1547, following its earlier cession to the Crown for bankruptcy by Thomas Bohier's son, despite the fact that Catherine wanted it. In 1551, Diane started a new garden on the bank of the Cher River, east of the forecourt, in an enclosed area of two and a half acres (Figure 4.5). She was not to enjoy it for long as, on Henri's death in 1559, her power and influence came to an abrupt halt. His widow Catherine now held the reins of power, as she became the Regent for her teenage son in 1560. To re-enforce her position, she 'negotiated' with Diane to exchange Chenonceaux for the Château de Chaumont-sur-Loire. Catherine created another garden near Diane's (Figure 4.6) but it was three fêtes held at Chenonceaux that marked the use of this garden as a political space. The first was in 1560 (Woodbridge 1986, 81) for the

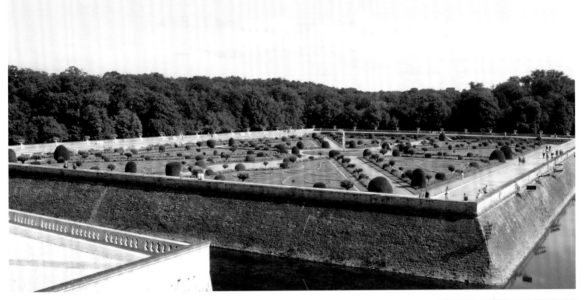

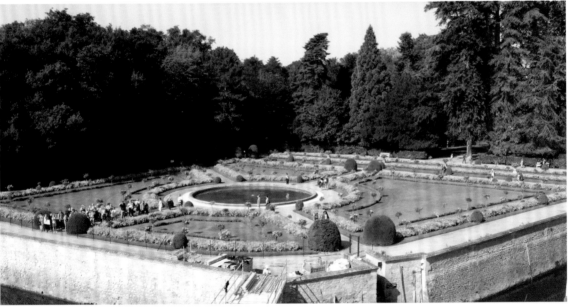

FIGURE 4.5 *(top)*. Château de Chenonceaux, Diane de Poitiers' garden.

FIGURE 4.6. Château de Chenonceaux, Catherine de' Medici's garden.

arrival of the new king, François II, and his wife, Mary Stuart. The second, in 1563, was a celebration of the short-term peace between the warring factions and the coming of age of the next of Catherine's sons to become king, Charles IX.[5] The last one in 1577 was to celebrate the Treaty of Bergerac.

These fêtes were not restricted to Chenonceaux. Catherine pursued this policy in the gardens at Fontainebleau where the newly decorated château was the setting for festivals in February and March 1564, after the first civil war had ended temporarily with the demise of the Duc de Guise. The theme here was the

supposed reconciliation of Protestant and Catholic by the monarchy as embodied by Charles IX and to demonstrate this, banquets and entertainments were given alternatively by leaders of the opposing religious factions (Woodbridge 1986, 82). At the Tuileries in Paris, she gave a garden reception for the Polish ambassadors, who came to offer her third son, the future Henri III, the Polish crown in 1573 (ffolliot 2001, 215). Although the gardens were already places of magnificence, for these events temporary structures such as triumphal arches were erected. Other devices that were put in for the fête such as artificial rocks over time became permanent, thus adding to the grandeur of the overall design.

The garden fêtes that Catherine held marked a notable change in the public display of monarchs. Events such as coronations and royal weddings until then, usually involved processions through specially decorated cities planned and paid for by the city grandees. ffolliott (2001, 214–5) notes that 'Catherine co-opted the public staging of power, changing both the rationale of and locus for display from city street to royal garden … [in doing so she] assumed a managerial role in the festivals that came to characterise the public face of French politics in the late sixteenth century … the queen regent exploited the garden – the traditional space where a woman could be in control – as the locus for her court to act the ideal politics of conciliation between Catholics and Protestants that she espoused'. With Catherine's death and the succession of Henri IV, the use of the garden as a background for spectacles diminished in importance, as the latter dedicated himself to expanding the size and layout of his royal landscapes. His successor, Louis XIII, spent most of his reign trying to retain control from rebellious factions and neither built any major gardens nor used them for display. In the early part of Louis XIV's reign, his mother as Regent and Cardinal Mazarin were in charge but as soon as Louis could assert his authority, he laid on a garden fête.

In June 1662, he celebrated not only the birth of an heir the previous year but more subtly the death of Mazarin. Louis had signalled that in future there would be no First Minister after Mazarin's demise: in other words, he would be in charge. The event was staged between the Louvre and the Tuileries (Thompson 2006, 49) and was the foretaste of the ones that were to come at Versailles. While little had been done to the main building, work on the gardens at Versailles was quite advanced by May 1664 when Louis decided to hold the first fête there. Ostensibly dedicated to his wife and mother, this five-day celebration was in fact for his mistress, Louise de la Vallière, as she and Louis had used Versailles for their assignations. A further one-day fête was held on the 18 July 1668 (Figure 4.7) to celebrate the Aix-la-Chapelle peace treaty: the successful outcome of Louis' war against Spain.[6] It gave the King the opportunity to show off to the large invited audience all the latest additions to the ever expanding garden. The last fête was in 1674, which not only marked another military victory (annexation of Franche-Comté), also signalled Madame de Montespan as the official mistress, as events were staged in parts of the garden associated with her.[7]

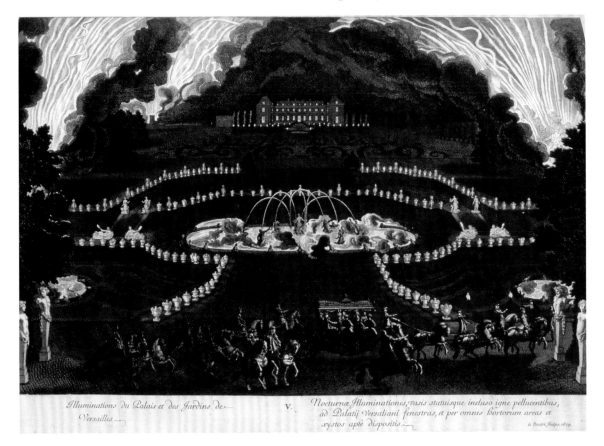

Illuminations du Palais et des Jardins de — Versailles — v. *Nocturnæ Illuminationes, vasis statuisque incluso igne pellucentibus, ad Palatij Versaliani fenestras, et per omnes hortorum areas et xystos aptè dispositis —*

Gardens as territorial control

While gardens provided the backdrop for politicised state occasions, they also were a statement of power in seventeenth century France. How these designed landscapes were used varied according to the message the owner wanted to give to the wider world. The assassination of Catherine's third son, Henri III in 1589 had led to a distant cousin Henri, king of Navarre, becoming the next French monarch. As a Protestant, he struggled to assert his authority particularly amongst the rebellious Catholic factions. The latter's stronghold was in Paris and after an unsuccessful siege by the new Henri IV, only a conversion to Catholicism allowed him to enter. It was therefore important that Henri should assert his control over the city. He made a deliberate policy of reviving Paris and its environs and its clear establishment as the capital in preference to the historical bases in the Loire Valley such as Amboise and Blois. Significant public building works were accompanied by major changes to the royal palaces of the Louvre, St Germain-en-Laye, both in the centre of Paris and Fontainebleau. In the city itself, there were improvements not only that benefited the population as a whole, such as improved access and sanitation but he introduced measures to stimulate trade and industry, for example the production of silk textiles.

While the public display of royal power was enhanced by the work at the Louvre and the neighbouring Tuileries palaces, it was to the royal residences outside the city where there were the grandest statements in terms of garden design. A second wave of Italian influence had come in the latter part of the sixteenth century. In 1573 Etienne du Pérac had published his views of the gardens of Tivoli, dedicated to Catherine de' Medici. These views of the Villa d'Este (Figure 3.9) amongst others provoked further interest in an increasingly ambitious Italian garden style. Du Pérac was subsequently appointed *Grand Architect du Roy* to Henri IV. How much he was involved in the remodelling of St Germain-en-Laye from 1599 (Figure 4.8) is unclear but 'the earth works, terraces, and hydraulic systems that Henri IV utilized in building the gardens … [there] … were as startling to the contemporary eye as some of the enormous fortifications he had constructed during the religious wars of the previous decades' (Adams 1979, 48). Clearly the king was demonstrating his military capabilities in his garden. Louis XIV had similar aspirations as a military leader, as shown not only in his foreign wars but also in the garden at Versailles.

An assassin cut Henri's life short in 1610 and as his son, Louis XIII, was only eight, his widow Marie de' Medici became Regent. The following year she began work on the Luxembourg Palace in the centre of Paris. It is said that she wanted a replica of the Pitti Palace and surrounding Boboli Gardens, that was her childhood home, though the end result had little resemblance to the original. The design, which was completed in 1629 (Figure 4.9) links the house and garden: something that had often been missing from earlier French gardens. There is also a clear Italian influence in the use of the complex waterworks by Salomon de Caus. However it was the innovation of *parterres de broderie* surrounded by balustraded terraces that was to have the major impact on the designed landscapes that followed it in France and elsewhere. The gardens at the Luxembourg palace were not only 'Jacques Boyceau's finest creation [but also] … firmly displays in its clear organization a step toward Le Nôtre's mature style of the formal garden' (Adams 1979, 57). In constructing this palace and garden, Marie was asserting her position as *de facto* ruler but control over her son came to an end in 1617 and she was sent into exile at Blois. Five years later, she was allowed to return to Paris and join the King's Council but she had an increasing powerful rival in Cardinal Richelieu. Marie's attempts to remove Richelieu as the king's chief advisor resulted in her final exile from France itself in 1630. Her legacy in terms of garden style remained and John Evelyn who visited her gardens at the Luxembourg Palace in 1644, noted that 'nothing is wanting to render this palace and gardens perfectly beautiful and magnificent' (Bray 1901, 62).

The rise of Richelieu marked a trend that was to continue throughout the first half of the seventeenth century, where the kings relied on ministers rather than the traditional nobility. The long civil wars of the sixteenth and early seventeenth centuries had weakened the latter's position as successive kings mistrusted them and their motives. With the ministers and officials in

FIGURE 4.8. Saint-Germain-en-Laye. *Le Château Neuf et le Vieux en 1614*, by Matthäus, Paris, Bibliothèque Nationale de France.
© RMN/AGENCE BULLOZ

FIGURE 4.9. Palais Royal (Luxembourg), after Perelle *c.*1670–95.
© TRUSTEES OF THE BRITISH MUSEUM

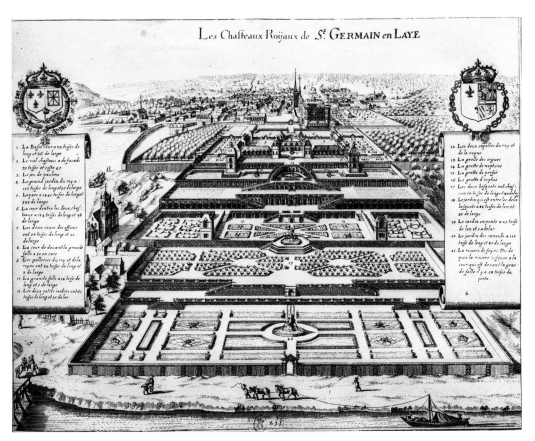

Les Chasteaux Roijaux de St GERMAIN en LAYE

1. La Basse cour a 39 toises de long et 25 de large
2. Le viel Chasteau a de façade 35 toises et coste 45
3. Le jeu de paulme
4. Le grand jardin du roy a : 103 toises de long et 97 de large
5. Le parc a 1445 toises de long et 382 de large
6. La cour dentre les deux chasteaux a 134 toises de long et 58 de large
7. Les deux cours des offices ont 20 toises de long et 20 de large
8. La cour de devant la grande salle a 30 en care
9. Les galleries du roy et la royne ont 74 toises de long et 7 de large
10. La grande salle a 14 toise de long et 5 de large
11. Les deux petits jardins ont 64 toises de long et 25 de lar

12. Les deux capelles du roy et de la royne
13. La grotte des orgues
14. La grotte de neptune
15. La grotte de persée
16. La grotte d'orphée
17. Les deux bosquets ont chacun 50 toises de long et 40 dela
18. Le jardin qui est entre les deux bosquets a 105 toises de lon et 40 de large
19. Le jardin en pente a 113 toise de long et 80 dela
20. Le jardin des canaulx a 113 toise de long et 80 de large
21. La riviere de seyne Ou de puis la riviere jusques a la cour qui est devant la grande salle il y a 28 toises de pente.

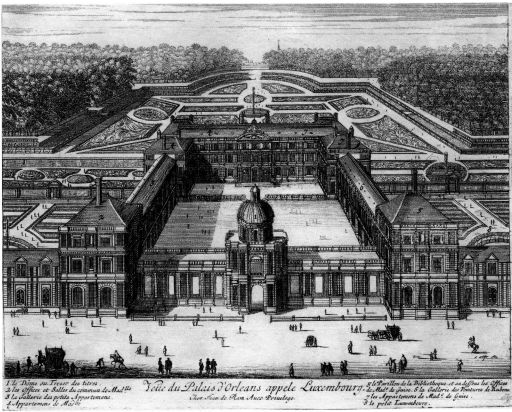

Veüe du Palais d'Orleans appelé Luxembourg

1. le Dôme ou Tresor des titres.
2. les Offices et Salles du commun de Madlle
3. la Gallerie des petits Appartemens.
4. Appartemens de Madlle

5. le Pavillon de la Bibliotheque. et au dessous les Offices de Madlle de Guise.
6. la Gallerie des Peintures de Rubens
7. les Appartemens de Madlle de Guise
8. le petit Luxembourg.

Chez Iean de Ram Avec Priuilege.

control of state policy, it was they who became powerful and rich through sales of hereditary offices and the collection of taxes. Many used their wealth to build gardens such as Particelli d'Emery, who worked for Richelieu and ultimately became the *Surintendant des Finances*.[8] He rebuilt the château of Tanlay in Burgundy and laid out the grounds in a suitably grand style. Another *Surintendant* was René de Longueil, who built the lavish Château de Maisons but in an echo of a more notorious incident later by a successor, Nicolas Fouquet, this ostentatious display was his downfall. In April 1651 he gave a sumptuous fête for the Queen and her sons, Louis XIV and Philippe, Duc d'Anjou at his estate. This was a big mistake as soon after he was relieved of his position. It was Cardinal Richelieu who amassed the greatest fortune as his revenue rose from twenty five thousand livres to over three million livres during his career. On joining the king's council in 1624, Richelieu came to dominate French politics. His great administrative ability was 'devoted to the aggrandisement of France, the triumph of Catholicism and the consolidation of the autocratic powers of the monarchy' (Woodbridge 1986, 132).

The gardens at his three properties were the most magnificent in the country at the time. Clearly he had no qualms about demonstrating his wealth and power, just as his fellow Cardinals had done around Rome a century earlier. In Paris, there was his city residence, the Palais Cardinal, begun in 1633, near the Louvre palace. At the family estate in the Loire, he built a whole new town and château from 1631, called Richelieu. The scale of this would only be matched by Versailles fifty years later. When Anne Marie Louise d'Orléans, Louis XIII's niece, visited it, she was 'impressed, though not surprised by the Cardinal's extravagance, "since it was the work of the most ambitious and ostentatious man in the world"' (Adams 1979, 76). It was at Rueil, west of Paris, which the Cardinal acquired in 1633 that was both his retreat and the most complex of his gardens. John Evelyn wrote in 1644: 'though the house [of Rueil] is not of the greatest, the gardens about it are so magnificent that I doubt whether Italy has any exceeding it for all varieties of pleasure ... what is most admirable is the vast enclosure, and variety of ground, in the large garden' (Bray 1901, 51–2). Although primarily a private place as opposed to his two other more public properties, Rueil's architect, 'Lemercier aimed to display the architecture of the house and its surroundings as a symbol of the status of the owner; his public image as it were' (Woodbridge 1991, 170).

Richelieu died in 1642 and Louis XIII the following year. Again the successor was a child, this time it was the four-year-old Louis XIV. His mother, Anne of Austria, became regent from 1643 to 1651 and Cardinal Mazarin, who had taken over from Richelieu, served as France's chief minister. Not as personally overtly ambitious as Richelieu, Mazarin feigned an air of modesty and sought compromise. He nevertheless amassed a large fortune but spent his money on art collections rather than garden building, perhaps as the latter would be too obvious to his detractors. The building of grand garden statements was left in this period to the likes of Nicolas Fouquet, who was appointed joint

Surintendant des Finances in 1653 by Cardinal Mazarin. Previous incumbents had been poor at raising money but Fouquet proved adept at persuasion! Like his master, he was a great patron of arts and could indulge his passion, as he came from a wealthy family but that did not help when accused of embezzlement of state funds. Vaux-le-Vicomte was a small estate he had inherited from his father in 1650 and Fouquet started work there two years later. André Le Nôtre designed the garden with buildings by Le Vau and it is considered a masterpiece of design (Figure 4.10).

As was often the case in France, the main problem was that the site was flat, so an enormous amount of earth had to be moved to improve it. The design idea was to enlarge the estate (either in reality or by optical illusion) by expanding the 'garden' into the surrounding parkland. This had been used for the first time at the Château de Richelieu. However what made Vaux different from previous gardens was that all elements of the garden, the formal areas including the parterres, the statues and the parkland were designed as a whole. It marked a turning point in garden design in France. Vaux's parterres, formal basins, *salles de verdures* (central area within a *bosquet* or wooded area), *palisades de verdure* (clipped hedges) and *patte d'oie* (radiating avenues) were all used to great effect in the impressive gardens that were to follow. However Fouquet did not have long to enjoy it, as he was arrested in 1661 following a notorious fête held there in King Louis XIV's honour. Orchestrated by the king's new economic advisor, Colbert, the charges against him were high treason and misappropriation of public funds. The clear implication was that he had used the state coffers to build the magnificence that was Vaux-le-Vicomte. While the case was never proven on the latter, what is clear is that in creating a landscape that appeared more extensive than in reality, it only served to re-enforce his opponents' perceptions of him and his activities.

While his erstwhile boss was languishing in prison, Le Nôtre's services were

FIGURE 4.10. Vaux-le-Vicomte.

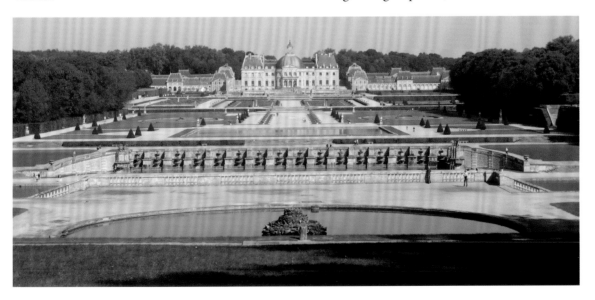

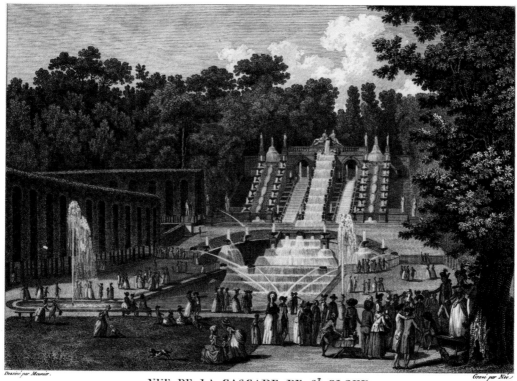

Deisné par Meunier. *Gravé par Née.*

VUE DE LA CASCADE DE S^T. CLOUD,
prise au bord de la Terrasse dans la Grande Allée.

part de la Scene et de Mar *S^t Cloud 12*

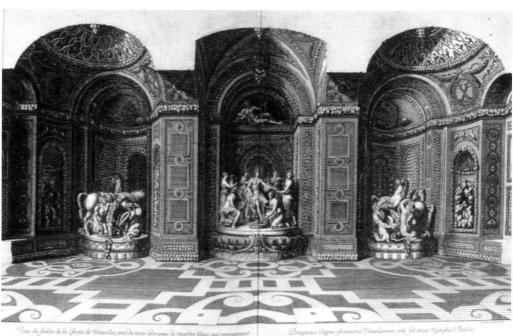

Vue du fonds de la Grotte de Versailles, orné de trois Groupes de marbre blanc, qui representent Prospectus Cryptæ interioris Versaliarum, ubi sol inter Nymphas Thetidis
le Soleil au milieu des Nymphes de Thetis, et ses chevaux pensés, par des Tritons. et qui opus cum Tritonibus, statuis marmoreis exhibentur

much in demand from the royal family and senior ministers, following his work at Vaux-le-Vicomte. While it was his overall design that was key, it was a team effort and he regularly worked with the architects Le Vau and Hardouin-Mansart and the sculptors Lerambert, Coysevox and Girardon. Until his retirement in 1693, Le Nôtre was involved in all the major gardens in France, in addition to Versailles: Saint-Germain-en-Laye, Tuileries, Fontainebleau, Trianon and probably Marly for Louis; Saint Cloud and Palais Royal for Monsieur (Louis' brother); Chantilly and Sceaux for Louis' ministers Condé and Colbert respectively. He provided for them the ultimate in status symbols, demonstrating their wealth and power. The common elements in these gardens were first the scale which meant considerable reshaping of the surrounding area, second the water features that needed extensive hydraulic systems (Figure 4.11) and third the complex planting schemes that required significant resources both in planting and maintenance.

Louis' use of symbolism and control in the garden

Mazarin's death in 1661 allowed Louis to assume personal control of the reins of government and this coincided with the start of his major building programme at Versailles. Work had effectively stopped at Vaux-le-Vicomte that year after the infamous visit by the King, with the latter taking Fouquet's employees. They went to Louis' new project: that of developing the old hunting lodge at Versailles. For Le Nôtre, this was the place that he would devote the rest of his working life as the original gardens and parkland of two hundred and fifty acres were expanded to more than four thousand acres by the time Louis died in 1715 (Figure 4.13). While Versailles was regarded as his showpiece, its constant evolution and sheer size negated his key skill of uniting a garden with its buildings and surrounding countryside. The issue for the designer was that these gardens were meant to reflect the shifts in both Louis' private and public life and how he wanted to be presented to the outside world.

Until 1680, the king's principal residence was Saint-Germain-en-Laye. Versailles, then under construction, occasionally welcomed the Court. The occasions of these visits and the *fêtes* meant that continual novelty was demanded. The pace of change increased once Louis and the court lived there permanently. As a showcase for the *le Roi Soleil* (The Sun King), the iconographic programme was as important as the overall size and design. This encompassed not only the key architectural features including the statues but also the use of plant material particularly flowers. The honoured guests to the garden would understand the illusions made. Whereas many parts of interior of the château of Versailles were specifically dedicated to the glory of Louis XIV and the French monarchy, there are only ever two images of him[9] in the gardens. Instead he was alluded to through mythology and allegory. Berger (1985, 64) thinks that by doing 'this, the creators of Versailles simply followed the traditions of Renaissance Baroque residences, in which the park was conceived of as an

idyllic, pastoral setting for the eternal Antique presences: the pagan deities, the personified forces of nature, and the *personae* of ancient mythology'.

The two main characters portrayed were Apollo, the Greek god of the sun and Hercules, the Roman demigod who represented strength. The former was built into an iconographic programme from 1664 with the *Grotte de Thétis*, (Figure 4.12) the first major feature in the park to represent it. This was destroyed in the expansion of the palace in 1684 but the other allusions to Louis as Apollo such as the Fountain of Latona and the Basin of Apollo remained. By this time, Louis had become known as *Le Grand* and seemed to have 'lost interest in playing the role of the Sun King or likening himself to Apollo' (Thompson 2006, 172), so perhaps this was the reason why the grotto was a casualty of the building programme. The 'Pillar of Hercules' was the name given to the vanishing point when from looking from the château through the park to the horizon, according to Ellingsen (2005, 150). It replicated an idea from Vaux-le-Vicomte, where a statue of Hercules is found at a similar place at the extent of the long allée. Whereas though the latter represented the end of the garden, the allusion to Hercules at Versailles represented Louis' control over the wider landscape.

Botanic gardens or a collection of particular plants was a way of demonstrating power and wealth of the sovereign and Louis XIV was no exception. As important as the hard landscaping were the flowers in the gardens of both the secondary palaces of Marly and the Trianon within the wider Versailles estate. He 'maintained the most spectacular displays of flowers that early modern Europe had yet seen, and he did so during the years when flowers were at the zenith of their popularity and fashionability in elite circles' (Hyde 2005, 169). These were mainly not for general view and the most precious flowers were in private areas reserved exclusively for the king and those he chose to invite there. Just as the statues and fountains had symbolic value, so too did these flowers which represented not only the obvious abundance and fertility, but also the nature of his reign as a time of peace and prosperity.

The publication of Jean Donneau de Visés *Histoire de Louis le Grand continue dans le rapports qui se trouvent entres ses actions, & les qualities, & vertus des Fleurs, & des Plants* in 1688 contained 'portraits of thirty-five different flowers, shrubs, and herbs that spoke directly to the king in accompanying texts…through which they compared their own practical uses to specific accomplishments of the Sun King' (Hyde 2005, 186). Although this text is particularly sycophantic, it is revealing in the analogies it makes between Louis and the flowers grown in his gardens. By being able to have flowers out of season, Louis was able to conquer whatever obstacles might confront him and that he had plants from around the world meant the whole world was praising him. The most politically overt example is the description of the anemone. De Visés compares the time when this plant was being bred by leading horticulturalists such as Bachelier, with the time when Mazarin controlled the state (Hyde 2005, 189). Louis was able to break free just as the anemone did from the horticulturalist. One

interesting omission from the list was the tulip but given its association with the main enemy, the Dutch, it was probably thought prudent not to mention it (Hyde 2005, 195).

Mukerji (2001) looks at another political aspect of the gardens of Versailles in the use of *parterres de broderie*. She believes (2001, 249) that 'to dress the land in [this] French style … [gave] it a political identity. This "dressing" of the countryside was a form of political "address", which claimed France to be a natural as well as cultural unit, designed both for political unity and greatness'. Olivier de Serres in his book of 1611, *Le Theatre d'agriculture et mesnages de champs*, recommended that by landowners maximising the productive ability of their land, the economic and political well-being of the whole population would benefit. One way he advocated was the cultivation of mulberry trees for the raising of silkworms for the silk industry. Thus early on, there was a connection between textiles and gardening as the complex designs of the parterres mirrored the woven textiles that were providing a significant part to the growth of French national wealth. By the time the parterres were being installed at Versailles, they had taken on a greater role. Using large collections of imported bulbs and other rare flowering plants, they showed not only superior (that is French) taste and the latest trends in design but also French strength in international trade and horticultural practice (Mukerji 2001, 253). France (and by implication Louis as absolute ruler) was pre-eminent and the gardens were re-enforcing this point.

It was in the diplomatic tours at Versailles that Louis could both control and show off his masterpiece. However as Weiss (1995, 47) observes 'Louis … was doubtlessly aware of the profoundly *formless* aspect of his formal gardens, which led him to write … a guide indicating … the king's itinerary, which he imposed upon the visitors to his gardens'. The first tour known tour was on 10 July 1664 for the Cardinal Flavio Chigi, nephew of Pope Alexander VII. A Governor of Tivoli, outside Rome, Chigi was knowledgeable about Italian gardens[10] and so Louis wanted to show him French design (Berger and Hedin 2008, 19) at Versailles and the other châteaux. In 1669, Louis received Cosimo III de' Medici[11] in the garden on the latter's tour of Europe but he was not shown the house as it was undergoing development. Personal tours by Louis continued in the 1670s with the last recorded one in 1679 for the Spanish ambassador (Berger and Hedin 2008, 25). As the new capital transferred to Versailles, the issue of ambassadorial garden tours became a priority (Berger and Hedin 2008, 24), as the process became formalised both in the palace and outside and spontaneous visits no longer took place.

There was also the increased use of political symbolism as the visit of the Algerian Ambassador in July 1684 demonstrated. The French fleet had been bombarding the Algerian capital because it was said to be harbouring pirates. The Algerian delegation was rather pointedly transported on the Grand Canal on a launch to the Trianon, demonstrating French naval power: this was the first time this had been done. During this trip, 'one of the Algerians remarked … that "the sea of Versailles was the sea of the Emperor of the World" … A

few days later, the Algerians were shown Marly and the Machine de Marly, thus continuing the theme of the Sun King's amazing subjugation of nature's waters' (Berger and 2008, 28). By 1686, Louis thought that the gardens were now complete and to see all that was on offer, now took least a one day. Three years later, came the first of his written itineraries, which together with stones placed at important viewing spots, ensured Louis was controlling what was being seen, even when he was not personally accompanying the visitor. Although there was no specific explanation of the iconography and symbolism contained in the garden in the tours, they did stop at the important features. In the 1694 version of the *Manière*, there was an explicit instruction to view *History Writing of the Deeds of Louis XIV* a marble group by Guidi (Berger and Hedin 2008, 65). After Louis' death in 1715, the tours stopped as the court moved back to Paris for the period of Louis XV's minority that lasted until 1722. It was at the Tuileries instead, where the Turkish ambassador was received in the garden in 1721, that there was the last recorded event of its type (Berger and Hedin 2008, 72).

The French garden after Louis XIV

Le Nôtre had died in 1700 but in many ways, the gardens at Versailles had already grown stagnant in terms of new design ideas well before this. The stagnation in the gardens was mirrored by the reign of Louis, who as he approached old age, began to suffer from his expansionist policies both at home and abroad. In the decade before the King's death in 1715, his declining government coffers resulted in the reduction of expenditure on the royal gardens. In 1698, nearly one hundred thousand livres were spent on Marly's terraces and gardens. By 1712 this figure had fallen to less than five thousand. As Adams (1979, 104) comments the 'Sun King's gardens, like his wars, were eventually reckoned in terms of the national debt'. Versailles was largely abandoned after 1715 and even when the court did return seven years later, the neglect of the grounds continued. Such a space required high levels of maintenance and there was just not the money for this. In time, Versailles turned into a series of 'picturesque' scenes, not dissimilar to the Italian gardens that inspired those who initiated the English landscape revolution. Just as the 'English style' began to dominate garden design in the second half of the eighteenth century, then so too did Britain politically and militarily. The French formal garden design of Versailles became so closely linked with Louis XIV's absolutist policies that those who desired political freedom, such as the Whigs in Britain, consciously rejected it.

Louis XV's sole contribution to the gardens at Versailles was to set up a botanical garden there at the Trianon. This followed the French state's interest in developing botanic gardens to promote trade and Louis' own personal interest in botany. Indicative of his reign and that of his successor, the unfortunate Louis XVI, was the decision to build the 'Petit Trianon' palace from 1761. Like his predecessor, Louis XV preferred the more intimate surroundings of the Grand Trianon to the main palace. At the former, he had built a new menagerie that

contained domestic animals, rather than wild exotic creatures. In effect this was a farm reflecting the new taste for the rustic life, albeit a rather sanitised version (not dissimilar to the *ferme ornée* idea of Wooburn, see Chapter 5). The new Petit Trianon was of an even smaller, domestic scale and when Queen Marie Antoinette, his grandson's wife, decided to landscape the area in 1774 in the 'English style', she added a series of rustic buildings known as the *Hameau de la Reine* (Queen's Hamlet). She notoriously retreated there to live a life of simplicity away from the formal court, seemingly oblivious to the stirrings of the French Revolution that were going on around her. This image of her living in an idealised hamlet while the real peasants were starving is perhaps overstated but the irony is that her rejection of the formal French style in the gardens, led ultimately to the French nation rejecting her and her husband and the absolute monarchy they represented.

Notes

1. From 'Maniere de montrer les jardins de Versailles' undated but post 1694, www.lettres. ac-versailles.fr/spip.php?article342 [consulted 29 March 2011].

2. Absolutism in Western Europe has been described as 'atypical in form and brief in duration' (Spellman 2001, 198). To succeed it had to buy off the nobles in terms of exemptions from taxes but needed a large army to carry out its expansionist policies. The tax burden therefore fell on the lower classes: a long term recipe for disaster.

3. Up until the early 16th century, large parts of northern France were part of the English crown and successive French kings had struggled to control the power of the powerful dukes.

4. Paris had lost its central role to the Loire Valley during the fourteenth century. By moving the capital back to Paris in 1528, he was also seeking a closer alliance with the bourgeoisie, to counterbalance the power of the nobles.

5. With the accession of François, the Duke of Guise (the king's uncle by marriage) and his brother seized power and their persecution of the Protestants led to 30 years of civil war. Catherine became regent for her second son, Charles, (king from 1660).

6. He had succeeded in keeping much of the territory of the Spanish Netherlands (Lille and other parts of Flanders) that he had occupied.

7. Such as the Marais, a *bosquet* and the Trianon de Porcelaine, (Thompson 2006, 167)

8. The position of 'Superintendent of Finances' was officially created in 1561 during the reign of Charles IX, and was effectively the royal financial advisor. It came from the 'Intendants of Finances', created in 1552 and at the time, three Intendants were named. One of them would also participate in the Privy Counsel, thus the designation 'Superintendent'.

9. Bernini's *Louis XIV Equestrian*, which was quickly transformed into Marcus Curtius and the one that remains in the Orangery by Martin Desjardins (Berger 1985, 56)

10. He also went onto to design the garden at his home, Villa Cetinale near Siena.

11. The husband of his first cousin.

Château de Versailles, Paris

Before Louis XIII built a modest hunting lodge there in 1623, Versailles and the surrounding area were a series of small villages, some 20 km from the centre of Paris. Louis had the place built supposedly to get away from the court and its women in particular! This was to be the strange contradiction of Versailles, as it became the place to escape to for the king and whoever was in his favour but in order to provide this required seclusion, it had to continue to expand. Louis XIII had laid out a small formal garden there, but the rest of the grounds were purely for hunting and Louis XIV's first visit to the site, at the age of 12, was in order to hunt. In 1632, Louis XIII purchased the manorial rights and it became a royal domain. Exactly 30 years later, Louis XIV started work on the gardens, despite the opposition of Colbert, his Finance Minister, who thought that he should concentrate on the existing royal residences. Louis though wanted Versailles as it had resonance as a purely Bourbon creation (Berger 1985, 5). All the other palaces had been created by the previous Valois dynasty[1] and furthermore, Louis had bad memories of Paris as it had been the scene of the revolts against him as a child.

For the design and execution, Louis imported the 'team' that had created Vaux-le-Vicomte, who now found themselves out of work following their employer, Fouquet's, arrest. Principal amongst these were André Le Nôtre who designed the garden and the architect, Louis Le Vau. Unlike at Vaux-le-Vicomte, the design changed and evolved over the next 50 years. The growth in power of the King was reflected by the growing overall size of the garden and the individual areas within it, by his concept of monarchy and his love affairs (Adams 1979, 84). As Mukerji (1997, 2) points out: 'the gardens [of Versailles] were not just marvels to transfix the viewer; they were laboratories for and demonstrations of French capacities to use the countryside as a political resource for power'. Representing France itself (and by implication, Louis as absolute monarch), the gardens at Versailles therefore had to keep changing to show that France was still the pre-eminent nation. While true at the start of Louis' reign, by the end Britain was rapidly taking over as the new world 'superpower' and despite strenuous efforts, the gardens at Versailles also began to diminish in creativity and ultimately importance.

The first phase of garden building by Louis XIV was completed by 1664 in time for the first major fête to be held (for his mistress, Louise de la Vallière) and was initially a rather conservative approach to the site. Using the existing boundaries from the 1630s layout, Le Nôtre began to extend the central western axis, away from the hunting lodge, towards the horizon. This was in line with then current iconographic building programme reflecting the Sun King, as

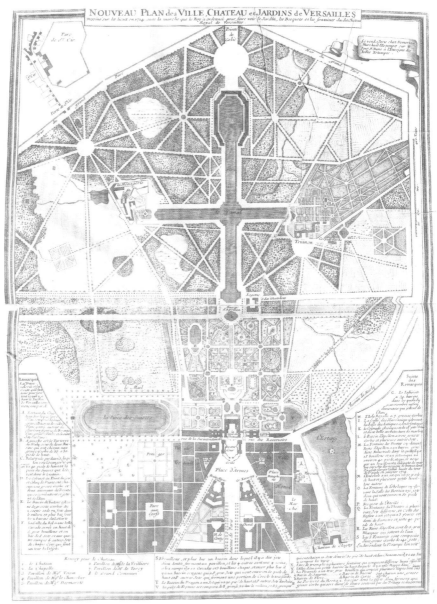

suitably, the west is where the sun set. The large basin (formal pool of water) was
retained and remodelled eventually becoming the *Bassin d'Appollon* (Adams 1979,
84). A new Orangerie was built to house the many citrus trees that had been
'acquired' from Vaux-le-Vicomte. The original parterres that Jacques Boyceau
had created in the 1630s, were embellished and a new *jardin-à-fleurs* was created
to the south of the main building to grow Louis' prized exotic flowers. The
only major construction is this period was the *Grotte de Thétys* (Figure 4.12). As
well as its iconic function,[2] it also had a technical role, as its roof supported a
reservoir that stored water pumped from the Clagny pond for the fountains
lower in the garden.

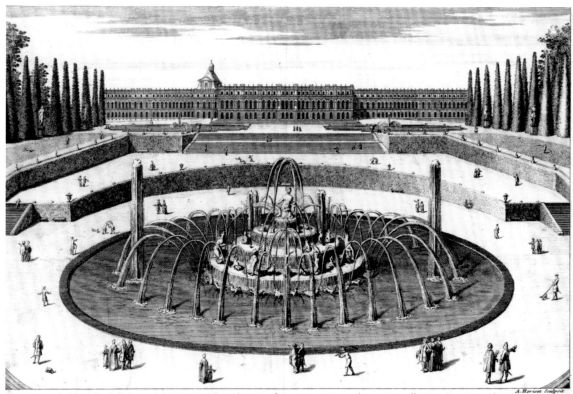

La Grande Façade du Château de Versailles sur les Jardins. *Propylæum Castelli Versaliensis ex hortis conspecti.*

It was not until the second phase that there were major structural changes to the grounds at Versailles. Louis was becoming more confident in his power base and the successful fête of 1664 must have spurred him to create an even more magnificent landscape. Le Nôtre was given the task of putting his sovereign's ambitions into practice, which accelerated after 1668 when the Marquise de Montespan became the official royal mistress. Creating a coherent design (Figure 4.13) was not easy but 'the spreading geometry of landscaped circles, squares, and intersecting walks – all centred on the main axis with several transversal lines – provided the basic ordering devices which enabled Le Nôtre to maintain unity and continuity in the face of unpredictable expansion' (Adams 1979, 86). Le Nôtre created a new north–south axis that ran parallel to the château, as well as continuing to extend the western one, which became known as the *Allée Royale.* The biggest change was the creation of new wooded areas or *bosquets.* Large numbers of trees were planted either in these areas or in the rapidly expanding avenues.[3]

The theme of the Sun King continued with the construction of the *Bassin de Latone,* which was designed by Le Nôtre and sculpted by Gaspard and Balthazar Marsy (Figure 4.14). Built between 1668 and 1670, the fountain depicts a tale from Ovid's *Metamorphoses.* Latona and her children, Apollo and Diana, are not allowed to drink from a pond belonging to some Lycian peasants and further indignity is heaped on the gods as mud is thrown at them. An appeal to Zeus

FIGURE 4.14. Fountain of Latona in gardens at Versailles, print by Hérisset *c.*1720.

results in the Lycians being turned into frogs. This mythological episode was chosen as a deliberate reference to the civil war known as the 'Fronde', in the first part of Louis' reign. The word *fronde* means slingshot, as this was the favoured weapon of the rebels, who were therefore being compared to the mud-slinging Lycians in the statue. The Dragon Fountain, finished in 1668, also referred to Louis' triumph over the rebellious *Frondes* (Thompson 2006, 147). It represents the Python, a large snake killed by Apollo.

While these statements of Louis' image were important, the Grand Canal built between 1668 and 1671 was the major centrepiece of the inner *Petit Parc* and a demonstration of French military engineering. It is 1500 m long and 62 m wide, with the cross-arms 75 m wide. The shape of the canal, in the form of a cross, has been interpreted as demonstrating Louis' reach over all parts of France. It also could be a reference to Louis styling himself as the 'Most Christian King' (Thompson 2006, 155). It was used primarily for boating parties[4] and three years later *Petite Venise* (Little Venice) was built at the junction of the Grand Canal and the northern transversal branch. This area housed various types of boats to be used on the canal, including the gondolas received as a gift from the Doge of Venice, following the visit by the Venetian ambassador in 1671 (Berger and Hedin 2008, 21).

The other major creation at this time in the gardens at Versailles was the Labyrinth (Figure 4.15). A metaphor for love, it was started around 1666 and completed eight years later. Its 39 fountains each illustrated one of Aesop's fables. Berger believes that the Labyrinth was unusual as it:

> 'presented an iconography unrelated to political or royal references … [and] the only garden attraction there with a didactic, moralizing content. Although apparently rare in gardens, and unexpected in a royal one, this type of content is a demonstration of the intellectualism so often found in French art of the grand *siècle* and frequent at Versailles.' (1985, 40)

These fables though could have a political meaning as Thompson (2006, 141) points out with reference to 'The Frogs and Jupiter' story. The frogs had asked Jupiter for a new king and he had initially sent them an inert log. When they complained that they wanted a more active monarch, he gives them a crane, which promptly ate the frogs. The message is that the subjects should accept their current monarch (even if he has faults), as the alternative might be worse: a tactic often used by authoritarian leaders both then and now.

From 1680, the third phase of building started but this was more about embellishment than large scale landscape planning. Versailles was to become the permanent base for Louis and his court in 1682 and the subsequent expansion of the palace building destroyed many of the garden features from the initial building work, such as the Grotte de Thétys and others such as the Orangerie were substantially rebuilt in a grander style. The areas that had significant development in this period were the gardens surrounding the new palaces that Louis built in the wider landscape, in order to escape court life with his favoured companions. These gardens had a special significance, as they were reserved for Louis and those who were favoured with an invitation. He had purchased

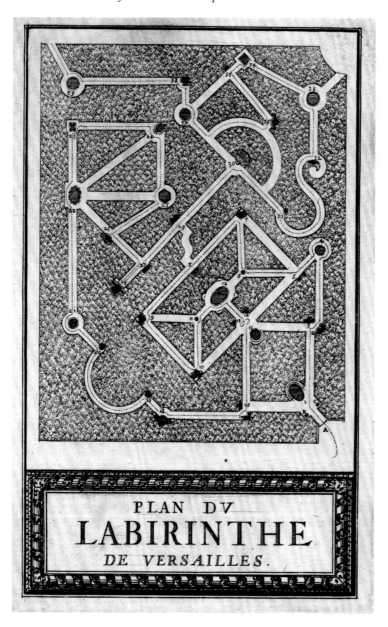

PLAN DV
LABIRINTHE
DE VERSAILLES.

FIGURE 4.15. Map of the
labyrinth in Versailles,
print by Leclerc *c*.1677.

the village of Trianon in 1670 and two years later, Le Vau built the 'Porcelain Pavilion'[5] for Louis and his then mistress, Mme de Montespan. However the building had deteriorated to such an extent that by 1687, it had to be demolished, no doubt encouraged by the king's new mistress, Mme de Maintenon who wanted to erase the memory of her predecessor (Thompson 2006, 208).

In 1688, the Grand Trianon palace was completed with a design by Louis' new favoured architect, Jules Hardouin-Mansart and the new gardens surrounding it were again laid out by Le Nôtre, although the latter's influence was slowly diminishing. He had worked well with Colbert, who had overseen all the building

work at Versailles, but after the latter's death in 1683, Le Nôtre did not enjoy the same close relationship with Louvois, Colbert's replacement. The last area that was developed was at Marly, the final place that Louis could escape to, at the edge of the Grand Parc (the greater park). Work started here on the pavilions from 1679, although the main changes to the surrounding landscape were not until the 1690s. As a result, there is some debate over who was responsible for this last phase as Le Nôtre was a very old man and in retirement by then.[6] What was different about this area is that it was a naturally attractive site and Hunt (2002, 104) has argued that this was the start of the French move away from the formal style to the 'picturesque'.

Due to financial constraints arising from the various wars in the last part of Louis' reign, no significant work on the gardens was undertaken and Versailles was largely abandoned after 1715 when Louis XIV died. During the reign of his successor, Louis XV, the only significant addition to the gardens was the completion of the *Bassin de Neptune* (1738–1741). However late in his reign, he did put on the last of the great fêtes to be held in the garden for the wedding of his heir and the Austrian princess in 1770 (Thompson 2006, 313). It is perhaps ironical that this couple, the future Louis XVI and Marie Antoinette should be the last to reign in France as absolute monarchs. It was not until Louis XVI's accession to the throne in 1774 that any major work was done the gardens. The storms during the winter of 1774 to 1775 prompted a complete replanting of the gardens, as by this stage, some of the trees were over 100 years old.

The initial plan was to turn the site into a newly fashionable *jardin anglais*[7] or English style 'informal' garden. However this would be difficult politically as it was associated with the English Whigs who were openly hostile to the French style of absolutist monarchy and also costly. So only the relatively private garden around the new Petit Trianon palace and its associated buildings were developed in this way. Elsewhere the lines of Le Nôtre's designs were retained although the *palissades* (clipped hedging that formed walls in the *bosquets*) were replaced with rows of lime trees or chestnut trees (Thompson 2006, 315). The *Grotte des Bains d'Apollon* by Hubert Robert in which the statues from the *Grotte de Thétys* were put, was the only feature created in this period. After the French revolution, which Versailles had survived after the initial chaos, it was opened to the public with the château becoming a museum. The gardens largely survived, although individual areas have undergone radical alterations. In the late nineteenth century, renewed historical interest in the French formal garden allowed some degree of restoration (the same happened at Vaux-le-Vicomte) under the curator, Pierre de Nolhac from 1887, though it has never returned to its glory days under the Sun King, Louis XIV.

Notes

1. Louis' grandfather, Henri IV, was the first Bourbon king and he had initially struggled to assert his authority after a long period of civil war.
2. Apollo at rest *chez Tethys* was an allegory of Louis XIV at ease at Versailles, a place for royal pleasure and diversion after strenuous toil (Berger 1985, 21).

3. In 1668 alone, nearly 50,000 elms were ordered, over 14,000 chestnuts and 7000 hornbeams, oaks and other trees (Thompson 2006, 107).

4. It became an established part of the official tour (Berger and Hedin 2008, 2).

5. So-called as it was made from blue and white tiles.

6. There is a plan by Le Nôtre for 'an initial plan for the river' at Marly (Orsenna 2000, 100).

7. The style was sometimes referred to as *le jardin anglo-chinois*, as the French could not bring themselves to full credit for their traditional enemy for its development (Hunt 2002, 94).

The Landscape Garden as a Political Tool for Whig England

The reason why Taste in Gardening was never discovered before the beginning of the present Century, is, that It was the result of all the happy combinations of an Empire of Freemen, an Empire formed by Trade, not by a military & conquering Spirit, maintained by the valour of independent Property, enjoying long tranquillity after virtuous struggles, & employing its opulence & good Sense on the refinements of rational Pleasure. (Quaintance 1979, 285)

If Horace Walpole is to be believed, the development of the supposed ideal landscape garden in the British Isles in the eighteenth century was due solely to (his brand of) Whig ideas. While this is a very neat shorthand to describe why this particular style of garden became so ubiquitous in Britain, it has two major flaws. The first is that the style somehow sprung up spontaneously without any historical precedent, although he does acknowledge the role of medieval deer parks. The second is that the political ideology of the Whig party of the first half of the eighteenth century alone was the driver for the creation of the English landscape garden. It is perhaps more accurate to say that the ruling elite, from all sides of the political spectrum, chose their estate as a means to demonstrate their political power and ideas.[1] Walpole notes: 'in general it is probably true, that the possessor, if he has any taste, must be the best designer of his own improvements' (Walpole 1995, 58). Working on one's estate was not only therefore a means of self-expression (Harwood 1993), it also demonstrated one of the key British values. As Rorschach points out:

'nearly all the creators of early landscape gardens used their gardens to express personal ideals ... Why did these garden owners choose to express such personal mythologies by means of a landscape garden? In the writings of Shaftesbury and others, nature was associated with morality ... the landscape garden [therefore] had also come to be associated with notions of English liberty.' (1983, 6)

Walpole's rather simplistic and biased arguments have left modern garden history scholars to dismiss his ideas and with some notable exceptions[2] downplay the political aspects of the English landscape 'revolution'. To explore further, there needs to be a separation between the overall design, which broadly went from the 'formal' to the 'informal'[3] reflecting the relative freedoms the

British increasingly enjoyed, from the overt political iconography in the garden in the planting, buildings and monuments. Did mainly the Whigs that Walpole approved of conduct such 'political gardening'? While labels are often neat shorthand to describe a political affiliation, they can also confuse the issue. In this period, political groupings reflected the small part of society (that is landowners) who were politically active and their relatively narrow aims, which mainly included staying in power!

Whilst there was the broad division of Whigs and Tories, in both parties there were 'Court' MPs and 'Country' MPs. The former mainly wanted to be involved in government and the latter were more like the backbenchers of today's UK parliament, often known rather impolitely as the 'awkward squad' for their refusal to toe the party line. Over time, the Whig party split. Those who opposed Robert Walpole in the 1730s called themselves 'True' or 'Patriot' Whigs, as they sought a 'purer' version of Whiggism. Later in the century, another group called 'Rockingham Whigs', opposed King George III and in particular the war with the American colonists. All these factions used their landscapes to make political statements but they were not always consistent, as shifting political allegiances forced them to make changes or, in political currency, U-turns.

The impact of the Glorious Revolution

Following the restoration of Charles II in 1660, the new gardens being developed at Versailles and other French royal palaces, provided the inspiration for those with the land and resources to develop them in Britain. As Mowl (2000, 50) points out: 'an aristocracy still reeling from Oliver Cromwell's abolition of the House of Lords showed its devotion to the restored monarchy by long avenues of trees and formal layouts up and down the country'. Added to Charles' reliance on his cousin Louis XIV for financial and military support, these French inspired gardens must have seemed an anathema to those who had supported the Commonwealth, most notably the First Earl of Shaftesbury. While Charles himself did not build anything on the scale of Versailles, he did redesign St James's Park soon after his return, employing the French designer, André Mollet. He put in the French style features of a *patte d'oie* (radiating avenues in the shape of a goose's foot) and a canal at Hampton Court in 1662. This was Charles' way of imposing his authority soon after his restoration to the throne and his power over a humbled Parliament that had invited him back (Mowl 2000, 48).

The Whig party had developed during the 'Exclusion Crisis' of 1678–81, under the leadership of Lord Shaftesbury. They opposed the succession of the Catholic James, Duke of York (Charles' brother) but more importantly were against the type of absolutist monarchy enjoyed by Louis XIV in France. James did become King in 1685 but his reign was short-lived. Following the Whig backed 'Glorious Revolution' of 1688, the Protestants William and Mary

took the throne. The new monarchs though had largely Tory administrations. Changes to the constitution in the following years, meant that Whig ideology became less radical and largely accepted the status quo. There was opposition from both sides of the political divide but they were rarely united until in 1694, the so-called 'Whig Junto'[4] effectively took control. In this period then, the logic would suggest a shift in garden style was from overt 'French' designs to the perhaps more acceptable 'Anglo-Dutch' which were smaller in scale but not necessary cost. However as with the Whig/Tory divide, it is not as straightforward as this.

The irony is that following the events of 1688 when Parliament reasserted its control over the monarchy, their new king, William, was quite passionate about formal gardens. Though some have used the phrase 'Anglo-Dutch' (Hunt and Jong 1988) to describe the gardens of the late seventeenth century, it is probably more accurate to represent such as Hampton Court (Figure 5.1) as 'Franco-Dutch'. The one thing that they were clearly not was uniquely British. Most were created in the late 1680s and 1690s after the Glorious Revolution, as by this stage their owners felt more secure in their position. They have all the elements that were seen in France and Holland: formal gardens near the house with complex parterres, topiary and fountains that could be enjoyed from the house and on the ground. Away from the house were long avenues or *allées*, often as *patte d'oie*, together with wooded areas or *bosquets*. Even the architecture at this time, a form of the Baroque, had its roots from across the channel.

Some of the grandest gardens were those belonging to the estates of the so-called Whig 'Kingmakers'.[5] Looking at estates such as Chatsworth (Duke of Devonshire), Kiveton (Duke of Leeds) and Heythrop (Duke of Shrewsbury),

FIGURE 5.1. Bird's eye view of Hampton Court from the South by Knyff *c.*1702.

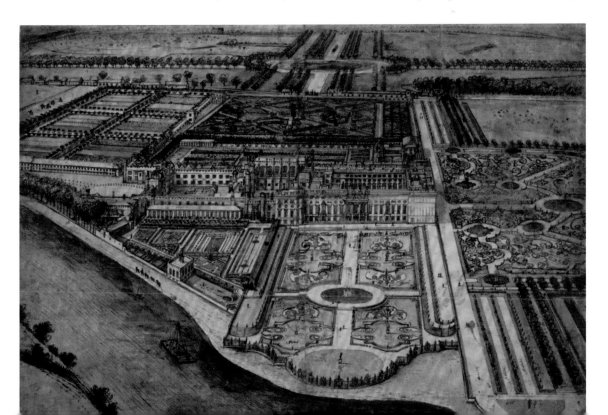

they clearly set the pattern for the extensive Whig landscapes into the eighteenth century. Eyres (1990, 34) states that 'these [kingmaker's] palaces proclaimed the liberation of the individual from absolutism through constitutional monarchy and Whig 'Liberty'. The latter embodied, after all, the freshly-won power to govern by self-interest and to demonstrate self-aggrandisement through architecture and landscape design'. Of these Chatsworth, built between 1687 and 1707, was one of the most lavish and outdid the royal palaces in splendour. Clearly the owners of these large estates were making a political statement merely by the virtue of their size and the expense lavished on them. A visitor to Chatsworth in 1690 'complained that the gardens had "nothing extraordinary but their situation, nothing wonderful but their cost, and nothing unusual but their solitariness". But on the whole, visitors were clearly overwhelmed by the scale of what they saw' (Barnatt and Williamson 2005, 65).

Apart from their size, did the gardens reflect the political views of their owners either in design or iconography? Richardson believes that a small group of influential Whigs such as Sir William Temple and William Bentinck (Earl of Portland) with their garden-making 'were vital for the precedent they set for future generations, stylistically speaking, and also in terms of the way they reformulated the cultural and political currency of gardens' (Richardson 2008, 56). This is based firstly on a discussion about the ideal garden reflecting the natural landscape by Temple and the latter's garden at Moor Park and secondly the influence of Bentinck's gardens at Zorgvliet in Holland and Bulstrode in Buckinghamshire. Both these men were very close to King William. In April 1689, Bentinck had been appointed as Superintendent of the Royal Gardens in England, a role he also had in Holland. He was therefore responsible for the changes at Hampton Court, which included the Great Parterre (Figure 5.1), the best example of Dutch style in England. The gardening style of these two men would therefore have an influence on those who wanted to ally themselves with the Glorious Revolution and by implication with King William.

Published in 1692, Temple wrote *Upon the Gardens of Epicurus: or, Of Gardening, in the Year 1685*, which described Moor Park in Hertfordshire.[6] Instead of being some new radical style, it was actually created in the early seventeenth century[7] and was inspired by Italian Renaissance gardens. Temple says Moor Park 'may serve for a Pattern to the best Gardens of our Manner, and that are most proper for our Country and Climate' (Hunt and Willis 1988, 98), implying that this 'Italianate' style should provide the model. If this is correct then he is predicting the style of Burlington's garden at Chiswick and Pope's at Twickenham, 20 years later. However he goes on:

'what I have said, of the best Forms of Gardens, is meant only of such as are in some Sort regular; for there may be other Forms wholly irregular, that may, for aught I know, have more Beauty than any of the others; but they must owe it to some extraordinary Dispositions of Nature in the Seat.' (Hunt and Willis 1988, 98–9)

In other words, some natural landscapes may be beautiful[8] and this has been interpreted as promoting the landscape style of Brown *et al*. Was he was merely

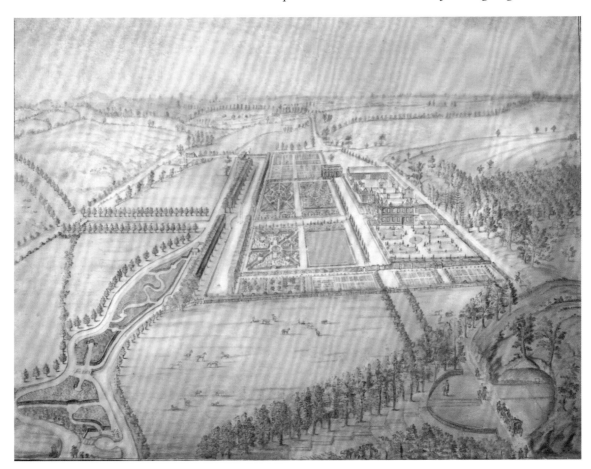

IGURE 5.2. Drawing of Sir William Temple's garden at Moor Park, Surrey attributed to Jan Kip *c*.1690.

saying that if you have a naturally beautiful site that is fine but for most a garden is the only way to improve the surroundings? Whatever his meaning, Temple's own garden does have an interesting design with an irregular 'wilderness' that breaks up the absolute formality and symmetry of the rest of the garden (Figure 5.2). This characteristic can also be seen in the garden belonging to Bentinck in his native Holland. At Zorgvliet next to largely regular layout, is a sinuous, natural stream within a semi-wild area.

What about iconography? Zorgvliet and Het Loo[9] had large collections of orange trees. The orange tree was linked to Hercules, who had taken the golden apples from the gardens of Hesperides as a reward for his courage and virtue. Thus in the Dutch royal gardens, orange trees were seen as a living emblem of the Dutch king and the imagery repeated by fountain of Hercules (de Jong 1990, 41). William was the new Hercules for his defence of his religion and his country against Louis XIV's France and this imagery was replicated outside the garden in medals, pamphlets and engravings. It seems he also took a leaf out of Louis' book by using the garden as a venue for diplomacy for foreign guests. He expected them to understand the symbolism of the various statues, the design and the plants used (de Jong 1990, 42).

William and Mary's two garden projects in England, Hampton Court and Kensington Gardens were equally as ambitious as Het Loo, not least in the cost both of making them and maintaining them. Many of their courtiers followed their style in adopting the parterres but these were smaller in scale and many incorporated French style landscaping. While it is true that there was a shift in style to a Franco-Dutch hybrid, inspired by William of Orange, this appears to be more dictated by notions of taste and the design capabilities of the likes of the Brompton Nursery, rather than making any political statement. As for iconography, William Temple apparently had the best orange trees (Hunt 1996a, 197) but having Orangeries was nothing new and statues of William as Hercules were non-existent at the time, although later statues of Hercules would become popular. At Chatsworth, William Cavendish built one of the largest Orangeries, perhaps symbolising his role in bringing William of Orange to the throne. The exedra[10] there was exactly like those at Het Loo and Zorgvliet. The statues in the gardens at Chatsworth had a strong nautical theme, again perhaps echoing the theme of the Glorious Revolution, which had come from across the sea (Barnatt and Williamson 2005, 90).

Coalition and opposition

The tenure of the Whig Junto was brief and by 1700, they were largely out of favour. With William's death in 1702, the Whigs formed an uneasy coalition with a Tory hierarchy supported by the Duke of Marlborough. When the latter fell from favour in 1710, the Whigs went into opposition and waited for the accession of George I. The reign of Queen Anne however had seen some subtle changes in style, as she simplified the royal gardens and thereby reduced expenditure.[11] Anne was reputed to dislike the smell of the box edging used in the parterres but perhaps it was the sheer extravagance of maintaining them that she objected to! While the parterre and topiary became unfashionable in the early eighteenth century for political and economic reasons, tree planting either in the form of avenues and wooded areas retained its appeal. The benefits of tree planting has a long history dating back to the timber shortages in the Tudor period and was given a philosophical voice by John Evelyn in his work *Sylva: A Discourse of Forest Trees.*[12] While many features of the formal garden were swept away in the eighteenth century, formal avenues remained and even were being planted alongside more natural features. At Lord Burlington's estate in Yorkshire, in 1742, Knowlton, his head gardener, was advised 'to plant again that part of the Avenue you mention in the Crossthorns, and … other places where you find necessary' (Henrey 1986, 193). By this stage, Burlington had joined the anti-Walpole faction and was possibly a Jacobite,[13] the retention of the avenues could be interpreted as a Tory or conservative thing to do.

Not long into Anne's reign, the War of the Spanish Succession started. As Louis XIV's France was the major foe, cultural contacts were diminished and Jacques (2000b, 32) has argued that this led to 'English gardenists increasingly

establish[ing] their own insular variants, not least with regard to avenues, forecourts, garden walls, parterres and wildernesses'. Two influential Whig writers then reopen the debate on the 'naturalness' of gardens: the third Earl of Shaftesbury and Joseph Addison. The former, the grandson of the founder of the Whig party, wrote *The Moralists* in 1705[14] and some have taken his praise of nature as encouragement for the gardening style that subsequently became popular. As with Temple's musing on the subject, probably too much has been read into this, in particular the lines:

> 'Things of a natural kind; where neither Art, nor the Conceit or Caprice of Man has spoil'd their genuine Order, by breaking in upon that primitive State. Even the rude Rocks, the mossy Caverns, the irregular unwrought Grotto's, and broken Falls of Waters, with all the horrid Graces of the Wilderness it-self, as representing NATURE more, will be the more engaging, and appear with a Magnificence beyond the formal Mockery of Princely Gardens.' (Hunt and Willis 1988, 124)

It is clear that Shaftesbury was trying to look for an alternative to the 'Princely Gardens' of France in particular but given his own rather conventional garden, was he endorsing a completely natural style of gardening? Perhaps not but as a poet and philosopher, he certainly was inspired by both the Italian gardens he visited between 1711 and 1713 and the wild landscape paintings of Salvator Rosa and Claude. For him, it was Nature that God created that was the true Art and so anything 'manufactured' could not compare to it. His main legacy to the English landscape garden was while in Italy, he hired artists for illustrations of the second edition of his book (Mowl 2004). They show many styles of garden buildings[15] that would be replicated in the next fifty years.

Joseph Addison wrote a series of articles in *The Tatler* and *The Spectator* between 1710 and 1712, where he too discusses the beauty of nature and what it means in relation to gardens. While Shaftesbury's ideas relied on the natural surroundings, Addison was more practical, influenced by John Locke's new ideas, he believed 'man came into the world with a blank state and, having nothing stamped on his mind, all his knowledge came from sense perception and experience' (Batey 2005, 189). He paved the way for gardens to be created in a 'natural style' that went against the current trends of formality.[16] In an essay in the Spectator on 25 June 1712, Addison is more specific what constitutes an ideal garden:

> 'The Beauties of the most stately Garden or Palace lie in a narrow Compass, the Imagination immediately runs them over, and requires something else to gratifie her; but, in the wide Fields of Nature, the Sight wanders up and down without confinement, and is fed with an infinite variety of Images … Hence it is that we take Delight in a Prospect which is well laid out, and diversified with Fields and Meadows, Woods and Rivers; in those accidental Landskips of Trees, Clouds and Cities, that are sometimes found in the Veins of Marble; in the curious Fret-work of Rocks and Grottos; and, in a Word, in any thing that hath such a Variety or Regularity as may seem the Effect of Design, in what we call the Works of Chance.' (Hunt and Willis 1988, 143)

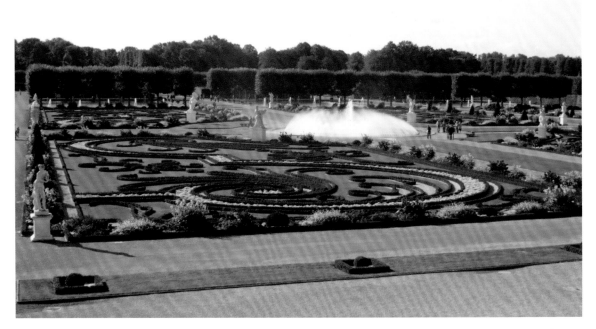

FIGURE 5.3. Formal gardens at Herrenhausen, the royal palace in Hanover.

The Serpentine Walk at Heythrop (seat of the Duke of Shrewsbury, one of the 'kingmakers') may have inspired this passage.[17] It was made between 1706 and 1712 and much admired and subsequently copied, most notably by Stephen Switzer in his influential books. Like Shaftesbury, Addison did not practice what he preached as the descriptions of his estate at Bilton Hall (Warwickshire) appeared to suggest a formal garden (Batey 2005, 206). While both Tories and Whigs were taking up the theme of more 'natural' style of gardening, it was the scale that differed. The Whigs continued to develop their large estates as wholly pleasure grounds, while the Tories preferred less ostentatious displays, mixing gardens with working farms. The latter would develop into the idea of *ferme ornées* later on in the eighteenth century.

What ties in all these ideas were allusions to ancient precedents: classical such as Virgil (Addison) and Homer (Temple and Pope) and even medieval (Shaftesbury). Were they trying to find a garden style that pre-dated France? Certainly all seemed to be taking delight in the native British countryside as the Ancient Greeks had done. The one imagery that did take root was Classical Rome, filtered through Renaissance eyes of Andrea Palladio whose building style was being replicated first in Hanover and then from 1709 in Britain.[18] While architecture was taking a new radical direction, garden design in the early neo-Palladian mansions still had highly formal gardens (Figure 5.3). There was also a search, particularly amongst the Tories initially and then the Jacobites, for something uniquely British and so 'Gothic', or perhaps Anglo-Saxon, the imagery is quite confused, buildings appear in the landscape (Figure 5.4). They were making a comparison between Anglo-Saxons who were crushed under Norman rule and themselves with the new Hanoverian dynasty (Charlesworth 1991).

The first evidence of a change of landscape style is at Castle Howard in Yorkshire, ironically a Baroque building. Charles Howard, the third Earl of Carlisle, was among the Whig elite who ensured that Queen Anne succeeded to the throne in 1702. However his sovereign was seemingly ungrateful for his help as he was immediately dismissed as First Lord of the Treasury! Although he returned briefly to government in 1715, his energies were largely directed thereafter towards his estate. Lord Carlisle's ambition was that his estate would be the most lavish of the 'kingmakers' palaces (Eyres 1990, 34). He had commissioned John Vanbrugh (another Whig) to design the house in 1699.[19] George London was approached to landscape the grounds in 1699 but Lord Carlisle rejected his proposal for 'Ray Wood'. Stephen Switzer, a leading garden designer, approved his decision, saying in 1718 that there was a:

> 'beautiful Wood belonging to the Earl of *Carlisle*, at *Castle-Howard*, where Mr. *London* design'd a Star, which would have spoil'd the Wood; but that his Lordship's superlative Genius prevented it, and to the great Advancement of the Design, has given it that Labyrinth diverting Model we now see it.' (Hunt and Willis 1988, 158)

Carlisle had visited Sir William Temple at his home, Moor Park in December 1697, so this may have influenced his decision about Wray Wood.

Accession of George I and the Tory response

Finally the Whigs were returned to power after the accession of George I in 1714. The year before the Treaty of Utrecht had been signed, ending the series of European wars that had made travel to the Continent difficult. For young aristocrats on the Grand Tour, they could now see for themselves the antiquities of Italy and its Renaissance gardens. One of those who set out in 1714 was Richard Boyle, the Third Earl of Burlington. On his return in 1716, Burlington erected the first Palladian garden buildings at his house at Chiswick.[20] However these buildings were sited at the end of a very conventional *patte d'oie* arrangement of avenues. Nearby in Twickenham, Alexander Pope was starting to create his influential garden from 1719. He was inspired by ancient Roman descriptions of gardens, as he 'saw himself as a modern embodiment of Horace, the Roman poet who advocated a life of retirement, away from urban and political concerns' (Rorschach 1983, 12). This appealed to him, as Pope was a Catholic and a Tory. The gardens, modelled on Homer's description of the gardens of Alcinous, had fruit trees and a vineyard. It was the garden's irregularity away from the main axis, echoing his comments about the rejection of formal gardens that marked it out as different.

With the Tories now in opposition, they start using the landscape to make political statements about their attitudes to landed estates and their design. Unlike the Whigs who were seeking new ways, distinct from French styles, these Tories continued with traditional layouts. Many were also Jacobites[21] and showing support for this cause inevitably had to be subtler, so there are indirect

references to former Stuart monarchs rather than direct ones to the Pretenders. The First Earl Bathurst was a conservative Tory who had been raised to the peerage by Queen Anne. On George I's accession, he retired from political life and directed his energies to developing his estate at Cirencester, Gloucestershire. It was a vast area of 5000 acres (c.2020 ha), laid out in long straight *allées*. This design was starting to go out of fashion but by choosing these, he was making a deliberate statement about his conservatism. He built the first 'Anglo-Saxon' building, a mock ruin called Alfred's Hall about 1721, possibly designed by Pope. King Alfred was a popular icon as he was seen as a defender of British liberty and a supporter of the English church. In 1741 Bathurst erected a statue of Queen Anne on top of a column. It was in direct alignment with the house and the nearby church, he therefore 'may have intended this as a subtle signal of his support for the closer connection between church and state which had existed during Anne's reign' (Rorschach 1983, 35).

Another prominent Tory was Thomas Wentworth who became the First Earl of Strafford (second creation). He had been a faithful servant of King William and Queen Anne and had negotiated the Treaty of Utrecht.[22] When King George came to power (along with the Whigs), he and others involved with the Treaty were arrested. Although he was subsequently released in 1717, his public career was effectively over. He remained politically active and supported the Jacobite cause until his death in 1739. In 1708, he had bought the estate of Stainborough Hall in Yorkshire, which he renamed Wentworth Castle in 1730. This was 6 miles (9.6 km) from the original Wentworth family estate that he had failed to inherit from his cousin William, Second Earl of Strafford (First creation) in 1695. He was the eldest surviving male relative and so expected to gain these wealthy estates. However it was left to the son of William's sister and the rivalry between these two branches of the Wentworth family provide an interesting backdrop to politics in the eighteenth century.[23] Land ownership was key to eighteenth century politics as it was the main source of wealth before the industrial revolution. It provided a 'direct influence (through persuasion or coercion) over the voting habits of tenants, dependents and tradesmen that the landowner could be expected to enjoy' (Charlesworth 1991, 16).

How did Strafford express his Tory (and increasingly) Jacobite sympathies in the landscape? Anglo-Saxon imagery had become popular following the erection of Alfred's Hall by Lord Bathurst. At Wentworth Castle, on a hill behind the main house, Strafford built the Gothic 'Stainborough Castle' between 1726 and 1730. This complete building (Figure 5.4) had the curious description *Re-built by THOMAS Earl of STRAFFORD in the Year 1730* as he had been told by local antiquarians that it was the site of an Anglo-Saxon fortification. It re-enforced the notion that he was from an ancient family, of Anglo-Saxons though, rather than Normans. The Jacobites felt that they were battling the Hanoverians in the same way that the Anglo-Saxons had done with the Normans. In 1734 he made a more overtly political statement by erecting an obelisk dedicated to Queen Anne. The inscription, while promoting himself through a list of his titles, also

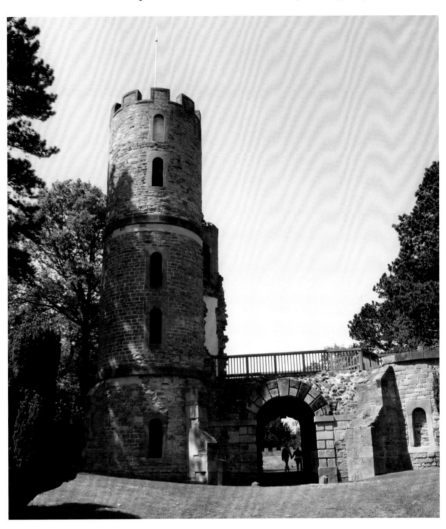

FIGURE 5.4. Stainborough Castle, Wentworth Castle.

states he was *at the death of that most Excellent PRINCESS was one of the seven appointed by act of PARLIAMENT to be REGENTS of the KINGDOME during the absence of the SUCCESSOR.* By not referring to George I by his name 20 years after the latter's accession, he is making the point that the legitimacy of the succession continued to be disputed (Charlesworth 1991, 25). As well as monuments, he laid out the 'Union Jack' garden in 1713, a wilderness or grove of trees with walks cut through them. Given the date, it may be a symbol of the new Union and in particular the Whig attempts to dissolve it (Eyres 2010a, 80).

Robert Benson was creating an alternative model at his 'pure' Palladian mansion at Bramham in Yorkshire. Created Lord Bingley in 1713, he had served as Chancellor of the Exchequer from 1711 to 1713 but like many Tories lost power when George I came to the throne. At that stage he had already created a French inspired garden with great axial rides radiating out from the

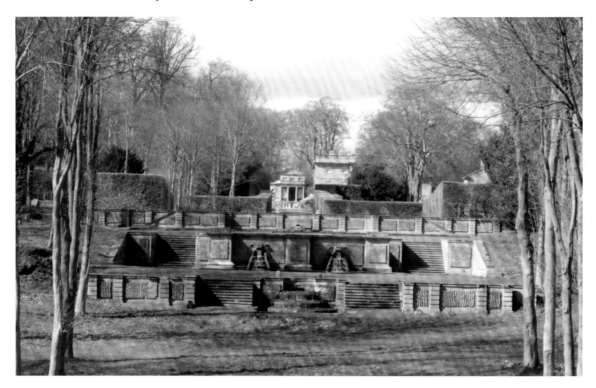

FIGURE 5.5. Cascades at Bramham

new house, although some of the wilderness areas were quite irregular. He had close links with Thomas Wentworth,[24] however Bingley did not appear to hold such overt Jacobite views as his friend. He continued to work on the landscape including the main water features including the T-pond and the cascades that remain today (Figure 5.5). By the time of his death in 1731, he had created a highly individual garden that 'was quite in tune with the kind of garden-making being pursued by Country Whigs and others disaffected with the regime [of Walpole]' (Richardson 2008, 333). So with the exception of 'hardline' Jacobites like Strafford, many Tories such as Bingley were happy to go into an alliance with disaffected Whigs. This was reflected in their gardens, whilst slightly old-fashioned in style, were not seen as a bold statement against the ruling Whigs.

Lord Bolingbroke was not only a leading Tory but openly backed the Jacobite cause. After the failure of the 1715 uprising, he fled to France and in 1720 leased the estate of La Source near Orléans. For the next five years he created a garden, details of which are scant but judging from a letter he wrote to Jonathan Swift dated July 28 1721, he wanted to make a political statement about the simplicity of his life:

> 'You must know that I am as busy about my hermitage … as if I was to pass my life in it … send me some mottos for groves, & streams, & fine prospects, & retreat, & contempt for grandeur etc. I have one for … an ally (sic) which leads to my apartment, which are happy enough … *fallentis semita vitae* [The untrodden paths of life].' (Woodbridge 1976, 50)

Most of the inscriptions were devoted to demonstrating his loyalty to Queen Anne: 'the longest such inscription … speaks of 'unjust banishment' caused by an 'insane band' of rivals' (Richardson 2008, 216). In 1725, he was given permission to return to England and immediately bought Dawley Manor near Uxbridge. He renamed it 'Dawley Farm' and created a more simplified landscape from the formal garden he had acquired. He was thus showing his opposition to the Whig government, whose members were creating grand estates, supposedly through corrupt practices. By converting large parts of the parterre to pasture, he was also setting the model for future Tory *ferme ornées*, such as the one developed by Philip Southcote at Woburn (Figure 5.6).

Development of the 'natural style' and Whig ideology

Given Walpole's assertion that the best landscapes were borne out of Whig principles, what about those Whig grandees, like Walpole's father at Houghton? At first they continued in the same manner as the 'kingmakers' of William's reign with formal parterres and long avenues. Sir Robert Walpole had inherited the estate in 1700 but it was not until 1717 that he undertook any major work in the landscape. Plans from this period (Eburne 2003) show some irregularity in the parterres but it is not until the 1730s that they disappear, together with other formal elements such as the avenues. These changes are attributed to

FIGURE 5.6. Woburn (or Wooburn) Farm, Surrey by Sullivan 1759.

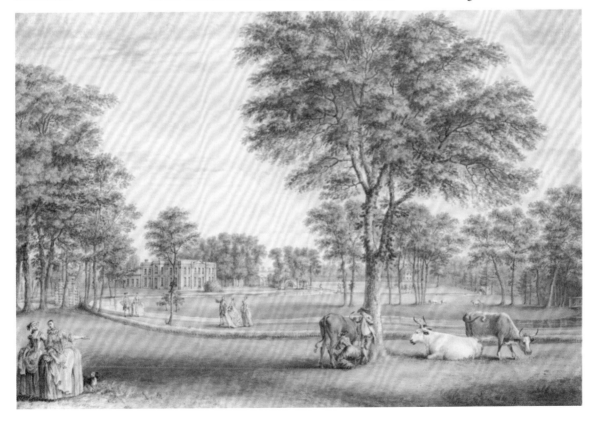

FIGURE 5.7. Octagon Pond and Upper Cascade at Rousham.

Charles Bridgeman. Like George London before him and William Kent after him, Bridgeman was largely carrying out the wishes of his patrons, however he is credited with making the transition from the highly formal (and French inspired) to the relatively informal and thereby sowing the seeds for the 'English landscape' style that Horace Walpole was so proud of. An apprentice in the firm of London & Wise, Bridgeman's first recorded work was at Blenheim in 1709, alongside Vanbrugh, the favoured Whig architect and landscape designer. By the 1720s, he was well established working at Claremont in Surrey for the Duke of Newcastle, a future Prime Minister but at the time part of the Walpole's government and many other estates such as Stowe and Rousham (Figure 5.7).

One of the most influential members of the ruling elite was Caroline, wife of George II. This was highly unusual for a woman at the time but she found herself as the intermediary between Robert Walpole and her politically unconcerned husband. She had been brought up in Berlin at the Court of the Electress of Brandenburg where there were many leading intellectual thinkers including Leibniz, who became her adviser. When she arrived in England in 1714 as Princess of Wales; she wanted to try the new landscaping ideas by 'helping Nature, not losing it in art'. By 1719 she had the landscape by the Thames at Richmond to execute these ideas (Batey *et al.* 1994).

Even when she became Queen in 1727, she devoted much of her energy on this garden and in 1732, she brought in William Kent to design first the Hermitage and then three years later, 'Merlin's Cave'. The Hermitage[25] sought not only to demonstrate link between natural philosophy and Newtonian science but also Caroline's forward thinking.

Merlin's Cave[26] however had more obvious political message, which made it the subject of Opposition derision, most notably by Bolingbroke in the *Craftsman*. The meanings behind this somewhat bizarre building, is that Caroline was trying to legitimise the Hanoverians claim, via their ancestral links to the Tudors and ultimately to the legend of King Arthur (Colton 1976). This was also in keeping with the increasingly favourite Anglo-Saxon symbolism that was being deployed by the Whig cause and to counteract its use by the Tories. It spectacularly backfired as the Opposition equated Merlin with Walpole. *The Craftsman* notes 'we have some *great Men* amongst us [a reference to Walpole and his government], who have justly acquir'd the Reputation of being *Wizards*, or *Conjurers*' (Colton 1976, 16). The implication being that Walpole and his cronies were responsible for large amounts of public funds being conjured away.

Rise of dissident Whigs and the alternative Court

In 1733, Lord Cobham and other 'dissident' Whigs went into opposition against the government of Sir Robert Walpole and they needed a figurehead. They were careful not to make the mistake Tories had done previously and align themselves with the Jacobite cause. Instead they found Frederick, Prince of Wales, as a suitable candidate. Like his father and grandfather before him, he had spent his youth in Hanover, not arriving in Britain until 1728, when he was 21. In Hanover, he had been the head of state since the age of seven, following his parents' move to Britain. Frederick's relationship with his parents was strained. He set up an alternative 'Court' and was happy to back any opposition to his father. He was a cultured man, unlike his father, and showed an interest in the arts including the newly fashionable laying out of gardens. Within his circle of friends were Lord Burlington, Alexander Pope and William Kent: all leading figures in the change of gardening style.

In 1732, Frederick bought Carlton House in London and brought in William Kent to redesign the gardens. Its significance was noted at the time, in a letter by Sir Thomas Robinson to the Earl of Carlisle dated 23 December 1734:

> 'There is a new taste in gardening just arisen, which has been practised with so great success at the Prince's garden in Town, that a general alteration of some of the most considerable gardens in the kingdom is begun, after Mr. Kent's notion of gardening, viz., to lay them out, and work without either level or line.'

The layout of the gardens was inspired by Pope's garden and the work Kent was doing at Chiswick for Lord Burlington in 'naturalising' the features. Kent soon became the favoured designer and his work at Stowe, Claremont and other important gardens finally signalled the death of the 'formal' garden. However with estate owners moving towards irregular gardens, were they making a political statement by following Frederick's lead or were they merely keeping up with fashion? Frederick's garden was not just making a statement about being in fashion by its style, it also used the more direct means of iconography.

Between 1735 and 1737, he had a pavilion built that displayed statues of King Alfred and the Black Prince: the former the founder of the English constitution and champion of English liberty and the latter as a model of bravery, clemency and generosity. Thus 'as the choice of subjects for the two busts suggests, Prince Frederick was positive and explicit in his desire to identify himself with his adopted nation' (Coombs 1997, 159).

The self-styled 'Patriot Whigs', led by Cobham, took the art of 'political gardening' to a new level. Cobham's estate at Stowe influenced some of his protégés, otherwise known as the 'Boy Patriots' or 'Cobham's Cubs'. George Lyttelton was the son of a loyal Whig but due to his close links with Prince Frederick,[27] he was persuaded by his uncle (Cobham) to join the Opposition cause. At his seat of Hagley in Worcestershire, George erected a Pillar with Frederick's statue about 1739. Accounts from the time say that 'the column was a gift from the Prince in recognition of George's political support as well as one of friendship' (Cousins 2007, 73). Another 'cub' was William Pitt the Elder who married Cobham's niece and his:

> 'interest in garden design is inextricably bound up with his political career … Through his family and political contacts he not only saw but advised on a considerable number of gardens and was instrumental in spreading a taste for the pictorial and varied type of garden scenery.' (Symes 1996, 126)

Finally there were the two nephews, Richard Grenville, later to inherit and develop the grounds at Stowe and his brother George. The latter not only used Lancelot Brown, then the head gardener at Stowe, to landscape the grounds at Wotton House, but 'Pitt is claimed to have helped Grenville plan the "enchanting two miles of water scenery still to be seen"' (Symes 1996, 134).

In this circle, was Sir Francis Dashwood, who politically speaking was an 'independent' but was persuaded by Prince Frederick to join the Whig Opposition and was influenced by their new style of gardening (Symes 2005, 4). His estate at West Wycombe Park is a testament to libertarianism in all areas of life and he was echoing the 'family motto … 'Pro Magna Carta', signifying the liberty that had been won at that time and to which the Whig Opposition frequently referred back' (Symes 2005, 6). His Temple of Apollo had the twin inscriptions *Libertas Amicitae Q Sac* (sacred to liberty and friendship) and *Fay ce que voudras* (do as you wish: the motto of the Hellfire Club).[28] Whereas at Stowe, the first motto has a serious intention, Dashwood's use was ironic as the building was used for cockfighting and as a lavatory! The rest of the garden, developed between 1740 and his death in 1781 is largely dedicated to enjoying the pleasures in life that liberty and wealth can bring. Towards the end of his political career in 1762, he even became Chancellor of the Exchequer but his tenure was short lived. An ill-advised policy of putting excise duty on domestic cider led to his resignation: perhaps once a maverick … his landscape though remains one of the highly individual designs that this period produced.

The last political gardens of Victory and Empire

Wentworth Woodhouse in Yorkshire was the ancestral seat of the Wentworths that Thomas Wentworth was so bitter about losing on the death of his cousin. Perhaps appropriately given the family history, its new owners, the Watson-Wentworths, were staunch Whigs and this estate formed a neat counterbalance to the overtly Tory and Jacobite activities at the neighbouring Wentworth Castle. Thomas Watson-Wentworth succeeded in 1723 and proceeded to lay out a suitably grand landscape in the favoured Whig style of long avenues stretching to the edges of the estate. He had inherited an Italianate house built by his ancestor in the 1630s and almost immediately started to remodel this in a Baroque style: presumably to rival the house Thomas Wentworth had constructed. This was the traditional front of the house and faced west. In 1730, realising that the fashionable Whig architectural style was now Palladian, he started to build on the other side (that is east facing) a new front. Finally completed in 1772, at 606 ft (*c*.185 m), it is the longest façade in England and was 'a measure of Rockingham's[29] princely status and political ambition that he capped Walpole's Houghton ... [Furthermore] this *about-turn* [in architectural style] demonstrated Rockingham's conformity to Whig cultural orthodoxy' (Eyres 1991, 79). An Ionic Temple that contained a statue of Hercules (that is William III) slaying a monster (France) marked his support for the Glorious Revolution.

He also gave his unwavering support to the government during the 1733 Excise crisis and most critically during the Jacobite rebellion of 1745. His loyalty was rewarded with honours and Rockingham responded by erecting the 'Hoober Stand' in 1748. This triangular tower stands on a ridge and therefore not only gives a wide view from the top, it is also visible from Stainborough Castle. In a direct riposte to the Queen Anne obelisk at Wentworth Castle, the inscription dedicating the building to King George II, only mentions one of Rockingham's titles.[30] It also refers to the Jacobite rebellion as 'Unnatural' reducing any legitimacy the rebels might have had. His son, Charles, succeeded in 1750 and followed his father as a leading Whig. He was close to the king and the Prime Minister, the Duke of Newcastle. The accession of George III in 1760 found Rockingham on the wrong side of the political divide. The new king wanted to assert his authority over what had become a dominant parliament, due to the lack of interest of his predecessors in British affairs.[31] The opposition coalesced around him and became known as the 'Rockingham Whigs'. Rockingham was briefly in power (as Prime Minister) in 1765 and 1782, when George's unpopular policies in America and at home forced the king's hand but for most of this period, he conducted the battle against the government in parliament and in his landscape.

Keppel's Tower, constructed in 1778, represented one of Rockingham's political victories. Admiral Keppel, an opponent of the American war (and 'Rockinghamite' MP), escaped a court martial for treasonal incompetence at the Battle of Ushant against the French, due to intense lobbying by Rockingham

in parliament and outside (Charlesworth 1991, 43–4). The Second Marquess also wanted to keep an eye on his suspect neighbours at Wentworth Castle, so in addition to the Hoober Stand, he built an observatory (known as 'Lady's Folly') on a knoll on the western edge of the park. Earl Fitzwilliam, his heir, built the last political building at Wentworth Woodhouse, the Mausoleum, after Rockingham's death in 1782. It is a monument to Rockingham and his political friends. To commemorate them in a landscape feature was apt because it was the ownership of the land that gave them the power (Charlesworth 1991, 48). A further expression of support by a Rockingham Whig, Sir Thomas Gascoigne, can be found at his estate of Parlington Hall, near Leeds. The main mansion has been demolished but the Triumphal Arch he erected in 1782 still stands at the approach to the house. While it now reads *LIBERTY IN N. AMERICA TRIUMPHANT MDCCLXXXIII*, the original inscription was different. Referring not only to American victory, but also the victory of the opposition, it read:[32] *To that Virtue which for a series of Years resisted Oppression & by a glorious Peace rescued it's [sic] Country & Millions from Slavery. T.G. Dedicates this Arch. 1782'* (Sheeran 2006, 19–20).

While these expressions by the Opposition continued, so too did monuments in the landscape that showed support for the ruling government. As at Wentworth Woodhouse, the crushing of the Jacobite rebellion in 1745 was a popular theme. At Aske Hall, near Richmond (Yorkshire), a Gothic Temple was erected between 1735 and 1756 for its new owner, the Whig Sir Conyers D'Arcy. The estate had belonged to the Duke of Wharton but he had gone over to the Jacobites and had been charged with treason in 1729. This building with its unfilled niches may have been similar to the Temple of British Worthies at Stowe (Sheeran 2006, 13). If so, did D'Arcy intend this as a statement of his loyalty and that the land was now in safe (Whig) hands? Perhaps, as the motto cast inside the temple was 'Un Dieu, Un Roy'. Nearby, the loyal Yorke family built the so-called Culloden Tower. It was almost certainly built to commemorate the battle of Dettingen,[33] in which Anglo-German troops led by George II defeated and inflicted severe casualties on much larger French forces' (Sheeran 2006, 13). The Seven Years War (1756–1763) was pivotal in establishing the British Empire. Britain's success was celebrated in monuments such as the Temple of Victory at Allerton Park in North Yorkshire and most famously the Temple of Concord and Victory at Stowe.

The last major 'political landscape' was the garden created at Kew by Prince Frederick's widow, Augusta. Although Frederick had acquired the site in 1731, he did not start work on it until the late 1740s. That it was next door to Richmond, where his estranged mother had created her (derided) garden, may have influenced the decision not to start immediately. Frederick's death in 1751 put a further halt to work until 1757. Augusta, with the help of Lord Bute, took his design layouts[34] and began to add a series of eclectic and politically motivated buildings. Overall the garden was a monument to Frederick but with the accession of her son, George III, it became the focus for the Opposition

to attack, much in the same way that Queen Caroline's had been thirty years earlier (Quaintance 2001, 14). Whilst they could not openly attack the royal family, as it would be treason, belittling the efforts in their gardens was seen as legitimate. The overall design was naturalistic reflecting current fashions. Two sheep meadows took up a quarter of the site, echoes perhaps of a Tory style *ferme ornée* and were used for George's flock of Spanish merino sheep, representing the agricultural revolution going on at the time. While a widely used feature in many estates, here 'Farmer' George was mocked. It was not helped by all the buildings from around the world that were meant to represent the growing British Empire. Instead: 'the garden … [had] come to symbolize a quite *un*natural, over-managed, elitist and faddish *island* in a society wanting leadership; the Pagoda Figure 5.8], a silly retreat from royal responsibility' (Quaintance 2001, 33).

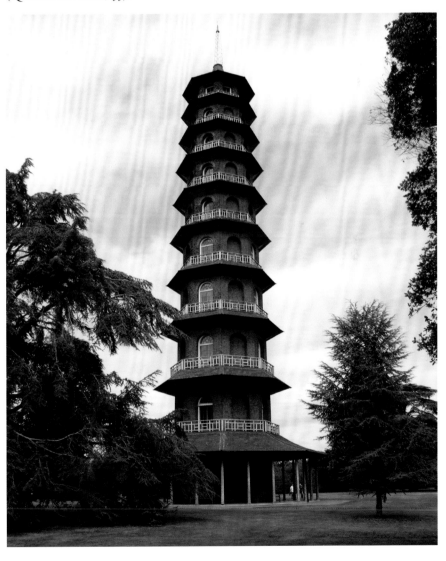

FIGURE 5.8. Chinese Pagoda at Royal Botanic Gardens, Kew.

Was Walpole right?

In the 100 years from 1660 and the restoration of Charles II to the accession of George III in 1760, Britain's gardens and landscapes had completely changed. Gone were the 'foreign' ideas and Walpole could justly claim that 'imitation of Nature in Gardens, or rather in laying out Ground, still called Gardening for want of a specific term to distinguish an Art totally new, is Original, and indisputably English!' (Walpole 1995, 7) However Walpole's assertion that it was due to Whig political ideas is partly right. Their promotion of parliament as the main power base, as opposed to the monarchy, gave a platform for exploration of new political ideas. For many it was at their estate that they chose to demonstrate these. It was from both sides of the political divide that landscapes were used. The individuals wanted to make statements about themselves and their ideas in their gardens. The relentless pace of change though from the formal French-Dutch style to the classical informality hawked around later in the century by Brown *et al.*, was largely driven by Whig ideology of progress: whether in government or in opposition.

The Tories seem to want to hold back the tide of progress and with a few exceptions showed their allegiances by sticking to old ideas or reinventing them for example the *ferme ornée*. Very few Tories showed open, especially Jacobite, dissent, as this was a very dangerous thing to do. Opposition took the form of criticising the landscaping of Queen Caroline and then her grandson, George III. This was a much safer option than attacking the person, or in their case, the monarchy directly. However with the rise of the Patriot Whigs, opposition ideas were channelled into monuments and garden buildings. The meanings of these political statements were clear to those who visited these estates but unlike political writings, they were oblique enough not to be treasonous. As they were permanent features, they could be embarrassing if you or your descendants changed sides or allegiances and there are many examples where statues are moved or temples 'reassigned'. Stowe's buildings are a testament to this. After 1760, there are a few 'political' buildings in the landscape erected but the great landowners were increasingly preoccupied with the events both inside and outside Britain, which would start to impact on their hold on power.

Notes

1. For Walpole, this meant a relatively weak monarchy, a strong parliament and above all, liberty.
2. See Quaintance (1979), *New Arcadian Journals* particularly those on Stowe (No 43/44), Wentworth Castle and Wentworth Woodhouse (Nos 31/32, 57/58 & 59/60) & Kew (No 51/52), Richardson (2008) and Sheeran (2006).
3. Some historians dislike this terminology and prefer 'regular' and 'irregular'.
4. This group had six prominent members: John Somers, Charles Montague, Thomas Wharton, Edward Russell (Earl of Orford), Earl of Romney, Duke of Shrewsbury and were supported by Robert Spencer (Earl of Sunderland) and William Bentinck (Earl of Portland).

5. Known as the 'Immortal Seven', these six peers and Henry Compton (the Bishop of London) signed a letter inviting William to take the throne.

6. Not to be confused with his estate in Surrey: the latter being named after the former.

7. For more details on this garden and a layout see Strong 1998, 141–6.

8. Here he mentions Chinese gardens although he had never seen them, relying instead on second-hand accounts.

9. William III's palace purchased in 1684 when he was Prince of Orange and where Bentinck had a major influence.

10. A curving arrangement of trees, often described as 'theatres' to display exotic plants such as oranges.

11. From £4800 per year to a more modest £1600 (Jacques and van der Horst 1988, 85). This high cost was reflected in the labour required to maintain these gardens, in one small garden in Kensington Palace for instance, 72 staff were employed in 1696.

12. First published in 1664, by the fourth edition in 1706, Evelyn had added a section called '*Dendrologia*, a cogent argument for the ornamental use of trees in the landscape' (Campbell-Culver 2006, 255).

13. Although nominally a Whig, some have speculated that Burlington was in fact a closet Jacobite – see Eyres (2010a, 78–9).

14. Published in 1709, this was incorporated into *Characteristicks of Men, Manners, Opinions, Times,* three volumes, first published in 1711 with a second illustrated edition in 1714.

15. These included a pyramid, domed temple, obelisk and Gothic cathedral. Many of these styles would find their way into the designs of William Kent, a close associate of Henry Trench, one of the illustrators, when they were both struggling artists in Rome.

16. For example, he is particularly scathing about topiary: 'Our British Gardeners … instead of humouring Nature, love to deviate from it as much as possible. Our Trees rise in Cones, Globes, and Pyramids … I do not know whether I am singular in my Opinion, but, for my own part, I would rather look upon a Tree in all its Luxuriancy and Diffusion of Bough and Branches, than when it thus cut and trimmed into a Mathematical Figure', *The Spectator*, No. 414, 25 June 1712, (Hunt and Willis 1988, 143). This is an interesting statement given that complex topiary was a key feature of the Dutch gardens of William and Mary. These sentiments were echoed by Alexander Pope, a Tory, in an essay from *The Guardian* in 1713.

19. Description of this in Phibbs (2010, 36–7).

18. The first 'Neo-Palladian' building was Wilbury House in Wiltshire started in 1709 by William Benson who had visited in Hanover in 1704–6, see Fry (2003).

19. The main parts of the building were constructed between 1701 and 1709, although final completion took another 100 years.

20. The Domed Building (now known as the Pantheon) in 1716 and the Bagnio the next year.

21. That is supporters of James II's son and grandson (James and Charles, the Old and Young Pretender respectively) as rightful heirs to the throne.

22. This had brought peace to Britain in 1713 and the Whigs had opposed it.

23. This is well documented in Charlesworth (1986) and Eyres (1991).

24. He is recorded (in a letter by Wentworth's mother) as supervising building work on the new mansion at Stainborough (now Wentworth Castle) in 1709.

25. With its busts of the scientists Newton, Locke and Robert Boyle and the radical theologians, Samuel Clarke and William Wollaston.

26. It was in reality a Gothic cottage that contained six wax models including Merlin, his

secretary, Queen Elizabeth I, Elizabeth of York (Henry's VII's wife), Minerva or possibly Britannia.

27. He became the Royal Secretary in 1737.
28. Dashwood was the 'Grand Master' of this group known in its time as the Knights of St Francis of Wycombe. Based at Medmenham, a former Cistercian abbey, this 'monastic' order supposedly carried out scandalous acts but it was really a statement of Dashwood's rejection of organised religion.
29. Watson-Wentworth became the First Marquess of Rockingham in 1746.
30. See Charlesworth (1991, 39) for a full discussion of the Hoober stand.
31. Both were more concerned with what was happening in their native Hanover.
32. Rockingham and his allies had formed a new government.
33. A decisive battle in the War of the Austrian Succession in 1743.
34. Included a 'Physic and Exotic Garden': the start of the Botanic Garden that ultimately Kew would be famous for, see Chapter 8.

Stowe, Buckinghamshire

The manor at Stowe had belonged to the abbey of Osney at Oxford and after dissolution, to the bishopric of Oxford. In 1571, Peter Temple (a yeoman sheep farmer) took the lease, attracted not only for its suitability for sheep but also 'by the fact the local town of Buckingham, one of the old rotten boroughs, had two MPs elected by only thirteen voters' (Bevington 2005a, 57). When his son, John, bought it in 1589, the park consisted of about 77 acres (*c.*31 ha) of farmland. In 1614, the Luffield estate to the north was added through his grandson, Peter's, marriage and the woods were laid out with ridings. Sir Peter took over the estate in 1630 and continued to enclose the common fields, thereby enlarging the estate further. However Sir Peter left his heir, Richard, with large debts on his death in 1653 but the latter's position as an MP (and an advantageous marriage) allowed him to clear these.

Sir Richard Temple laid the foundations of the current house and from 1668 started improvement works on the garden, following the popular formal styles of the period. He constructed a walled kitchen garden and in 1680 as the house nearer completion, he began the 'Parlour Garden': a small garden in the fashionable 'Anglo-Dutch' style outside the south front. Sir Richard also planted an avenue of poplars south of the formal gardens in 1682, which ran down to the fishponds (later the Octagon lake). To the west of the walled garden a 'wilderness' was laid out the following year, a wooded area with a semi-circular spread of paths. Sir Richard's son, (also Richard) inherited the estate in 1697 and his father's position as the local (Whig) MP. He had a parallel career in the army and by 1710 was a lieutenant-general. Although he was dismissed from the Army in 1713, the return of the Whigs to power the following year meant he could turn his attentions to politics. In 1718, he was rewarded for his loyalty by his elevation to the peerage as Lord Cobham. By 1719, 'he had the means and standing to make Stowe match his ambitions … he was a man 'who does not hate a difficulty', a theme echoed by Pope with regard to Cobham's gardening in his *Epistle to Burlington*':

> *Start ev'n from difficulty, strike from chance;*
> *Nature shall join you; time shall make it grow*
> *A work to wonder at – perhaps a STOWE* (Bevington 2005b, 60)

In 1711, he started work on the estate, first by reshaping his father's parlour garden. Opening out the three terraces created a vast formal parterre with basin and fountain. In 1714 he called in Bridgeman to initiate major work on the landscape including the building of the Octagon pond. Vanbrugh was employed to create the garden buildings including the Rotondo in 1720 and the Lake Pavilions in

View of the Great Bafon from the Entrance of the Great Walk to the Houfe. Veüe du Grand Baffin prise a l'Entree de la Grand Allee qui monte au Chateau

1719 (Figure 5.9). Cobham was closely involved in its design and he was confident enough to employ a known Tory (and possibly Jacobite), James Gibbs, to design garden buildings for him from 1726. Cobham's political allegiances were already being made explicit at this time. The first was the statue of King George I that he erected in 1723 on the western approach to the house, which remained in place until 1797. A statue of George II as Prince of Wales, put up at a similar time overlooking the main garden, though was ignominiously moved after 1733 to a less prominent position amongst some trees. Queen Caroline was similarly honoured: the inscription on her statue (erected just before 1727) reads '*Honori, Laudi, Virtuti Divae Carolineae* ('To the Honour, Praise and Virtue of the Divine Caroline'), as if to number her among the other deities of the garden' (Marsden 2005, 15) but her statue was also moved in the 1760s.

Gibb's Temple of Fame (an open domed building), erected in 1729, had eight busts inside including William III that were later transferred to the Temple of British Worthies. The most unusual iconography used at this period was the creation of the 'Saxon Deities' (seven Saxon gods who gave their names to the days of the week). The belief that the Saxons had brought liberal government to the English nation was outlined in the book by Richard Verstegen, *A Restitution of Decayed Intelligence in Antiquities* (1605) and the illustrations formed the basis of the statues by Rysbrack. It may also be a riposte to Tories such as Bathurst and Strafford who were trying to claim the Anglo-Saxon heritage for their own political purposes.

FIGURE 5.9. Octagon Pond and Lake Pavilions at Stowe, print by Rigaud 1733–9.

Lord Cobham 'retired' from politics in 1733 and he used his garden from then on as a political weapon. Up until then, it had been a fashionable (if rather conventional) Whig landscape that upheld the values of the ruling elite. It is the sheer number and variety of the landscape features that sets it apart from other 'political gardens'. His many and varied garden buildings and features 'reflect[ed] in their iconography Cobham's dislike of Walpole and his love of freedom from corruption and tyranny' (Bevington 2005b, 64). They were not especially subtle with the most overt ones being built in the ten years up to Walpole's final defeat in 1742. It was not only buildings, the design was important as well.

He wanted to use the more naturalistic style that the Prince of Wales had adopted. For the new area he was developing in the eastern part of the garden that came to be known as the 'Elysian Fields', he turned to the leading exponent of the new style, William Kent. Kent kept a lot of the natural features around the valley that was formed by the former millstream and added the main buildings. The Temple of Ancient Virtue (Figure 5.10), erected in 1737, was counterbalanced by the Temple of Modern Virtue built at the same time. The former had four figures of Greek heroes that had been victims of tyranny[1] and embodied the virtues that were sadly lacking with the leaders at the time. The latter, a mock ruined Classical building, had a headless statue, whether it was meant to be of Walpole has long been debated. The ideas these buildings represented were clear to those who visited.[2] An anonymous French visitor in 1748 commented:

> 'The temple represents the flourishing state of Ancient Virtue, still untarnished and inviolate despite the passage of centuries; these tumbledown structures with their ruinous statuary are intended to show the fragility and the transience of Modern Virtue, decrepit even from the moment of birth. From which one can draw the following Moral: Fame founded on true virtue exists for ever, whereas Reputations built solely on popular acclamation evaporate easily.' (Marsden 2005, 27)

The most obviously political was the Temple of British Worthies (1734–5). The Exedra (Figure 5.11) had 16 niches to which busts were progressively added, half of which had been in the Gibb's building. On the left hand side were the 'thinkers' and on the other side the 'men of action'. It is the latter side, which is interesting from a political point of view. New additions here included King Alfred as a riposte to the perceived lack of 'kingly' qualities of George II and the Black Prince who was an allusion to Prince Frederick (Roscoe 1997, 52). Sir Walter Raleigh and Sir Francis Drake were references to Cobham's dissatisfaction over Walpole's peace treaty with Spain in 1733. Sir Thomas Gresham, the sixteenth century financier, 'represented 'the honourable profession of a merchant' and the City interest, ranged solidly against Walpole' (Clarke 1973, 569). Sir John Barnard MP, who led the resistance to Walpole's Excise bill (Smith 1997, 32), was added by Earl Temple in 1763 (along with Alexander Pope on the opposite side).

The area known as Hawkwell Field (to the east of the Elysian Fields) was developed between 1739 and 1745, with the buildings being constructed by James Gibbs. The Temple of Friendship was started in 1739, following visit by Prince Frederick two years earlier and it originally contained ten busts of the leading

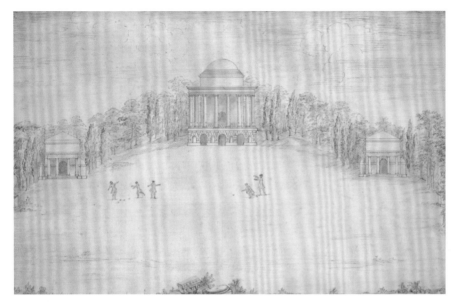

FIGURE 5.10. Temple of Ancient Virtue at Stowe by William Kent 1730–40.

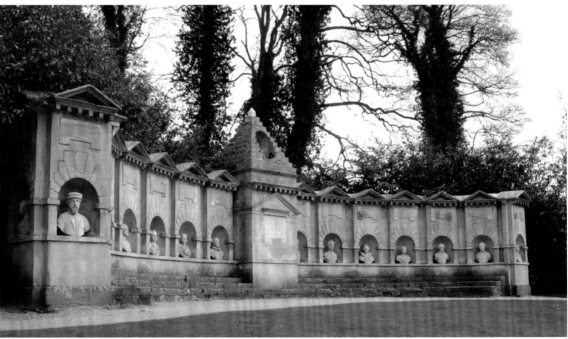

FIGURE 5.11. Temple of British Worthies at Stowe.

members of the 'Patriot' Opposition including Cobham and his 'Cubs'.[3] Following Walpole's demise in 1742, the 'Patriots' began to quarrel amongst themselves and Robinson (1990, 103) says that one or two busts had to be removed (although he does not say which ones). As always Horace Walpole summarises the situation aptly, as he likened the Temple of Friendship to 'A Temple of Janus [the two faced Roman god], sometimes open to war, and sometimes shut up in factious cabals' (Wheeler 2006, 82). Inside were also murals making political statements, described in Seeley's guidebook of 1747 thus:

'Upon the Ceiling is seated Britannia: Labels inscribed with the Reigns of Edward 3. and Q. Elizabeth are held on one Side of her; and on the other is offered the Reign of – [i.e. George II] which she covers with her Mantle, and seems unwilling to accept.' (Marsden 2005, 40)

The Queen's Temple was the place where Lady Cobham and her friends could gather (as the Temple of Friendship was a male domain). Designed around 1742 and completed six years later, its decoration of ladies employed in suitably ladylike pursuits (shell work and music) reflected Lady Cobham's lack of interference in political life of her husband, a possible dig at Queen Caroline. The last major building is this area is the Gothic Temple (Figure 5.12), designed in 1741 and completed in 1748. This followed the Opposition's adoption of the style to demonstrate their British credentials and it is dedicated 'To the Liberties of our Ancestors'. Cobham labours the point by putting the following inscription over the entrance: '*Je rends grace aux Dieux de n'estre pas Romain*' or 'I thank the Gods that I am not a Roman'.

Lord Cobham employed Lancelot 'Capability' Brown in 1741 and Brown developed the last major part of the garden, known as the 'Grecian Valley'. It was here that the Grecian Temple (started 1747, later to become the Temple of Concord and Victory) and the Lord Cobham's Pillar (1747–9) were erected. This area:

'may have been initially conceived as a tribute to Britain's successes in the war [of Austrian Succession] … the war gave Cobham an opportunity to press for his commercial and colonial empire, thus putting his political ideology of empire into practice'. (Coutu 1997, 70)

By 1748, the Treaty of Aix-la-Chapelle had put paid to Cobham's ideas and it seems to a triumphal arch. With Cobham's death in 1749, its new owner, Earl

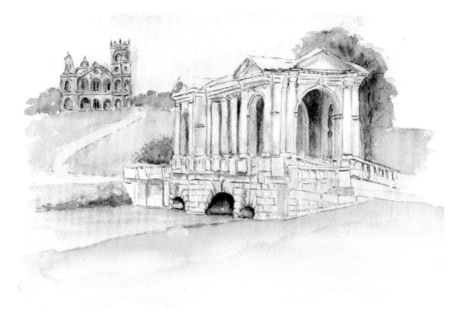

FIGURE 5.12. Gothic Temple and Palladian Bridge at Stowe.
PAINTING BY JILL BISHOP.

Temple, softened the landscape by removing the straight edges of the lakes and canals and changing the avenues of trees into clumps.

Whereas his uncle had eclectic tastes, mixing the Classical with the Anglo-Saxon and the Chinese, Temple began to 'classicise' the garden buildings, removing the Chinese House to his other estate at Wotton in 1750. He changed the Grecian Temple to the Temple of Concord and Victory in 1764. It had been re-dedicated to commemorate the successes in the Seven Years War (1756–63), which Temple believed he and his political allies (notably William Pitt) were responsible for. In June 1761, with peace negotiations under way, his intention was that the building would be called the 'Temple of Peace' in honour of George III (Eyres 2001, 67). He and Pitt had to resign in October 1761 and so the temple acquired its current name as it 'affirmed Pitt's authorship of the Concord that generated Victory, and commemorated the Grenville dynasty as an agent of Whig ideology and national prosperity' (Eyres 2001, 67). The temple became by implication a criticism of the new monarch and a return to Stowe's by now traditional role of promoting the Opposition's ideas.[4]

Notes

1. These were a general (Epaminondas), a legislator (Lycurgus), a poet (Homer) and a philosopher (Socrates), for full descriptions of the inscriptions see Marsden (2005, 26).
2. As soon as Cobham started work on the gardens, they were 'open to the public' and Stowe was the first garden to have a guidebook in 1744.
3. These were Prince Frederick, Lord Cobham, George Lyttelton, Lord Gower, Lord Marchmont, Lord Westmoreland, Lord Chesterfield, Richard Grenville, William Pitt, Lord Bathurst.
4. See Eyres (2001) for a detailed discussion of the meaning of the Temple of Concord and Victory.

The Picturesque Debate
as a Political Metaphor

> The neatness, simplicity, and elegance of English gardening, have acquired the approbation of the present century, as the happy medium betwixt the wildness of nature and the stiffness of art; in the same manner as the English constitution is the happy medium between the liberty of savages, and the despotic government; and so long as we enjoy the benefit of these middle degrees, between the extremes of each, let experiments of untried theoretical improvement be made in some other country. (Repton 1795, 70)

In this open letter to Uvedale Price, Humphry Repton was responding to one of the great advocates of the 'picturesque' style. He was also indirectly attacking another, Richard Payne Knight, whose radical views on landscaping were portrayed as being dangerously close to the ideas causing chaos and the 'Terror' across the channel in France. The two had both published their views that year, 1794, on the picturesque: Knight with his poem, *The Landscape*, and Price with his *Essay on the Picturesque*. The former, addressed to Price, discussed the alternative to the ubiquitous 'Brownian parks' and illustrated like Repton's 'before and after' pictures of the landscape. In the picturesque 'after' landscape (Figure 6.1) depicted, it is wildly overgrown with a Tudor 'Gothic' house, rather than the usual Palladian mansion that can be seen in the 'before' picture (Figure 6.2), surrounded by a smooth lawn, serpentine water and clumps of trees. As the aristocracy were losing their lands (and often their heads) in France, for many this was too close to the bone. Horace Walpole as always provides a pithy rebuke in a letter to the influential author of *The English Garden*, William Mason:

> 'this pretended and ill-warranted dictator to all taste [i.e. Knight], who Jacobinically would level the purity of gardens, would as Malignantly as Tom Paine or Priestley guillotine Mr Brown … I did ardently wish you had overturned and expelled out of the gardens this new Priapus, who is only fit to be erected in the Palais de l'Egalité.'[1]

Knight and Price's ideas in terms of landscape design though in many ways, were the logical conclusion of the 'natural revolution' that had been started by Alexander Pope, William Kent and others at the beginning of the century. For their successors in the art of landscape gardening such as Repton, these

FIGURE 6.1. Plate I from *The Landscape* by R. P. Knight, after Hearne.

FIGURE 6.2. Plate II from *The Landscape* by R. P. Knight, after Hearne.

naturalistic (although man-made) landscapes were in the currency of the time, the 'polite' or politically acceptable picturesque. Knight and to some extent, Price, were veering dangerously towards the 'impolite' or what could be described as, wild or rustic picturesque. There was an increasing concern amongst the more established landowners that those without 'taste' were, with the help of professionals, trying to join their ranks through improving their

estates. These newcomers had often gained their wealth through the by now flourishing trade in the colonies: an interesting by product of the Whigs' reign of power as trumpeted by Walpole (see opening quote in Chapter 5).

One such example was George Durant at Tong Hall in Shropshire. He had made his fortune in the West Indies and in 1764, he purchased the rundown estate from the Duke of Kingston Upon Hull. The following year, he employed Lancelot Brown to remodel the estate and possibly design the new Gothic house (Turner 1999, 148). On a visit to the estate in 1792, John Byng, the noted diarist, summed up the conservative (and his) view of estates of such 'nouveaux riches':

> 'how people can build these pompous edifices without a sufficiency of surrounding estate is wonderful! And yet it is commonly done. Vanity easily triumphs over reason. It impoverishes the first and now ruins the succeeding generations … with an encircling estate of ten thousand pounds per annum, this would be a grand place.'
> (Quest-Ritson 2001, 146)

For Byng, an estate was something built up over generations and on a scale to keep it exclusively for the upper echelons of society. Already by this period, social mobility through acquired wealth, was beginning to increase and reflected the types of gardens that were being created. Up to 1795, the aristocracy mainly employed Humphry Repton, after that it was self-made men such as merchants and manufacturers who were his main clients. As Repton himself ruefully remarked: 'I have had perhaps more than most men opportunities of observing the gradual changes by which barriers have been removed betwixt the two classes of our landed and monied interests' (Gore and Carter 2005, 118).

Lancelot 'Capability' Brown and his contemporary 'improvers'[2] are credited for the landscape revolution. Their critics accused them of creating identikits of a Palladian mansion surrounded by a sea of turf (protected from animals by a ha-ha or sunken fence), a nicely positioned lake, clumps of native trees breaking up the vista and 'enclosed' by a shelter belt of more trees. The landowners enthusiastically took up this 'model', as it was highly adaptable to the situation and more importantly to the size of the estate. Brown's nickname of 'Capability' came from the fact that he could use the capabilities of a site to its best advantage. Britain in the second half of the eighteenth century was changing rapidly with the industrial and agricultural revolutions well under way and the start of the consumer society. The population was increasing with urban areas expanding. However rural areas were experiencing a decrease in inhabitants, with the twin pressures of more opportunities in the towns and cities and the reduction in the land available for the small farmer.

The acceleration of enclosed land, much of which at the expense of previously 'common land', benefited the larger estate. In 1760, 400,000 acres (*c.*162,000 ha) were subject to enclosure, by 1800, this had grown to 21,000,000 acres (*c.*8,500,000 a). This additional land could be put to good use. The new landscape parks could be let out for grazing, which provided a better income than being used for crops.[3] The shelterbelts of native trees that hid the 'unsightly' farms and

local village buildings provided income for the estate. Those with coal benefited from the increasing demand from the new factories. Land ownership in Britain had always provided a route to political power and influence and it was also now becoming an increasing source of wealth. No wonder that Richard Payne Knight's ideas on the picturesque landscape were seen as such a threat both economically and politically by the large landowners, both Whig and Tory.

This debate on the landscape ultimately led back though to more formal gardens in the nineteenth century. Perhaps these landowners wanted to restore some control over their landscapes and the population as a whole, who were becoming increasingly politicised. Perhaps the idea of an increasingly informal landscape had reached a dead end. The creativity that had led to the early landscape gardens was lost when '*la belle nature anglaise* ... became ... [a] most admired and imitated form; but ... slipped into being a misunderstood, banal and bland cliché – the garden that eliminated the garden' (Hunt 1996b, 221). So the only way forward was backwards to ideas from the past. The formal versus informal landscape discussion returned in the 1870s with the publication of William Robinson's *The Wild Garden* but by this stage, gardening had spread to the middle classes and the debate had largely lost its political potency.

At the height of the picturesque controversy in the last years of the eighteenth century, Repton's appeal for a 'middle way' and for restraint in the wilder aspects of landscape design, would have had a strong political resonance for both those engaged in the debate and those following it. Repton professed to be apolitical. In 1804, he commented 'in the course of my profession, I have had the honour to become acquainted with almost all the Statesmen and all the Leaders of different Parties, without sacrificing the pursuits of taste for those of politics' (Repton 1804, vi–vii). Being the leading opponent though to Price and Knight and taking garden design back to more formal elements, he was reflecting the views of the majority who felt threatened by where the 'landscape revolution' was heading.

It took some time for Repton to move away from the Brown style and develop his own way of designing in the landscape. In 1803, he said 'I do not profess to follow either Le Nôtre or Brown, but, selecting beauties from the style of each ... each has its proper situation; and good taste will make fashion subservient to good sense' (Repton 1803, 125). While he never entirely abandoned the picturesque principles that he first started with, his work at the end of his career in the 1810s marked the transition to the increasing formality of the British garden and its shrinking size. At the heart of this was his view that 'the ornamental gardens should be treated as an extension of the house and that it should be possible to move conveniently and directly from one to another' (Goodchild n.d., 4). In contrast Brown's landscapes started immediately at the house and many more formal features such as kitchen and flower gardens were positioned well way, usually out of the main views. Brown was creating 'Arcadias' or idealised landscapes for his clients that shut off the outside or real

world, Repton developed a more practical approach. This pragmatism versus idealism in many ways summed up British political thinking where visions of a Utopia have always been tempered by the practicalities of life and human nature.

The beginnings of the picturesque

Whilst landowners such as Lord Cobham and the Wentworths were using their gardens as political statements in the first half of the eighteenth century, many were simply trying to recreate an Arcadia for themselves, their family and visitors to enjoy. They had been on the Grand Tour and brought home Old Masters' landscape paintings such as those by Claude, Poussin and Salvator Rosa from the Continent. These young men were influenced by their purchases and when they returned home to England 'they started to turn their gardens into three-dimensional Claudes and Poussins … Henry Hoare predicted that his creation at Stourhead would be 'a charm[in]g Gasp[ar] picture'' (Quest-Ritson 2001, 120). Hoare had returned from Grand Tour to inherit the estate in 1741. The landscape at Stourhead was created between 1745 and 1765 with purely Classical buildings initially and drew its inspiration from Virgil's poem *Aeneid*. It is built as a circuit walk around the lake and remains today an inspirational landscape.

The link between painting and landscape is important as the picturesque style is often described as creating a picture in a landscape. Hunt defines it thus:

> 'in all it [the picturesque garden] would be emotionally and aesthetically pleasing, the latter effect resulting at least in part from the design being reminiscent of landscape paintings and engravings or from suggesting itself as subject matter for them. But not every picturesque landscape needed this appeal to painting for its essential structure and impact.' (2002, 8)

If an estate owner were particularly fortunate, he would have the basis for a naturally beautiful landscape that only needed minor modifications. Examples of such sites are: Plumpton Rocks and Hackfall, both in Yorkshire; Hawkstone in Shropshire; Hafod and Piercefield in Wales. Richard Payne Knight's estate at Downton in Herefordshire had the attractive Teme Gorge that he was able to landscape in a suitably picturesque way (Figure 6.3).

Daniel Lascelles bought the estate of Plumpton Rocks, near Harrogate, in 1754. The pleasure ground was made using the natural millstone grit outcrops in the area and damming a stream and fishponds to create a lake (Figure 6.4). When Lascelles decided to buy the neighbouring estate of Goldsborough in 1759, the garden became solely a place to visit (Lynch 2010, 127). The mansion was removed in the 1780s to complete the naturalistic scheme. Almost from its original inception, this landscape was on the (genteel) tourist trade. In the 1770s, following William Gilpin's book on the picturesque, many visitors recognised that this was a landscape that had been created but nevertheless contrived to look natural. One visitor, Dorothy Richardson notes in 1771:

FIGURE 6.3. River Gorge at Downton, painting by Hearne 1785.

FIGURE 6.4. Plumpton Rocks, Yorkshire.

'the Gardens are uncommonly Romantic; &tho they are not large, appear so, from being laid out with great Judgement ... No Idea can be given of these Gardens by an description ... they are particularly pleasing, but in a different style from any I ever saw, tho I know none that exceed them, or where so great Taste has been shewn.' (Lynch 2010, 132)

From early on, picturesque landscapes are those that had been developed with 'taste'.

Hawkstone (Figure 6.5) was also firmly on the 'polite' tourist's trial. Like Plumpton, it used the naturally occurring sandstone outcrop to create a picturesque landscape. Sir Rowland Hill started work on the grounds in the 1740s and in 1748, it was visited by William Aislabie (Hackfall's owner). He comments that 'this place [Hawkstone] has great rude beauties and the owner is continually improving it. The rocks are more frequent and wild than that at Studley and the prospect more extensive and various' (Jacques 1983, 62). The first description was published in 1766 and by 1790, Sir Rowland's son, Richard, had opened the site as the first 'theme park' with an extensive range of 'attractions' such as grottoes, caves, a ruined keep and a hermitage, complete with resident hermit. Hafod, owned by Knight's cousin, Thomas Johnes, just used the natural beauty of the site, eschewing 'artificial ornaments'. Indeed he had deliberately chosen to live there despite inheriting the estate of Croft Castle in Herefordshire, so that he could create his own landscape. In 1783, he says 'this place is my own, and I trust when finished will realise my idea of resembling a fairy scene' (Cumberland 1996, 4). Eleven years later, he was proud of his achievements: 'you [George Cumberland], who have seen this place in

FIGURE 6.5. Hawkstone in Shropshire, photograph by Frith 1850.

PHOTO © VICTORIA AND ALBERT MUSEUM, LONDON

its original wildness, that by *beautifying it* I have *neither shorn* or *tormented* it' (Cumberland 1996, 4). His remarks were at the heart of the picturesque debate that centred on getting the balance right between the wild (or sublime) and the smooth (beautiful).

Edmund Burke's book *Philosophical Inquiry into the Origin of our Ideas of the Sublime and the Beautiful*, first published in 1757, formed the basis of the debate about these new 'natural' landscapes. He was returning to a concept of the sublime that the Third Earl of Shaftesbury had first referred to in his essay *The Moralists*. When describing a:

> 'tremendous Alpine scene, with precipices, cataracts, and storms … Shaftesbury makes sublimity … the "moral emblem" of ruin and decay, a *memento mori* on a gigantic scale … When the newness [of the scene] had worn off, the wayfarer … would be struck by the "forces of nature" and the eminently picturesque character of the scenery.' (Hussey 1967, 55–6)

These wild or sublime landscapes, while inducing a measure of horror and terror, nevertheless were wonders to behold and were the culmination of the Renaissance ideas of going beyond the security of the walled garden to the wider (and wilder) landscape.

Burke contrasted the Sublime with the Beautiful, which was clear, smooth and delicate. He makes the analogy possibly of the contrast between a Brown style park with the wild landscape:

> 'most people must have observed the sort of sense they have had, on being swiftly drawn in an easy coach, on a smooth turf, with gradual ascents and declivities. This will give a better idea of the beautiful … On the contrary; when one is hurried over a rough, rocky, broken road, the pain felt by these sudden inequalities shews why familiar sights, feelings and sounds are so contrary to beauty.' (Burke 1757, 159)

In 1765 Burke became an MP and was a close associate of the Marquess of Rockingham. His ideas of nature reflected his politics. He supported the Americans' bid for independence and initially welcomed the French Revolution but in his *Reflections on the Revolution in France* (1790), he condemned what was happening there. Clearly for him the sublime aspects of the revolution had taken over from the beautiful ones.

The 'landscape revolution'

For many landscape owners, their estate did not have naturally attractive features. To say that the large-scale landscaping of British estates after 1750 was purely driven by aesthetic values is wrong: economics parted a large part. The long period of dominance by the Whig oligarchy had led to the landed aristocracy becoming more powerful and wealthy. They wanted to develop their estates at a time when farming on a large scale had become increasingly profitable. Many were old medieval deer parks and so were easy to 'convert' to landscape parks. Conveniently the 'landscape formula' could be applied to most

estates, large or small and although it was expensive initially, once completed, it was a lot cheaper to maintain than earlier formal styles.

Mostly native trees were planted and used as a cash crop. The grass areas were 'maintained' by sheep or other grazing animals, with other areas put aside for hay that became more valuable as the number of domestic animals, especially horses, rose. There was potentially a political element to the design, particularly with regard to the planting. Phibbs argues that the use of native plants by Brown and others started at Stowe and reflected the desire for all things English in the garden, including the use of Gothic architecture. Certainly:

> 'the major contemporary witnesses of Brownian landscape were hostile to exotics. William Mason mocked the landowner (perhaps Sir Laurence Dundas at Aske, North Yorkshire) who planted them in Swaledale … Even Uvedale Price found common ground with these Brownians, describing "foreign trees … in the out-skirts of a wood" as "much like a group of young Englishmen at an Italian conversazione".'
> (Phibbs 2003, 123)

Knight in the notes to his poem *The Landscape*, rebuked Repton not only for his waning interest in the picturesque principles of gardening but also mocked him for:

> 'giving grandeur of character to a place, by hanging the family arms of the proprietor on the sign-post of a neighbouring inn, or emblazoning them on the neighbouring milestones … Neither Mr Brown, *nor any of the tasteless herd of his followers*, ever thought of this happy expedient.'[4]

The implication was that Repton was giving his clients a step up the social scale. Knight however was in a position to make the design changes to his estate himself, as Walpole had advocated: 'that the possessor, if he has any taste, must be the best designer of his own improvements' (Walpole 1995, 58). However ideas had changed and with William Kent paving the way, it became perfectly acceptable to have a professional to do the improvements on one's estate.

It was though a highly specialised profession and only a few individuals landscaped the majority of estates in the second half of the eighteenth century, with Lancelot Brown being the most prolific. Brown's first major position was head gardener at Stowe from 1740 and here he honed his skills of simplifying formal gardens, drew inspiration from the work of William Kent and then started to advise on other gardens. In 1751, he left Stowe with an excellent set of contacts and set up his own practice at Hammersmith. He is thought to have worked on over two hundred commissions[5] principally for the great landowners of the age, until his death in 1783. It was these landowners who set the trend for developing their estates that made the informal style pre-eminent. Brown himself was a highly successful businessman: he charged ten guineas a day. Although each commission was looked at individually to assess the 'capabilities' of the site, there were the common elements: water (usually in the form of an informal lake), trees in clumps and belts for screening purposes and turf which ran right up the house with ha-has to prevent livestock getting too close.

Brown died a wealthy man and his success encouraged others to join the ranks of the 'professional improver'. Some, like Brown, had been estate gardeners. William Emes had been the head gardener at Kedlestone, Derbyshire from 1756. In 1763, he gained his first independent commission for Arley Hall in Cheshire and he worked at over ninety sites until his death in 1803. His style was very similar to Brown's but on smaller landscapes. Richard Woods was a nurseryman from Chertsey, whose first known design work was in 1759. He too worked on much smaller projects and with greater variety than Brown. His style was a mix of old and new ideas, perhaps reflecting his more conservative clientele and he had over forty commissions. Thomas White, originally one of Brown's foremen[6] in the early 1760s had his first commissions in Yorkshire from 1765 and worked mainly in the north of England and Scotland, possibly to avoid competing directly with Brown who concentrated on the area south of Yorkshire. He worked on over forty sites until 1811.

When Repton decided to join their ranks in June 1788, although of slightly higher social status than his contemporaries, including Brown, it was deemed perfectly acceptable. He had been originally a gentleman farmer and through contacts such as James Edward Smith of the Linnean Society and Joseph Banks, he became interested in botany. It was as an amateur artist that he saw his point of difference, commenting:

> 'in every place I was consulted I found that I was gifted with a peculiar faculty for seeing almost immediately the way in which it might be improved. I only wanted the means of making my ideas equally visible or intelligible to others. This led to my delivering reports accompanied by maps and such sketches that at once showed the present and proposed portraits [the 'before' and 'after' pictures] of the various scenes capable of improvement.' (Gore and Carter 2005, 25–26)

In his 30-year career, he worked at over 350 sites, either just preparing a 'Red Book'[7] or carrying out the improvements as well. When he started out, he aimed to follow Brown but with more 'picturesque' ideas, using his skills as an artist. However he needed clients and he found these through his political contacts, most notably William Windham III, Thomas Coke and the Duke of Portland. In 1778, he had settled in Sustead, Norfolk, next to Felbrigg, the seat of the Windhams. He was enlisted into Windham's campaigns for a parliamentary seat in the elections of 1780 and 1784, when the latter finally became an MP. When Repton embarked on his new career as a landscape gardener, he used his Norfolk political contacts to establish his network of clients (Daniels 1999, 77). The first was Jeremiah Ives at Catton, mayor of Norwich and friend of Windham. Repton's help with Thomas Coke's campaign in the election of 1788, also paid off with the commission at Holkham the following year.

While Catton was relatively small at 112 acres (*c*.53 ha), Holkham was the largest estate in Norfolk at 2000 acres (*c*.807 ha) and most of the famous landscapers had worked there including Kent and Brown. Repton worked on the relatively small area of the pleasure grounds, which he says that he

incorporated the 'picturesque' principles of Knight, whom he had consulted while producing a *Red Book* for Ferney Hall in Shropshire at the same time. It was at this time that he met Uvedale Price with whom he took excursions around Herefordshire, with the latter praising his skill in drawing. By far his most important patron was the Duke of Portland.[8] Although a Whig, Portland had joined William Pitt's Tory government due to his unease over his leader Charles James Fox's support for the French Revolution. This put him at odds with Knight who was a fellow radical and Fox supporter.

So what exactly did these professional improvers offer their clients? Jacques sums it up thus:

> 'the Whig political principles of liberty and free trade … were buoyed up by a vision of Man in his perfect state – that is when living as a simple shepherd in some Arcadian free state. Nature herself was, by analogy, also perfected when complying with this vision. Lancelot Brown was the practitioner *par excellence* of turning this conception into reality.' (1983, 73)

While this may be true, in many ways, the improvers gave the estate owners conformity, which was at odds with the landscape gardens of the earlier period that celebrated their individuality. They also concentrated on the 'green' aspects rather than hard landscaping. Buildings could be full of political resonance and one aspect of this lack of garden buildings could also reflect the shift from the 'polite' picturesque of say Hackfall to the wilder picturesque as advocated by Knight.

The new ideas of the landscape garden were spread by writers such as Thomas Whately whose *Observations on Modern Gardening* (1770) describes the fashionable gardens of the day including Blenheim, Painshill and Stowe. In his view (1770, 1), 'Gardening, in the perfection to which it has been lately bought in England, is entitled to a place of considerable rank among the liberal arts'. William Mason wrote the first poem dedicated to the new style of gardening: *The English Garden* in 1772 and of course Horace Walpole discussed the Whig view of the history of gardening in his work of 1780. However it was William Gilpin, who with his 'picturesque tours' gave polite society the indication of what should be visited and what was attractive scenery. His observations and more importantly his sketches were published from 1782. He encouraged his readers to notice and appreciate the wider natural landscape as inspiration for designed landscapes.

His first work, published anonymously in 1748, was *A Dialogue upon the Gardens of the Right Honourable the Lord Viscount Cobham, at Stow in Buckinghamshire*. It was intended for those who had already visited Stowe as a reminder of its qualities. At this stage though Gilpin was aware of the limitations of its site, saying 'had Lord Cobham had such materials to work with as he himself had recently enjoyed viewing in the north, he pointed out, 'it could not but be that he would make a most noble picture" (Percy 2001, 3). After the success of his 'tour' books, Gilpin published two more concerning aspects of the picturesque.[9] While it was left to others such as Uvedale Price to apply

the principles of the picturesque directly to landscapes, he certainly influenced how landscape gardening was viewed. Batey believes that he: 'had given his readers the concept of regional characteristics ('how variously Nature works up landscape') which caused a reaction to systematized landscape gardening where a formula could be applied in any county without regard to the character of the area' (Percy 2001, ix), that was one of the accusations later to be levelled at Brown and his fellow improvers.

Alternative ideas and the rebellion against Brown

The lack of arable farming in the parkland at these estates, which was more labour intensive and would have interfered with the 'Arcadian' vision, was not seen as wasteful at the time of the creation of the great landscape parks. Indeed these large estates were seen as the driver for economic growth and by implication, vindication of the English political way of life. Not all felt comfortable with this model, particularly those with smaller estates. The idea of the *ferme ornée* had started in the early part of the century with Tories such as Bolingbroke, trying to find an alternative to the grand Whig landscapes. Philip Southcote was a Catholic and a nephew to one of the leading Jacobites in France. An advantageous marriage allowed him to purchase the estate of Woburn (sometimes spelt as Wooburn) near Chertsey, Surrey in 1735. Its relatively small size (116 acres/*c*.47 ha) limited his options with landscaping and so he opted for the ornamental farm approach.

Prints of 1759 (Figure 5.6) famously show cattle and sheep wandering in the landscape in a seemingly bucolic tableau, while visitors admire the scene. In reality, this was more a garden than a farm and it certainly was not a long-term economic proposition. Chambers (1999) believes though that there was a subtext to this garden as Southcote borrowed the wider landscape that could be viewed from the ridge on the perimeter walk. The view to the west via St Anne's Hill was towards Windsor Castle. Two places would have had significance for him as a Catholic and supporter of the Stuart cause: the ruins of St Ann's Abbey that stood on the hill and Windsor, which was the burial place of Charles I. To the east was Twickenham and Chiswick, site of Pope's and Burlington's influential gardens (the latter had advised him on the layout). While this may have been politically motivated, his idea of looking outside the confines of the estate to the wider world was at odds with the later landscape gardens, which consciously excluded the 'outside' world by dense planting on the perimeters. Just as the Renaissance gardens of the Medici broke through to the wider landscape, then this 'revolutionary' concept would appeal to the picturesque ideas of Knight and Price.

Whilst many like Walpole praised Brown, during his lifetime there were dissenters. George Mason, while acknowledging the superiority of the new style of English landscaping, attacks those owners who needed to employ a professional:

'the difficulty attending this mechanical part of gardening had induced many proprietors to commit the whole of it to artists by profession, whose contracted geniuses (without the least *capability* of enlargement) have stampt an unmeaning sameness upon half the principal seats in the Kingdom.' (Mason 1768, 37–8)

In 1770, Oliver Goldsmith in the poem, *The Deserted Village*, condemns the Brown style park 'improvements'. The irony is that the inspiration for the poem was the removal of the village of Newnham Courtenay in 1761 to improve the vista of the Earl Harcourt's estate. Lord Harcourt had moved to the property in Oxfordshire in 1755, as it offered better landscaping opportunities than his ancestral home of Stanton-Harcourt. Gilpin approved of this decision on a visit in 1772 and another visitor, Professor Hirschfeld believed that 'no other country house in England that has such beautiful and well chosen prospects as Nuneham' (Batey and Lambert 1990, 231).

This thinly veiled criticism by Goldsmith, may have led to the Second Earl's decision on inheriting the estate in 1777, to call in William Mason and Brown to redesign the landscape. Mason broke up the unlimited vista that had necessitated the removal of the village with foreground planting and Brown landscaped the park. The overall effect was to create a picturesque 'circuit' as Gilpin had described in his books. Mason had earlier created the famous informal flower garden at Nuneham, which was inspired by Jean-Jacques Rousseau's description of a garden in his book *La Nouvelle Heloïse* (1761). Both George Harcourt and Mason were radical Whigs, with the former known for his republican leanings (Jacques 1983, 94). By using Rousseau's ideas of the beauty of unaltered nature and a free society, Harcourt was making a statement through the garden: an idea that would subsequently be taken up by Knight.

Chambers in his *Dissertation on Oriental Gardening*, while promoting Chinese gardens, also attacks the professional improvers' efforts:

'Our gardens differ very little from common fields, so closely is nature copied in most of them; there is generally so little variety in the objects, such a poverty of imagination in the contrivance, and of the art in arrangement, that these compositions rather appear the offspring of chance than design.' (1772, v)

The book is dedicated to the King, not a surprise as he was the 'Comptroller General of His Majesty's Works' and responsible for many of the buildings at Kew Gardens. However this allowed opponents of the king to attack his ideas, which they considered to be unpatriotic. William Mason's riposte to Chambers comes the following year in *An Heroic Epistle to Sir William Chambers*. In the Preface, he reminds his readers that:

'it is the author's [i.e. Chambers] professed aim in extolling the taste of the Chinese, to condemn that mean and paltry manner that Kent introduced, which Southcote, Hamilton and Brown followed, and which, to our national disgrace, is called the English style of gardening.' (1773, 3)

With this, the attacks on Brown subsided although his ideas of large-scale improvement became unfashionable and, more importantly, uneconomic. Few

estates had any major landscaping between 1770 and 1800 with landowners more concerned with profitable schemes such as planting oaks, which they saw as their patriotic duty. Due to the high demand for timber, particularly for ships, England had one of the lowest levels of woodland in northern Europe. So by developing plantations, they were not only helping the British economy through international trade but also aiding the growing Navy needed for the expanding Empire.

The picturesque debate

William Mason continued to add to his original work *The English Garden*, with three more 'Books'. From his first Book, Mason says:

> *If yet thy art be dubious how to treat*
> *Nature's neglected features, turn thy eye*
> *To those, the masters of correct design,*
>
> *Who, from her vast variety, have cull'd*
> *The loveliest, boldest parts, and new arrang'd;*
> *Yet, herself approv'd, herself inspired.* (1783, 12)

Burgh comments on this section: 'thus we see the picturesque principle exemplified and applied to the living scenery of Nature' (Mason 1783, 38). In other words, a garden should be a series of scenes that would look as good as a painting. This was not a new idea. William Kent had designed gardens in this way fifty years earlier. It was the classical Italian paintings to which they turned for inspiration. Whereas 'Brownian' landscapes had almost no buildings, those advocating the picturesque style could include 'appropriate' architectural features. When Repton set out to become a landscape gardener, it is:

> 'Burgh's edition of *The English Garden*, Gilpin's tours …, Whately's *Observations on Modern Gardening* and Malthus' translation [of Giraudin's], *An Essay on Landscape* [that he turned to] … the last advised that "no scene in nature should be attempted till it has first been painted" … [so] the improver should "form a just idea of effects before they are carried into execution".' (Jacques 1983, 134–5)

Together with Repton's political connections, the first years of his practice were very fruitful and he grew in confidence. He soon realised that his early

> 'enthusiasm for the picturesque, had originally led me to fancy greater affinity betwixt Painting and Gardening, than I found to exist after more practical experience; because, in whatever relates to man, propriety and convenience are not less good objects of taste, than picturesque effect.' (1795, 70)

In 1794, he was preparing to publish *Sketches and Hints on Landscape Gardening*, a treatise on his ideas and working methods. This was supposed to cement his career as the leading landscape gardener and further build his flourishing practice Indeed he sought permission to dedicate the volume to the king (Gore and Carter 2005, 142). However Knight and Price, his erstwhile fellow followers of the picturesque, made a deliberate attempt to derail Repton's career by

putting forward their views in print first. In trying to defend himself against their accusations, Repton's book did not appear until the following year by which stage the damage had been done.

Knight and Price were not united in their views of what constituted a picturesque landscape. Both men were influenced by their respective estates, with Knight having the advantage of a naturally attractive setting at Downton (Figure 6.3) in the hilly area of the north of Herefordshire. Price's estate, Foxley, was further south and lacked the dramatic setting of rocks and cascading water of the former. His great-grandfather, Robert, had acquired the estate through marriage and the succeeding generations had continually 'improved' the landscape. Uvedale inherited the family estate on coming of age in 1768 and he too enthusiastically swept away the remains of the formal garden following the Brown style. His regret later is clear:

> 'having done myself, what I so condemn in others, [I] destroyed an old-fashioned garden.' (1810b, 118)

Price in his *Essay on the Picturesque* had a clear aim to put the picturesque as a concept alongside Burke's ideas of the beautiful and the sublime. In his view, the best exponent of this style was the improved landscape but not that of Brown *et al.*, whom he described (1810b, 144) as 'the despotism of modern improvers'.

For Price, these improvers had not followed the principle of creating a picture with the natural landscape. Instead they had imposed a predetermined set of features that was the same throughout the country (1810a, 332–3): 'No two painters saw nature with the same eyes … but any one of Mr. Brown's followers might say, with great truth, "we have but one idea among us"'. Reflecting the then current fear of invasion from France, he likens these improvements to a (1810a, 33) 'military style … our improvers are fearful of an enemy being in ambuscade among the bushes'. Price was reflecting the older view of landscape improvements where individuality was key and the liberal nature of the English constitution allowed such freedom of expression. He notes (1810a, 331–2) 'my love for this country, is, I trust as ardent as theirs [Walpole and Mason], but it has taken a different turn; and I feel anxious to free it from the disgrace of propagating a system [i.e. Brown's], which, should it become universal, would disfigure the face of all Europe. It is my wish that a more liberal and extended idea of improvement should prevail'. He thus argued for a variety of styles, including the derided formality of previous times.

Knight was aware of Price's intentions to publish his work and had proposed that the two works should form a single volume. However Price's *Essay* was not ready, so instead Knight decided to dedicate his poem on the subject to Price and publish his work first. Whilst reaching a lot of the same conclusions on garden design, Price was clearly giving advice on how the landscape should look in order to be picturesque. Knight in contrast referred 'his readers to Price's essay, if they wanted that sort of advice, but dwelt at some length on developing associations of ideas … [when] someone [was] walking round a

landscape' (Ballantyne 1997, 190). Knight took a more philosophical view that saw beauty in the landscape as a wider range of possibilities including the wild and unkempt, an anathema to the professional improver, as he says:

'Or, like our prim improvers, cut away
Each hoary branch that verges to decay' (1794, 52)[10]

He also attacks the current style of improvement on the basis of taste, much as Price had done:

'And shews poor Nature, shaven and defac'd,
To gratify the jaundic'd eye of taste' (1794, 2)

However the most contentious part appears at the end when Knight suggests that not only should wildness be celebrated, it should also be created with the destruction of the Brown style 'improvements':

'But break the mound, and let the waters flow;
Headlong and fierce their turbid currents go;
Sweep down the fences, and tear up the soil;
And roar along, 'midst havock waste and spoil' (1794, 71)

This could be interpreted as celebrating the scenery of his estate at Downton but his support for the French Revolution in the next lines gave ammunition to his critics:

'So when rebellion breaks the despot's chain,
First wasteful ruin marks the rabble's reign;
Till tir'd their fury, and their vengeance spent,
One common int'rest bids their hearts relent;
Then temp'rate order from confusion springs,
And, fann'd by freedom, genius spreads its wings.
… Yet from these horrors, future times may see,
Just order spring, and genuine liberty' (Knight 1794, 72–3)

In the footnote, he says that by way of explanation, these lines above were written in September 1793 when Queen Marie Antoinette was awaiting execution in France. Was he playing down his enthusiasm for the Revolution, as the full horror of the Terror was becoming known? Perhaps he was anticipating the backlash that subsequently came. While he attacks Brown as others had done before him, he also criticised Repton, which was more contentious. The reason may have been that Repton enjoyed the patronage of Lord Portland, who was now Secretary of State and responsible for highly repressive measures against civil liberties. This would have put Knight at odds with Repton (Daniels 1999, 111).

These political implications took the debate away from somewhat esoteric definitions of an ideal improved landscape in Price's work, to a wider discussion on the management of estates and by implication to the way Britain was being run. Knight's work was clearly political as Ballantyre (1997, 191) points out: 'If … we read it [*The Landscape*] as a poem about politics and religion, which uses landscape as a source of metaphor, then it makes much more coherent

sense'. Knight was encouraging his readers to *think* about the landscape rather than adopt some predetermined model as set out by a professional improver or replicating a picture. This tied in with the revolutionary ideas about the individual and their rights that had started in America and had influenced the French Revolution. No wonder his critics such as Walpole, compared his thoughts with those of Tom Paine whose books, *Rights of Man* (1791) and *The Age of Reason* (1794), had encouraged such free thinking.

Almost as soon as *The Landscape* was published, Repton sent a letter to the *Times* saying he had been misquoted about his improvements for Tatton Park. An article in *The Monthly Review* by William Marshall was published in Repton's defence. Repton himself felt he had to respond and this time it was to Uvedale Price with his open letter of the 1 July. More supporters entered the fray, in particular John Matthews with his anonymous parody *A Sketch from The Landscape: a Didactic Poem addressed to R. P. Knight Esq.* Matthews had consulted Repton about his estate, Belmont House in Herefordshire and so this was 'the unusual instance of an eighteenth-century client defending the merits of his professional advisors' (Fryer 1994, 173). Matthews also compares Knight's ideas to radicals such as Thomas Paine, though by changing the spelling to 'Payne' makes him appear as a relation of Knight's:

> PAYNE *blusters for the Rights of Man;*
> *Of Woman, on the same bold plan,*
> *The fair Miss WOLLSTONCROFT does prattle:*
> *I trust your patience to be heard*
> *Whilst softly I put in a word*
> *In favour of the Rights of Cattle* (Ballantyne 1997, 226)

In the final line, when Matthews accuses Knight of neglecting cattle, he is implying that Knight's wild ideas would also impact on farming, which was a major part of the economy.

Finally in 1795, Repton published his own work, *Sketches and Hints on Landscape Gardening*, where he responds to the criticisms of Knight and Price. He says that:

> 'the publication of ... [Knight's] didactic poem ... obliges me to defend not only my own principles, and the reputation of my late predecessor, Mr. Brown, but also the art [of landscape gardening] itself, from attacks, which are the more dangerous, from the manner in which they are conveyed.' (1795, 48)

He accuses Price (1795, 70) of having 'frequently adopted my ideas; and has, in some instances, robbed me of originality'. With Knight, his main concern is to set the record straight with regard to the proposals of the avenue in the *Red Book* for Tatton Park. He makes the wider point with regard to landscape design:

> 'there ought to be some difference betwixt a park and a forest; and as the whole of that false or mistaken theory, which Mr. Knight endeavours to introduce, by confounding the two ideas, proceeds from not duly considering the degree of affinity betwixt painting and gardening.' (1795, 54)

Repton though was complimentary about Knight's work at his estate of Downton, which he describes as:

> 'one of the most beautiful and romantic valleys that the imagination can conceive. It is impossible by description to convey an idea of its natural charms, or to do justice to that taste which has displayed these charms to the greatest advantage.' (1795, 64)

If Repton had thought that he had won the arguments, he was wrong.

Knight published a second edition of *The Landscape* in 1795 and while he continued to mock Repton for his ideas, his anger was mainly directed at the wider criticism of his own work. His final sentence was:

> 'All I entreat is, that they will not at this time, when men's minds are so full of plots and conspiracies, endeavour to find analogies between picturesque composition and political confusion; or suppose that the preservation of trees and terraces has any connection with the destruction of states and kingdoms.' (1795, 104)

He had allowed his critics to describe him as unpatriotic, which was unwise at a time of heightened political tension. From the spring of 1794, Pitt's government had been bringing an increasing number of prosecutions against those deemed to be writing seditious literature and with the suspension of Habeas Corpus in May of that year many were detained indefinitely without redress.

Price published his response in *A Letter to H. Repton Esq. on the Application of the Practice as well as the Principles of Landscape-Painting to Landscape-Gardening* in 1795. While Repton's letter to him had been to the point, this was a very long restatement of his arguments! In particular, Price considered the relation between landscaping and political ideology was deeper than Repton's analogy. He was more concerned about the events going on at the time and as a landowner more aware of the consequences of a French style revolution. Price was perhaps concerned that the aristocracy fencing themselves off in their landscape parks was a dangerous idea, as they would not be aware of the outside threats that had affected their peers across the Channel.

The impact of these arguments in print was clear with regard to Repton's business. Taking the known *Red Books*, which give us an accurate date, the picture is quite stark. From 1788 to 1795, there are 70 *Red Books*: in the next eight years to 1803 there are 27 and then only 19 to the end of his career.[11] He was accused by his erstwhile supporter, William Marshall, in January 1796 of 'provoking and prolonging it [the debate]. If Repton had not assumed 'the titles *Landscape Gardening* and *Landscape Gardener*, the dispute would never have arisen' (Daniels 1999, 130). It probably did not help during this period that there was an increased demand for both timber and more importantly home produced grain. Clearly the need for increased arable farming impacted on the landscaping of the large estates that had been Repton's clients. Any gains made from increased farming rents was mitigated by the introduction of income tax in 1799 putting a further strain on an estate's resources: this temporary measure was in place until 1815. Repton ruefully observed 'we now begin a new Century,

the first years of which excited such alarm through all ranks of people that I felt as if my profession was become extinct' (Gore and Carter 2005, 118).

The outcome of the debate

By 1797, the debate on the accepted style of landscaping and whether this should follow picturesque principles was largely limited to the three main protagonists, Repton, Price and Knight, who continued arguing in print for over ten more years. Repton had his livelihood to defend, although large-scale landscaping projects were few and far between. A partnership with the architect, John Nash from 1795, allowed them to exploit the fashion for a new villa and garden, particularly amongst the nouveaux riches. This partnership ended acrimoniously in 1800 and Repton needed to focus again on the gardens. While still working on some wider landscape projects, he began concentrating on the 'pleasure gardens' that surrounded the house. He also started to look at different styles, most notably those from the (more formal) past.

At Bulstrode, the estate of his patron, the Duke of Portland, Repton describes his work thus:

> 'the pleasure ground is perfect as a whole, while its several parts may furnish models of the following different characters of taste in gardening: the *ancient garden*, the *American garden*, the *modern terrace walks* and the *flower garden* … Flower gardens on a small scale may, with propriety, be formal and artificial.' (1803, 100)

During this difficult period for Repton, he was working on *Observations on the Theory and Practice of Landscape Gardening*, which was published in 1803 and reprinted two years later due to its success. Nearly ten years on from his first book, the world had changed and Repton became more conservative due to political events at home and abroad. This change in his political ideology affected his landscape designs (Daniels 1982, 112). The radicalism therefore that had dominated landscape design for a century, seemed to be at an end.

In the year of the publication of *Observations*, there was a very real threat of invasion from France and by late 1804, with nearly one in five eligible men part of the defence force, there was a renewed British spirit of nationalism. The time that was invoked was the Tudor period when the country faced a similar invasion threat from the Armada. Repton reflected this in the section on the history of gardening, where unlike Walpole who had dismissed all other styles, Repton observed (1803, 121) 'it is not my intention to enter into a minute history of gardening … I shall confine myself to a few observations on the change in the *fashion* of gardens, to shew how much of each different style, may be preserved or rejected with advantage'. In other words, he was willing to consider styles other than the now orthodox Brownian landscape. Clearly Repton felt more confident in his opinions and was trying to shift the debate away to the practicalities of creating an attractive designed landscape, rather than the prescriptive model advocated by Price and Knight.

Perhaps mindful of the previous discussions on the picturesque and to re-

enforce his points, in his next book *An Inquiry into the Changes in Taste in Landscape Gardening* (1806), Repton again gives his interpretation of the history of gardening, where he starts 'from the period when Mr. Walpole left off, and trace[s] it from Kent, through Brown, to the present time' (Loudon 1840, 323). Perhaps the most surprising part is his conclusion: 'that we are on the eve of some great future change in [gardening] … in consequence of our having lately become acquainted with the scenery and buildings in the interior provinces of India' (Loudon 1840, 340). At the time he was preparing a *Red Book* for the Brighton Pavilion, which he published in 1808, though he did not secure the commission. He had also recently been consulted by the owner of Sezincote in Gloucestershire, also built in the Indian style. His recommendation for both was not to use the current English landscape style but use elements of the Mughal (or Hindu as he called it) garden such as regular pools, straight gravel walks and flower borders. This is one of the first examples of the cultural effect of its Empire on Britain.

By 1810, Price and Repton were largely of the same opinion with regard to how landscapes should be laid out. Price's comments reflected exactly what Repton was putting into practice:

> 'the old improvers went abruptly from the formal garden to the grounds, or park; but the modern pleasure garden with its shrubs and exotics, would just form a very just and easy graduation from architectural ornaments, to the natural woods, thickets and pastures. All the highly ornamented walks, such as terraces, &c. of course can only have place near the house.' (1810b, 148)

By now, Knight had withdrawn from the controversy and retired to his estate, as he and Price were no longer united in their ideas. Perhaps appropriately the last words came from Repton in his final work. He now concluded that the argument on the picturesque was between Price and Knight and he was only the 'moderator' (Repton 1816, 33).

The public appetite for the discussion had not only waned but had turned to satire with the publication of *The Tour of Doctor Syntax in Search of the Picturesque*, a spoof of Gilpin's tours, in 1812 and the novel *Headlong Hall* (1816). In the latter Repton is parodied as Marmaduke Milestone[12] and his client is Lord Littlebrain. Napoleon had been finally defeated and with it the imminent threat of invasion lifted. The fear amongst the aristocracy that Britain would become a republic and worse still, they would lose their lands, was gone. That is not to say that ideas on a free society and the rights of man had gone away, they would soon re-surface in the reform movement of the 1820s and 1830s: the result of which would lead in part to public parks. Britain's rapidly expanding trade was slowly eroding land as the main driver for wealth creation and power and how the private estate landscapes were developed lost its political potency.

Repton's view in 1795 that there should be a 'middle way' in landscape design was curiously prescient, even though it denied him the large landscaping projects that his predecessors like Brown had been able to undertake. It perhaps reflected the confusion felt at the time amongst professional improvers, who had seen the ideas of Brown rejected but saw no consensus about what should

replace it. Repton's last major commission was at Ashridge in Hertfordshire in 1814, which has fifteen different kinds of gardens, many re-interpretations of older styles such as a 'monk's garden', an 'embroidered parterre' and a 'Rosarium and Fountain'. He justified his choice thus:

> 'Every part of the modern pleasure-ground is alike; and, unless varied by views into the adjoining country, we soon tire of the sameness [of them] … therefore I have ventured boldly to go back to those ancient trim gardens, which formerly delighted the venerable inhabitants of this curious spot.' (1816, 139)

John Claudius Loudon, who was to be so influential in the development of gardens and public landscapes in first half of the nineteenth century, had joined the picturesque debate in 1803. He declared himself as a supporter of Price's view of the picturesque and the first landscape gardener to carry out its principles (Loudon 1804, 214–5). He found that like Repton, this was difficult to turn into reality and by 1835, Loudon remarked:

> 'the taste of the present day in landscape-gardening may be considered as comparatively chastened and refined by so much discussion [on the picturesque] … It is also more liberal than it was half a century ago; admitting the use of the beauties of every style, even the geometric, as occasion requires; in short, considering *beauty as always relative* to the state of the society.' (1835, 326)

The taste and the politics of a few had influenced the way Britain had been landscaped until the end of the eighteenth century. Now the way gardens and gardening were to be created and developed, like the franchise, was opening up to a wider audience.

Notes

1. Letter from Horace Walpole to William Mason, 22 March 1796.
2. Often referred to as 'professional improvers' to distinguish them from the estate owners who designed their landscapes themselves.
3. Quest-Ritson (2001, 140) estimates that the differential was as much as 50%.
4. Knight (1794, 11) The reference is to a suggestion in the Red Book for Tatton Park, which Repton strongly disputed in his open letter to Uvedale Price.
5. See Turner (1999) for a full list of sites associated with Brown.
6. See Brown (2001) for more information on other professional improvers who started by working with Brown.
7. These plans including the famous 'before and after' paintings of an estate were usually bound in red leather, hence the name. For a full listing of these and the sites he worked on see Daniels (1999).
8. Having been briefly Prime Minister in 1783, Portland became Home Secretary in 1794.
9. *Remarks on Forest Scenery, and other Woodland Views, relative chiefly to Picturesque Beauty* (1791) and *Three Essays: On Picturesque Beauty; On Picturesque Travel; and on Sketching Landscape* (1792), the latter also containing a poem *On Landscape Painting*.
10. In the notes he comments that 'It was a maxim of the late Mr. Brown's, that everything that indicated decay should be removed'.
11. For full list see Daniels (1999).
12. His name referring to the debate over mile markers in the *Red Book* for Tatton.

Hackfall, Yorkshire

John Aislabie had bought the land at Grewelthorpe in 1731 mainly as an investment. The site provided farmland that could be leased out, woodland to provide timber and quarries for stone and tufa for his main project at Studley Royal. Aislabie had been elected as a Whig MP in 1695 and he became the Chancellor of the Exchequer in 1718. His tenure was brief as he was held responsible for the South Sea Bubble financial crisis of 1720 and was impeached the following year. Now a political exile, Aislabie returned to his estate and devoted the last twenty years of life creating a natural, 'poetic' landscape that was a direct response to French formality (Eyres 1985a) and by implication a rejection of the Stuart cause.

The overall design, remaining largely intact today, weaves through a natural river valley and ends with a view of the ruins of Fountains Abbey. As at Stowe, the temples and statues in the landscape have political meaning. Outside the Temple of Venus, there was the statue of The Dying Gladiator: an illusion to the mortal wounding of the owner's political career (Eyres 1985a, 9). With the Temple of Hercules (renamed as the Temple of Piety by his son, Figure 6.6), Aislabie was making reference to William of Orange and the ascendancy of Britain over France. Inside the temple were busts of the Roman Emperors Vespasian (representing 'Good Government') and Nero ('Bad Government'): a comment on the corrupt regime of Robert Walpole (Eyres 1985a, 11).

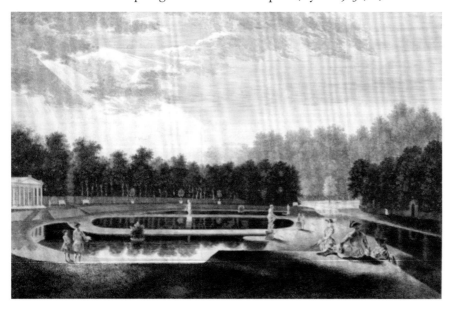

FIGURE 6.6. Moon Pond, and the Temple of Piety at Studley, print by Walker *c.*1742–65.

FIGURE 6.7. View of Hackfall from the Ruin.

FIGURE 6.8. Fisher's Hall, Hackfall.

John's son, William, while also an MP, appeared to have not had the political ambitions of his father. On inheriting in 1742, he seemed to prefer to continue the work developing the estate at Studley. In 1750 though he started a new project, turning part of the land at Grewelthorpe along the River Ure into a garden. Known as 'Hackfall', this wooded area had a sharp bend in the river, with the Grewelthorpe Beck falling steeply to join it. It thus had all the ingredients for what Aislabie intended as a 'natural' garden (Figure 6.7), although in its early stages, it would have been nearer the more 'formal' Studley (Harwood 1987, 398) that clearly inspired by it.

The waterworks, such as the waterfall called the 'Forty Foot Fall' and other cascades, were designed to appear as natural as possible. Despite his father's political (and to some extent financial) problems over the South Sea Bubble, others members of the family did profit (Eyres 1985b, 30), so William was able to expend considerable resources on the garden at Hackfall over the next 17 years. This included a number of buildings in the landscape, the first in 1750 being 'Fisher's Hall' (Figure 6.8), a riverside pavilion. Hackfall was a place for the family to visit, with the main home remaining at Studley, just as at Plumpton Rocks (Figure 6.4), there was never the intention to live there.

Unlike other key landscapes of the period such as Stourhead or indeed Studley itself, there was no evidence of a prescribed route. This was key to the design and why it was an innovation for its time. The buildings such as the Ruin (Figure 6.9) and Mowbray Castle (Figure 6.10) just provided places for the family and their friends to stop and eat, particularly after the completion of the

FIGURE 6.9. The Ruin, Hackfall.

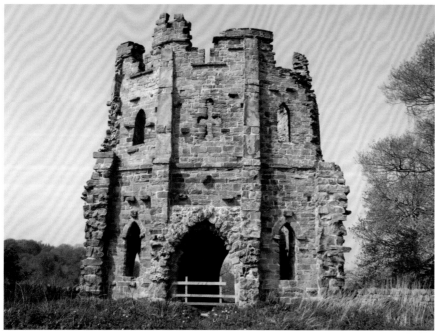

FIGURE 6.10. Mowbray Castle, Hackfall.

kitchen at the former in 1774 (Harwood 1987, 397). The rest of the constructions provided focal points and created interest in the landscape, in particular the Rustic Temple and Fountain Pond (Figure 6.11). While essentially a private garden, along with the increased interest in the 'picturesque' style of garden, it began to attract visitors from the mid-1760s.

Influential writers, such as William Gilpin who visited in 1772, extolled Hackfall's beauties. Gilpin (1808, 187) remarked that when 'the folding-doors of

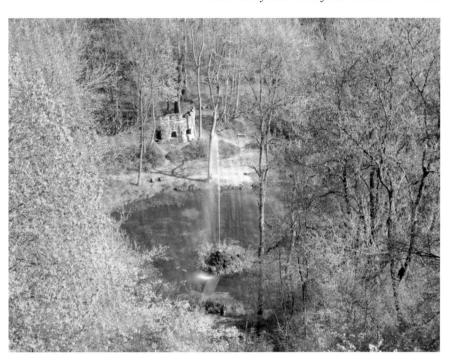

FIGURE 6.11. Rustic Temple and Fountain Pond, Hackfall.

the building at Mowbray-point ... [are] thrown open, you are struck with one of the grander, and most beautiful bursts of country, that the imagination can form.' In 1769, Arthur Young described it as sublime (Eyre 1985b, 31) and alongside other picturesque landscapes it helped fuel the 'picturesque debate' on what constituted the ideal designed landscape, which would become so politicised by the end of the century. This was perhaps an unintended consequence of Aislabie's creation.

Views of it were painted famously by Turner, Nicholson (Figure 6.12) and others and by the start of the nineteenth century it was firmly on the tourist trail. Its success was due to Aislabie having 'embellished Hackfall's natural Sublime with Picturesque features' (Eyre 1985b, 32). However as the debate on the picturesque showed, you could only achieve such effects if you had a good natural landscape to start with. William Aislabie died in 1781 and the estate passed to one of his daughters and her heirs. Hackfall remained a popular tourist attraction with a later owner widening the footpaths when better transport increased the visitor numbers in the second half of the nineteenth century. By this stage, it had become rather overgrown and was seen as a 'wild landscape' and quite different to other contemporary Victorian gardens.

Like many other estates in the twentieth century, it began to suffer from a lack of maintenance due to diminishing funds. The owners of the Studley Estate finally sold Hackfall in 1933 to a timber merchant. Ironically, given its important role now in conservation, the National Trust refused to accept it on the grounds of lack of a supporting endowment. For 50 years, the site was used for timber and its buildings and water features were slowly left to decay. Today it is a testament to a dedicated group of locals who formed the Hackfall Trust in 1987 to try and

FIGURE 6.12. Hackfall, Yorkshire by Nicholson, etching by Burne 1809.

restore this important designed landscape. Together with the Woodland Trust, who bought the site in 1989, they have ensured that the visiting public can once more enjoy William Aislabie's 'picturesque' garden.

Nineteenth Century Public Parks in British Reform Politics

> They hope and trust that the time is arrived when an earnest and growing interest in all that relates to the welfare of the humble classes is taking possession of the Public Mind. As one means of carrying these wishes into effect, they hope that Public Walks may be gradually established in the neighbourhood of every populous Town in the Kingdom. (House of Commons 1833, 11)

'They' were the Select Committee, which had been appointed by the British Parliament on 21 February 1833 to investigate the provision of public walks ('green' areas set aside in towns and cities that later became public parks). Their main recommendation above was only taken up gradually. While seen as a 'good thing', the perceived benefits of public walks for individuals and society as a whole were not clearly defined. As a result the required public funds for such large-scale projects were very reluctantly given. In the report (1833, 3), it was claimed that public walks would 'conduce to the health, comfort and content of the [middle and humble] classes'. It would not only be their bodies that would be improved by having access to such open spaces but their minds as well. The history of the urban park has largely focussed on the former, as one historian, Ponte points out:

> 'the concept of a public park emerged as a response to problems of sanitation and urban growth. The public park was one of the principal means by which nineteenth century reform endeavoured to improve the situation and thus the quality of life.' (1991, 373)

This has become the standard view of the rationale for public parks but for the politicians of the mid-nineteenth century, promotion of parks had a more overt political use. Politicians could *show* how enlightened they were without really doing much about the actual conditions that the majority of the urban poor lived in.

Layton-Jones (2010) points out that the creation of these parks did little to improve the health or well being of the poor. The parks were often out of reach both physically and literally for them as access and behaviour was often controlled. In effect it became, in modern parlance, a public relations exercise.

What the politicians really wanted was to avoid demonstrations and a dilution of political power through mass enfranchisement. There were serious food shortages and a major famine in Ireland in the 1840s that led to considerable discontent. Public parks, by providing a controlled diversion, were seen as a counterbalance to this. In the debate preceding the appointment of the Select Committee in 1833, its main proponent, Robert Slaney noted that:

> 'at present, the poor workman in the large manufacturing towns, was actually forced into the public house, there being no other place for him to amuse himself in. Independently of this, it was well known that healthy happy men were not disposed to enter into conspiracies. Want of recreation generated incipient disease, and disease, discontent; which, in its turn, led to attacks upon the Government.' (Hansard, 21 February 1833, 15, 1049–59)

The revolutions between 1830 and 1848 in Europe, though not replicated in Britain, had provided a stark reminder to the political elite of the revolutions in France and America and their consequences. The new Whig administration in the House of Commons had tried to pass a parliamentary Reform Bill in 1831, but the Tory dominated House of Lords defeated it. Riots and serious disturbances broke out soon after in London, Birmingham and other major cities, leading to a fear in government that unless there was some reform, there might be a revolution instead. Finally the *Great Reform Act* was passed in 1832 and the subsequent election brought in a lot of new MPs from the rapidly expanding urban centres, previously without representation such as Manchester.[1]

These new MPs were concerned about the impact of industrialisation on their constituencies, not only for their voters, who were still from the upper and middle classes but also for the working class who were yet to get the vote. The latter's attempts to gain political rights and therefore influence led to the Chartism movement that emerged in 1836. Three petitions[2] were presented to Parliament in 1839, 1842 and 1848 but all were rejected. The plan for the last petition[3] was to deliver it to Parliament after a peaceful mass meeting on Kennington Common in London. The government was concerned that this was turning into a revolution and eight thousand soldiers were sent, but in the event only twenty thousand Chartists turned up. The use of uncontrolled public green space (such as the Common and St Peter's Fields, the site of the Peterloo Massacre in 1819) as a meeting place for potentially seditious activity[4] was later used as an argument to the provision of parks at public expense, notably Battersea Park and Kennington itself, which was turned into a park in 1852.

The pleasure gardens of the eighteenth century had shown that private enterprise could give the urban dweller attractive gardens to visit, without control or interference by the government (Conlin 2008). So why then did these promoters of urban parks in the nineteenth century think that they should be provided by the state? The *laissez-faire* attitude that had prevailed in Britain also applied to pleasure gardens that were open to all (who could pay) and the activities in them were unregulated. Pleasure gardens acquired a reputation for

drunkenness and behaviour, which the more puritanical elements of the new Victorian society believed had a negative effect on society, particularly the lower orders. The new public parks were conceived as being different. The House of Commons report noted that:

> 'the advantages which the Public Walks (properly regulated and open to the middle and humbler classes) give to the improvement in the cleanliness, neatness and personal appearance of those who frequent them. A man walking out with his family among his neighbours of different ranks, will naturally be desirous to be properly clothed, and that his Wife and Children should be so also: but this desire duly directed and controlled, is found by experience to be of the most powerful effect in promoting Civilisation, and exciting Industry.' (1833, 9)

From the outset, public parks had a social purpose. Gardens, for the Victorian social improver, could provide a means of raising the 'standards' of all strands of society. Edward Kemp (1858, 131) wrote in his important treatise *How to Lay Out a Garden*: 'a garden is for comfort and convenience, and luxury, and use, as well as for making a beautiful picture. It is to express civilization, and care, and design, and refinement'. While Kemp's book was aimed at the growing middle class some of whom now had the luxury of their own private garden, these ideas were also carried over to the creation of public parks. Kemp had been the Superintendent of Birkenhead Park and was responsible for the design of a number of important early public parks such as Newsham and Stanley Parks in Liverpool. This view of public parks as a civilising agent continued throughout the nineteenth century, not only in Britain. Frederick Olmsted, designer of Central Park in New York, in 1880 described the progress of the public park in the United States as a 'common, spontaneous movement, of that sort which we conveniently refer to as the Genius of Civilization' (Ponte 1991, 386). The nineteenth century public park in Britain developed from an uneasy mix of the state wanting to control its population's behaviour, private philanthropy of wealthy industrialists, property speculation and a genuine concern to improve the lives and health of the urban poor (Taylor 1995, 202).

Origins of the Public Park

The park or a large enclosed landscaped area had long been the preserve of the powerful and influential, going back to the hunting parks of Assyrians. Admittance was strictly controlled and this idea continued in medieval Europe, where royalty and the nobility fenced off areas of their land as a park. Inside these areas, animals were bred for hunting and there were severe penalties for trespass and poaching of the stock. Many of these hunting parks in Britain were the basis of the large landscape parks of the late seventeenth and eighteenth centuries, as the large landowners increased their estates through enclosure. Designers such as Lancelot Brown were quite adept at enhancing the estate by screening out any view of the lower classes and their dwellings, the enclosed park of the estate providing a very private environment for its owner.

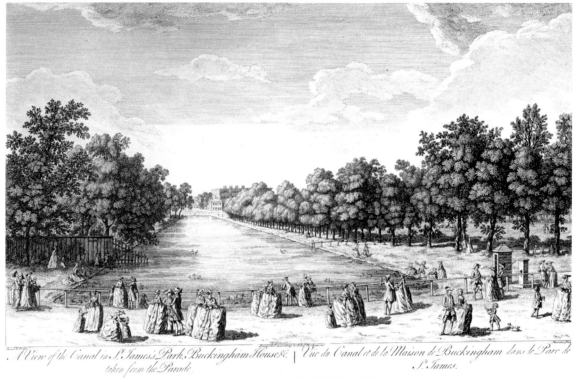

. *View of the Canal in S.t James's Park; Buckingham House &c.* | *Vue du Canal et de la Maison de Buckingham dans le Parc de*
taken from the Parade. | *S.t James.*

Published 12 May 1794 by LAURIE & WHITTLE, 53 Fleet Street, London.

For the majority of the population, there was the 'common land' or 'commons' (that is land open to all) in most areas from small villages to cities such as London, where general access was unrestricted. The only exceptions to these, prior to the nineteenth century, were the royal parks in London and a few public walks. Following the restoration of Charles II to the throne in 1660, he re-designed and then opened up St James's Park (Figure 7.1) to the public. Together with Hyde Park, which had been opened in 1637, they became popular public spaces. When Queen Caroline, wife of George II, 'asked Sir Robert Walpole what it would cost to restrict its [St James's Park] use to members of the royal family. The prime minister's famous reply, "Only three crowns, Madam", deterred any future action' (Batey and Lambert 1990, 254). In 1808, there were proposals to sell off part of Hyde Park. Thomas Creevey, a Whig MP, objected as 'the public had paid no less than seventy-one thousand pounds for the improvement of the [royal] Parks, [so] he could not help thinking that they [the public] had a pretty good claim to the use of them at least' (Hansard 30 June 1808, 11, 1122–6). That is not to say that these spaces were entirely open, as the royal parks remained walled until well into the nineteenth century and so access could be restricted. A campaign by John Loudon led to the gradual replacement of walls by railings, such as Hyde Park in 1828. Other royal parks were opened to the public after much political pressure, such as Green Park

FIGURE 7.1. Canal at St James's Park London, 1794 reprint of an original published in 1751.
PHOTO © VICTORIA AND ALBERT MUSEUM, LONDON

in 1826 and Regent's Park in 1835, although the latter was for only two days a week.[5] It seemed that once an area became a public space, then it was unlikely to revert easily to a private one, whoever was the landowner.

Outside the capital, a few public walks were created in the eighteenth century such as 'The Quarry' in Shrewsbury and the 'New Walk' in Leicester, laid out by the local authority in 1785. In Liverpool, 'Ladies Walk' and 'St James Walk' were created in the mid-eighteenth century. Begun in 1767, the latter was a means of providing employment during a time of high food prices and being free, it was an important part of the provision of public green space in Liverpool (Layton-Jones and Lee 2008, 7). A hundred years later, the same idea of public works to provide employment, was used in Lancashire when the reduction in supply of raw cotton from the US caused widespread unemployment. The nineteenth century public did have other urban green spaces to enjoy but at a price. Whilst not free, the pleasure gardens that had thrived in the seventeenth and eighteenth centuries still provided somewhere to go in the summer months. Born out of a desire to have places in the city with clean air (and it was thought free from diseases such as bubonic plague), they developed over time to be great places of entertainment.

Some were no more than a bowling green at an inn or a tea garden, others had gravelled walks for exercise but the true forerunners of the urban park were those such as the famous Vauxhall (Figure 7.2) and Ranelagh Gardens in London. Vauxhall started life as the New Spring Gardens in 1661 and its rather racy reputation was due partly to the fact all-comers were admitted provided they could pay the entrance fee of a shilling. It was not only in London, established cities such as Norwich and Bath had pleasure gardens, as

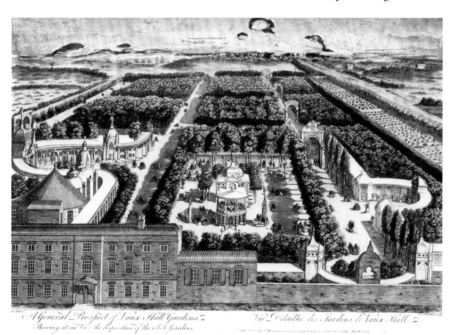

FIGURE 7.2. General view of Vauxhall Gardens by Wale *c*.1775.

did the new cities such as Liverpool, Manchester and Birmingham and they were often named after their London counterparts (Downing 2009, 39–50). By the mid-nineteenth century, most city centre pleasure gardens had gone, as the burgeoning middle class sought entertainment elsewhere. They could now travel easily out of the city by train for entertainment and increasingly had gardens of their own. The legacy that the pleasure gardens left, along with royal parks was a sense of sharing space for all (Downing 2009, 62–3).

Regent's Park in London was a former royal hunting park of 500 acres (*c.*202 ha) but it had become farmland when John Nash produced a plan for its development as a park and landscaped housing estate in 1811. Part of his grand scheme was to link the new park, via Regent Street to St James's Park and then to Carlton House, the residence of the Regent. It was meant to rival Napoleon's developments in Paris and 'in Prince Pückler-Muskau's words, give central London 'the air of a seat of Government and not of an immeasurable metropolis of shopkeepers to use Napoleon's expression" (Batey 1995, 72). Nash's first proposal was to build villas inside the new park but it was changed, with the houses put around the perimeter instead. Regent's Park became the model for future park developments that used the sale of private housing to fund the surrounding public green space. Nash's ideas on town planning that integrated green space were taken up elsewhere such as the development of Kemp Town in Brighton from 1823.

Other town planning schemes though were difficult to implement as most areas were privately owned and there was little available space. The large-scale redevelopment of Paris by Haussmann in the 1850s and 1860s, for instance, would have been unthinkable in any British city. The problem lay in the massive cost of buying, building, and maintaining parks in built up areas, without any discernable benefit to the local taxpayers. However increasingly common and waste land in the towns and cities were preserved, as these urban centres grew (Malchow 1985, 100). Moor Park in Preston was created by the local authority, who enclosed some common land in 1833 in order to improve it and make it beneficial to the community (Conway 1996, 9).

The case for the publicly funded park

Judging by the comment made during the Commons debate about Hyde Park in 1808 by William Windham that 'it was a saying of Lord Chatham [William Pitt the Elder], that the parks were the lungs of London' (Hansard 30 June 1808, 11, 1122–6), the importance of green spaces within an urban area was already established in the mid-eighteenth century. It is clear that Windham linked parks to public health benefits as he noted that 'any contraction of that scene of public exercise and recreation [Hyde Park] would be extremely injurious to the health and comforts of the inhabitants of this great metropolis' (Hansard 29 June 1808, 11, 1104–6). Although the royal parks remained open, many of the private pleasure gardens were closing as the riots of 1830 and 1848 began

to deter the wealthier customers from going (Stuart 1988, 41). In the face of this increasing urbanisation and the lack of any public green spaces in many areas, two men took up the cause. One was a politician and the other, a garden designer and writer. While each had their own agenda, together they provided the impetus for the campaign for urban public parks.

Robert Slaney was a Whig who was first elected in 1826 as the MP for Shrewsbury. Two years earlier he had published *Essay on the Beneficial Direction of Rural Expenditure* and in it, he sets out his case 'On the Advantage Derived from Public Walks and Gardens'. He states that:

> 'the formation of a public walk near a town … is a beneficial direction of expenditure. It seems somewhat extraordinary, that in this country, where the good of the whole is so much thought of, so little care has hitherto been taken to provide public walks and places of exercise.' (1824, 204)

Jeremy Bentham and his theory of utilitarianism[6] had influenced Slaney and his view on the public park's importance in benefiting society as a whole, is shown by his remark that:

> 'some place where the working classes may be amused, and induced to take exercise, is of much greater consequence than we may at first sight deem it; if they have none they are driven on Sundays and holidays to public-houses, where, brooding over real or imaginary grievances, they often read the worst publications, and listen to idle schemes of hasty or impracticable reform.' (1824, 206)

The garden designer and writer John Claudius Loudon had no doubt also influenced Slaney (Turner 1982, 35). Loudon had published an article about the management of London's squares and their importance to the health of its inhabitants in 1803. In the first edition of his *Encyclopaedia of Gardening*, he discusses public parks specifically for the first time (1822, 1186), noting that they 'are valuable appendages to large cities'. However he bemoaned the fact (1822, 1186) that 'our continental neighbours have hitherto excelled us in this department of gardening: almost every town of consequence having promenades for its citizens'. He wrote *Breathing Places for the Metropolis* in his new publication *The Gardener's Magazine*, which 'the idea of a circular promenade was developed into an extremely far-sighted greenbelt proposal' (Turner 1982, 33) for London. This was in response to a debate surrounding the demand for Hampstead Heath to be enclosed and developed by its owner. For many the potential loss of Hampstead Heath as a public space was part of the creeping reduction of London's open spaces and their role as the city's critical 'lungs' (Ponte 1991, 373). Loudon's campaign for public parks (Simo 1981, 200), particularly in London, was taken up by the politicians and led to the creation of Victoria Park and others.

Loudon too was a follower of Jeremy Bentham, believing that landscape gardeners should promote the principles of utilitarianism. He was a passionate advocate of education for all and believed that public parks should play a role in this regard (Batey 1995, 87). Loudon's ideas were put into practice through

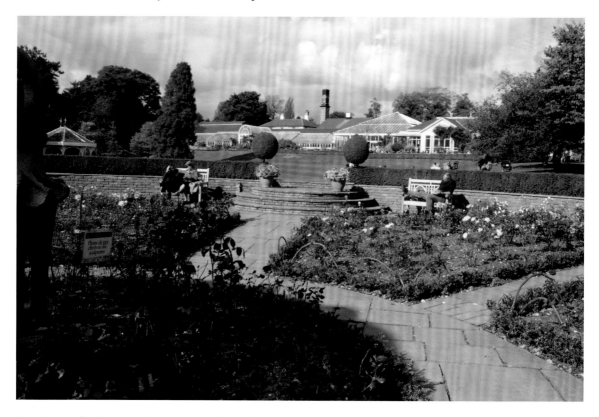

his design for Birmingham Botanical Gardens in 1830 (Figure 7.3). Privately financed by the local inhabitants[7] and opened to the public in 1832, the layout cost far more than had been raised. Ongoing operational costs nearly brought the scheme to closure in 1848. Only a large donation and the reduction in the site's size led to its continued existence (Ballard 1985, 71–2). Loudon was also involved in another project, the Derby Arboretum, which opened in 1841 on land donated by Joseph Strutt, who also financed its construction. Strutt wanted Loudon to create a 'Pleasure Ground' or 'Recreation Ground' to 'offer the inhabitants of the town the opportunity of enjoying, with their families, exercise and recreation in the fresh air, in public walks and grounds devoted to that purpose'.[8] While both these gardens had laudable aims of educating as well as providing a green urban environment and Derby was free for two days a week (including Sunday when most workers had the day off), they did not provide a sustainable model. The income generated did not match the required expenditure. In many ways, Strutt's 'gift' to Derby caused a problem, as the local authority could not use the rates (local taxes) to maintain it.

Clearly there had to be a more sustainable alternative and the few public walks that existed initially provided the model. In 1833 Slaney, now an MP in the first Parliament since the Great Reform Act, successfully argued for a review into public walks with the appointment of a Select Committee, with him as Chairman. His arguments for this Committee centred on the massive expansion

FIGURE 7.3. Birmingham Botanical Garden.

in the urban population and the wealth these urban workers generated. The assumption was if money was spent on improving the latter's lives, then all would benefit through a growing economy. In terms of funding he argued:

> 'the expense would not be so considerable as was supposed ... there were in the neighbourhood of some large towns commons which might be advantageously used ... Several of the [Town's] Corporations were also possessed of lands and open spaces which might be profitably applied for similar purposes ... any town raising a sum by subscription or otherwise for the purpose of building public walks should receive a certain proportion of money from the public Treasury ... and that Commissioners should be appointed to prevent any waste of this money.' (Hansard 21 February 1833, 15, 1049–59)

Reflecting his utilitarian views, Slaney 'was quite sure the public, when they knew the purpose for which this money was granted, would not grumble at the expenditure. He also felt confident that the humbler classes, when they knew that it was expended for the improvement of their own condition, would accept it gratefully, and take it as earnest of the kind intentions of the Legislature towards them. By attention to these and other apparently unimportant matters, he was sure the wealthy would reap a rich harvest of reward in the happiness and contentment of the humbler classes of the community' (Hansard 21 February 1833, 15, 1049–59). Even at this point, there was some scepticism amongst other MPs as to whether having public walks would materially benefit the poor and thus justify the expenditure, Edward Portman (Hansard 21 February 1833, 15, 1049–59) for example 'confessed it did strike his mind that there were considerable difficulties in the way of carrying any such plan into effect—there was obviously a want of funds – whence then were the means to come? He deprecated anything in the nature of additional taxation, either general or local'.

The Committee took evidence from residents of the major manufacturing towns and London. While recommending public walks generally in the former, they made some specific examples for the capital. Primrose Hill, to the north of Regent's Park, should be taken into public ownership and Copenhagen Fields, Hackney Downs, Mill Wall and Kennington Common should be turned into public walks, as well as a stretch along both banks of the River Thames. The Committee saw two potential obstacles: one was the sale of entailed land[9] to allow improvement of estates and the other was the funding of the walks. Their suggestion on the latter would be first to make any future turnpike or canal project to include public walks. Secondly that lands could be obtained from any suitable Crown properties or 'large Proprietors (aware of the advantage to their other Property) [who] may be willing to dedicate a part to increase the value of the remainder, or from a laudable desire to promote a great Public Improvement' (House of Commons 1833, 10). The money to develop and maintain them could come from voluntary subscriptions or donations but when these cannot 'be raised, it seems the duty of the Government to assist in providing for the Health of the People by whose efforts they are supported'

(House of Commons 1833, 10). The Committee however was optimistic that 'in many instances, the liberality of individuals, if properly assisted, would furnish all that is necessary, when their attention is directed to the importance of the subject' (House of Commons 1833, 10).

The problem of funding remained though as James Buckingham, MP for the industrial city of Sheffield, tried to bring in a series of bills in 1835 and 1836 without success to allow the authorities to levy a special rate (tax) on householders to build public walks and other 'beneficial' institutions. There was some support for the general principles as this contemporary comment shows:

> 'public gardens are just beginning to be thought of in England [there were many more in formation in France, Germany and Holland]; and, like most other great domestic improvements in our country, they have originated in the spirit of the people, rather than in that of the government. On the Continent, the contrary has generally been the case ... we may refer to the favourable reception given to the bill brought forward during the last session of parliament, by Mr Buckingham, for establishing a public park at every town and village where a majority of the rate-paying inhabitants expressed a desire to have one.' (Stuart 1988, 100)

In 1836, an amendment was made to the Common Fields Enclosure Act that prohibited enclosure 'of any open or common fields being within ten miles of the city of London' and those near to other towns and cities containing more than two thousand inhabitants. The following year, it was agreed 'that in all Inclosure Bills provision be made for leaving an open space sufficient for the purposes of exercise and recreation of the neighbouring population' (Hansard, 9 March 1837, 37, 162–4). As a result commons on the edge of towns started to be enclosed as public parks for example in Southampton, where a series of parks was laid out from 1846.

First public parks and their impact

In 1839, Slaney tried again to raise the subject of public walks as little had been done since the publication of the Select Committee six years earlier, despite his party being in power. The first public urban park, Victoria Park in Bath, had opened in 1830 but the land was leased, not owned by the local authority and visitors were charged entry. However it was another Victoria Park, this one in Bethnal Green, London that was the first new public park funded by the state. It was a direct result of the recommendations of the Select Committee on Public Walks and a petition to the Queen[10] orchestrated in part by the Chartist *London Democratic Association* (Clark 1973, 33). The money (£1000) had come from the sale of the royal property, York House,[11] in 1841 and the bill approving the expenditure was passed the following year. Despite this, work has still not started two years later, as the authorities struggled to get the required site at a reasonable price and the park was not finally opened until 1845. It was hoped that money could be recouped by selling plots as had been done successfully

at Regent's Park. They did not sell as well as expected due to the location in the poor East End. The limited funds allocated by the government meant that the roads intended to link the park to the city were not built, making it even more unattractive to investors (Conway 1996, 11).

This lesson was only partially learnt when the Government approved the creation of Battersea Park in 1846, the second state funded park. Purely private ventures such as Prince's Park in Liverpool, which was laid out between 1842 and 1844, were more successful. Richard Vaughan Yates had approached the Liverpool Corporation but they declined to get involved in the project and private shareholders financed it (Layton-Jones and Lee 2008, 16). Using the Regent's Park model of prestigious housing set around a landscaped park designed by Joseph Paxton, the park was only accessible for the residents (similar to many town and city squares) on a permanent basis. However it was often open for events where the public paid to come. In 1849, the 'Philanthropic Festival' was staged: a large-scale event whose aim was to raise money for local hospital (Layton-Jones and Lee 2008, 18). Despite such generosity, the fact that it was not open fully to the public and mainly for the benefit of the nearby wealthy homeowners was criticised by those trying to improve the local health and welfare of the city's inhabitants. The city's Corporation was blamed in particular for not getting involved (Layton-Jones and Lee 2008, 20).

In 1841, £10,000 was finally approved by Parliament for the promotion of public parks. The scheme was to give a grant at least equal to that put up by those proposing to set up a park. By 1849, up to £5000 had been allocated to schemes in Dundee, Arbroath, Manchester, Portsmouth, and Preston and a further £3000 set aside for applications from Leicester, Harrogate, Stockport, Sunderland, and Oldham (Hansard, 31 May 1849, 105, 1009). Given the costs of setting up and maintaining these parks, typically over £100,000, this was hardly generous. Therefore a lot of parks were the result of speculative investment along the 'Regent's Park' model, such as Birkenhead, the first 'municipal'[12] park, in Liverpool. In Manchester, three new public parks were created through public subscription.[13] Philips, Queen's and Peel Park (Salford) in 1846. While individual councillors in Manchester backed this scheme, the local authority made no financial contribution to their construction but the parks passed into their care for maintenance.

The exception was the creation of Battersea Park in London, which the government agreed to finance from the Public Works Loans Fund in 1846. This project highlighted the inconsistency of the politicians and their attitude towards the provision of public parks. Progress was very slow and by 1853 the transformation of the former Battersea Fields was still not complete. Worse still, questions were being raised as to the validity of the scheme. Gladstone, the new Tory Chancellor of the Exchequer, was particularly scathing:

'no speculation was ever so absurd as that of Battersea Park. The persons who undertook the enterprise were ignorant of all the circumstances with which they had to deal. They purchased a great deal of land, and made arrangements by which

twenty years must elapse, even if they are successful, before they receive any rents; and the margin reserved for the Government is so slight, that instead of repaying the principal, it will probably never defray the sum that is already due for accumulated interest.' (Hansard, 16 December 1852, 123, 1570–698)

Not only did the park have to be built, and by 1853 the cost of this had risen to £308,000, but also a new bridge needed to be built across the Thames to allow access to it. In addition work needed to be done on the river embankment pushing the cost to over half a million pounds. In order to recoup this money, they believed they would get back just over half in ground rents and sales. Sixty-two thousand pounds would come from the embankment and the bridge tolls would add a further £6600 a year (Hansard, 5 August 1853, 129, 1407–14). Battersea Park and its accompanying bridge were finally opened to the public in 1858. The MP, Shelley neatly summed up the problems with the project which:

> 'had [been] done so on the recommendation of the Royal Commission, who reported the Battersea Fields were a nuisance. They formed a park for the working classes, and then they found that nobody would go to it, and that the land around it would not let. They built a bridge at an expense of eighty thousand pounds to get out of that difficulty, and they placed a toll upon it, which destroyed the efficiency of the remedy. If they took off the toll people would go to the park, and the land would be readily taken up at three thousand pounds an acre or more, and they would get back at least some of the money which had been so badly spent.' (Hansard 16 July 1858, 151, 1648–52)

This difficult experience for the Government put paid to them sanctioning any further publicly funded parks for the next decade. Using national public funds for essentially local projects was setting a precedent that many MPs objected to,[14] never mind the question as to whether the state was best placed to undertake these projects.[15] Elsewhere the new public parks had been funded largely by private means such as those in Manchester and Glasgow, where £90,000 was raised in 1853 for the latter's construction. The development of parks in the 1860s was characterised mainly by private benefactors giving land for parks, stimulated by two Acts of Parliament. The new Liberal government were responsible for the *Recreation Grounds Act* of 1859, which allowed land to be held by trustees for recreation and the *Public Improvement Act* of 1860 that allowed the levy of local rates for improvements such as public parks.

While philanthropy may have been at the core, if the benefactor retained an interest in the land surrounding the new park, then the motivation could also be self-interest. However schemes such as Victoria Park in London and others in the regions such as Pearson Park in Hull (opened in 1860) were not always financially successful. More controversially was the use of parks as an outlet for poor relief. The 'cotton famine' in early 1860s in Lancashire, due to the American Civil War disrupting supply of the raw material, had led to mass unemployment. Amongst the Acts that were passed to provide relief, the *Public Works (Manufacturing Districts) Act* 1863 allowed authorities to borrow money

for public works to provide employment for cotton workers at Corporation Park, Blackburn; Alexandra Park, Oldham; Avenham, Miller and Moor Parks in Preston.

Slaney was still actively putting forward the argument for public parks. In 1860, he recommended that the government should encourage private individuals to build parks and open part of the time for free, in return for tax concessions (Hansard 15 May 1860, 158, 1287–93). He cited the example of the Crystal Palace Park. The Great Exhibition building of 1851 had been sold to the Crystal Palace Company, who raised £500,000 to buy it and transfer to a new site at Sydenham.[16] Joseph Paxton, one of the company's directors, created a new public park around it between 1852 and 1854. While not a great success commercially, as it was hampered by not being able to open on a Sunday, *politically* it was important and did influence future public parks, not only in terms of economics but also its design. As one writer notes after the opening:

> 'the more people have of new plants, and the more they delight in them, the happier and the better they will be ... we make for them parks and gardens, where they may walk unrestrained ... And what is the consequence of this? We must condense the reply into one sentence – We have had no Revolution.' (Stuart 1988, 45)

This was more of an enhanced pleasure garden that aimed to offer 'refined recreation to elevate the intellect and instruct the mind' (Conway 1996, 17) all year round. The design of Crystal Palace park, with the use of 'formal' features such as Italianate terraces and carpet bedding, sent out a signal that the park was to be a controlled space not only for the plants but for the people as well.

The legacy of the parks movement

Parks had become a tool for the moderate reformers of the Whig and then Liberal parties of the mid-nineteenth century, who feared revolution in Britain after events in Europe in 1830 and 1848. The country had undergone massive economic and social change and the political elite wanted to steer a course of the middle way: neither despotism nor 'American style' democracy (that is one man, one vote). This they achieved, as Schama (2002, 146) notes 'the British revolution had been put out to grass', both literally, through the development of public parks, and metaphorically. It had helped that the economy improved in the 1850s and events such as the Great Exhibition provided a diversion for potential discontent. In 1867, the *Second Reform Act* increased the adult male representation in urban areas, with a further widening of the political franchise in 1884. By 1900, there were about 300 public parks across Britain, with the majority of them built after 1880.

In the 50 years since Robert Slaney had first proposed the idea of a park in every town and city, this was now coming to fruition. The main difference was that these later parks were not on the outskirts of towns and cities but in the crowded residential areas. This was only made possible by the rise of town planning incorporating green areas. Local urban authorities had gained more

power from the centre, most notably through the *Public Health Act* of 1875.[17] This Act allowed local authorities to acquire and maintain land for recreation and raise government loans to do so, without having to go through the process of individual legislation. This increased the confidence of local councillors and the earlier grand large projects gave way to smaller ones, helped also by the *Open Spaces Act* of 1881, as it was finally recognised that a lot of the large parks were inaccessible to many of the residents.

Private pressure groups started to get involved, for example Lord Brabazon set up the Metropolitan Public Gardens Association in 1882. The Association's aim was to buy up sites such as burial sites, waste grounds and enclosed squares, convert to a park or playground and then hand over to local authority in the capital. The Commons Preservation Society[18] founded in 1865, was designed to keep open spaces near large towns, particularly London. Through their lobbying, the 1866 *Metropolitan Commons Act* that aimed to improve, protect and manage commons around London, was passed. By highlighting the fact that some landlords of commons were trying to deny access and profit from them, the parks movement became part of a more radical Liberal agenda, attacking these so-called 'feudal' landlords (Malchow 1985, 101). The fight for commons preservation also contributed to local authorities acquiring open spaces for example the Leeds Corporation finally bought Roundhay Park in 1870. These early pressure groups were to be very influential in the politicisation of the conservation movement of the twentieth century.

In the late-nineteenth century, another garden designer took up the cause for more green urban spaces. William Robinson proposed that a more systematic approach should be taken with regard to planning parks in Britain's towns and cities. He contrasted the policy adopted in France under Emperor Napoleon III with that in Britain, noting (1869, xviii) that 'a great many of us Britons are apt to connect real city improvement with autocratic government' as a possible reason. He also questioned the types of public parks that were being created: essentially large vanity projects that were too expensive to create and maintain, particularly given the penchant for labour intensive planting of tender species (Robinson 1869, xx–xxii). His challenge, such as giving the city of London the power to develop a plan for its parks, gardens and promenades, made landscape planning an important part of public debate, especially how public funds were allocated (Conan and Wangheng 2008, 7–8). It was clear that the previous policy of using public parks as a means of keeping the general public happy to avoid revolution, was becoming less tenable. Parks and other improvements in the urban areas were not sufficient for those demanding greater democratic rights.

The idea that places such as Victoria Park in the East End of London could draw prosperous householders into the area and thereby improve the 'moral fibre' of the slum dwellers, had proved to be wildly optimistic. The wealthy did not come to the area just because a park had been built and ironically by the late 1880s, Victoria Park was a favourite gathering place for trade unionists and socialist speakers (Malchow 1985, 123). It was also not true that the large

parks built on the peripheries of the urban centres 'to improve the air quality'[19] significantly contributed to better public health. Most of the diseases that were the major killers, for example cholera and typhus, were not transmitted by 'bad air' and thrived in the densely populated slum areas, which were ignored by most politicians (Layton-Jones 2010, 7). That is not to say that the later parks were free from political propaganda, both at a national and local level. They became a place where the British Empire, its wars and the royals were celebrated. Local achievements by politicians were given prominence such as the Stewart Memorial Fountain in Kelvingrove Park, erected in 1872, to celebrate the bringing of clean water from Loch Katrine to Glasgow (Robert Stewart had been responsible for this), much like the Medici bringing water to Florence (see Chapter 3). Conway (1996, 7) describes parks as 'practical, physical landscapes set in urban environments and they reflected the social, economic and political imperatives of the time'.

For the early advocates of public parks, such as Slaney, they were about control. A moderate reformer, he wanted to improve the life of the majority of British citizens but not at the risk of outright revolution, which he believed to be more harmful in the long run. Public parks provided the answer in his mind and the campaign by him and other politicians in the urban districts meant that the case for having them was not seriously challenged. It was helped that a lot of private money went in to, and subsequently benefited by, the creation of these urban parks. After a period of decline following the Second World War, public parks in Britain are once more receiving large amounts of money and attention. The Heritage Lottery Fund, the main source of funds, with over half a billion pounds to date for their 'Parks for People' programme, have made parks a priority. They state (2006, 3) that 'urban parks are seen as integral to not only the national heritage but to the fabric, character and quality of life of all our towns and cities'. While the original intentions of the creators of the first parks may be questioned, their legacy continues to be appreciated to this day.

Notes

1. Robert Slaney in the debate to set up the 1833 Committee says 'he now rejoiced at the delay which had thus taken place; for, in the mean time, a Reformed Parliament had been summoned, and there now sat as Members of it, several persons, Representatives of those large towns that were most interested in the present question' (Hansard 21 February 1833, 15, 1049–59).

2. Six Points of the Charter were: manhood suffrage, vote by ballot, equal electoral districts, payment of MPs, annual parliaments and abolition of property qualification for candidates.

3. It was claimed to have 6 million signatures, nearly a quarter of Britain's population.

4. Concern over the use of public spaces is shown by the Duke of Wellington's remark 'What was the meaning of two friends of Government collecting a mob in Hyde-park and the Regent's-park, on one of the days in which the House of Lords was discussing the Reform Bill?' (Hansard 27 February 1832, 10, 731–63) and Chartist meetings were held at Victoria Park in 1848.

5. It became fully open to the public in 1841.

6. Broadly the importance of actions should be determined by the amount of happiness (and pleasure) they bring to the greatest number of people.

7. Six hundred £5 pound shares were sold (Ballard 1985, 66)

8. www.derbyarboretum.co.uk [consulted 27 January 2011].

9. Land that had restrictions on its use, by virtue usually of previous owners' wishes.

10. 'A Memorial, signed by 30,000 inhabitants of the Tower Hamlets, was presented to Her Majesty in 1841, praying Her Majesty 'to grant the inestimable benefit of the space' now included in Victoria Park 'as a Royal Park' (Hansard 24 February 1887, 311, 478).

11. Hansard, 11 May 1841, 58, 257–8, now known as Lancaster House.

12. That is funded and maintained by the local council for the benefit of the local population, where entrance was free.

13. £30,000 was subscribed (Hansard 19 May 1853, 127, 388–422).

14. Benjamin Disraeli said that 'he … considered that Battersea Park ought never to have been made. He objected to the expenditure of so large a sum of money as £500,000 upon the formation of such a park. He wished to stop the system, for having constructed that park, why should they not be called upon to-morrow to make a park at Finsbury?… Such objects ought, in his opinion, to be accomplished by local funds … He thought the time had come when they must put an end to these grants of public money for local objects' (Hansard 5 August 1853, 129, 1407–14).

15. Henry Drummond 'said, that it had always appeared to him that public works were carried on at a much greater cost than similar works executed for private individuals. The fact was, that persons made enormous profits out of Government contracts' (Hansard 19 May 1853, 127, 388–422).

16. www.crystalpalacefoundation.org.uk/History/default.asp?ID=2 [consulted 31 January 2011].

17. Relevant section from Act: 'Any urban authority may purchase or take on lease lay out plant improve and maintain lands for the purpose of being used as public walks or pleasure grounds, and may support or contribute to the support of public walks or pleasure grounds provided by any person whomsoever. Any urban authority may make byelaws for the regulation of any such public walk or pleasure ground, and may by such byelaws provide for the removal from such public walk or pleasure ground of any person infringing any such byelaw by any officer of the urban authority or constable' *Public Health Act* 1875, c55, part IV.

18. Now the Open Spaces Society.

19. It is often debatable whether they even did this if the surrounding area was heavily polluted (Layton-Jones 2010, 8).

CASE STUDY SEVEN

Birkenhead Park, Merseyside

In 1850, the American architect Frederick Olmsted visited the newly opened Birkenhead Park. He describes the impact that the visit had on him:

> 'Walking a short distance up an avenue, we passed through another light iron gate into a thick, luxuriant, and diversified garden. Five minutes of admiration, and a few more spent in studying the manner in which art had been employed to obtain from nature so much beauty, and I was ready to admit that in democratic America there was nothing to be thought of as comparable with this People's Garden. Indeed, gardening, had here reached a perfection that I had never before dreamed of.' (Olmsted 1852, 79)

In 1857 Olmsted was appointed as the superintendent for the proposed Central Park in New York. His winning design (with Calvert Vaux) for the park in 1858 owed much to his visit to Birkenhead. It was not only a similar physical layout that linked the two, it was also the rationale behind their creation. Both were hailed as masterpieces of design (Figure 7.4) but they were driven by political considerations. The parks were meant to be democratic institutions and have a 'civilising' effect on the population. It was also no coincidence that both sites were in undesirable and uneconomical areas (Henneberger 2002, 14). In the case of Central Park, the winners of the competition had close links to the Republican park commissioners. Olmsted had been given the post of 'park superintendent, with the suggestion, as…[he] later recalled, that he would be a "Republican the

FIGURE 7.4. Birkenhead Park Sale Plan 1850.
IMAGE COURTESY OF WIRRAL ARCHIVES SERVICE

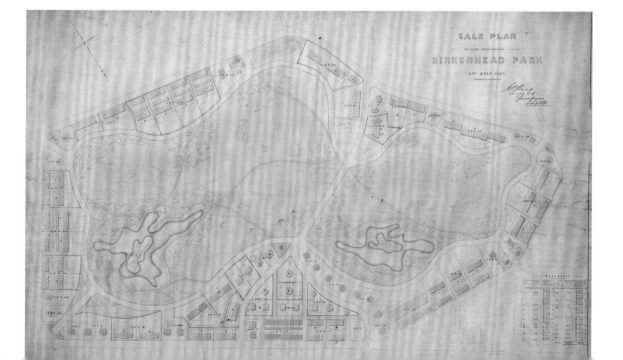

Democrats could live with" (Blackmar and Rosenzweig 1992, 119). The politicians thus wanted to control this important piece of urban planning.

The idea for the park at Birkenhead had been initiated by Isaac Holmes, a Liverpool councillor and brought to fruition by the efforts of Sir William Jackson, the chairman of the local Improvement Committee. Birkenhead in Cheshire, which faces Liverpool across the River Mersey, had traditionally been a rural environment. Liverpool had been expanding rapidly in the eighteenth century on the back of transatlantic trade. The introduction of the steam-powered Mersey Ferry and the subsequent dock development in the 1820s transformed Birkenhead. In 1833, the Birkenhead Improvement Commission was set up to oversee the development of the area. Eight years later, Birkenhead had a population of over eight thousand. In 1842, the commissioners announced that they were going to purchase land for the construction of a public park and cemetery. A private Act of Parliament approved this the following year, allowing a loan of sixty thousand pounds to be made from central government. The loan, on behalf of the city ratepayers, made 'the proviso that not less than seventy acres [28.25 ha] was to be set aside for the "free recreation of the town's inhabitants"' (Henneberger 2002, 17).

The councillors wanted to improve the conditions of the local inhabitants and believed like many others in Britain that the provision of public parks was one of the answers. They had seen the model of the Princes Park in Liverpool, designed by Joseph Paxton in 1842 and wanted to replicate this. The main difference was that the former was funded through private subscription and only part of the park was open to the general public (Layton-Jones and Lee 2008, 16). Birkenhead Park instead was paid for by public money, with some part of money being recouped by selling housing around the perimeter (Figure 7.4) and all of it would be freely accessible to the local inhabitants. However these city grandees were not entirely altruistic. The value of the land increased seven-fold between the initial proposal and the first auction of housing plots in 1845 and many of the Commissioners personally benefited from this (Conway 1996, 15).

In all the Commissioners bought 226 acres (91.2 ha) of which 120 acres (48.4 ha) were for the public park. Joseph Paxton was approached in August 1843 to design and construct the park at a fee of £800. He took his inspiration from the designed landscapes around country mansions (Figure 7.5), effectively creating a rural idyll in an urban setting. He planted many large trees and shrubs to act as a screen and included winding paths to maximise the space available. His biggest challenge was that the land was marshy and needed to be drained. He solved the problem by the creation of the lakes (Figure 7.6) and the drainage system laid alongside the road around the park. Another feature he introduced was a series of rocky outcrops (Figure 7.7) that also gave the impression of a natural landscape (Taylor 1995, 206).

Echoes of the country estate were found in the array of buildings in all sorts of styles. There was the Grand Entrance (Figure 7.8) designed by Lewis Hornblower, together with a further six lodges around the perimeter. Inside the grounds itself was the Swiss Bridge (Figure 7.9) and the Roman Boathouse (Figure 7.6). In keeping with the spirit of the creators' aim to encourage use of

FIGURE 7.5. Lake in
Upper Park, Birkenhead
Park.

FIGURE 7.6. Lake and
Boathouse in Lower
Park, Birkenhead Park.

FIGURE 7.7. Rockery,
Birkenhead Park.

the park and take the population away from the local taverns, areas for sport were included. Birkenhead Park Cricket Club was founded in 1846 and its Rugby Football Club followed in 1871. The Park was officially opened on 5 April 1847. The work had been completed some months previously, but the formal ceremony was delayed to coincide with the opening of the new Birkenhead dock complex, another important project of the Improvement Commission.

FIGURE 7.8. Grand Entrance, Birkenhead Park.

FIGURE 7.9. Swiss Bridge, Birkenhead Park.

The initial plan was that the money spent on the project, estimated at £127,000 by the *Liverpool Mercury* at the park's opening, would be recouped by the sales of the housing on the reminder of the site. However the late 1840s was a period of economic instability and the demand for the more premium houses was less than expected. In the auctions, some of the lots for housing were not sold and they became part of the park, so it is unlikely that all the costs were covered. Birkenhead Park though 'illustrated the potential of using the premium on property values created by parks as a financial *raison d'etre* to pay for public parks in urban areas' (Crompton 2007, 221–2) and it was often cited by other municipal authorities in their arguments.

Despite many problems, including being bombed in the Second World War, it remained an important part of the civic pride of Birkenhead for the next 150 years. It certainly fulfilled many of the aspirations of its initiators although they may not have been that pleased when it became the venue for political meetings. In the 1895 election campaign, the Liberal candidate, William Lever, addressed a crowd outside the Grand Entrance. In 1976 a Friends of Birkenhead Park group was set up to preserve this important piece of national heritage. In 2004 a Heritage Lottery Fund grant was awarded to the park of nearly 12 million pounds and the park has now been restored to its former glory.

CHAPTER 8

Botanic Gardens, Politics and Empire

A national botanical garden would be the centre round which all minor establishments of the same nature should be arranged, they all should be in the control of the chief of that garden, acting in concert with him, and through him with each other … aiding the Mother Country in everything that is useful in the vegetable kingdom. Medicine, commerce, agriculture, horticulture, and many valuable branches of manufacture, would derive much benefit from the adoption of such a system. From a garden of this kind, Government would be able to obtain authentic and official information on points connected with the founding of new colonies: it would afford the plants these required.

This was from the report (House of Commons 1840, 5) by Lindley into the royal botanic gardens at Kew, which argued that it should be taken into public ownership, principally for its role in fostering prosperity across the Empire. This was a time of reform within the political system in Britain and Drayton (2000, 129) argues the 'story of how Kew became public provides a parable of the politics of reform in the nineteenth century'. The transfer to state control was granted in 1840, and together with the botanic gardens in Edinburgh and Dublin, they have been maintained by their respective countries ever since. The international role of Kew remains. Its annual report (2010, 3) states its mission 'is to inspire and deliver science-based plant conservation worldwide, enhancing the quality of life'. This international focus is inextricably linked to its former role in the British Empire and the latter's trade, where a symbiotic relationship developed between botanic gardens and their respective colonies.

Just as the Empire was controlled at arms length from London, so Kew built up an informal network of the botanic gardens based in the colonies: a model that was copied in other European empires (Drayton 2000, 254). While these gardens did have significant scientific pedigrees, their main purpose was to aid their colonies' economic growth, the key to maintaining political stability. Through the transfer of key crops such as tea, cinchona (the basis for quinine) and rubber to Imperial territories, the botanic gardens had a substantial impact on the supply of these goods to the Empire's industries and the economic advantages that it brought. In 1854, less than one per cent of tea imported into Britain came from the Empire, by 1913 the figure was 87% (Cain 1999, 43).

The 'nationalisation' of Kew and other colonial botanic gardens in the 1840s came at a critical time for the Empire when the government in London was

pursuing a policy of free trade.[1] For this to work to Britain's best advantage, more goods had to come from the colonies and thus the push to transfer economically important crops to parts of the British Empire where they could be grown successfully. This was not a new idea. Potatoes from the New World had been 'trialled' in a private botanic garden in 1596 (Brockway 2002, 39) and subsequently became the staple crop in many European countries. The demand for expensive spices from the Far East led to these plants being transplanted and grown in newly acquired colonies at a lower cost. The same happened with the sugar industry that was developed in the West Indies in the late seventeenth century. Crops were also grown to *support* fledgling colonies such as tobacco in Virginia in the 1620s. Without it, the colony would have struggled to survive as other crops that had been tried, had failed.

Botanic gardens have been described as the 'world in a garden' because of their original aim to encompass all known plant species. While that was impossible in any one place, the advantage of the network of colonial gardens in the extensive British Empire (where the sun never set …) was that a greater diversity of plants could be grown. The Enlightenment ideas in the eighteenth century led the government to support the study of plants in the belief that the 'Empire might be an instrument of cosmopolitan progress, and could benefit the imperialised as well as the imperialisers' (Drayton 1998, 250). The expanding domain of the East India Company, in the late eighteenth century, was criticised for being merely an exploitative operation. It therefore tried to be seen as 'an enlightened ruler in India and the encouragement of scientific investigation was a way of appearing enlightened' (Thomas 2006, 166). In the mid-nineteenth century, when the state took formal control of all its colonies, botanic gardens became an instrument of imperial expansion and government. These colonies needed to prosper to be self-sustaining, as the cost of the Empire to Britain was continually questioned. In 1776, Adam Smith wrote in his *Wealth of Nations*: 'if any of the provinces of the British empire cannot be made to contribute towards the support of the whole empire, it is surely time that Great Britain should free herself from the expense of defending those provinces in time of war, and of supporting any part of their civil or military establishments in time of peace'.

Even now, there is a debate amongst historians as to whether it was to Britain's benefit economically to have built up and maintained such a large area of overseas territories (Porter 1999, 25–7). The Empire only ever provided at most thirty per cent of imports into Britain and a similar share for its export trade during the nineteenth century (Cain 1999, 32–5). The view that having overseas lands contributed to the mother country's and its own economy through agriculture was an entrenched one and dated back to the first thoughts of colonies in the late sixteenth century. Richard Hakluyt, in his *Discourse of Western Planting* from 1585, supporting the establishment of Virginia, states: 'That spedie plantinge in divers fitt places is moste necessarie upon these luckye westerne discoveries for feare of the daunger of being prevented by other nations w^ch have the like intentions' (Samson 2001, 22–3). It was more though than

just economics: a poor colony with problems feeding its inhabitants would be a difficult one politically for the ruling country's government.

First botanic gardens and their purpose

Plants have been grown in the garden for specific purposes since antiquity. In the medieval period, monasteries had an 'infirmary garden' that consisted of plants used in herbal remedies. There is some debate as to whether these were indeed 'botanic gardens', if you take the definition of the latter to be 'an establishment where plants are grown for scientific study and display to the public' (*Oxford Dictionary of English*). The writings of Greek botanists such as Dioscorides[2] led physicians of the medieval period to lay out gardens with useful plants that came to be known as *hortus medicus* or 'physic gardens'. In Islamic Spain, Ibn Wafid, a noted physician and pharmacologist, created a garden in Toledo[3] in the eleventh century. Ibn Bassal took his ideas to Seville, when the Christians captured Toledo in 1085, and another physic garden was created at Guadix in the late twelfth century (Ruggles 2000, 18 and 22–3). With the foundation of the first universities in Europe in the thirteenth century, new physic gardens were created, such as the one at Montpellier's medical school in France.[4] Plants were also being grown for economic purposes as early as the eighth century in Spain. There was a report[5] of pomegranate seeds from Syria being planted in the royal gardens and then distributed amongst the people's groves.

The idea of trying to grow *all* known plants may have stemmed from the idea of the Garden of Eden in the Bible (Prest 1981). Before the explorations of the fifteenth century, it was believed that the Garden of Eden actually existed, albeit outside the known world. When this was proved false with the discovery of America, the idea was to recreate the paradise garden by collecting specimens from around the world. This would become 'an epitome or encyclopaedia of creation, just like the first Garden of Eden had been' (Prest 1981, 42). This notion, together with Renaissance ideas of scientific enquiry, led to the first true botanic gardens. Designed for scientific study, they were created first at the universities of Pisa and Padua in Italy. The former was founded in 1543[6] by Cosimo de' Medici, the Florentine ruler. He gave a grant of land to the renowned herbalist and physician, Luca Ghini, for the purpose of teaching botany. In 1545, Ghini recorded that he had collected plants, 'which I have planted in a garden of Pisa to be useful for the students' (Garbari 2006, 4).

Padua botanic garden (Figure 8.1) was the result of a proposal by Francesco Bonafede. In 1533 he had founded the chair of 'simples'[7] (*Lectura Simplicium*) at the university, the first in Europe. In May 1545, the Senate of the Republic of Venice voted by decree for the garden's construction and its first curator was Luigi Squalerno, who had been a student of Ghini. Both these gardens had four quarters representing the four known continents of the world, with plants grouped according to their family at the time. This quadripartite layout, which might have been inspired by Islamic gardens,[8] was used as a model for future

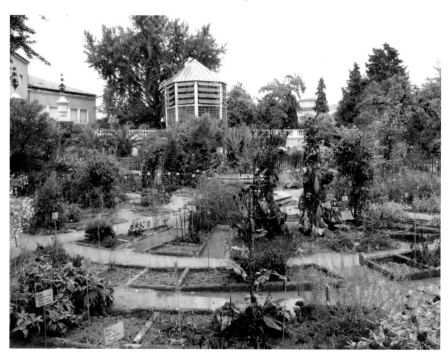

FIGURE 8.1. Planting beds at Padua Botanic Garden, Italy.

gardens in the later sixteenth and seventeenth centuries. Padua was unusual in having a circular outer wall, rather than the usual square. It is believed that it was done to make best use of the slightly sloping site (Tomasi 2005, 107). In both cases, it was political leaders who were actively set them up. This was consistent with Renaissance rulers using gardens as status symbols to demonstrate their wealth and cultivation (both literally and metaphorically!). As botanic gardens developed their collections of exotic plants, Drayton (2000, 26) points out that they 'were not merely status symbols … From a world in a garden, men might organise the government of the world'.

Leiden, in Holland, started as a physic garden in 1587 but Clusius, its first scientific director, remodelled it seven years later as a botanic garden (Figure 8.2). The change reflected the new plant material that was coming in particularly from the Americas and Southern Africa. Until then, the gardens had mainly concentrated on plants from the Mediterranean. Prior to his appointment, Clusius had laid out a garden for the Emperor of Austria. He brought with him to Leiden, a large collection of the newly fashionable tulips and other bulbs, which formed the basis of the lucrative Dutch bulb trade.[9] With the creation of the Dutch East India Company in 1602, Clusius wrote to their Board, asking that physicians and other travellers collect exotic plant material for study at Lieden (van Uffelen 2006, 6). The more tender specimens needed to be protected and as a result, the first glasshouses were developed:[10] an important technology that was to revolutionise the way plants could be grown.

In Britain, there were a few private physic gardens in the sixteenth century, such as those created by the herbalists William Turner, near Kew and John

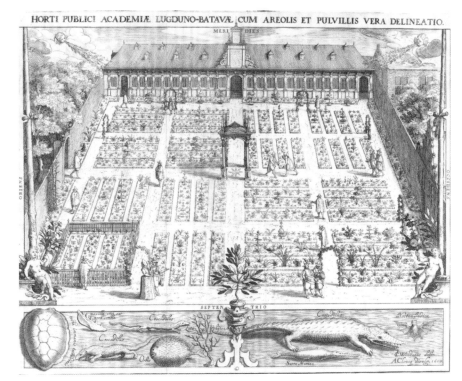

FIGURE 8.2. The Botanical Garden of the University of Leiden, print by van Swanenburg 1610.

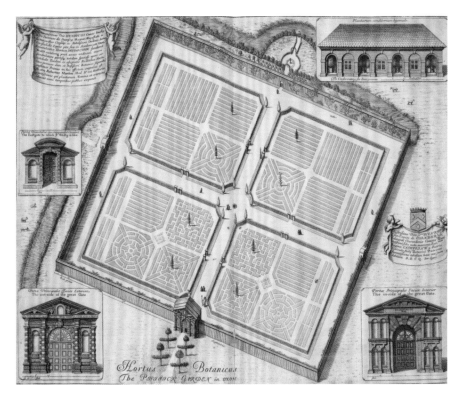

FIGURE 8.3. Oxford Botanic Garden, print by Loggan 1675.

Gerard in Holborn.[11] Both men published famous 'Herbals' or list of plants. The first botanic garden in England was founded in 1621 at Oxford University[12] (Figure 8.3), modelled on those in Italy such as Padua. It relied on plant hunters such as John Tradescant, and the increasing fleet of English merchant[13] and naval ships, to bring back exotic plants. The Chelsea Physic Garden was unusual in that it was founded by a group of professionals, the Society of Apothecaries, in 1673 and not linked to a university. Designed to further their professional knowledge, it is there that John Evelyn[14] in 1685 describes the first heated glasshouse, protecting a cinchona tree, known to be a source for quinine.

While exotic plant collections were becoming prized amongst royalty and nobility, largely in a game of one-upmanship, these could not be regarded as botanic gardens in the true sense. The foundation of the *Jardin des Plantes*[15] in 1626 by Louis XIII's physician, Guy de la Brosse, changed this. It was set up in direct competition to the one founded at the University of Paris in 1594, showing that it had a political rather than a purely academic role. Louis XIV and his minister, Colbert, recognised its potential and sponsored missions from 1670 onwards to Canada, China, French West Indies, the Levant and Abyssinia to collect new specimens for it (Drayton 2000, 17). The French royal botanic garden continued to expand throughout the eighteenth century and in 1772, Louis XV approved its remodelling at a cost of 52,000 livres (Drayton 2000, 77). This was an important project for the French state and until the French Revolution, they led the way in botanical development. The value of these gardens as a means of promoting trade, exploration and ultimately colonisation became firmly established. While the 'academic' or university botanic gardens continued and their numbers increased,[16] it was this new type of state-sponsored operation[17] that took the lead in developing and moving plant material around the world. The development of Kew in Britain as a royal botanical garden in the 1760s came quite late in relation to its European peers.

Economic botany, trading companies and Empire

The link between economic botany,[18] trade and ultimately empire is shown by the fact that the first English 'colonies' in Ulster and then America, were described as 'plantations' (Canny 1998, 8). Indeed the official body established in 1660 to oversee such projects in Britain was called the Council of Trade and Plantations. The way in which European countries that developed overseas territories from the sixteenth century used botany and specifically botanic gardens, reflected their political structures (Schiebinger and Swan 2005, 4). The first important empire was that of Spain, an absolutist monarchy, who saw its possessions abroad as part of the Iberian socio-political structure. They were countries within the greater Spanish state, whose main function was to provide revenue through the extraction of natural resources. There was therefore little need for large-scale botanical expertise as most of the resources were minerals. The Portuguese and later on the Dutch were both 'trading post empires' but

the former, with its state control of trade, did not develop any botanic gardens until the late eighteenth century. The Dutch Republic, by contrast, relied on private enterprise not only for its trade but also for the application of scientific knowledge, especially in regard to the transfer of important economic crops. They were at the forefront of developing botanic gardens in the seventeenth century.

The absolutist monarchs of France saw their gardens as a means of self-promotion (see Chapter 4) and botanic gardens both at home and abroad were an extension of this (Mukerji 2005). Providing the best scientific resources at home and abroad, the French state provided a model that eventually Britain would follow. It was no coincidence that St Domingue (now Haiti) was the single richest and most productive colony in the world in 1780 (Schiebinger and Swan 2005, 5). However the loss of colonies to Britain and the Revolution put paid to this royal scientific network. Up until the 1780s, Britain had adopted the Dutch private enterprise model both for trade and botanic gardens, reflecting the power of parliament in a constitutional monarchy. The rapid accumulation of overseas dependencies forced a rethink on the degree of state control necessary. Progress was slow and it was not until sixty years later that the full scope of the colonial botanic garden network started to be exploited by the British state.

The 'plantations' in Virginia were meant to be settled and become not only self-sufficient in terms of food but also be commercially viable through the production of crops such as mulberry trees, wheat, maize, flax and oilseeds (Canny 1998, 10). Such hopes were ill founded as these crops failed to be economically viable. In 1624, the state took over from the failed trading company[19] and the lands became the first Crown colony. The successful trial of tobacco plants in 1612 (Musgrave and Musgrave 2000, 24), brought from the Spanish West Indies, ensured the colony's survival and future prosperity. Similarly in the Caribbean islands that had come under British control,[20] a thriving sugar industry developed to supply increasing domestic British demand by the 1660s, using plants that had originally been trialled by Columbus in the region in 1494.[21] The eighteenth century saw a significant expansion of territories controlled by British interests, either directly by Government or through state-sponsored trading companies. By 1800, the British were the dominant European colonial power, despite the loss of the American colonies, mainly at the expense of the French and Dutch.

The British Empire remained firmly based on trade, not only in goods and services but also in knowledge. From the establishment of the Royal Society in 1660, Britain had become one of the leading scientific centres. During the eighteenth century, the possession of an expanding empire allowed not only the British scientist increased opportunities for study, but it also 'spread across the world ... British learned societies and botanical gardens' (Marshall 1998, 18). This was largely 'an informal empire of gentlemanly amateurs ... [where] observations, information, specimens, and argument, journeyed from physicians

in Edinburgh to absentee planters in London, parsons in New England, and merchants in Calcutta and Canton' (Drayton 1998, 237). In this the British were lagging behind their Continental neighbours. As early as 1688, John Ray, the botanist and author of *Historia Plantarum* (History of Plants), noted the large amount of research undertaken by the Dutch in the tropics (Drayton 1998, 237). Their enviable network was best typified by their development of the coffee industry.[22]

Yet it was not until the middle of the eighteenth century that the British state took an active role in promoting science, spurred on by the activities of its main enemy, France. In the important French botanic gardens, such as the *Jardin des Plantes*, valuable plants were trialled before being sent to the colonies, most famously coffee from Amsterdam, which was successfully transferred to Martinique in 1723 (Brockway 2002, 51). The French *Ministère de la Marine et Colonies* despatched botanists to survey their colonies from the 1730s and set up colonial botanic gardens with the aim of transferring economically important crops such as spices from the East to the West Indies. The French colonies' success by the 1780s in growing cloves, black pepper and other valuable crops signalled the end of the traditional Eastern spice route, dominated by the Dutch.

By contrast in Britain, the transfer of crops had been mainly promoted by a private organisations, such as the Society of Arts. In 1759, they issued a reward to the first person 'to preserve the seeds of spice trees' (Drayton 2000, 64) from the East Indies and they were also instrumental in setting up the botanic garden in St Vincent. Faced with an increasing national debt, Pitt's government looked to improve revenues from the colonies from 1783. The state increasingly got involved in the acclimatisation of economic crops within the British Empire, leading to the network of British colonial botanic gardens that were to be so important both to domestic partners such as Kew and arguably to the continuing success of the Empire itself.

Colonial botanic gardens

In 1652, the Dutch East India Company established a trading post in the Cape in South Africa and set up a garden to grow provisions for its ships. Over time, as the cargo increasingly included plants, this site became a place to trial plants from all over the world and also to send them to new destinations (Prest 1981, 48–9). In effect it became a botanic garden. The first overseas French botanic garden was established at Cayenne, French Guiana in 1732, where coffee was successfully introduced. The French had recognised early on the economic benefits of the transfer of crops. In the 1730s, Buffon, the head of the *Jardin des Plantes*, actively promoted the collection of plant material via the French naval network. His aim was to have a garden that reflected the status of the French king in having the most complete collection of plants. This spirit of plant collection encouraged the French East India Company to set up experimental

gardens in Pondicherry (India), Mauritius and Réunion (Drayton 2000, 75). The garden in Mauritius became a fully-fledged botanic garden in 1753 and by 1770 it had started growing the valuable spices of cinnamon, pepper, nutmeg and cloves.[23]

John Bartram had planted an experimental garden in Philadelphia in 1728 (Drayton 2000, 65) but the first true botanic garden in a British colony was on the Caribbean island of St Vincent. Established in 1765, it was the result of advertisements placed between 1762 and 1766 in the *Transaction of the Society of Arts*. This offered rewards to anyone who:

> 'should cultivate a spot in the West Indies in which plants, useful in medicine and profitable articles of commerce might be propagated and where a nursery of the valuable products of Asia and the distant parts might be formed for the benefit of His Majesty's colonies.' (Guilding 1825, 5)

St Vincent's Governor, General Melville, cleared 20 acres (8 ha) of land at his own expense, further extending the acreage in 1766. The gardens were given to the army surgeon, Dr George Young, to look after, an echo back perhaps to the physic garden. The garden had a rather chequered history and the Government took it over in 1785, after a period of neglect. Although it was finally closed down in 1822,[24] it has a place in history as the destination for the cargo of breadfruit plants on the ill-fated *Bounty* voyage between 1787 and 1789 (where the famous mutiny took place). In Jamaica, it was the planters who took the initiative in 1775, by voting for the establishment of two botanic gardens. The second of these, created at Bath in 1779, became an important hub in the Caribbean. These later West Indian gardens were a result of the sugar industry becoming not only uneconomic but also politically embarrassing with the rise of the anti-slavery movement. Efforts were made therefore to find alternative cash crops.

It was the garden established in Calcutta in 1786 that was to become the most important botanical centre outside of Britain (Figure 8.4). Although the East India Company sponsored the initiative, it had strong support from Sir

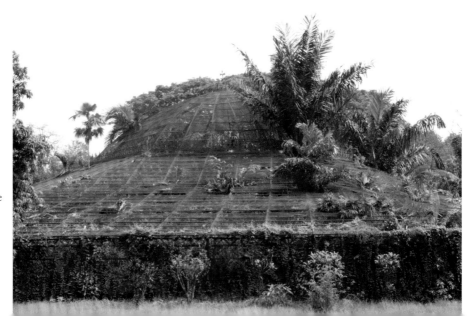

FIGURE 8.4. Glasshouse at Calcutta Botanic Garden, Kolkata.

Joseph Banks, a key adviser on such matters to the British Government. The initial proposal had come from Robert Kyd, Military Secretary to the Board of Inspection, whose main concern was the alleviation of famine amongst the local population. The local EIC government had argued for grain depots as a solution (Grove 1995, 334) but Kyd believed a botanic garden would be better as it could test out crops such sago palms, which had been used successfully in Sumatra. In his second letter to the Bengal government, he also points out the potential economic benefits to sway the Company officials:

> 'I take this opportunity of suggesting … a Botanical Garden … for establishing a stock for disseminating such articles as may prove beneficial to the inhabitants [of Bengal], as well of the natives of Great Britain, and which ultimately may tend to the extension of the national commerce and riches.' (Thomas 2006, 167)

The company officials enthusiastically accepted Kyd's proposal, as did Banks with whom the EIC consulted. It fitted in with the idea that Banks had of a network of botanic gardens, first suggested by Patrick Russell.[25] The first of these was botanic garden on the island of St Helena in 1787. It served two purposes: firstly as a mid-way point between the East and West Indies for plant exchanges and secondly as a way of rescuing the colony from drought (Drayton 2000, 120). The Calcutta garden thrived under the stewardships of Kyd and William Roxburgh from 1793, despite costs being much higher than originally anticipated.[26] The EIC (and ultimately the British government) had to demonstrate they were not just grabbing territory but improving the lot of the local population and could cite the generous support of the garden as an example.

Banks too suggested and drew up a plan for a botanical garden in the newly acquired territory of Ceylon in 1810.[27] After the first site chosen was found to be unsuitable, the gardens were moved to Peradeniya (Figure 8.5) in 1821. To start with it was mostly planted with coffee and cinnamon as cash crops but by the middle of the nineteenth century, it took on a new role as a scientific centre for developing new crops, particularly cinchona and rubber.[28] The botanic garden established at Bogor in Java by the Dutch in 1817, in many ways played an equally vital role for the British Empire.[29] In 1848 it received four oil palm seeds from West Africa and the resulting plants were the foundation of both the Dutch Javan and British Malaysian palm oil industries. Between 1860 and 1879, the gardens in Ceylon and at Bogor exchanged seeds and information about the various cinchona species, in order to find which one yielded the highest levels of the active ingredient, quinine (Brockway 2002, 119).

As the British acquired more territories at the beginning of the nineteenth century, so the network of colonial gardens grew, taking over existing gardens such as the French one in Mauritius and the Dutch one in the Cape or the establishing new ones. In Singapore, the colony's founder, Stamford Raffles, set up a garden in 1822, although it only survived until 1829. In 1802, Governor Picton planned a garden in Trinidad, newly acquired from the Spanish. Completed in 1818, five years later it acquired the collection of the defunct

FIGURE 8.5. Peradeniya Botanic Garden, Sri Lanka.

St Vincent garden (Pemberton 1999). For the new Australian penal colony, founded in 1788, 'Governor Phillip had collected both at Rio de Janiero and at the Cape many economic plants, while he had brought wheat and other cereals from England' (Maiden 1906, 206) and started an experimental garden that became the Sydney Botanic Garden in 1817. From being the exception, the colonial botanic garden was now becoming the norm, however by the 1840s many of the gardens had 'sunk into lethargy, gradually becoming the preserve of the adjacent governor's domain' (McCracken 1997, 18). The impetus for their revival came with the state taking over control of Kew and the policy of the latter's far-sighted Directors.

Banks and the central role of Kew

Sir Joseph Banks was a wealthy amateur botanist, who had accompanied Captain Cook on his voyage around the world from 1768. In 1771, George III invited Banks to be his unofficial horticultural adviser at Kew and in this role he was responsible for sending out many plant-hunting expeditions to bring back ornamental and economic plants for Kew. It was his unofficial role as the promoter of science, particularly botany, in the government that was critical in the development of both Kew and its colonial cousins. He intervened both in the setting up of privately funded operations such as Calcutta and St Helena and also those in Crown colonies like Ceylon. Above all, he wanted Kew to be the leading botanic garden and to outstrip its rivals in France and Austria. To do this, he demanded that 'as many of the new plants as possible should make their first appearance at the Royal Gardens' (Desmond 1995, 91).

It was not only plants and seeds that were being transferred from one botanic

garden to another. Many of the people associated with Kew and Banks, either gardeners or plant hunters, subsequently found positions at colonial gardens, setting a trend that continued well into the twentieth century. The first of these were Christopher Smith, who went to Calcutta in 1793, and James Wiles, appointed superintendent at Jamaica in 1794. William Kerr appointed Superintendent in Ceylon in 1810, was followed by another Kew gardener, Alexander Moon, two years later (Desmond 1995, 125). Kew's influence even spread to non-British gardens when James Hooper was made the head gardener at the new Dutch garden in Java in 1817. In proposing Hooper for the post, Reinwardt, professor of botany in Amsterdam and Leiden and chief proponent, stated that Hooper 'has had a service of six years in one of the most renowned and richest gardens of Europe, viz., in the Royal Gardens at Kew' (Kew 1893, 174).

Kew was dealt a double blow in 1820 by the death of both George III and Joseph Banks. Together they had built up a leading botanic garden, whose influence was felt worldwide. George's successors showed little interest in the garden and slowly over time, expenditure on it was reduced.[30] Its role as the national botanic garden was being challenged by new provincial gardens,[31] the first of which was Liverpool, started by William Roscoe in 1803. Founded by private subscriptions, it was one of the ways that the newly emergent industrial cities sought to demonstrate their cultural identity and led to the creation of urban parks in the nineteenth century. In Liverpool's case, it was to distance itself from the more unsavoury aspects of basis for the city's wealth, slavery (Law 2007, 181). With the accession of Queen Victoria in 1837, more royal cost cutting was needed and one of the areas under scrutiny were the royal gardens. Ironically, this was to be the salvation of Kew, as the man appointed to lead a commission to review the gardens was John Lindley and as Desmond (1995, 143) points out without his vision, 'it is doubtful whether Kew would have survived the Treasury's cost-cutting exercise'.

Lindley's brief on Kew specifically was to determine whether it should remain as a royal garden that opened to the public or fulfil its role as a true botanic garden. In his report of 28 February 1838, he was critical of its present state, particularly with regard to its role as the leading scientific garden. He complained that:

> 'a great desire is felt in the Colonies to produce plants from this country; it is equally well know that applications to other gardens for such assistance are extremely common [i.e. Liverpool]; it is therefore singular that what happens so frequently elsewhere, should so seldom happen in the Botanical Garden of Kew.' (House of Commons 1840, 3)

His conclusion was quite stark: either Kew should be taken into public ownership and make it 'worthy of the country, and ... into a powerful means of promoting national science, or it should be abandoned' (House of Commons 1840, 4). He pointed out the only 'civilised' nation without a national public botanic garden was Britain. Furthermore, as a result of no central control, the colonial gardens lacked purpose and were a waste of public funds.

Lindley proposed expanding the garden and reorganising it at an initial cost of £20,000 (House of Commons 1840, 5). He estimated that annual running costs would be £4000 a year, nearly three times the previous expenditure. Lindley argued that this should not be refused by Parliament, given the importance of such an institution both at home and abroad. His recommendations were agreed in principle but there was the question of finance. The Treasury prevaricated as an alternative scheme for a national botanic garden at Regent's Park was mooted. By 1840, questions were being raised in Parliament and the press as to Kew's future. Finally, after Lindley's report was presented, the Treasury sanctioned the transfer on the 25 June to the government department of the Board of Woods and Forests and Land Revenues.

The man in charge was William Jackson Hooker, who proved to be as adept as Banks in promoting, and more importantly, defending Kew when politicians questioned its validity (and by implication cost). Taking Lindley's report as a blueprint, he expanded and improved the botanic garden and re-established the links with existing colonial botanic gardens, many of which had become moribund. During his tenure the iconic glasshouses (Figures 8.6 and 8.7) were erected, which allowed more tender plants to be trialled and grown. Hooker also established a Museum of Economic Botany in 1846, demonstrating the link between botany, trade and the Empire. The Secretary of State for Foreign Affairs sent out instructions that British consuls abroad should send items to it (Desmond 1995, 191). Perhaps more importantly the Museum provided a free advice service to businessmen and manufacturers on economic crops (Desmond 1995, 213).

There were two areas, the transfer of tea and cinchona plants to the colonies, where its supporters trumpeted the role of Kew. Tea from China was a major import for Britain in the mid-nineteenth century, however the payment for it, partly by the illegal opium trade, was becoming a problem. In 1820, there was an important breakthrough when the leaves of a camellia plant growing wild in

FIGURE 8.6. Palm House, Royal Botanic Gardens Kew.

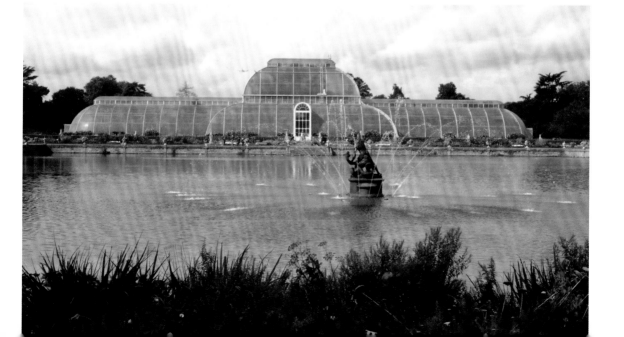

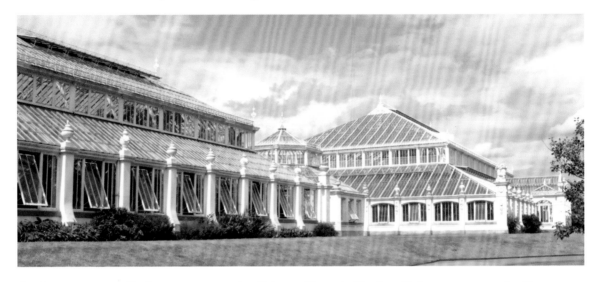

FIGURE 8.7. Temperate
House, Royal Botanic
Gardens Kew.

the Assam region of India were sent to the Calcutta Botanic Garden. Calcutta in turn sent them to Kew for identification, which confirmed that they were from *Camellia sinensis* or tea plant (Musgrave and Musgrave 2000, 99). In 1832, Nathaniel Wallich, the Superintendent of the Calcutta garden made the case for growing tea in India, so that 'we shall not long continue dependent on the will and caprice of a despotic nation [China] for the supply of one of the greatest comforts and luxuries of civilized life.'[32] The Superintendent of the Saharanpur Botanic Garden in the Himalayan foothills, John Forbes Royle, reported that this area would be suitable for tea production two years later. The attempts made to establish tea plantations in India were though unsuccessful, as the plants were grown in the wrong conditions. In 1848, the plant hunter Robert Fortune was sent to China to collect plants and seeds. He sent back over 20,000 plants, with more than 12,000 of them going to the garden at Saharanpur (Fortune 1852, vi and 363) but more importantly he brought back the expertise of Chinese tea growers. Joseph Dalton Hooker (1854, 5) however credits the colonial botanic gardens, saying that: 'the establishment of the tea-trade in the Himalaya and Assam is almost entirely the work of the superintendents of the gardens of Calcutta and Seharunpore'.

Bark from cinchona trees is the source of quinine that was used to treat malaria. Originating in Peru, its curative properties were known from the seventeenth century. As the British moved into more malaria-prone areas, such as India, at the end of the eighteenth century, there was concern over the limited supply and the cost of quinine powder.[33] The solution proposed by Banks and others was to establish cinchona plantations in the colonies. In 1816, George Govan suggested that it should be tried at the new botanic garden at Saharanpur, but the East India Company did nothing until 1852 when instructions were given to consuls in South America to acquire seeds. The South Americans realised that their lucrative business would decline if the trees could be grown successfully elsewhere, so tried to stop their export. Following the

Indian Mutiny of 1857, political power in the region passed into the hands of the Crown and an increasing army and civilian staff needed protection against malaria. As George Bidie noted in 1879:

> 'to England, with her numerous and extensive Colonial possessions, it [cinchona bark] is simply priceless; and it is not too much to say, that if portions of her tropical empire are upheld by the bayonet, the arm that wields the weapon would be nerveless but for Cinchona bark and its active principles.' (Brockway 2002, 103)

In 1859, an expedition sponsored by the India Office and aided by Kew, went to Peru and acquired seeds and plants, which were sent, via London, to the botanic garden in Ooty, South India two years later. Further expeditions brought out more species[34] and three botanic gardens (Ooty, Peradeniya in Ceylon and Buitenzorg in Java) exchanged information on which species or hybrid produced the highest levels of quinine. Ultimately it was the trees on Java that performed the best and the Dutch took the lead in supplying high quality quinine for worldwide export. The cinchona plantations in Ceylon and India were devoted mainly to domestic needs, as were those started in other colonies in Asia, Africa and the West Indies. A myth grew that the entire colony's inhabitants benefited with the inaccurate and much repeated quote that 'a dose of quinine can be purchased at any Indian post office' (Bean 1908, xviii). In reality most supplies went to Government medical stores for the benefit only of the colonial administration and its dependants (Brockway 2002, 124).

William Hooker died in 1865 and his son, Joseph, succeeded him as Director of Kew. Hooker senior had been an influential figure and enjoyed the support of senior political figures such as Lord John Russell[35] and the Duke of Newcastle, first Commissioner of Woods and Forests, subsequently Colonial Secretary. Hooker junior's tenure was to prove to be more difficult than his father's, as the incoming Liberal government in 1868, headed by William Gladstone, was looking for ways to reduce expenditure. Acton Ayrton was appointed as First Commissioner of Works, the government body overseeing Kew. He proposed that the costly scientific functions of Kew should be transferred and that the gardens should be retained purely as a public park. This proposal prompted a confrontation with Hooker, who threatened to resign. Leading scientists such as Charles Darwin supported Kew's cause, as did most of the press, who were appalled by the idea (Desmond 1995, 243). Hooker finally won the argument and Ayrton was transferred to another post, helped no doubt by the scientists' appeal to Gladstone. They once again stressed the importance of Kew to the Empire by declaring that: 'the records of the Colonial and India Offices will show of what immense importance the establishment at Kew has been to the welfare of the entire British Empire'.[36] The role of Kew and its funding by the state was not seriously challenged again until well into the twentieth century.

In the wake of his success, Joseph Hooker successfully applied for more government funds and appointed an Assistant Director, William Thistelton-Dyer, in 1875. Thistelton-Dyer immediately took charge of seed and plant transfers in the colonial garden network and was responsible for the role of Kew

in the transplantation of another important economic crop, rubber. Like the transfer of cinchona, the first step was to acquire seeds from its native habitat, in this case, Brazil. Although there are over 200 species that can produce rubber, the most productive is *Hevea brasiliensis*. After a few unsuccessful attempts, Kew managed to germinate over 2000 in 1876 and then sent on most of these to the botanic garden of Peradeniya in Ceylon.[37] This would form the basis of all the millions of rubber trees that were subsequently planted in the region. In Ceylon they experimented with the growing location and also the techniques of 'tapping' to extract the rubber.

In 1888, the Singapore Botanic Garden got involved by raising new plants and setting up a series of scientific tests on the best extraction methods. This was going to be a cash crop like tea and coffee, rather than one that would benefit the local population in reducing disease or famine. The initial set-up costs meant that it took a long time for the authorities to persuade private individuals and companies to invest. Slowly the planters of the Malay Peninsula and Ceylon turned to producing rubber as demand for it grew and other alternative cash crops such as coffee became less attractive. By 1934, 99% of the world production in rubber came from the colonies in south-east Asia belonging mainly to Britain.[38] The ultimate success of the rubber trade was down to Kew and its colonial network. As Brockway points out: Kew was

> 'responsible for every phase of the development of cultivated *Hevea* rubber ... [and] the colonial gardens functioned as agricultural experimental stations, [by] doing the development work, [and] educating the planters by personal contact and published bulletins.' (2002, 165)

How important was the botanic garden to the Empire?

In 1844, William Hooker declared that:

> 'there scarcely exists a garden or a country however remote, which has not already felt the benefit of this establishment [Kew]. All our public gardens abroad – those of Ceylon, Mauritius, Sydney & Trinidad ... Governors of our own colonies, & consuls are supplied with various products of such other climes as may be deemed suitable to them.' (Desmond 1995, 213)

By 1914, there were over 100 British colonial botanic gardens. By contrast in 1838 there had been ten, with only eight of them actually functioning. In 1910, there were 160 'Kew men' serving in botanic gardens outside Europe (Bruce 1910, 115). How important individually were these colonial outposts of botanical expertise? Taking the example of two of them, Calcutta and the Durban Botanic Garden in South Africa, the evidence is not clear-cut.

Calcutta was set up by the East India Company as a scientific establishment to improve the lives of its inhabitants, both materially and intellectually. The role of the EIC changed from a trading enterprise to a *de facto* government in the early nineteenth century. The purpose of the garden moved therefore from being solely a centre for knowledge to one that would 'improve Indian

agriculture by introducing new food crops and developing commercial products such as cotton and tea that might stimulate trade and raise profits' (Axelby 2008, 153). In the 1830s, Superintendent Wallich, when challenged as to the need for such a garden, replied that:

> 'no enlightened Government, least of all the British in this Country, can fail appreciating the beneficial influence which must result to the Governed from imparting to them a taste for agriculture and gardening – of all the human occupations the most pure, useful and Civilized.' (Arnold 2008, 912)

While there was much discussion in Britain and across the Empire of the *economic* importance of botanic gardens, in reality it was the act of making a garden and growing different plants that mattered to those who ran these institutions. Although he promoted the cultivation of tea, coffee and teak plantations in India, Wallich's greatest achievement was the dissemination of ornamental plants around the world.[39] From the 1850s, it became the 'Kew' of

FIGURE 8.8. Durban Botanic Garden, Natal, South Africa.

Asia, providing the administrative network for the region and returning to its original function as a scientific centre.

Established in 1851 by the local Agricultural and Horticultural Society, the Durban Botanic Garden (Figure 8.8) aimed to help the fledging colony by providing an income for the settlers who were being incentivised to emigrate from Britain. Natal had been nicknamed the 'Colony of Samples' as every conceivable crop had been tried. The Curator of the Botanic Garden had trialled Assam tea, coffee, arrowroot and fruits such as pawpaw and mango (McCracken 1987, 67) but the crop that was to prove successful in the long term, sugar, was started by a local entrepreneur, Edmund Morewood, in 1848. He planted a trial plantation of canes imported from Mauritius and possibly some that had been brought to the Cape by the Portuguese and Dutch (Osborn 1964, 116). When disease affected the cane varieties grown in Natal in the late 1870s and 1880s, the botanic garden did play a role in trying out new strains from Mauritius and India. The latter was said to have 'saved the sugar industry in Natal in the second half of '80s' (Osborn 1964, 120). The garden had by this time been taken over from the practically defunct Horticultural Society by the colonial government (McCracken 1987, 70). The new Curator, John Medley Wood, turned it into a proper scientific establishment and carried out vital botanical research. He wrote newspaper articles detailing experiments and giving advice to farmers and horticulturalists (McCracken 1987, 70). Its funding was relatively short-lived and by 1913, the garden was transferred to the city's authorities and became a public park and its herbarium given to the Department of Agriculture. The success of economic crops in the colonies was thus often thanks more to the efforts of the local planters and their agricultural societies, than to the state-sponsored botanic garden.

The theme of the importance of the botanic garden to the British Empire, first suggested by Banks at the end of the eighteenth century, continued throughout the next century and beyond. Whenever the status of Kew or other colonial botanic gardens was threatened, their role in the Empire was brought out as a major justification for their continued existence. In time, the argument became self-fulfilling and by 1910, Kew was described by a Treasury committee of in 1900 as '*in the first place* an organisation dealing with and giving assistance to His Majesty's Government on questions arising in various parts of the Empire in which botanic science is involved' (Bruce 1910, 115). While that was undoubtedly true, the economic case is unproven. Given that Imperial trade only contributed at most 5–6% to British national income by 1914 (Offer 1999, 708), the lauded triumphs of tea, rubber and oilseeds transfers were an insignificant part.[40] The role of cheap quinine did help though in the expansion into Africa in the latter half of the nineteenth century. Perhaps the real political significance of state support for botanic gardens was its encouragement of scientific enquiry into plants to help those colonies survive and prosper.

Notes

1. Free trade is defined as the flow of goods in and out of a country without taxes (usually known as tariffs) or controls such as quotas. These two are often imposed to protect domestic industries from perceived 'unfair' foreign competition.

2. *De Materia Medica*, written about 78 AD, was continually reprinted with additions throughout the mediaeval period in Byzantine, Islamic and then Christian countries.

3. Believed to be the site of the current Huerta del Rey at the 13th century Palacio de Galiana.

4. Tradition has it that Arab physicians from Spain founded the medical school. The site was later used for the first botanic garden created in 1593.

5. The story is recorded by a tenth century historian, al-Maqqari, so it may be a metaphor for the adaptation of new species in Al-Andulus as a similar tale is recorded about figs from Byzantium (Ruggles 2000, 17–18).

6. There is some debate (and rivalry) over who was first between these two organisations. Pisa claims the earlier date as this is when land was granted for it.

7. Medical herbs.

8. The design may also have come from the *hortus conclusus* of the medieval monastery (Tomasi 2005, 106).

9. Clusius had received seeds and bulbs from Busbecq, the former imperial ambassador to the Turkish court at Istanbul, while prefect of the imperial gardens in Vienna from 1573 to 1577 (van Uffelen 2006, 6).

10. The 'Ambulacrum' or permanent building to house delicate plants was constructed in 1600.

11. His catalogue of 1596 lists 1030 plants.

12. Funded by the Earl of Danby.

13. The British East India Company had been formed in 1600.

14. '7th August. I went to see Mr. Watts, keeper of the Apothecaries' garden of simples at Chelsea, where there is a collection of innumerable rarities of that sort particularly, besides many rare annuals, the tree bearing Jesuit's bark, which had done such wonders in quartan agues [fever]. What was very ingenious was the subterranean heat, conveyed by a stove under the conservatory, all vaulted with brick, so as he has the doors and windows open in the hardest frosts, secluding only the snow' (Dobson 1906, 173).

15. Originally the *Jardin du Roi*, it was not planted until 1635 and it would be another five years before it was officially opened.

16. These included Zurich (1560), Bologna (1568), Heidelberg (1593), Uppsala (1657) and Amsterdam (1682).

17. Examples are the Imperial Botanic Garden in St Petersburg, founded by Peter the Great in 1714, the gardens founded in Berlin by the Elector of Brandenburg in 1679 and Vienna by the Empress Maria Theresa in 1754.

18. The use of plants by people.

19. The Virginia Company founded in 1607 by royal charter.

20. St Kitts (1624), Barbados (1627), Nevis (1628), Antigua and Montserrat (1632) and Jamaica (1655).

21. Sugar cane had previously been grown on the Atlantic islands of Madeira and the Canaries (Musgrave and Musgrave 2000, 39–41).

22. In 1659, the Dutch had taken coffee plants from India to Ceylon successfully (they had originated in Ethiopia, these plants had been taken to India by Arab traders), and in 1696, they transferred them to Java. One of these plants then was sent to the new

botanic garden at Amsterdam in 1706 and its offspring provided the basis for the South American coffee business (Brockway 2002, 51).

23. The first two had been smuggled into the colony by the aptly named Pierre Poivre, who subsequently became Director of the garden.

24. Its cost at the time was put at seven hundred pounds per annum (Guilding 1825, 3). Its collection was transferred to the new garden on Trinidad in 1823.

25. He had been appointed as the official botanist to the Madras Presidency of the East India Company in 1786 (Grove 1995, 331).

26. Four to five thousand rupees a month by 1800, compared to the estimate by Kyd of two hundred rupees (Thomas 2006, 175).

27. Previously a Dutch colony, it was taken over in 1796.

28. A new garden at Hakgala, at higher altitude, was established in 1861 specifically to grow cinchona trees and a third botanic garden, Henaratgoda, was developed in 1876 for the new rubber trees.

29. The territory had been briefly occupied by the British and in 1814 Stamford Raffles had started a botanic garden there.

30. From nineteen hundred pounds per annum on average between 1824 and 1827 to one thousand two hundred between 1832 and 1836 (Desmond 1995, 140).

31. Others included Hull (1812), Glasgow (1817), Bury St Edmunds (1819), Belfast (1829), Birmingham (1832), Sheffield (1833).

32. 'Observations on the Cultivation of the Tea Plant for Commercial Purposes, in the mountainous part of Hindustan', 3 February 1832 by Wallich to Charles Grant, President of the Board of Control for Indian Affairs (Samson 2001, 111).

33. It cost £53,000 per annum to buy quinine for India in the 1850s, according to Clements Markham who was the leader of the trip to Peru.

34. There are over 30 species but *C. succirubra*, *C. calisaya*, *C. pitayensis* and *C. officinalis* and their hybrids were the ones that provided the best sources of quinine.

35. Prime Minister 1846–52 and 1856-66; Foreign Secretary.

36. Memorial presented to the First Lord of the Treasury [W. E. Gladstone], respecting the National Herbaria (Cavendish 1874, 31–2).

37. Ceylon was chosen as earlier trials at Calcutta had failed (Musgrave and Musgrave 2000, 174).

38. British colonies accounted for seventy per cent (Brockway 2002, 141).

39. A list of 190,000 plants (covering nearly 700 genera and 1700 species) was distributed from the botanic garden between 1836 and 1840. The plants went to more than 2000 institutions and individuals (Arnold 2008, 917).

40. They each provided about 1% of the value of imports into Britain in 1913 (Cain 1999, 43).

Royal Botanic Gardens Kew, London

Kew had been leased to Prince Frederick of Wales in 1731 from the Capel family. Sir Henry Capel had built up an extensive plant collection in the late seventeenth century, admired by John Evelyn.[1] Prince Frederick was busy with his other projects such as Carlton House, and only drew up plans for the grounds shortly before his death in 1751. In 1759, his widow, Princess Augusta, acquired the freehold and started to put her husband's plans in action. There were notable new plant introductions, supervised by Lord Bute, a noted amateur botanist and confidante of the Princess. In 1761, the garden acquired many plants from the estate of Bute's uncle, the Duke of Argyll and became the country's foremost botanical collection.[2] William Aiton was appointed to look after this 'Physick Garden' and by 1768, it had over 3000 species according to the first *Hortus Kewensis*, compiled by John Hill (Desmond 1995, 43). George III showed a great interest in the garden and in 1771, the estate was merged with the nearby royal lands at Richmond.

King George appointed Sir Joseph Banks as his new (unofficial) horticultural adviser in 1773, replacing Bute who had fallen from favour in 1763 after an unsuccessful spell as Prime Minister. Banks' main achievement was to encourage worldwide plant exploration, with many species coming directly to Kew during his nearly 50-year tenure. Before his time, the collection had been rather a haphazard affair but the support of specific expeditions such as those by Francis Masson to the Cape in 1772–4 meant that more a rigorous approach could be taken. The newly formed colonial botanic gardens at St Vincent in the West Indies, Calcutta and St Helena also sent seeds and plants to Kew and the latter reciprocated. By 1789, the number of species at Kew was over 5000 and this had more than doubled to 11,000 by the publication of the 1810–13 edition of *Hortus Kewensis* (Desmond 1995, 107).

By the 1790s, Kew had caught up with its rivals in Paris and other European capitals but it remained at heart a royal prestige project. Between 1794 and 1811, about half a million pounds was spent on the estate, buying further land and planning a new palace that survived until 1829 (Drayton 2000, 89). During George III's reign it remained a dynamic operation but his death in 1820, together with that of Banks in the same year, marked the beginning of a period of decline. George IV and his brother, William IV, took little interest in Kew and the Director, William Townsend Aiton, struggled to maintain it on increasingly limited resources.[3] By 1838, the gardens were in a poor state with nine overcrowded greenhouses or 'stoves' and a 'propagating pit and hospital' (House of Commons 1840, 1). The plants here and outside were poorly labelled and little if any scientific investigation was being carried. Probably most damning politically was the report:

'that no communication is maintained with colonial gardens ... since ... 1830, the only deliveries to colonial gardens, or in aid of the British Government, have been one to the garden of New South Wales [Sydney], and one to Lord Auckland, when proceeding to his government in India' (House of Commons 1840, 3).

The Lindley report[4] proved to be a catalyst for change as it passed the ownership of the botanic gardens into state hands in 1840. This, together with another inspired Director in William Jackson Hooker, led not only to the revival in the garden's fortunes but also its expansion. Hooker had no board of trustees, nor any instructions from the government agency now responsible, so he chose to adopt Lindley's recommendations to make a public garden that was at the forefront of botanical science. The small botanic garden and nearby arboretum were extremely overcrowded, particularly the glasshouses. One of Hooker's first actions was to commission the iconic Palm House (Figure 8.6), designed by Decimus Burton and built by Richard Turner between 1844 and 1848, and the Waterlily House, constructed in 1852 (Figure 8.9).

The building of the Temperate House (Figure 8.7) followed in 1862. These buildings were vital for the important scientific work that Kew was now undertaking for the colonial authorities on economic plant trials. Hooker was hampered by the fact that the limited herbarium[5] (collection of dried specimens) had been moved to the British Museum and there was no library. He therefore transferred his own private herbarium to Kew, to which donations were added such as that of George Bentham in 1854. This was finally bought by the state, together with his library after his death in 1866 (Desmond 1995, 205). Hooker's initiative set an important trend as most of the leading herbaria in Britain henceforth were donated to Kew, allowing it to build up an unprecedented collection.[6]

From the outset, there was pressure to turn the garden into a public park[7] and to curb its more expensive scientific activities. While the rationale for this

FIGURE 8.9. Waterlily House, Royal Botanic Gardens Kew, print by Adlard 1854.

was usually based on the cost to government (and taxpayer), it was often a more ideological debate centred on whether such tasks as testing new plants would not be better to be done by private organisations such as The Horticultural Society.[8] These pressures culminated in the so-called 'Ayrton affair' in the early 1870s. William's son, Joseph, was now the Director and he used his 'victory' over Ayrton's plans to push for further expansion, increasing the scope of the garden, particularly in relation to the colonial network. In response to the increasing numbers of visitors,[9] William Andrews Nesfield was brought in to landscape the grounds from 1845. Nesfield's vision of flowerbeds, laid out as formal parterres, clipped shrubs and other then-fashionable 'Italianate' features were not well received by William Hooker. He wanted to stick to the principles of botanic garden layouts with plants in their 'families' and so Nesfield's plans were only partially implemented. This tension continued as the vogue for bedding schemes became more popular in Victorian Britain during the 1850s and Kew was under continued pressure to offer these colourful displays as a way of attracting visitors.

The latter part of the nineteenth century, under the direction of William Thiselton-Dyer, was a time more of information rather than plant exchange, particularly amongst the colonial garden network. The *Kew Bulletin*, started in 1887, and although somewhat intermittent due to cost pressures imposed by the Treasury from 1892, provided a major source of information, not only for British concerns but also for the overseas territories of other nations.[10] With a donation from Charles Darwin in his will, the first comprehensive list of all known plants, *Index Kewensis*, was drawn up and published in 1892 and has been continually updated ever since.[11] Thiselton-Dyer was also responsible for major changes to the garden's layout, creating the Rock Garden in 1882 to show hardy alpine plants and ferns and improving the arboretum. He presided over the height of the garden's prestige and influence at home and abroad.

However the problem of funding continued and in 1916, entrance charges (a penny) were introduced to help pay for the costs of Kew's maintenance. Its imperial role as scientific advisor started to diminish, its previous activities being taken up by new bodies such as the Imperial Institute, established in 1887. The formation of the Empire Marketing Board in 1926 gave Kew a grant to appoint an Economic Botanist and to send staff overseas on botanical missions again.[12] These posts continued through direct funding from the Treasury as, once again, it was pointed out 'that Kew is devoted in the first instance to Imperial and economic interests and research' (Desmond 1995, 316). During the Second World War, while the fabric of the garden itself suffered, Kew's role of economic botany continued, both for the colonies and for Britain itself, which needed to produce more of its own fruit and vegetables. Post-war austerity continued to prevent any large-scale improvements, but the two hundredth anniversary in 1959 provided the impetus to restore the gardens, including many historic features, back to its former glory[13] to cement in people's minds Kew's long role in botanic science.

Under the *National Heritage Act* of 1983, Kew was given management of its affairs for the first time with the appointment of a Board of Trustees. One of the Board's main responsibilities was to 'carry out investigation and research into the science of plants and related subjects, and disseminate the results of the investigation and research' (House of Commons 1983), so after 150 years

Kew's main role was finally enshrined in law. The garden still relied on state support however and in 1990, the Kew Foundation was set up to raise funds,[14] in addition to those generated by admissions and retailing activities, which now make a significant contribution.[15] In 1995, the Millennium Seed Bank project was started which aims to collect 25% of the entire known worldwide flora by 2020, with priority given to those plants with potentially the most use in the future.[16] So the spirit of Joseph Banks' economic botany lives on 250 years later.

Notes

1. Evelyn visited this on a number of occasions, first on 27 August 1678 when he praises the orchards, again on the 30 October 1682 seeing the construction of glasshouses for oranges and myrtles and finally on the 24 March 1688, where he notes the completed fine orangery (Dobson 1906, 19, 116 and 231).

2. In a letter of 27 February 1763, Thomas Knowlton says that Kew has 'one of the best Collections in the Kingdom if not in the World' (Henrey 1986, 257).

3. Finances were overseen by the Board of the Green Cloth, led by the Lord Steward. The monarchy and its activities is funded by the 'civil list', a grant from Parliament.

4. The Chairman of the working party commissioned to look into the royal gardens was John Lindley and he was assisted by John Wilson and Joseph Paxton.

5. During Banks' tenure, all dried plants given to Kew went to his private herbarium in Soho Square. After 1820, some duplicate sets went to direct to Kew and these were the ones Aiton passed onto the British Museum, which already had Banks' collection. The entire collection is now part of the Natural History Museum.

6. It now has over 7 million specimens with over 350,000 'type specimens', the original specimens on which new species descriptions have been based and about 37,000 are added each year, source: www.kew.org/collections/herbcol.html [consulted 4 January 2011].

7. Sir Benjamin Hall, First Commissioner of Works from 1855, was a particular advocate.

8. Founded in 1804 by Joseph Banks amongst others and the precursor to the Royal Horticultural Society, it had experimental gardens first in Chiswick from 1823 and then in Kensington from 1861.

9. In 1841, there were fewer than 10,000 visitors but ten years later, this had risen to over 300,000 (Desmond 1995, 390–1).

10. Report on the development of the sisal plant in German East Africa and Kew's role (Brockway 2002, 167–83).

11. The most recent revision has been completed in December 2010 in conjunction with Missouri Botanic Garden. Kew press release, 'Kew and Missouri Botanical Garden announce the completion of The Plant List', issued 29 December 2010.

12. Four thousand pounds was granted in 1927 and further amounts were given until the Empire Marketing Board finished in 1933 (Desmond 1995, 313–16).

13. These included a period garden at Kew palace, restoration of the Palm and Temperate Houses and the Georgian Orangery.

14. In the financial year ending 31 March 2010, this generated nearly £2 million but was less than 6% of the size of the grant from the government, source *Kew Annual Report and Accounts* 2009/10.

15. Over £10 million, nearly a quarter of all incoming resources (*Kew Annual Report and Accounts* 2009/10).

16. www.kew.org/science-conservation/conservation-climate-change/millennium-seed-bank/about-the-msb/our-future/index.htm [consulted 5th January 2011].

Gardens in Japan: Religion, Politics and Culture

When creating a garden, first be aware of the basic concepts.

- Select several places within the property according to the shape of the land and the ponds, and create a subtle atmosphere, reflecting again and again on one's memories of wild nature.
- When creating a garden, let the exceptional work of past master gardeners be your guide. Heed the desires of the master of the house, yet heed as well one's own taste.
- Visualise the famous landscapes of our country and come to understand their most interesting points. Re-create the essence of those scenes in a garden, but do so interpretatively, not strictly. (Takei and Keane 2008, 151–2)

This passage comes from the start of an eleventh century 'gardening manual', the *Sakuteiki*,[1] whose title in the earliest manuscript is '*The Art of Setting Stones*'. To a non-Japanese view this might appear strange, as gardens are more often associated with living plant material, but that is to miss the point. The stones or rocks 'serve as [the] 'bone' structure of the garden [and are] used to create effects of mountains, outcroppings, waterfalls, stream beds, natural bridges' (Slawson 1991, 61) and mythical creatures. So although the points above were (and still are) the overall basis of Japanese garden design, a garden is only complete if its stones are chosen and placed correctly. It could be argued that these rocks, in being revered and highly valued, mirrored the role of the Japanese Emperor throughout the past 1500 years.

Being able to master the art of setting stones was an important skill and the manual was later referred to as *Senzai Hisshō* or the '*Secret Selection of Gardens*' (Takei and Keane 2008, 5). Clearly this was a book for a select few, which in Japan at this time meant the Imperial family and the aristocracy, as the end of the Tanimura Scroll version says 'Precious – it must be secret, it must be secret'.[2] The manual's author is believed to be Tachibana Toshitsuna, a member not only of one of the 'Four Great Families'[3] of the nobility but also the natural son of Fujiwara Yorimichi, an Imperial regent for nearly 50 years. Kuitert (2002, 30–1) discusses why information on gardens should have been secret and links it to the restriction of all types of information by the leading families, in

particular the powerful Fujiwara clan, following the old adage that 'knowledge is power'. Certainly by the time that the first extant copy was transcribed in 1289, 'the knowledge contained in the scroll had acquired commercial value for a Japanese nobility which had lost most of its power to the *samurai*' (Nitschke 2007, 56).

Unlike in China where the Emperor remained absolute, the aristocracy weak and senior royal servants gained their position through merit, in Japan political power was restricted to those born in the right clan or family. So whereas the Chinese 'Mandarins' or civil servants created gardens, in Japan this was initially purely a nobleman's pursuit. In writing the manual, Toshitsuna was perhaps 'stimulated by the recognition that … [he] was creating his own body of secret knowledge and thus could contribute something to reinforce Fujiwara supremacy and ensure his own position' (Kuitert 2002, 31). The act of creating a garden in Japan from early on was symbolic as well as an act of artistic creation. As the Japanese garden developed over time, it was 'directly related to changing attitudes to nature, to socio-political conditions and to religio-philosophical trends; in short, to the intellectual climate as a whole' (Nitschke 2007, 27). It could be argued that it is difficult to disentangle the garden from Japanese culture and *vice versa*. When Japan finally opened up to the outside world in the mid-nineteenth century, its style of gardening was one of the 'arts' that it took to exhibitions in Europe and America.

The secret of the garden had come, like many other cultural references, from the Chinese influence in Japan. In the eighth century, one-third of the nobles claimed to be of Korean or Chinese descent, showing the high level of cultural affinity with these countries (Spellman 2001, 56). There are some written references to gardens in Japan from first century AD, which mention ponds and winding streams but they were probably quite unsophisticated (Nitschke 2007, 30). In 607, Japan's Empress Suiko sent the first embassy to China. Up until then all knowledge of its neighbour had been largely second-hand through Korea. The Japanese ambassador, Ono Imoko, visited the Chinese Emperor Sui Yangdi in Luoyang. The latter's father had devoted his energies in reuniting China after a long period of civil war but Sui Yangdi was 'said to have found in the idea of Imperial greatness unbounded possibilities for the expression of [his] megalomania' (Keswick 2003, 59).

At his new Eastern capital of Luoyang, he built a large landscape park that was 75 miles (*c.*121 km) in circumference, larger than anything that had been built by the previous Han dynasty. The main lake alone was 6 miles (9.6 km) long with three artificial islands representing the mythical Isles of the Immortals, with more 'pools and streams to symbolise the five lakes and the four seas of the ordered universe' (Keswick 2003, 59). Ono must have been impressed as soon after his return in 612, the first known gardens were built in Japan using the Chinese ideas (Nitschke 2007, 31). These gardens were based on the Taoist philosophy that dictated not only how people should live but also determined the site and layout of gardens. There had to be harmony, as without it the people

could not live in peace. The basic elements of these new landscapes were rock, hill or mountain (the *yang*, the stimulating male force) and still water (the *yin*, the tranquillising female force).

When these garden ideas transferred to Japan, they were also influenced by the indigenous religion, Shinto. This belief system reveres all types of remarkable objects including trees, rocks, waterfalls and other parts of the natural scenery, as well as ancestor worship. The sanctified space of the Shinto shrine was a precursor to the new garden ideas imported from China (Treib and Herman 2003, 3). The gravelled courtyards of the Shinto temples gradually acquired rocks, water and trees therefore to replicate their natural surroundings. Fused with Buddhism and Chinese Taoism, the importance of the natural landscape is reflected in Japanese gardens but it is always controlled. The Shinto shrine usually has a *shime-nawa*,[4] which defines a sacred area or sanctifies a holy object in it. Nitschke (2007, 18) believes that *shime* is the source of the word *shima* (originally 'land that has been taken possession of' but now also a 'garden') and could explain the 'Japanese fascination, indeed obsession with binding, manipulating and even crippling plants for gardens or miniature landscapes' (Nitschke 2007, 18), so as to keep the gardens at a human level. It could also justify the motivation by those in power to restrict the people who could make a garden, as highlighted by the secretive nature of the *Sakuteki*. While the Emperor in Japan has often been a mere figurehead with no real political power, the fact that he is the supreme priest of the Shinto religion and believed to be descended from the sun goddess, has meant that his position has largely gone unchallenged (Spellman 2001, 59). The creation of gardens therefore may have been one of the ways that the Emperor (whether actively ruling or 'retired') and then the politically impotent nobility from the twelfth century could demonstrate some control over their land.

Alongside the Shinto religion, Buddhism was introduced around AD 552, probably from Korea and has since co-existed in various forms ever since. Initially six main sects developed but they shared a common approach, which focussed on intellectual debate and the government (in the form of the bureaucracy) were heavily involved including choosing the sects' leaders. As the 'Pure Land'[5] or *Jodo*, sect of Buddhism became more popular and politically influential, it was enthusiastically embraced by the Fujiwara princes in the mid-eleventh century, as a way of gaining power over the bureaucrats. The princes built many Pure Land temples in and around Heian-kyo (modern Kyoto), which were used not only for prayers but also for social gatherings. These recreations of 'Buddha's paradise on earth' had similar layouts to the Imperial and noble palaces, complete with gardens. The aristocrats may have used these temples and gardens as a way of staking their claim to power but without using the Shinto religion that was aligned to the Emperor.

The *samurai* or warriors, who took effective power from the late twelfth century, in turn were attracted to Zen Buddhism. In contrast to the earlier Pure Land sect, followers of the Zen Buddhism placed a greater emphasis on

individual faith and less on external salvation, which appealed to this warrior class. A key component of Zen Buddhism is meditation and this was reflected in the design of the gardens in two possible ways.[6] First the gardens in Zen temples required great skill and dedication to ensure the raked gravel was kept in perfect order. Secondly the temples were places for deep thought and contemplation and perhaps required garden spaces next to the buildings to be looked on, rather than places to move in and delight the senses. Many of the Buddhist temples of the esoteric or *Jodo* form of the religion had originally been Shinto shrines, such as Saiho-ji (Jacobs 2004, 2). When they were taken over in turn by the new Zen followers, it was a political act to show the shift in power. However the new gardens that were created in these temples were put alongside the existing ones, demonstrating continuity and giving legitimacy to the new beliefs. In 1358, the new Ashikaga Shogunate put the new Zen monasteries under state control though the system of *gozan*, a hierarchical structure of five groups, although not all Zen temples were part of this (Kuitert 2002, 72).

Heian era and 'Pure Land' pond gardens

Up until the move to Nara, in 710, each new Emperor had established his own capital city, partly to disassociate themselves from the death of his predecessor but also to establish their authority. Japan historically had been fragmented due not only to geography (a lot of land is mountainous and therefore communication is difficult) but also due to the warring clans. The introduction of Buddhism in the sixth century led to another group vying for power, the Buddhist priests, particularly in Nara. This prompted Emperor Kammu to seek a new capital. By the establishment of Heian-kyo as the new capital in 794, political power had been largely centralised, with most of the main island of Honshu under the control of the Yamato court. The structure of both Nara

FIGURE 9.1. Heian Shrine, Kyoto.

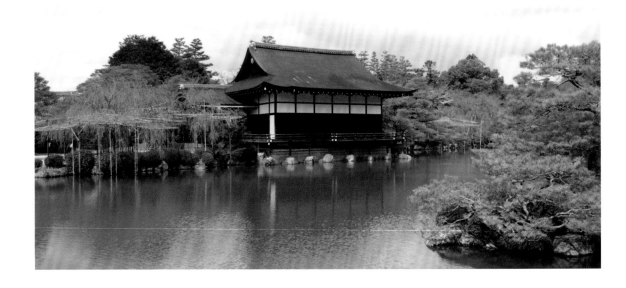

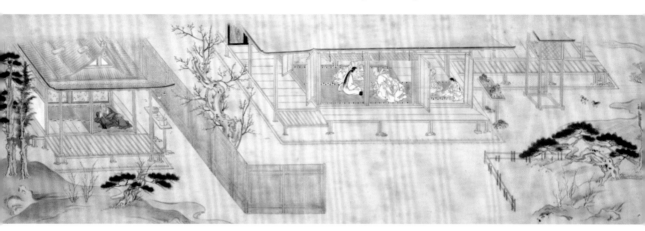

and Heian-kyo were essentially Chinese, based on the grid layout of Chang'an (now Xi'an), the main capital of China under the Sui and Tang dynasties. It defined the size of the noble's house and gardens. A mid level aristocrat in the later Heian period would have a plot of one *chō*, about 1 hectare, for example (Kuitert 2002, 5). The gardens' main feature was a large pond or lake with an island. Although none remain in their original condition, one was recreated at the Heian Shrine, built in 1894 in Kyoto to commemorate the founding of the city 1100 years earlier (Figure 9.1).

In front of the main building (*Shinden*) lay a *nan-tei* (south garden) that only contained white sand and a cherry tree[7] (*sakura*) and a citrus tree (*tachibana*) either side of the main steps (Figure 9.2). This was an example of *yin* and *yang* with the evergreen citrus representing things eternal and the cherry, the ephemeral nature of life through change. Cherries also 'served to assure the coming of spring, seen in association with the firm ruling of an emperor' (Kuitert 2007, 130) and were regarded as Japanese rather than the plum, which was linked to China (Ohnuki-Tierney 2003, 54). Nitschke believes that this type of garden had:

> 'their origins in the dual function of the early Japanese emperors as both political ruler and chief priest. South gardens were originally reserved for religious and state purposes; empty, they provided a suitable stage for the colourful court rituals.' (2007, 38)

However this space and its cherry tree in particular becomes an important symbol of power (or lack of it). During the reign of Emperor Koken (749–58), a double cherry tree (originally from the wild) was taken from the Emperor's palace garden, which had been planted by the previous emperor Shomu. The priests at Kofuku-ji, the family temple of Fujiwara clan, symbolically planted it in front of one of their temple halls, following its removal from the palace (Kuitert 2007, 131).

By the tenth century, there was relative political stability and much of the business of state was transferred to bureaucrats, following the Chinese model. This left time for the nobility to devote themselves to a life dedicated to poetry,

painting and enjoying their gardens. The Heian nobles not only had properties within the main city but they also built villas and gardens on the outskirts, estates known as *rikyu* (detached palaces), where there was more space. The Fujiwaras in particular used their gardens for display and spectacles. In addition to the ceremonial gatherings in the south garden, there was boating on the pond and musicians played on the islands and pavilions. As such a public statement, the layout of the gardens was critical and in *Sakuteiki*, Toshitsuna discusses the pitfalls of breaking taboos. In referring to the garden of his father (Fujiwara Yorimichi, the Imperial regent), he says:

> 'with the building of the palace, Kayanoin,[8] there was no one proficient in gardening, just people who thought that they might be of help. In the end, displeased with the results, Lord Uji [Fujiwara] took the task of designing the garden upon himself.' (Takei and Keane 2008, 192)

These were probably enclosed gardens as no mention is made in *Sakuteiki* of the outside scenery or *shakkei* (borrowed landscape) that became a popular design device later. This was more a reflection of the inward looking view of the Heian society in its capital, rather than the actual gardens themselves. For the Imperial gardens, they took no chances when it came to breaking taboos by employing a number of bureaucrats to oversee their design and maintenance. The Imperial Bureau of Gardens was specifically responsible for the maintenance of the gardens and grounds owned by the Imperial Family. Other Bureaus were also involved, such as the Bureau of Geomancy, which checked on designs and layouts and also it seemed, worked for the aristocracy (Takei and Keane 2008, 32 and 67).

Rise of the Samurai and Zen Buddhist gardens

The success of the Heian court had been its control over the hereditary landowners who had paid rent to the Imperial capital. The latter group slowly loosened their ties with the court and set up their own systems to control their affairs. From the middle of the twelfth to the fourteenth century, these increasingly powerful and militarised lords gained control over an ineffectual court and a weakening central government. Attempts by the Emperors to restore Imperial rule by plotting against the emerging alternative warrior government, only served to strengthen the hand of the latter. The political centre moved to Kamakura, the base of this emerging warrior or *samurai* class and Heian-kyo went into a period of decline. A final attempt was made by Emperor Go-Daigo to reassert control in 1333. Although this was initially successful, the Emperor's decision to build an expensive new palace when Imperial funds were low, led to unrest and finally to the Ashikaga Shogunate in 1338 (Keene 2003, 12).

The Shogun, Ashikaga Takauji, who decided to move back to Heian-kyo from Kamakura, signalled that he was now the country's real political leader instead of the Emperor. He re-enforced this by founding the Zen Buddhist temple Tenryu-ji at Arashiyama (Kyoto) in 1339. Ostensibly designed to soothe

the soul of the exiled emperor who had died that year, in fact taking control of this estate was just as important. It had belonged first to a Heian prince and then to the Emperor Go-Saga from 1270 (Kuitert 2002, 77). In a further act of political dominance, in 1357 'the warlords put their own cherry tree [variety Oshima – from Kamakura, as opposed to Yoshina favoured by Emperors] in front of the main hall of the Imperial palace in Kyoto' (Kuitert 2007, 135).

Despite the apparent contempt that the *samurai* had for the Imperial court and the Heian nobility, they did take up the latter's style of garden building, although it was for temples initially rather than palaces. The first to establish a military government (*bakufu*) was Minamoto Yoritomo and in 1189, he built a large temple and attached garden near his capital of Kamakura. Although it was destroyed two centuries later, a contemporary source records:

> 'that Yoritomo, on one of his visits to the … site, ordered several rocks to be repositioned more to his liking, thereby putting his own stamp on the garden, as well as indicating that he was a man of taste and discrimination.' (Ketchell 2009, 12)

Clearly he had either read the *Sakuteiki* or wanted to demonstrate his knowledge of it, as around this time, the text had started to be referred to as 'secret'.

In 1253, an important Zen Buddhist temple was built in Kamakura, Kenchô-ji, designed by Rankei Doryu, the priest who introduced the 'pure' (that is Chinese Song) version of the sect to Japan. The layout of the buildings was heavily based on Chinese models and reflected the re-emergence of cultural links between the two nations that had disappeared when the Heian court had broken off diplomatic relations in 894. The 'pond and island' garden while resembling that of the Heian palaces was subtly different. The Chinese Zen

FIGURE 9.3. Main pond at Saiho-ji, Kyoto.

monks had also bought with them paintings of their native landscape and this inspired the integration of the buildings and the garden in order to compose a picture. They also started putting buildings in the garden, which encouraged people to walk around the designed landscape, rather than just viewing it from the main building or on a boat on the lake.

With the move by Takauji back to Heian-kyo, the new Shogun set out to promote the new Rinzai Zen sect of Buddhism and he set up a system of monasteries across the country that could be controlled by him. His main advisor was Muso Kokushi, whose name is associated with many gardens of the time. Kuitert (2002, 74) doubts that he actually designed any of them but rather he provided inspiration to the wealthy warrior class to build gardens. One such garden was Saiho-ji, now popularly called the Moss Temple (Figure 9.3). Dating originally from eighth century,[9] it was rebuilt twice in the late twelfth century by Fujiwara Morokazu and finally Morokazu's grandson, Chikahide, restored it as a Zen temple in 1338. In the southern section is the pond, which although much reduced in size now, originates from the twelfth century when it was a Pure Land temple. In the northern section, there is possibly the first known example of a *kare-sansui* (dry landscape garden) (Figure 9.4) that would become synonymous with later Zen temple gardens. Inspired by Chinese landscape painting, the aim was to replicate the scenery, using rocks, moss and raked gravel. Saiho-ji thus represents the transition between the Pure Land paradise garden and austere gardens of the later Muromachi period but retains elements of both.

The Shoguns started to demonstrate their interest in gardens in secular buildings as well. Yoshimitsu, grandson of Ashikaga Takauji, built a palace

FIGURE 9.4. *Kare-sansui* at Saiho-ji, Kyoto.

popularly known as *Hana no gosho* (Flowery Palace) for its numerous gardens and large number of cherry trees: that symbol of political power. In 'retirement', former Shoguns built themselves retreats in the countryside around Kyoto, designed for them and close associates to go and discuss religion and the arts. This has parallels to their Medici near contemporaries in Renaissance Italy (see Chapter 3), whose used similar estates around Florence to debate the latest philosophical thinking. Whether these places were used to discuss politics and state matters is not known but Yoshimitsu used his retreat, Kinkaku-ji (popularly known as the Golden Pavilion, Figure 9.5) for official functions even after his retirement. Although he had abdicated in favour of his eight-year-old son to become a monk in 1394, he was still effectively in charge until his death in 1408 (Keene 2003, 90). The building at Kinkaku-ji is clearly influenced by the Chinese Song dynasty but the garden layout reflects the fact that this was formerly a Heian era estate with its typical central pond. What was different were the large rocks placed on the islands in the lake. Many of these 'rocks were gifts from Yoshimitsu's vassals as a means of tribute, and small wooden name tags were placed by them identifying the donors in question' (Ketchell 2009, 13).

Ginkaku-ji (now known as the Silver Pavilion) was built by the Shogun, Yoshimasa, about 1482 after his 'retirement'. A singularly ineffectual ruler who preferred the pursuit of aesthetics rather than politics, his reign led to the outbreak of civil war in 1467 and the widespread destruction of Kyoto following ten years of strife. The design layout of Ginkaku-ji followed Saiho-ji in having two parts to the garden: a lower pond area and an upper dry landscape garden, as Yoshimasa had been a frequent visitor to Saiho-ji. Yoshimasa's main legacy was

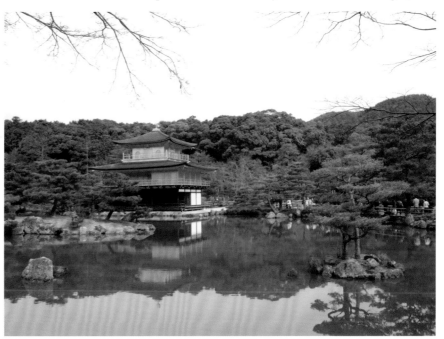

FIGURE 9.5. Kinkaku-ji (Golden Pavilion), Kyoto.

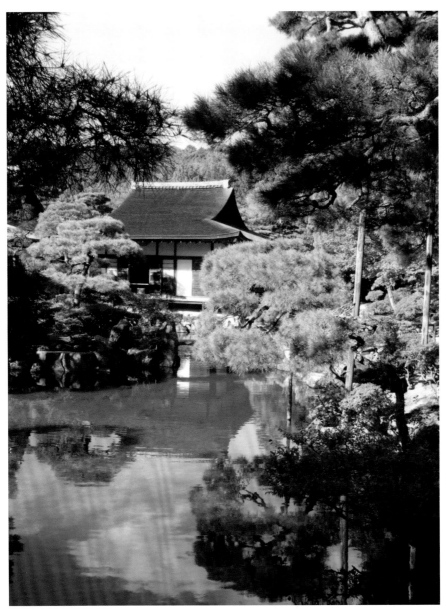

FIGURE 9.6. Togu-do at Ginkaku-ji (Silver Pavilion), Kyoto.

the promotion of the *chanoyu* or tea ceremony and the Togu-do at Ginkaku-ji (Figure 9.6) may have been the prototype for the teahouse (Treib and Herman 2003, 127).[10] Tea had been introduced from China in the Nara period but its popularity had declined during the Heian period. The Zen monks relaunched it in the twelfth century, regarding it as having both medicinal and moral properties that would improve mind and body. *Chanoyu* had also a subtler political message as the temple that is most associated with its development, Daitoku-ji in Kyoto, was not part of the *gozan* system and therefore outside state control (Keane 2009, 50). By the end of the sixteenth century, the *wabi-*

cha (simple tea ceremony) had become firmly established. The simplicity of the special teahouses (Figure 9.7) and then gardens that were created both in temples and secular buildings was in sharp contrast to the other gardens being created at this time. The latter was all about flaunting wealth and power but the tea garden was about restraint.

As the new Zen temples expanded and subtemples were established, small inner gardens began to appear in the early fourteenth century. They were of two types, one used a dry waterfall design (the first being Tenryu-ji in Kyoto) and the other was composition of gravel and rocks, the best known of the latter is the one at the Ryoan-ji temple, again in Kyoto (Figure 9.8). The first garden at Ryoan-ji (now the lower pond area) was built by Fujiwara Saneyoshi at start of eleventh century in typical Heian style. In 1450, Hosokawa Katsumoto, the Shogun's deputy in several offices, acquired the site and founded the Zen temple in the upper half of the garden. It was destroyed by fire but rebuilt around 1488 and it is thought that the famous dry garden may date from this time.[11]

This is, and was, a very important garden and there is debate over who created it. Some records attribute it to Kasumoto himself and others to Soami, the famous painter and garden designer.[12] However, it may have been the Zen monks together with *sensui kawaramono* (riverbank workers as gardeners)

FIGURE 9.7. Teahouse at Toji-in, Kyoto.

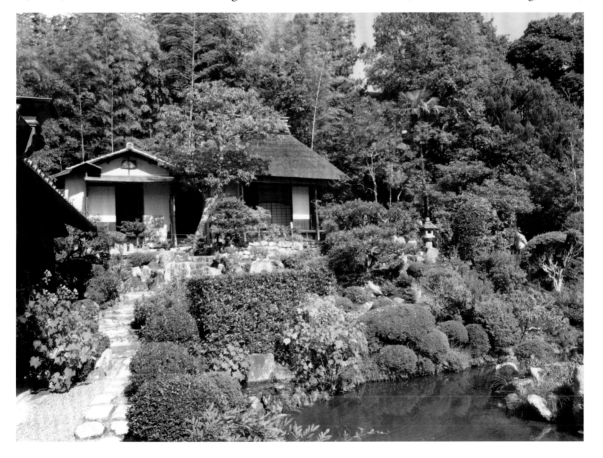

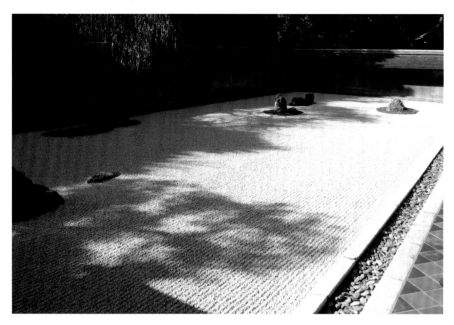

FIGURE 9.8. *Kare-sansui* at Ryoan-ji, Kyoto.

(Nitschke 2007, 90). The fact that there is the need to attribute it to a master or someone of high rank meant that the traditions of the 'special nature of garden making' still held true. It was built at a difficult time. Following the civil war, there was a power struggle amongst the provincial *daimyo* trying to gain control of a weakened Shogun and Emperor. In the mid-sixteenth century, Oda Nobunaga took power in Kyoto and began the process to unify the country militarily but it was his successor, Hideyoshi, who achieved absolute control of Japan. These two leaders had the disadvantage of being perceived as uncivilised and lacking knowledge of the finer things in life. Supporters of the old regime therefore wanted to demonstrate their superiority by claiming that the design of this important landscape was by one of them, rather than the lower rank monks and even lower class gardeners.

The new *daimyo* Shoguns recognised that 'political supremacy also meant intellectual supremacy over a cultured city elite' (Kuitert 2002, 152) and their response was to engage 'teachers' such as Sen Rikyu, the tea master. These teachers organised cultural gatherings as a way of bringing together the new and old guard through meetings at tea gardens. At these events, 'donating or receiving prized teacups or other implements symbolised the reinforcing of relations of political power' (Kuitert 2002, 153). The *daimyo* had constructed many new castles and planned cities in their individual areas of control. They followed the Shogun's example and started adding teahouses to their residential areas and so these tea masters exerted a high degree of political control as official advisors.

The tea masters had an indirect influence on the design of gardens as the more simplistic style of the tea garden became popular, in marked contrast to the palaces that Hideyoshi and others were having constructed. In 1586,

he built a large castle complex in Kyoto, known as *Juraku-dai* (Mansion of Assembled Pleasures) on the site of the original Imperial palace. Two years later, the Emperor made a visit, thus establishing who had the real power base but also re-enforcing Hideyoshi's legitimacy. Its large pond garden was furnished with many fine rocks and plants 'donated' by other *daimyo* and local townspeople in Kyoto. This was a common practice, as the rocks were revered and had an important symbolism with regard to their placement. When the palace was dismantled in 1623, the important buildings were relocated. So too were the rocks that made their way to the gardens of the Nishi Hongan-ji and the Sambo-in temples.

The Tokugawa Shogunate and the stroll garden

In 1602, the Tokugawa Shogunate, led by Ieyasu came to power. The Tokugawa clan would remain the country's leaders until the nineteenth century. Although this era brought prosperity, there was strict control and enforcement of the social hierarchy with the Shoguns and their families at the top, followed by the *daimyo*, the *samurai* and finally the farmers, artisans and merchants. There were restrictions on many areas of life including contact with the outside world and from 1633, there was a ban on foreign trade and cultural exchange. The Shogun was concerned about the level of influence of the Jesuit missionaries and the threat that Christianity posed to the 'state religions' of Shinto and Buddhism. Gardens continued on the ideas of the previous centuries with little outside influence, albeit on a grander scale, for the next two centuries.

Gardens became a substitute for the lack of overseas travel, with their recreations of 'famous views' but that is not to say they were static. As Treib and Herman point out:

> 'it has been said that the history of Japan's use of foreign ideas has been 'adopt, adapt, adept'. This dictum applies equally to Japanese garden art. By the seventeenth century, Japan had surpassed its cultural parent China in creating landscapes of beauty and intricacy.' (2003, 32)

Harking back to the Heian period when the Imperial Bureau of Gardens operated, the new central government appointed commissioners of public works. Their role was to control the construction of public monuments and buildings, including gardens. While the commissioners were only responsible for the final layout, with gardeners doing the implementation, these 'culturally disposed [individuals] … in close cooperation with garden workers, both freely developing their own specialty, produced gardens of a very high quality' (Kuitert 2002, 184).

One of the commissioners, Kobori Enshū, was responsible for the palace gardens but his influence on garden design was much wider. An expert in the tea ceremony, he was from an aristocratic background and provided one of the links between the court and the Shogun, not dissimilar to the earlier role of the 'teachers'. There were restrictions placed on building of temples and

shrines to limit the power of the Buddhist priests and other religious leaders, so commissioners like Enshū had to careful when working on new temple complexes. Konch-in sub-temple in Kyoto was commissioned by the head priest, Sūden, who was also a powerful politician and in charge of the monasteries. The Shogun, Iemitsu, had planned to visit it in 1634 and in preparation, Enshū worked on the garden in front of the main hall of the abbot's quarters (*hojo*). The layout of turtle and crane 'stone islands' in front of raked gravel was a common design idea[13] but what was different was the *reihaiseki* (worshipping stone) between these and in direct alignment with both the centre of the *hojo* and the shrine dedicated to the spirit of the first Tokugawa Shogun, Ieyasu.

Sūden died in 1633 and the Shogun did not visit but this clearly politically motivated design was not limited to temples. Just as his predecessors had done, Ieyasu built an imposing residence, Nijo Castle, in the Imperial capital, Kyoto, to demonstrate his power in 1603. Enshū again was responsible for its remodelling in advance of the visit of Emperor Go-Mizunoo in 1626. A temporary residence was built for the use of the Emperor next to the main pond and the Shogun, Iemitsu, ordered that the enormous rock groups were turned to face the Imperial residence (Nitschke 2007, 126), a not unsubtle means of showing who was in charge. As if to re-enforce the point, the garden was called *Hachijin no niwa* (Garden of Eight Camps), reflecting the positions usually adopted by the seven army camps surrounding the shogunal headquarters (Nitschke 2007, 128).

The Tokugawa Shoguns moved the capital to Edo (Tokyo) and under the *sankin kotai* (law of alternate attendance), the *daimyo* were required to spend half the year there. In addition, when they were absent, their family remained behind in Edo, thus enforcing the control of the Shogun. This meant the nobles had to have an estate in Edo as well as one in their hometown. Their regular travel between the two places contributed to the spread of cultural ideas, including gardens, throughout the country. Over time the artistry and complexity of these gardens increased, as the nobles sought to vie with one another. Ketchell (2009, 15) believes that: 'there was also an ulterior motive in the encouragement given to creating gardens, as it soaked up the finances of *daimyo* and thereby limited their capacity to arm and present a military threat to the central authority'. This certainly worked for a long time but by the middle of the nineteenth century, the drain on the resources of the *daimyo* and the corresponding rise in economic power of the merchant class, ultimately led to the collapse of the feudal system. For the new capital, the symbol of power, the cherry tree, was widely planted and many regional warlords brought native trees from their areas, with the result that there were soon over two hundred and fifty varieties (Ohnuki-Tierney 2003, 55) in Edo.

The Emperor and the Imperial family had little role in the real affairs of state and Emperors often 'retired' or abdicated in favour of a child or relative. A favourite pastime for a retired Emperor, which was indirectly encouraged by the Shoguns,[14] was to build a garden. The concept of *shakkei*[15] (borrowed landscape) became popular as around Kyoto in particular, the natural hills could provide a

dramatic backdrop to a garden. One of the best examples of this is Shugaku-in built by Emperor Go-Mizunoo. He had abdicated in 1630 and spent last 50 years of his life developing the estate. It was originally a temple in the foothills of the Higashiyama mountain range but that had been destroyed by the time the Emperor chose the spot. Originally covering 73 acres (*c.*29.5 ha), Shugaku-in was completed in 1655 with three main gardens each with its own villa. The upper one with its central lake (Figure 9.9) uses the *shakkei* to create a dramatic effect. He was inspired by the Heian gardens of his ancestors, perhaps looking back ruefully to the time when they had power. Although the estate was not insubstantial, the use of the surrounding landscape gave the impression that his landowning (and therefore power) was larger than it actually was.

It was the two other Imperial gardens of Katsura and Sento Gosho in Kyoto (the latter also designed by Go-Mizunoo, Figure 9.10) that provided the inspiration for the large landscape 'stroll' gardens both in Edo itself and the *daimyo* provincial estates. The idea of creating a garden following a circuit to give varying views occurs in many other gardens around the world. At Versailles there was a prescribed route by the king (see Chapter 4) and the great British landscape gardens of the eighteenth century also had walking and carriage routes. In Japan, the circuit in the stroll garden may have been linked to the

FIGURE 9.9. Upper garden and *shakkei* at Shugaku-in, Kyoto.

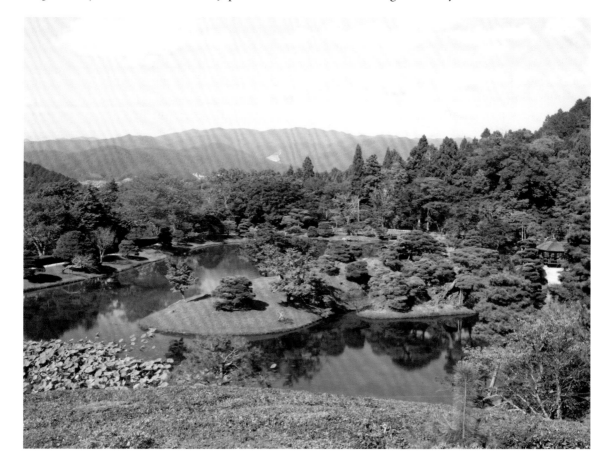

FIGURE 9.10. Sento Gosho imperial palace garden, Kyoto.

popular pilgrimage circuits around a sequence of Buddhist temples (Nitschke 2007, 184). As with other religious pilgrimages, the aim was to earn merit and thus go to paradise but in the secular garden, it was more about reminding visitors of the power and status of the owner. For the aristocracy such as Prince Toshihito and his son, the creators of Katsura, it was the only expression they could use. The first article of the 'Edicts for the Conduct of the Nobility' of 1615 passed by the new central government was 'the Imperial court should keep to the arts and above all pursue learning' (Kuitert 2002, 166). In other words, they had to stay out of politics.

In Edo, the *daimyo* (there were about 100) had a main residence (*kami yashihi*) near the main gate of the castle but they were also allowed to have another outside central Edo (known as *shimo yashiki* and *nama yashiki*) and it was at the latter, that the new stroll gardens were created. One of the first was Koishikawa Korakuen, dating from 1629, which was built by Tokugawa Yorifusa, and Mitsukuni, his son and nephew of the ruling Shogun. While the design was clearly influenced by China with its reproduction of Seiko Lake and a 'Full Moon Bridge', it was the use of Chinese philosophical texts to give it its name that is more relevant to its political role. Mitsukuni had admired the Chinese text *Gakuyoro-ki* by Hanchuen that said there is 'a need for those in power to worry about maintaining power first and then enjoy power later'. Thus, the name Korakuen, meaning 'the garden for enjoying power later on' that was chosen (*Koishikawa Korakuen Garden* leaflet) clearly showed that the Tokugawa family felt firmly in control and so were free to enjoy their gardens.

The Korakuen also incorporated elements of the Japanese landscape, both natural such as Mount Fuji and others replicating famous gardens, such as the

bridge over an area full of maples, like the one at the Tofuku-ji temple in Kyoto. This idea became known as *shukkei* (literally 'shrunken or reduced scenery') (Ketchell 2009, 16). At another later garden in Edo, Rikugien completed in 1702, there were 88 *sekichu* (stone markers) indicating the views of the garden that were of special beauty or interest. Built by Yanagisawa Yoshiyasu, a trusted confidante to the fifth Tokugawa Shogun, it is based on the theme of *waka* (classical Japanese poetry) and its name refers to a system for dividing Chinese poetry into six categories (*Rikugien Garden* leaflet). Yoshiyasu shared his love of *waka* with the Shogun and while not as an overt statement as the naming of Korakuen was, nevertheless it demonstrated Yoshiyasu's proximity to power.

As well as the new capital, the *daimyo* had properties in their homelands. Many of their castles had ceased their defensive role by the middle of the seventeenth century and large stroll gardens were built next to them. As land was not restricted, as was the case in the capital, these became statements of power and prestige, not unlike the estates of the nobles in Western Europe at the time. Many were developed over the next hundred years and became highly individual statements for their owners. One of the largest is Ritsurin (Figure 9.11) in Takamatsu, on the southern island of Shikoku, started in the early seventeenth century and completed in 1745. It is over seven hundred and fifty thousand square metres. Other *daimyo* gardens of the period averaged one hundred thousand square metres. Despite its size, it still follows the principles of gardens such as Katsura where each view on the circuit is new and interesting.

Though these gardens were worked on over a long period by successive generations, they were added to rather than the strategy adopted in the West,

FIGURE 9.11. Ritsurin Park, Takamatsu.

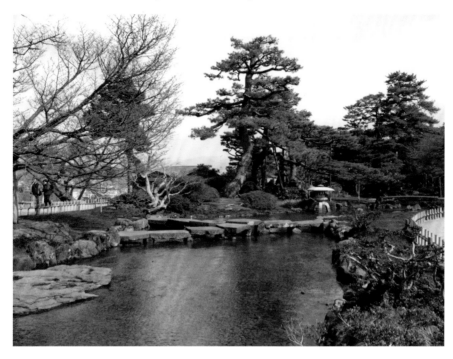

FIGURE 9.12. Kenrokuen
Park, Kanazawa.

where a new garden was laid often on top of an old one. In this respect, 'in
adding his own, new contribution, each designer was thereby careful to respect
the work of his predecessors and the harmony of the whole' (Nitschke 2007,
187). In other words, the owner was following the principles of the *Sakuteiki*.
On a smaller scale, the garden of Kenrokuen next to Kanazawa Castle (Figure
9.12) was started in 1676 and work on it continued until well into the nineteenth
century. It only acquired its name in 1822, Kenrokuen being the name of one
of gardens in the *Chronicles of the Famous Luoyang Gardens* by the Chinese poet
Li Gefei. It had the six attributes of a perfect landscape: spaciousness, seclusion,
artifice, antiquity, watercourses and panoramas (*Kenrokuen Garden* leaflet).

As the stroll garden became more popular and larger, there was a move away
from expensive rocks to clipping of plants to achieve the required effect. Known
as *okarikomi*, this pruning to form shapes (sometimes now referred to as 'cloud
pruning') was popularised by Kobori Enshū in the early seventeenth century.
Pruning had long been a feature of Japanese gardens but this particular form,
which started in temples such as Raikyu-ji (Figure 9.13), soon became part of
the secular garden. This new style of topiary developed about the same time
as the same technique in Western Europe. While this may be a coincidence
as foreign influence was largely absent, there were some contacts through the
Dutch trading port at Nagasaki. However only a select few could acquire foreign
books before 1720, mainly through the annual gifts that the Dutch traders sent
the Shogun. Although scientific books on cartography and the techniques of
perspective drawing were known to have been available, there does not seem
to be any specifically on gardens or topiary.

FIGURE 9.13. Raikyu-ji, Takahashi.

By the middle of the eighteenth century, with the increasing prosperity of ordinary population and in particular the merchants, gardens were no longer exclusively for the *daimyo*. The 'secret' was finally out as a new class of professional gardeners created gardens and the advent of woodblock printing allowed for the production of cheap gardening manuals. One of these was Enkin Kitamura's *Transmission of Making Mountains and Creating Gardens* written in 1735. As well as giving advice on garden construction, it also had woodcuts of the old gardens such as Kinkaku-ji, as inspiration. When Akizato Rito republished the book in 1828, he added a section, which categorised Japanese gardens into three types: *shin* (elaborate or formal, for example a stroll garden), *gyo* (partly simplified or semi-formal, for example a temple garden with a pond) and *so* (highly simplified or informal, a dry landscape). The one chosen depended on the site with the first being suitable for hilly areas and the latter for flat spaces. This approach has been criticised by modern historians of the Japanese garden (Nitschke 2007, 205 and Kuck 1968, 240–1) as destroying the creative spirit of the Japanese garden but it was more a reflection of the times when the garden had lost its association with power and prestige. This was not unique to Japan, as this was happening as well in Western Europe in the nineteenth century.

Japanese garden travels west and revitalised at home

By the middle of the nineteenth century, the increasing contact with Western traders and their ideas, slowly led to the rejection of the orthodox Confucian ethic of the unquestioning of class relationships and social hierarchy, particularly

amongst the *samurai* elite and prosperous merchants. Events were brought to a head by the 'gunboat diplomacy' of the United States, which wished to trade with Japan. There was a push for the Emperor to become the real head of state once more and a return to Shintoism as the major religion. With Meiji ('enlightened rule') restoration of the Emperor's powers in 1868 and the demise of the Shogunate, Japan's isolation ended and there was a period of rapid industrialisation. By 1905, the country had been transformed into a major economic and political force in the region.

Initially the country needed to trade to earn foreign currency and the new government sent the first delegation from Japan to an exhibition in Paris in 1867 where it took portable works of art, such as paintings. These caused much interest, with artists such as Claude Monet acquiring prints by Hiroshige. One of these, *Wisteria Blooms over Water at Kameido*, is thought to have inspired Monet's bridge over his much painted lily pond (Herries 2001, 19). Further exhibitions followed in Vienna in 1873 and Philadelphia in 1876 and these included elements of the Japanese garden. However it was more about selling plants and individual items such as stone lanterns, rather than the whole concept of a garden. This Western concept of having a 'Japanese garden',[16] alongside the trend for similar 'Italian gardens' was in part a search for novelty and Josiah Conder, who published *Landscape Architecture in Japan* in 1893, fuelled interest further. Although he had lived in Japan, Conder was heavily reliant on the books by Akizato Rito and others, which deconstructed the garden into easily reproducible elements and led to a misguided view of what constituted a true Japanese garden.

The Japanese-British exhibition of 1910 had two gardens constructed by gardeners from Japan: the *Garden of Peace* and the *Garden of the Floating Islands*. Again these were not authentic gardens, as the Japanese Department of Education pointed out:

> 'the gardens are not purely Japanese. They manifest the good feeling existing between the horticulturalists of England and Japan; equally they symbolise the alliance between our countries, for Japan supplied the ideas and the plants while Great Britain contributed the site and materials.' (Herries 2001, 21)

Some of the Japanese gardeners stayed on after the exhibition and a number of Japanese-style gardens were created immediately after. Laurence Weaver's comment in 1915 that: 'the disposition of a few typical ornaments, of a bronze stork her and a stone lantern there, does not make a Japanese; it only makes an English garden speak with a Japanese voice' (Herries 2001, 36), was apt. It would seem that the Japanese garden was too firmly embedded in its native country to be easily transported.

In Japan, the shift in power away from the Shogun and the *daimyo* had a significant impact on their gardens and those of the Buddhist temples they supported. In 1867, as a show of support for the new Emperor, the leaders of the four most important feudal families turned over their estates to him, claiming that they were 'returning to the Son of Heaven what had originally

been his 'so uniform rule may prevail throughout the Empire" (Spellman 2001, 62). In July 1869, an Imperial decree ordered that all the other *daimyo* pass over their lands in return for the political post of governor. Two year later, a new law turned many of the *daimyo* gardens and temples into public parks. By this stage, many had fallen into disrepair and needed restoration. In the Meiji era of the late nineteenth century, there was a demand for all things Western, particularly culture, so curiously the gardeners put in charge of these new public gardens were sent to Europe to look at, and learn from, the latter's parks. The gardeners brought back new architectural styles but their gardens remained essentially Japanese, particularly the stroll gardens, which had much in common with the Western park. However many historic smaller gardens were neglected and important components such as rocks and stone lanterns were sold off. The problem it seemed that gardening in Japan stopped being an art. With few private patrons, gardens were therefore merely maintained rather than developed.

In Europe there was a growing interest in historic gardens at the end of the nineteenth century, but there was little serious scholarship into the history of the Japanese garden in Japan. Two prominent gardens built in the last decade of the nineteenth century demonstrate the attitudes of the time and Jihei Ogawa, a leading designer was responsible for both of them. Murin-an Villa in Kyoto was built in 1896 by the prince and statesman, Aritomo Yamagata. Both in terms of architecture and the garden, it shows the influence of Western ideas. Next to a Neo-classical house is a traditional *shoin* and the garden is essentially a stroll garden but with a lawn added (Figure 9.14). The other was the Heian

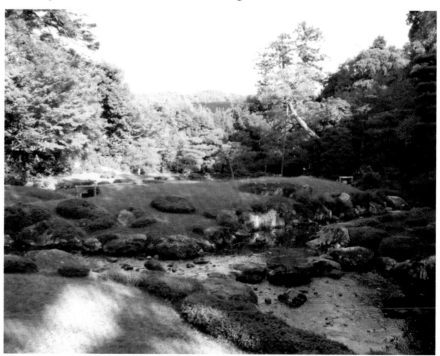

FIGURE 9.14. Murin-an, Kyoto.

Shrine (Figure 9.1, above) completed a year earlier, a reconstruction of a Heian era *Chodo-in* (Hall of State) and garden. Although the building was historically accurate, albeit on a reduced scale, the garden resembled more of a later stroll garden instead of an authentic palace 'pond garden'.

In the Showa era (1926–1988), alongside heightened nationalism, there was a resurgence in traditional Japanese gardens prompted principally by Mirei Shigemori. In 1934, he began a survey of significant gardens in Japan. Four years later, he published *Illustrated Book on the History of the Japanese Garden* in 26 volumes. This was an unprecedented and meticulous documentation of major gardens in the country. However Shigemori was not content to just look back, he was the first major designer not only to appreciate Japan's garden heritage but also bring some genuinely new ideas. The *Hojo* garden at Tofuku-ji temple, commissioned in 1939, was one of his first designs in an historic landscape. The four gardens that surround the building are all of the dry landscape type and while the south garden has many traditional elements (Figure 9.15), it is

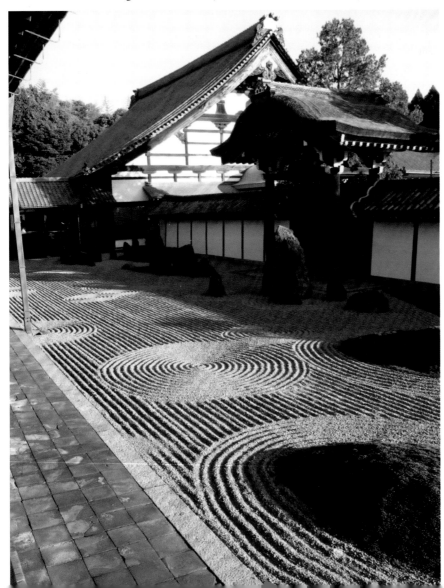

FIGURE 9.15. South garden at *hojo*, Tofuku-ji, Kyoto.

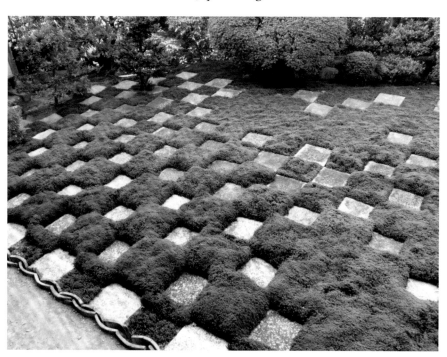

FIGURE 9.16. North garden at *hojo*, Tofuku-ji, Kyoto.

the radical nature of the other three (Figure 9.16), in particular their geometry that sets it apart.

Although much admired by contemporary modernist landscape architects, there is debate as to whether he was the first great reformer of Japanese garden art or the last of the traditionalists (Tschumi 2007, 13). In 1971, he wrote *Shin-Sakuteiki*, (or '*The New Art of Setting Stones*') an essay that was intended to provide an update on the iconic eleventh century original, which Shigemori felt was now out of date for a modern world. Traditional architecture had been replaced by the ubiquitous Modernist style but the simplicity of the dry landscape garden seemed to suit it well (much better in fact than Western gardens). Shigemori believed that you should follow the line in the original Sakuteiki: 'when creating a garden, let the exceptional work of past master gardeners be your guide. Heed the desires of the master of the house, yet heed as well one's own taste' (Takei and Keane 2008, 151). So the unique Japanese garden style remains an important part of Japanese culture but has adapted itself and is just as likely to be found in corporate headquarters or local government offices as well as private residences.

Notes

1. This has been variously translated as 'Notes on Garden Making' or 'Records on Garden Making'.
2. In this version the full inscription at the end is: 'On the 27th day of the 6th month, in 1289, bored with the world, I read through this. An Old Fool. The volume is the property of Gokyogokudono. Precious – it must be secret, it must be secret' (Takei and Keane 2008, 201).

3. The others being the Genji, Heike and the Fujiwara, the latter was the most powerful through intermarriage with the royal family and many periods as Imperial regent or de facto ruler.

4. *Shima* means literally a bound artefact and *shima-nawa*, a rope of occupation (Nitschke 2007, 18).

5. A branch of Mahayana Buddhism, its main focus was on achieving salvation through contemplation or by uttering the name of Amida Buddha. This led to a flourishing of the arts (as other worldly endeavours seemed futile), in particular gardens.

6. There is some debate about the phrase 'Zen Gardens' and the relationship between the dry landscape gardens and Zen Buddhism. The first known reference is in 1935 by Lorraine Kuck in *One Hundred Kyoto Gardens* and is perhaps more a reflection of that time when commentators were trying to link the 'Japanese spirit' with Zen teachings, (Kuitert 2002, 129–38).

7. Originally this was probably a plum, but was replaced by a cherry between 834 and 848 in the Imperial garden (Kuitert 2007, 131).

8. This was his main residence in Kyoto city itself and was four times the size of the average nobleman's plot.

9. Thought to be the temple Kawara-in, founded in 731 by Gyoki Bosatsu on orders of Emperor Shomu (Jacobs 2004, 2).

10. This has been disputed as the fact that the building had a central brazier, did not indicate that it was necessarily for preparing tea.

11. The first descriptions of it date from the 1680s.

12. This is the claim from the temple's guidebook.

13. Cranes and turtles are associated with the Chinese myth of the Isles of the Blest, five islands to the east of China where the population were immortal. These people flew around on the backs of cranes and the islands themselves were carried of giant sea turtles. In Japan, these creatures became symbols of longevity and their use as symbols in gardens started in the seventh century (Slawson 1991, 127).

14. Funds for Imperial palaces and gardens came from central state coffers: a way of 'buying off' the Emperor and his family (Kuitert 2002, 167).

15. The original term for *shakkei* was *ikedori* or 'to capture alive' meaning that it was not just about a view but about 'capturing alive' natural and man-made features (Nitschke 2007, 181–2).

16. This usually meant assorted stone lanterns, a red half-moon bridge, clipped bushes, cherry and maple trees and a pond with some stones or pebbles.

Katsura Rikyu, Kyoto

Prince Toshihito, the creator of the Katsura Imperial Villa (often referred to *rikyu* or 'detached palace'), was the grandson of an Emperor and thus a member of the Imperial family. At the age of seven, he had had the additional good fortune to be 'adopted' by the military leader, Hideyoshi and expected to become the imperial regent (*Kampaku*) after the latter's death. However although he was 'disinherited' when Hideyoshi's son was born, he was given some financial compensation that would allow him subsequently to develop his estate at Katsura. His path then to some (albeit limited) political power was to succeed his brother, Go-Yozei, as Emperor. With his brother's abdication in 1611, Toshihito again lost out. This time it was to his nephew, Go-Mizunoo, who would create the gardens at the Sento Gosho and Shugaku-in imperial residences (Figures 9.9 and 9.10). However by this stage the Tokugawa Shogun, Ieyasu, was in charge and the Emperor had lost most of his political power. Partly because of Toshihito's links with both the Imperial family and the Shogunate, he was allowed to acquire a country estate.

A rather poetic story has Toshihito taking a walk alongside the Katsura River, to the west of the centre of Kyoto, on 27 June 1616 and deciding to build a *rikyu* there. Whether this is true, what is certain is that around this time, he purchased the estate on which the villa and garden were to be built. The Fujiwara family, who had provided the Imperial Regents until the mid-fourteenth century, had owned the property for many generations. It was associated with the classical *Tale of Genji*, set in the Heian period when nobles such as Toshihito would have had political influence. Completed around 1620, this was quite a simple place and reflecting the burgeoning tea culture, it was originally called 'Simple Tea House in the Melon Fields' (Keane 2009, 172). Only part of the main building (*Koshoin*) still exists from his time and following his death in 1629, the garden fell into disrepair. His son, Toshitada, completed the design after 1642 that is carefully preserved today. The delay was caused by a lack of resources, which was remedied by Toshitada's marriage to the daughter of Maeda Toshitsune, a powerful warlord. Toshitada was said to have been inspired by the *Tale of Genji* and an account published in 1682 commented that 'people who saw the place said with astonishment that it was just as though the glories of the past had reappeared in this world' (Kuitert 2002, 204).

This is a relatively small site of about 17 acres (*c*.6.9 ha), with a large central lake (Figure 9.17). Together with Sento Gosho, it was one of the first 'stroll gardens'. As visitors went on a circuit (Figure 9.18) around the lake, they were presented with a series of varying views of the lake itself, the buildings (including the main villa), stone ornaments, rocks and the precise planting.

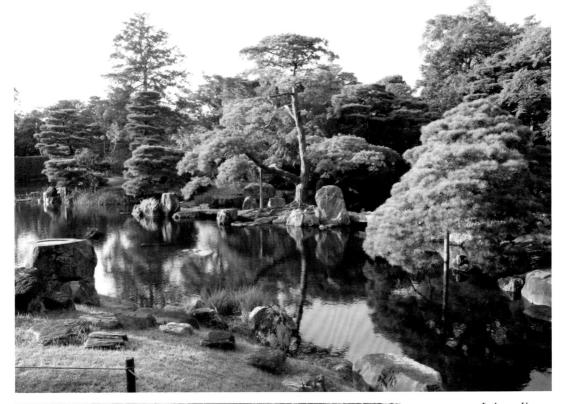

FIGURE 9.17. Lake at Katsura *rikyu*, Kyoto.

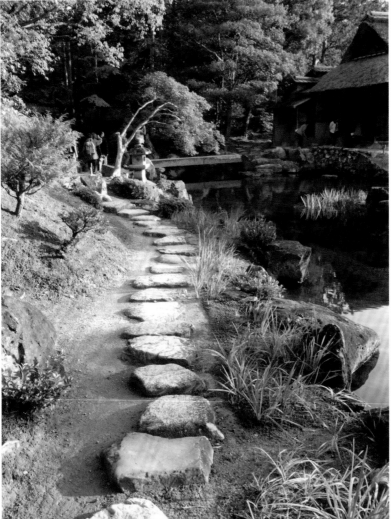

FIGURE 9.18. Stepping stones on circuit around Katsura *rikyu*, Kyoto.

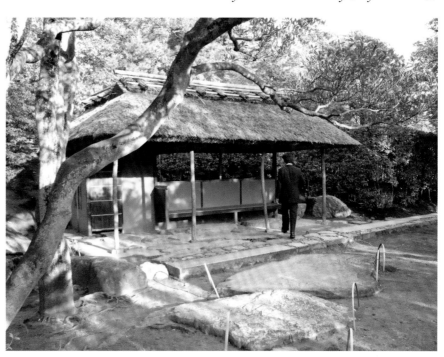

FIGURE 9.19. *Soto-koshikake* (waiting pavilion) at Katsura *rikyu*, Kyoto.

There are recreations of famous views, such as the *Amano-hashidate* (Figure 9.20) or 'Heavenly Bridge', a spit of land on the Japan Sea coast (Keane 2009, 174), another idea that would later become a popular feature of stroll gardens. Although some believe that Kobori Enshū, the tea master, was the designer, it is probable that it was Toshitada himself who created it (Moore *et al.* 1993, 100). He certainly devoted a lot of his time to it and is recorded as having spent a lot of time supervising the work (Kuitert 2002, 204), until its final completion in 1662. Its design is a curious mix of the grand and the simple, with the grand central villa contrasting with the rustic simplicity of the garden buildings (Figure 9.19). Keane (2009, 174) describes the design aesthetic as straddling 'the boundary between *daimyo-cha* [the sophisticated tea ceremony of the lords] and *wabi-cha* [the simple tea ceremony]'. Toshitada was thus trying to create a style that showed both his position but also his sophistication.

There are four teahouses in this garden, showing how important the *chanoyu* or tea ceremony had become. The Shokin-tei (Figure 9.20) is considered the best of these and follows the principles laid down by Enshū. For Toshitada and his father before him, with their lives controlled by the Edicts for the Conduct of the Nobility, they had little option but to immerse themselves into pastimes such as garden building and the intricacies of the *chanoyu*. The 'retired' Emperor, Go-Mizunoo was said to have found inspiration here for his garden at Shugaku-in, when he made an unofficial visit in 1658 (Treib and Herman 2003, 110). Go-Mizunoo then made a formal visit in 1663, a year after Toshitada had died. Prince Yasuhito, his son and the new owner, welcomed the Emperor. Toshitada had adopted Yasuhito, as he had had no sons of his own and thus it ensured that the garden remained the property of the Imperial family. More

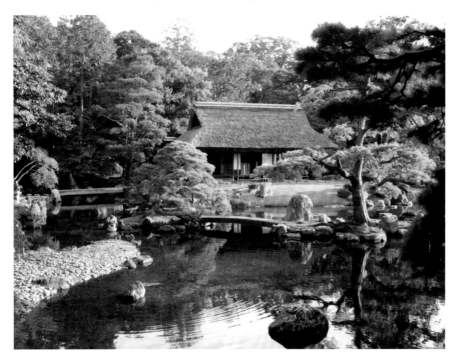

FIGURE 9.20. *Amano-hashidate* in foreground and *Shokin-tei* (teahouse) at Katsura *rikyu*, Kyoto.

importantly it meant that the garden has remained largely unchanged since then. The only changes have been a painted red bridge that was originally in front of the Shokin-tei being removed and the lawn in front of the main villa would originally have been a gravelled area (Turner 2011, 271).

In an interesting postscript, the Modernist architect, Bruno Taut visited Katsura in 1933. He admired its apparent simplicity and purity of form. Others took up his enthusiasm for the garden such as Walter Gropius, who together with the Japanese architect, Kenzo Tange wrote a book on Katsura in 1960. What these Modernist architects admired was the complete integration of the buildings in the designed landscape: something they were struggling to do with their own style of architecture (see Chapter 10). However they missed the complexity and background in which it was created. This was a time of a tense relationship between the Imperial family and the new political force, the Tokugawa shoguns. Katsura garden is a subtle political message of the previous importance of the former and the new conditions imposed by the latter.

Twentieth Century Gardens:
Socialist Politics and Conservation

> There is a tendency for each generation to sweep away the creations of their parents but to value the creations of their grandparents and great grandparents. (Watkins and Wright 2007, 11)

Gardens do not stay the same: they evolve through the hand of man and by nature itself. By the start of the twentieth century, many different styles and fashions in gardens in Britain had come and gone or been reinvented for a new generation during the preceding century. Humphry Repton, towards the end of his career, had started experimenting with 'old styles' having seemingly exhausted the debate on the extent to which a landscape should replicate nature. John Claudius Loudon had admired the formal gardens on the Continent and the few remaining in Britain. He described these in his *An Encyclopaedia of Gardening*, first published in 1822.

This 'historical revivalism'[1] led to three main trends in Victorian garden design from the 1840s. First was the 'Italian style' derived from the surviving gardens of the Italian Renaissance and spurred on by Repton's notion that this was the English style before the rise of the landscape garden.[2] The second was based around the seventeenth century French *parterre de broderie* or French style, but not called that at the time and its champion was William Andrews Nesfield. The last one was the 'Dutch garden' although Elliott (2000, 19) points out that this was never clearly defined and was often interchangeable with Italian gardens. It was mainly associated with the use of architectural topiary with survivors such as the gardens at Levens Hall in Cumbria becoming fashionable once more. Gertrude Jekyll remarked that:

> 'precious indeed, are the few remaining gardens that have anything of the character of this wonderful one of Levens: gardens that above all others show somewhat of the actual feeling and temperament of our ancestors.' (1904, 65)

Increasingly these styles merely came to be labelled as 'old-fashioned', in other words pre-dating the ubiquitous 'landscape gardens' created by Lancelot Brown and others in the second half of the eighteenth century, which had well and truly fallen out of favour.

By the end of the century, with the British Empire at its zenith and nationalism at its height, a new term became fashionable: 'English Renaissance'. Following architectural styles that were consciously referring back to the past such as Gothic and Tudor, this 'new' style harked back to the 'formality' during the reign of Queen Anne and earlier. In Reginald Blomfield's seminal work, *The Formal Garden in England*, details of the surviving formal gardens in England were described, with the emphasis of the unity between house and garden. Blomfield noted:

> 'those who attack the old English formal garden do not take the trouble to master its very considerable difference from the continental gardens of the same period. They seem to regard the English Renaissance as the same as the Italian.' (1892, 17)

Above all Blomfield rejected the 'natural' style of gardening be it by Lancelot Brown of the eighteenth century or his nearer contemporary, William Robinson.

Alicia Amherst's *History of Gardening in England*, was the first detailed account of English gardens from Roman times and she concludes:

> 'with the many beautiful gardens which exist throughout England there need be no plea of ignorance. Anyone laying out a garden can see examples of every style … This is an age of progress in Gardening, as in other arts, and if garden design is carefully studied … the newest gardens of the nineteenth century might easily surpass anything that has yet been seen in England.' (1895, 306)

Blomfield and Amherst's appreciation for the historic gardens of England were the first indications that a certain style should be preserved or at least retained. Until then, gardens and landscapes had been changed often with little regard for what had gone before. These 'old gardens' had survived only because previous owners had been unable or unwilling to keep up to date with the latest fashions.

It was not only in Britain that there was a new interest in historic gardens. Italy had been on the tourist circuit for over two centuries and its gardens much admired and copied. By the end of the nineteenth century though many Italian gardens were neglected, as their native owners had either lost interest or struggled to maintain them. Two important books, Charles Platt's *Italian Gardens* and Edith Wharton's *Italian Villas and Their Gardens*, led to the acquisition of many Italian estates by wealthy Anglo-Americans who carefully restored or remodelled them. Platt ruefully notes that:

> 'the gardens existing today have all passed through a variety of changes. Some of them have gone almost to ruin through neglect or difference of taste in their owners, and, with one or two exceptions, those which are at present the most carefully kept up have suffered the most severely from the changing fashion of the time.' (1894, 4–6)

Wharton (1904, 12) dismissed the vogue for 'Italian style' gardens outside of Italy describing the gardens as '*untranslatable*, that it cannot be adequately rendered in another landscape and in another age', so you could only have a

true Italian garden in Italy itself. The new owners were undaunted though and created whole new gardens such as the one at Villa I Tatti (Figure 10.1), built in 1910 for Bernard Berenson in Settignano, outside Florence. Inspired by the nearby Villa Gamberaia (Figure 10.2), which had recently been renovated, it follows the Renaissance ideal of the formal and informal. In 1903, Arthur and Hortense Acton rented the four hundred year old estate of La Pietra (Figure 10.3), outside Florence and they redesigned the garden to reflect their vision of a Renaissance garden. The formal gardens of about 8 acres (3.2 ha) had been swept away in the 1860s when the site was turned into an English style park, a not uncommon fate and one that Platt refers to above.

The 1830 revolution in France had not only brought about a new king and government, it also marked a new regard for the history of France, both the 1789 revolution and the *ancien regime* that preceded it. The Interior Minister, Francois Guizet, appointed Ludovic Vitet as the first *Inspecteur des monuments historiques.* This was followed in 1837 by the creation of the Commission of Historical Monuments, headed by Vitet's successor, Prosper Mérimée. He drew up the first list of just under one thousand important buildings in 1840 but no gardens were specifically mentioned, although châteaux such as Chenonceaux (Figures 4.5 and 4.6) in the Loire Valley were recognised. This new attitude towards the preservation of a country's cultural legacy in France did not go unnoticed elsewhere. Austen Layard, Chief Commissioner of Works and Buildings, proposed the first list of historic monuments in Britain in 1869.[3]

The period between 1870 and 1914 was marked in France by a strong nationalistic ideology, thus the more natural styles that had been popular

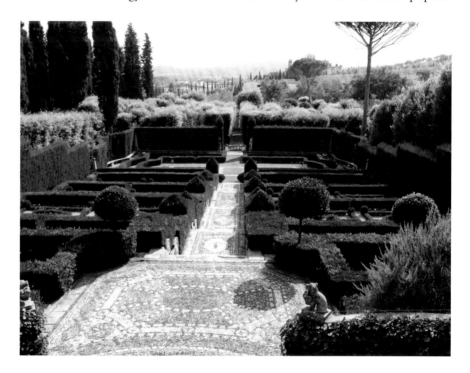

FIGURE 10.1. Villa I Tatti, Settignano.

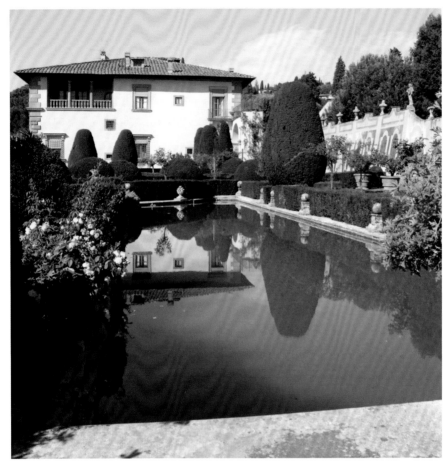

FIGURE 10.2. Villa Gamberaia, Settignano.

(particularly English!) were slowly rejected. Le Nôtre became a focus for the highly politicised reinterpretation of the history of France and its gardens. Many of his gardens restored to their former glory and most notably Achille Duchene created new gardens in the French formal style. The main beneficiary from this was Versailles, which had been merely maintained for two centuries, more active restoration not taking place until the second half of the twentieth century. In 1775 Louis XVI, when faced with the deterioration of the park, decided not to redesign in the fashionable *jardin anglais* style but to replant following the original plan laid out in 1665 (Adams 1993, 95).

Some 'recreations' went even further back such as the gardens built at Villandry. The château had been built around 1536 by Jean le Breton but the gardens had been destroyed in the nineteenth century and no plans existed of them. The new gardens, started around 1913, were therefore based on the owner, Joachim Carvallo's, interpretation of a sixteenth century design (Figure 10.4). This very act was designed, according to Adams, to:

'deliver a political … message … It was time, [Carvallo] … decided, to declare war on Jean-Jacques Rousseau's philosophy manifest in the fashionable *jardin anglais*

FIGURE 10.3. Villa La
Pietra, Florence.

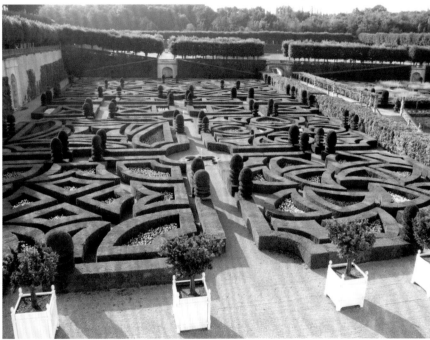

FIGURE 10.4. Château de
Villandry knot garden,
Loire Valley.

that had persisted in France for more than a century ... [these gardens] clearly
represented to [him] ... an assault on sound Roman Catholic doctrine and civic
order.' (1993, 1)

This 'recreation' of a garden, designed to complement the existing building next to it but not based on historical evidence, continues both in France and elsewhere. It is now a controversial approach as repair or restoration of existing or known features, through documentary evidence, is always preferred.[4]

In Prussia and then the unified Germany from 1871, interest was taken in historical buildings but again not their gardens and parks. In 1892, the Association of German Garden Artists started to lobby to:

> 'preserve the most outstanding examples of renaissance gardens [sixteenth and seventeenth centuries, also Baroque], rococo gardens [eighteenth century], and ultimately the most perfect gardens of the landscape style [nineteenth century] in their original shapes, plantations, and guiding ideas.' (Gröning 2000, 33).

Two years later the same body suggested drawing up a list of the best public and private gardens in Germany for tourists to visit but sadly this was only completed a century later in 1992 (Gröning 2000, 33). The twentieth century had started in terms of garden design looking backwards for inspiration, how then did the forward looking political ideas of socialism come to influence designed landscapes in that century?

The Arts & Crafts Movement and romantic socialism

The roots of the most popular garden style in the early twentieth century, often referred to as 'Arts and Crafts'[5] gardens, lie in the previous century. The Arts and Crafts movement, founded by William Morris in the 1860s, was inspired by the ideas of John Ruskin who was against mass production and wanted a return to traditional crafts. In garden design, initially it meant a more natural style rather than the formality (and artificiality) of the bedding schemes of the high Victorian garden. Morris admired in particular the simplicity of the country cottage and its garden, with its naturalness and mixed style of planting with perennials, annuals, shrubs and vegetables grown together. By the 1870s, these cottages had become a popular subject for artists, increasing the popularity of the style. They were an idealised view of these cottages and gardens, which in reality were tough for the inhabitants and not the rural idyll that was portrayed in the paintings. Morris' own gardens at the Red House and Kelmscott Manor reflected his approach of reverting to older, simpler styles although the first was purpose built by Philip Webb in 1859 and the second was a late sixteenth century manor house.

At the Red House:

> 'the garden was planned with the same care and originality as the house; in both alike the study of older models never sank into mere antiquarianism or imitation of obsolete forms … Red House garden, with its long grass walks, its midsummer lilies and autumn sunflowers, its wattled rose-trellises inclosing richly-flowered square garden plots, was then as unique as the house it surrounded. The building had been planned with such care that hardly a tree in the orchard had to be cut down.' (Mackail 1899, 143–4).

In Kelmscott Manor, where Morris moved in 1871, he found that:

> 'the garden, divided by old clipped yew hedges, is quite unaffected and very pleasant, and looks in fact as if it were, if not a part of the house, yet at least the clothes of it: which I think ought to be the aim of the layer out of a garden.' (Mackail 1899, 229–30)

Morris was not involved in designing any gardens himself but he was a great influence on Gertrude Jekyll, whose early career was in the decorative arts. Together with the architect, Edwin Lutyens, Jeykll defined the 'Arts and Crafts' style that relied on the imagery of 'old England': a world before Lancelot Brown. While much admired at the time and to this day, such gardens were still for the relatively wealthy, due to not only the initial cost but also the high level of maintenance. These gardens reflected the Edwardian period when most were constructed: a time of calm before the storm of the First World War and the last days of the supremacy of Britain and its Empire.

It is surprising that these gardens for the elite, regarded as status symbols, should have been inspired by Morris and others, whose political ideas were socialist. Brown (1999, 47) comments that 'garden history is only green cultural history, and the Arts and Crafts gardens were the product of the romantic socialism of Ruskin and Morris'. Although he was originally a member of the Liberal Party, Morris formed the Socialist League in 1884, which advocated the revolutionary socialism of Karl Marx. In contrast the Fabian Society founded in the same year, eschewed 'revolution in favour of a long campaign of re-educating both the political elite and the working class – the first to a new sense of their social responsibilities, the latter to a new sense of their legitimate social rights' (Schama 2002, 316). This moderate socialism was more practical and accepted the current situation, encouraging the improvement in living conditions in urban areas including the provision of open spaces. Morris however just wanted to turn the clock back, declaring (1887) 'it is profit which draws men into enormous unmanageable aggregations called towns, for instance; profit which crowds them up when they are there into quarters without gardens or open spaces'.

Morris did recognise that those seeking Utopia were 'every one who tried to keep alive traditions of art, or who tried to bridge the gap between the masses by helping the opening of museums and galleries and gardens and other pleasures which could be shared by all' (Morris 1883). Out of this came the seeds of the conservation movement. For Morris, it was buildings that he sought to conserve through the Society for the Protection of Ancient Buildings, which he founded in 1877. In its manifesto, the SPAB, urges that:

> 'for all these buildings, therefore, of all times and styles, that we plead, and call upon those who have to deal with them to put Protection in the place of Restoration … [and] to treat our ancient buildings as monuments of a bygone art, created by bygone manners, that modern art cannot meddle with without destroying … thus only can we protect our ancient buildings, and hand them down instructive and venerable to those that come after us.'

In Parliament, following Layard's suggestion of a list of protected ancient monuments, a bill to enshrine it in law was first introduced in 1874 by Sir John Lubbock. It was defeated because its opponents believed it was an infringement of the rights of the owners and a burden on taxpayers, not that the principle of preservation was wrong and should not be encouraged (Hansard 15 April 1874, 218, 574–95). Lubbock was undeterred and continued to re-introduce the bill. Finally in 1882 he persuaded the Government at least to appoint the first Inspectors, although when the bill became law, their powers were limited as any required action on the part of the owner was voluntary.[6] This difficulty of reconciling the rights of the private owner versus the perceived public good would continue to frustrate those who were trying to preserve the country's heritage for the next 100 years.

It was left to Fabians such as Octavia Hill, the founder of the National Trust, to preserve these ancient sites for the greater public good: both buildings and the landscape.[7] Hill had joined the Commons Preservation Society, set up by radical Liberals, in 1875 and two years later, she wrote *Our Common Land*. She observed that with the introduction of bank holidays in 1871, the masses were seeking places to visit. Perhaps anticipating the modern popularity of the 'day out', which organisations like the National Trust have encouraged, she noted:

> 'in spite of the really bad sights to be seen at every public-house on the road … which show how sadly intoxication is still bound up with the idea and practical use of a holiday to hundreds of our people, how much intense enjoyment the day gives! … And watch, when at last the open spaces are reached … every place seems swarming with an undisciplined, but heartily happy, crowd … Now, have you ever paused to think what Londoners would do without this holiday, or what it would be without these open spaces … Every atom of open space you have left to these people is needed; take care you lose none of it; it is becoming yearly of more vital importance to save or increase it.' (Hill 1877, 2–5)

The establishment of the National Trust was initially inspired in 1884 by Hill trying to save Sayes Court, a seventeenth century garden created by John Evelyn in Deptford. The owner, a descendent of Evelyn, wanted to preserve it for prosperity but found there was no organisation with the necessary legal powers to do so. The solution was a new company that could fulfil this role but in this instance, it was not enacted. Instead part of Sayes Court was eventually given to the public and laid out as a park by the Kyrle Society, set up by Miranda Hill, Octavia's sister. In 1893, though when speculators threatened a property in the Lake District, the idea of a company was revived. The Trust in its early years mainly concentrated on buildings and areas of open countryside. In 1907, it acquired Barrington Court in Somerset, its first large house. Once restored, instead of opening to the public, it was leased to Colonel Lyle in 1920. He brought in the architect Forbes who redesigned the house and sought advice from Gertrude Jekyll on the design of the garden.[8] Although the garden played homage to the building, it was not a reconstruction. Many other iconic Arts and Crafts gardens built at this time in historic landscapes, for example

FIGURE 10.5. Great Plat at Hestercombe, Somerset.

Hestercombe, also in Somerset (Figure 10.5) while harking back to the past, were very much creations of their time. Later gardens in this style such as the highly influential Hidcote and Sissinghurst showed there was still an appetite to create new gardens 'sympathetic' to the older building.

Modern gardens, civic planning and international socialism

For a while after the First World War, in Britain at least, it seemed that the world had not changed in terms of gardens. The Arts and Crafts style still predominated, alongside the more formal 'Italian style' of landscape architects such as Geoffrey Jellicoe. He had gone to Italy in 1923 and studied the Italian Renaissance villas and gardens, which led to his book on the subject (Jellicoe and Shepherd 1925). One of Jellicoe's first major commissions in 1935 was for Ditchley Park, an early eighteenth century mansion by James Gibbs in Oxfordshire. While Loudon had laid out the grounds in the early 1800s, following landscaping in the previous century, by the time Jellicoe arrived nothing of the garden remained. He was therefore presented with a blank canvas but did have the plan of 1727 by Gibbs to use and thus 'could take advantage of those never-fulfilled intentions as well as of the terms of reference in his own commission ... [so] that Ditchley should not be reconstructed simply as a historical exercise' (Spens 1992, 56). Recognising the Italian roots of Gibbs' plan (particularly the long terrace), he used his experience of his time in Italy to create a new formal garden. Although he had used a historic plan, it was more of an inspiration rather than a blueprint, as Jellicoe was already being influenced by the new styles of landscape architecture associated with modernism.

This reaction to historic revivalism, both in architecture and then the

landscape, started in the 1920s and came to be known as 'Modernist'. It was very much an international movement and was designed to mirror the worldwide political revolutions that the Marxists hoped would follow the one in Russia in 1917. As Brown (2000, 8) points out 'these political connections can never be entirely erased – the modern pioneers undoubtedly saw their designs as suitable for life in the 'global village' that our Earth has apparently become'. What they wanted above all was a clear break from the past. Many of the exponents of this new style such as Walter Gropius and Erich Mendelsohn had personally suffered in the First World War. That conflict had been caused, in their eyes, by the 'tainted aristocracy' whose gardens they now rejected (Brown 2000, 9). It was the architect, Le Corbusier, who defined the Modernist landscape style by largely ignoring the landscape that surrounded the building and preferring 'overgrown landscape parks' (Woudstra 2000, 137).

Christopher Tunnard was one of the few designers to adopt the Modernist style in Britain in the 1930s. He trained at the Royal Horticultural Society and first worked with Percy Cane, a noted Arts and Crafts exponent from 1932 to 1935. After a trip to Europe where he saw the new architectural styles (both house and garden), he set up his own practice in 1936. Tunnard's ideas were contained in his book (1938) where 'it [was] quite difficult to disentangle Tunnard's modern ideas from his long tirade against the past, which has to be seemingly expounded before it can be rejected' (Brown 2000, 65). His commission for St Ann's Hill in Chertsey, Surrey between 1936 and 1938 is perhaps typical of this confusion. The site had a Georgian mansion, stables and mature landscaped grounds. While the house was demolished, a large part of the garden and more surprisingly the old wisteria and *Magnolia grandiflora* that was growing on the old house were retained. The new house was built on the same spot around these climbers (Brown 2000, 62–3).

That the old house at St Ann's Hill had been pulled down was becoming a concerning trend. Such buildings were not protected under the legislation of ancient monuments, as occupied houses had been specifically excluded. In 1934, Lord Conway said:

> 'many of our ancient houses, houses of first-class historical importance, have already suffered. Some have been pulled down; many are no longer inhabited and no longer taken any good care of, and they are in a condition of peril.' (Hansard 25 April 1934, 91, 713–23)

The struggle though to break free from the past proved almost impossible with the Arts and Crafts style hard to shift from private gardens. It was to public space that the idea of 'modernist gardens' found more fertile ground. In many ways, this was more in keeping with the international socialist principles where in the Marxist world all assets should be state owned.

The first public green spaces were the parks created in the nineteenth century that grew out of a concern for improving the environment in the growing towns and cities for both social and political reasons. As local authorities gained more power and resources, they were able to build more parks. The problem remained

that the urban areas continued to grow with suburban areas swallowing up the countryside. While some advocated stopping people from moving from the rural areas to the towns[9] in reality, it was the search for work that drove these erstwhile rural dwellers to come to the urban centres, however much living in the country was a better experience. In trying to reconcile these forces, Ebenezer Howard came up with the solution of the 'garden city',[10] which he first discussed in his book *To-morrow: a Peaceful Path to Real Reform* in 1898. The following year he founded the Garden Cities Association, now the Town and Country Planning Institute, who began to lobby for a change in town and country planning policy.

Howard talked about the 'magnets', which drew people to a place and in his view:

> 'neither the Town magnet nor the Country magnet represents the full plan and purpose of nature. Human society and the beauty of nature are meant to be enjoyed together. The two magnets must be made one ... Town and country must be married, and out of this joyous union will spring a new hope, a new life, a new civilisation.' (1902, 17–18)

Garden cities were intended to be planned, self-contained communities surrounded by greenbelts with housing, green spaces and industry side by side. The first in Letchworth, Hertfordshire was started in 1903 following the establishment of First City Garden Ltd, a not for profit development company. In 1905, their exhibition of 'cheap cottages' was much praised[11] and the whole idea had found political favour with Lloyd George, the Liberal Chancellor (Hansard 22 October 1909, 12, 658–97).

The garden city movement had a major influence on the radical Liberal government's Housing and Town Planning Act of 1909.[12] Garden designers turned increasingly to 'Civic Art' as Mawson referred to it: a mixture of town planning and park making (Waymark 2009, 185) and a natural progression from the design of public parks. After World War One, there was a need to increase the housing stock and the first publicly backed[13] garden city was created at Welwyn, Hertfordshire, again by Howard, in 1920. The concept continued with the 'New Towns' following the Act of 1946 when development corporations were set up to actively create new urban areas: an idea that Le Corbusier had suggested in the 1920s (Woudstra 2000, 139–45).

The era of the modernist 'landscape architect' had truly arrived and they made their mark on the many public works initiated since then, with mixed results. Perhaps this is because of Corbusier's ideas on landscape, which Woudstra (2000, 150) describes as 'simplistic and obsessively directed towards the control of the living environment irrespective of people's needs, without sympathy and sensitivity towards people, places and nature'. As Jacques (2000a, 90) points out, for the modernist ideas to move into the private sphere, there needed to be greater economic and political changes than even the post-war Labour government brought in. For many socialists in the West of the 1930s, the idea they could create a better world, was tempered by the Cold War of the

late 1940s and 1950s. Modernist architecture and landscapes became associated with the 'Soviet brutalist' style of civic planning and while fine for public works, were privately rejected by the inherent conservatism of the British nation.

The conservation movement and politics

In 1933, Geoffrey Jellicoe was asked to produce an 'Advisory Plan and Report for the Parish of Broadway, Worcestershire', a beautiful village in the Cotswolds. Much admired by the Arts and Crafts movement, it has a place in conservation history. William Morris rented the nearby Broadway Tower, a late eighteenth century mock castle, where he drafted the letter in 1876 that ultimately led to the foundation of the Society for the Protection of Ancient Buildings (Mackail 1899, 340). Jellicoe, it is argued (Spens 1992, 50), saved the village for prosperity by including not only the buildings but also the surrounding landscape in his plan for the future. This was not the first case of an historic landscape and its views being considered valuable enough to preserve.

The campaign to save the view from Richmond Hill in Surrey had become a *cause célèbre* as early as 1896.[14] Two years later, the Cunard family bought the nearby Marble Hill estate. They proposed a housing development in its grounds, leading to vigorous opposition by the locals and interested pressure groups.[15] In 1902, the latter's persistence paid off and an Act was passed 'to provide for vesting common and other land in local authorities as public open spaces in order to preserve the view from Richmond Hill; and for other purposes' (Hansard 18 November 1902, 114, 1225). Effectively preventing the housing development, the Cunards had no choice but to sell it to the local council. With financial contributions by the council itself and private subscriptions, the estate was turned into a public park.[16] The Richmond Hill campaign led to the *National Trust Act* of 1907, which declared that its properties 'shall be held by the National Trust for preservation for the benefit of the nation … and shall be inalienable [not able to be sold or given away]'.[17]

While the responsibility for safeguarding the 'amenity of the area, particularly places of natural beauty and historical interest' was vested in local government by the 1909 *Housing and Town Act*, it was clear that without pressure groups such as the National Trust, this would be ineffectual in preventing the destruction of historic places (Batey, Lambert and Wilkie 2000, 23). There was general support amongst politicians between the wars for preserving the rural environment,[18] but the case for the stately home and its associated landscape was more mixed. Labour politicians like James Ede, wanted a redistribution of land, as he stated:

> 'it is very necessary to realise that the public policy of this country since 1894 has been having the effect of breaking up the big estates. I desire to see the breaking up of big estates. The Noble Lord [Lord Eustace Percy] may desire to see them preserved provided they are preserved in certain hands.' (Hansard 23 January 1931, 247, 537–71)

The *Town and Country Planning Act* of 1932 aimed to 'provide for the protection of rural amenities and the preservation of buildings and other objects of interest or beauty'. The Conservative MP, Walker Smith declared that 'these proposals vest local authorities and Government Departments with an enormous amount of power of control over the rights of property, and that is a suitable Measure for a Socialist Government anxious to pack the local authorities in order to facilitate the adoption of the Socialist creed. Legislation of this kind is necessary to carry Socialist principles into effect' (Hansard 2 February 1932, 261, 39–122).

While gardens and designed landscapes were never specifically mentioned in these debates on conserving historical assets, at least there was some recognition of the former's impact on the countryside by John Buchan, the writer and MP. He comments that:

> 'the beauty which we admire in rural England and which most of us imagine to have been going on forever is really rather a late creation. It came in the eighteenth century when hedges were set, when woodlands were cared for and when the river valleys were drained. And mark this it came because of its relation to the habits and the life of man. The beauty of rural England, its specific charm, is the beauty of a habitable and settled place and not of a wilderness. It is worth remembering that that familiar beauty would never have come into being had it not been for development.' (Hansard 2 February 1932, 261, 39–122)

The Second World War led indirectly to many gardens and designed landscapes being lost or radically altered, as many private estates were requisitioned for the war effort. The National Trust recognising this, took the first garden, Hidcote, into their care in 1948. This set a precedent for accepting gardens without a main house, supporting estate or an endowment to maintain the garden. The National Trust's Gardens Committee also took on the task of looking after the landscapes of existing properties, which now number over 300. In 1946, the Labour Chancellor, Hugh Dalton set up the Land Fund, with reserves of £50 million. It was designed to help non-profit making bodies such as the National Trust acquire land for the public enjoyment in the case when estates were given in lieu of death duties, particularly tracts of coast and open countryside, Dalton's particular favourite as he was known as the 'Red Rambler'. His rationale was clear: 'much land has passed … from private into public ownership and it is the declared policy of the Labour Party that much more should so pass, and that the principle of the public ownership of land should be progressively applied' (Hansard 9 April 1946, 421, 1803–68).

However this supposed generosity on the part of the government to protect the nation's assets was not backed by action. By 1951, the fund had actually grown to £53 million with accumulated interest (Hansard 31 July 1951, 491, 163–4W). The following year, the fund still stood at nearly £52 million and it had only helped with the purchase of 27 properties, although the important landscape of Claremont in Surrey, designed by Charles Bridgeman and William Kent, was among them (Hansard 17 July 1952, 503, 2310–1). By 1954, the balance was nearly £57 million and since the inception of the Fund, only just over

£900,000 had been spent (Hansard 29 June 1954, 529, 1096–7) for the purpose for which it had been set up. From 1953, works of art were also included as a way of reducing the balance. It was no surprise that in 1957, the fund was reduced to £10 million (Hansard 9 April 1957, 568, 978–9). Arthur Woodburn summed one of the reasons why the Fund had not been used more:

> 'the National Trust was offered a property where a wealthy owner in the past had laid out one of the most beautiful gardens, which people came from every part of the world to see, and there are other places of like great value to the nation. The National Trust, as has already been pointed out, was unable to accept the property because, while it could have got the property, it could not have maintained it.' (Hansard 1 July 1957, 572, 769–823)

In 1960, Tatton Park in Cheshire was transferred to the National Trust through the auspices of the Land Fund and was described by Sir Edward Boyle, as 'historically interesting as being unspoilt parkland laid out by world-famous eighteenth century landscape architects'.[19] He added:

> 'the whole property is being let on a ninety-nine year lease to Cheshire County Council, who have accepted full financial responsibility for its upkeep. The transaction is therefore an excellent example of co-operation between a local authority, the National Trust and the Government to preserve a great house and estate for the nation.' (Hansard 20 December 1960, 632, 143–4W)

This was an important move as historically it had been the gardens before the eighteenth century that had been the subject of interest and to some extent conservation. The landscape movement of Brown *et al.* had been criticised precisely because it had 'swept away' these earlier formal gardens.

As the 'Modernists' struggled to identify a landscape style to suit the modern architecture, two of its leading exponents, Pevsner and Wittokwer, were exploring the work of the early eighteenth century pioneer, Lord Burlington. Pevsner in his article (1944) noticed that both modern gardens and the eighteenth century landscape movement in Britain used irregular features. He made the connection between:

> 'Burlington's politics and his art as a parallel to the Socialism and Modern Art in his own day. He did this around the theme of freedom – Burlington's Whiggery and his invention of the landscape garden were both, he thought, aspects of it.' (Jacques 2000a, 95)

So by looking backwards to define the current style, Pevsner and Wittokwer had sparked renewed interest in what was perhaps Britain's greatest contribution to the arts, the landscape garden. Even Lancelot Brown's reputation started to be restored with Dorothy Stroud's seminal biography in 1950 of the designer, 150 years after Price and Knight had dismissed him and his ideas.

Such appreciation of the eighteenth century landscape garden appeared not to be shared by those in power at the time. While the post war Labour government and local councils were busy acquiring large aristocratic estates for a variety of purposes including for new teacher training colleges and headquarters

for the recently nationalised industries,[20] little thought was given to the surrounding landscape. In the notorious case of Wentworth Woodhouse in Yorkshire, the Labour minister for Fuel and Power, Emanuel Shinwell, allowed open cast mining on this important eighteenth century landscape garden. In spite of reassurances by the Minister for Town and Country Planning, Silkin, 'that when working is completed and the surface restored, the general character of this outstanding park will not be materially impaired' (Hansard 12 February 1946, 419, 79W). There was much opposition to it, including by the local miners, who argued that the coal should be extracted from underground, a much more expensive process. They were even prepared to call a strike but this had no effect.

The Tory MP for nearby Sheffield, Peter Roberts, wondered that 'if it had been a private concern trying to do that, I have no doubt that the wishes of Mr. Joe Hall and the miners behind him would have had a very great influence, and would have stopped the workings' (Hansard 20 May 1946, 423, 44–153). Clearly for many, this had been a politically motivated act by the Labour minister against Earl Fitzwilliam, who not only owned Wentworth Woodhouse but also the local mines before nationalisation. A similar proposal at Himley Hall, with its Brown designed landscape, was rejected. Himley had been bought by the West Midland Regional Coal Board as their headquarters and Lord Hinchingbrooke, when questioning Shinwell about this, enquired 'in view of this decision and the decision taken in the case of Wentworth Woodhouse, will the right hon. Gentleman [Shinwell] say whether there is one law for the powerful Socialist and another for the dispossessed peer?' (Hansard 30 January 1947, 432, 1088).

While the *Historic Buildings and Monuments Act* of 1953 had started to protect important houses, gardens and designed landscapes were not included. The pressure group, the Garden History Society, was founded in 1966, not only to study garden history but also to try and preserve historic parks and gardens. One of its founders, Mavis Batey (2010), recounts the struggle she and others had to get official recognition for the importance of saving these places. Through the *Town and Country Amenities Act* of 1974, they managed to get the upkeep of gardens of historic interest included in the grants allowed for historic buildings under the 1953 Act. It was recognised that

> 'if … the original house has been demolished, or is not of outstanding quality, no matter how splendid the gardens, even if designed by Capability Brown, Humphrey [*sic*] Repton or Paxton, under the present rules no grant may be paid … The clause would afford – I think for the first time – official recognition to historic gardens in their own right. I am advised that there may be as many as two hundred such gardens in Britain, and I believe that this simple clause, costing nothing, will bring pleasure to many lovers of our historic gardens and man-made landscapes.' (Hansard 25 January 1974, 867, 2062)

It was a small but significant step despite the fact that there was no definition of what constituted an historic garden and the numbers were significantly

FIGURE 10.6. Walled garden at Scampston Hall, Yorkshire.

underrepresented! The Garden History Society in response, using volunteers, began to compile a list and in 1983, the newly formed English Heritage created the first official Register of Parks and Gardens of Special Historic Interest in England.[21] Many historic landscapes on the Register began to be restored as grants became available from a number of publicly backed sources, including latterly the Heritage Lottery Fund. However the tricky question remains on what you preserve in terms of the 'historic layers' and how you pay for the maintenance. There has been gardening activity in Britain for 2000 years and although few Roman landscapes remain, there are many sites which in the past may have had a Medieval deer park, Tudor or Stuart 'formal' garden, Georgian landscape park, Victorian formal garden or an early twentieth century Italian or Arts and Crafts garden. Where one is overlaid on another, what do you restore and what evidence do you use for your 'restoration'? If the garden or designed landscape is open to the public, how does that affect what you do and can you introduce a modern garden into an historic landscape such as the new garden, designed by Piet Oudolf, in the old kitchen garden at Scampston Hall in Yorkshire (Figure 10.6)?

Gardens in the twentieth century: moving forwards or backwards?

Exactly halfway through the twentieth century came the first of the 'Garden Festivals' at the Festival of Britain in 1951. The government's aim with was to showcase the best of British garden design and to inspire a new generation of gardeners and designers.[22] The Festival of Britain was spread over a number

of sites with the main area at the South Bank in London and the site of the pleasure gardens was at Battersea Park. This was an interesting choice given the debacle of the latter's creation a hundred years before (see Chapter 7) but the park had suffered in the war and the government wanted to use the Festival as a means of improving it. It was however a controversial move, being seen as a frivolous exercise. In the debate on the Festival pleasure gardens in Parliament, those in favour argued:

> 'what better than a lovely garden? And after all, gardens are an essential part of English genius. Battersea Park is already a very beautiful park and in the developing of the best that is in the park into one of the finest urban landscape gardens in the world we have a worthy part of this project.' (Hansard 23 November 1949, 470, 373–463)

The two sites were both landscaped by leading designers who were aiming to contribute to this idealised view of the future, as envisioned by the post war Labour government. It was hoped that the Festival would do for twentieth century Britain what the Crystal Palace had done for the Victorian era in demonstrating and encouraging progress. However in terms of garden design, the two sites typified its split personality between the past and the future. The Exhibition site on the South Bank featured modern designs, both public in terms of landscaped areas and private with the exhibition gardens of the Homes and Gardens pavilion. At Battersea, the modern designer Russell Page was responsible, together with James Gardener. As Brown points out their:

> 'modern layout ... [was] overrun by the gothick fantasies (the revived obsession with the eighteenth century) of John Piper and Osbert Lancaster ... [and Page's innovative] planting [scheme] ... gave way to ... massed bedding layouts (which would not have disgraced the park keepers of Battersea of 100 years earlier) ... British nostalgia [had] confounded the modern garden at Battersea.' (2000, 157)

Both sights were extremely popular and each had over 8 million visitors during the five months that the Festival was open. They certainly succeeded in their objective of encouraging the post-war generation to create gardens, helped first by the advent of inspirational books by designers such as Brenda Colvin and Sylvia Crowe and then mass media especially television (Brown 1999, 224–5). Politically it was not popular, particularly with the incoming Conservative government. The new Minister of Works, labelled it a 'disgraceful waste of public money' (Hansard 26 November 1951, 494, 1013–79) due to the alleged gross mismanagement of the publicly funded company running it. He acknowledged that it had been popular, with the vast proportion of visitors coming from London itself and the large debt incurred could be recouped by keeping the site open for a further three years. The idea of having a state sponsored garden festival though was not repeated for another 30 years.

In 1984 Liverpool became the first site in a plan to have a garden festival every two years around the country, an idea taken from the *Bundesgartenschau* (State Garden Shows) in Germany.[23] They were more about urban regeneration

(Theokas 2004, 143) and providing employment (Hansard 26 October 1983, 47, 123W), as early nineteenth century parks had been, than promoting horticultural excellence and inspiring garden design. It was perhaps no coincidence that the site at Toxteth had been the scene of riots in 1981. Michael Heseltine, the minister responsible, was following his nineteenth century predecessors who tried to use the creation of public parks to pacify the disaffected, although in this case it did not result in a permanent park.[24] This national initiative was not welcomed for political reasons by Liverpool City Council, which was dominated by the 'hard left' under its leader, Derek Hatton and they decided not to co-operate in promoting the event. In the aftermath of the success of the Liverpool venture, four more garden festivals were planned, the last being in South Wales in 1992. The initiative stopped as the government believed the costs outweighed the benefits, both economically and politically (Theokas 2004, 201).

It seemed the stage was set for the modern garden to come of age and start to develop in new directions by 1960. The world was changing rapidly and so were people's lives due in no small part to technological advances. It was not to be, as in Britain at least, the lure of the historic (and formerly aristocratic) garden was undiminished. More and more previously private estates were opening up to the public, courtesy of the National Trust and many local authorities who converted them into 'country parks'.[25] Now the masses could see the beautiful gardens and designed landscapes that had been the preserve of the few. This did more to 'democratise' gardening and lead to the conservation of many historic sites than any imposed conditions from the central government. Although the population had to live for the most part in houses that others had designed, they had the freedom to design their gardens.

Perhaps ultimately that is what William Morris and his fellow 'natural' socialists had achieved by their campaigns in the previous century to preserve the landscape heritage of the country. International socialism had brought many new ideas that had benefited the working population's lives but its counterpart in modernist architecture and its associated landscape designs were largely rejected. Today in the twenty-first century, in Britain and elsewhere, we can see far more of the actual historic garden and designed landscape ideas recreated or preserved, than was possible a hundred years ago. Many historic sites have been lost in the last century but the next generations have been given an important legacy, by the dogged determination of the campaigners for historic parks and gardens to preserve and restore this important part of a nation's cultural heritage.

Notes

1. See Elliott (2000) for a discussion of the concept and its impact in the nineteenth century on garden design.
2. 'The gardens in England have, at one time, imitated those of Italy' (Loudon 1840, 326).
3. The list was to be drawn up by the Society of Antiquaries (Hansard 2 April 1869, 195, 27–9).

4. See Watkins and Wright (2007, 25–8) for a discussion about the relevant merits of each approach to an historic landscape.

5. These have been difficult to define but related to the smaller gardens being built mainly in the Edwardian period alongside Arts and Crafts houses. Gertrude Jekyll in her 1912 book on the subject describes them as 'Gardens for Small Country Houses'.

6. Ancient Monuments Act of 1882 (Hansard 18 July 1882, 272, 833).

7. Lord De Vesci: 'I think a further sub-section should be added on Report to enable county councils to divest themselves of these monuments and pass them on to the Board of Works or to the National Trust' (Hansard 25 July 1898, 62,9 90–1) on amendment to the Ancient Monuments Act of 1882.

8. Somerset Historic Environment Record: http://webapp1.somerset.gov.uk/her/details. asp?prn=55164 [consulted 23 February 2011].

9. Sir John Gorst, Conservative MP, in the *Daily Chronicle*, 6 November, 1891 says: 'If they wanted a permanent remedy of the evil they must remove the cause; they must back the tide, and stop the migration of the people into the towns, and get the people back to the land. The interest and the safety of the towns themselves were involved in the solution of the problem' (Howard 1902, 11).

10. Howard refers to these as 'Town-Country magnets'.

11. Ronald Munro-Ferguson MP described them as 'an excellent thing' in the debate on housing for the working class (Hansard 27 April 1906, 156, 131–80).

12. John Burns MP stated 'the Bill aims in broad outlines at, and hopes to secure, the home healthy, the house beautiful, the town pleasant, the city dignified, and the suburb salubrious … No one can go to Port Sunlight, or Earswick, or Hull, or Wolverhampton where the son, I think, of a distinguished Member of this House, Sir Richard Paget, has undertaken a great garden city scheme, and other places without recognising the enormous progress which has been made during the last ten years' (Hansard 12 May 1908, 188, 947–1063).

13. The funding was through loans made from the Public Works Loan Commissioners, who were granted this power in 1919 (Hansard 8 December 1920, 135, 2189–203). £288, 454 was loaned to the development company, Welwyn Garden City Company with a further £146,704 advanced to others mainly for house construction (Hansard 16 November 1926, 199, 1706-7W).

14. Thomas Skewes-Cox on the Petersham and Ham Lands and Footpaths Bill: 'denied that the changes proposed by the Bill would affect the view from Richmond Hill'. The bill was rejected (Hansard 12 March 1896, 38, 729–41).

15. www.marblehillsociety.org.uk/pages/2009/05/history-of-house.shtml [consulted 25 February 2011].

16. www.marblehillsociety.org.uk/pages/2009/05/history-of-house.shtml [consulted 25 February 2011].

17. The *National Trust Act* 1907, Section 21, 7 Edw. VII, CHAPTER cxxxvi.

18. In the debate on the proposed Rural Amenities Bill, its proposer, Sir Hilton Young comments 'I would say that this Measure has proceeded throughout as one which has got no party aspect at all. It is a refreshing thing that the conscience, as it were, of the whole country having been awakened on this subject this question, in contrast to so many other questions, should have been raised entirely above the atmosphere of party strife' (Hansard 23 January 1931, 247, 537–71).

19. The main landscape was laid out by Humphry Repton.

20. David Lambert (2010) has noted the many acquisitions in the Labour stronghold of South and West Yorkshire, reflecting the fact that post-war, 'historic houses formed part of a left-wing vision of the future'.

21. There are now over 1600 sites in England are on the Register and are graded I, II* and II as are buildings. In Wales, Scotland and Northern Ireland there are a further 1000 sites on their respective registers. However it is estimated there are at least 10,000 sites of historical parks and gardens in the UK, with over 7000 on the Parks and Gardens database alone – see www.parksandgardens.ac.uk.

22. Francis Noel-Baker MP: 'I hope they will be an encouragement to boroughs, organisations and private people all over England to vie with the gardens at Battersea in brightening up their own parks, their own streets and their own gardens. I hope something of the work done all over England and in relation to the landscape gardens in Battersea Park will brighten some of the drearier parts of this country for many years to come' (Hansard 23 November 1949, 470, 373–463).

23. This is a bi-annual event which started in 1951 was specifically aimed at post-war urban regeneration.

24. After many years of neglect, planning delays and passing through numerous private hands, the site is now being restored, see www.festivalgardens.com [accessed 3 March 2011].

25. Principally set up after the *Countryside Act* of 1968 (Lambert 2006).

Painshill, Surrey

In 1980, the Painshill Park Trust was formed, following the acquisition by the local borough council of one hundred and fifty-eight acres of the original eighteenth century landscape, designed by Charles Hamilton. Painshill is important, not only as it ranks as one of the leading designed landscapes in Britain, but also as Mavis Batey (2010, 21) points out, 'the Garden History Society's campaign to save…[it] was…pioneering and…set the pattern for future conservation planning'. Concern had been expressed as to the state of the park as early as 1964. It took the combination of local pressure groups and changes in the government's attitude towards the preservation of historic landscapes, for the restoration in 1981 to finally begin.

Hamilton bought the parts of land that was to become Painshill between 1737 and 1740. It consisted firstly of a small estate comprising of four farms that had been put together in the early eighteenth century by a previous owner and a small house that Hamilton and his family were to live in. The second purchase was of another farm, which in total gave him over two hundred and fifty acres of arable land, meadows, pasture, woodland and heath. Through the estate ran the River Mole but it lacked any other visual merit as a landscape. This was exactly what Hamilton wanted: a blank canvas to experiment on. It has been argued (Kitz and Kitz 1984, 16) that Hamilton, having studied painting, wanted to recreate a painting in the landscape. This rather narrow view belies the ambition that Hamilton had for the site not only in terms of overall design but also the elements within it.

1738 had been an important year for Hamilton, as well as moving to Painshill, he had become a Clerk of the Household to Frederick, Prince of Wales (Symes 2006, 10). This would have brought him into contact with members of the Whig Opposition led by Lord Cobham (see Chapter 5). This group's highly political and radical ideas on landscape design must have been a great influence. The Prince however dismissed Hamilton in 1746, as he had started siding with the Government and the Court of King George II (Symes 2010, 36) while briefly an MP. He clearly had an overall plan for the landscape, as the well planned 'circuit' shows, but to what extent was it politically inspired? Its design, using the then fashionable idea of creating a natural landscape to reflect the liberties enjoyed by the English, as opposed to the geometric formality of the French autocracy, gave it a 'political flavour' (Symes 2010, 12). However Hamilton was no political animal, unlike Cobham, and perhaps after his experience with Prince Frederick, declared that he had an aversion to politics and the Court (Feluś 2010, 42). The garden buildings are largely decorative, although three are in the Gothic or 'Anglo-Saxon' style that was deemed to be patriotic (see Chapter 5). The Chinese

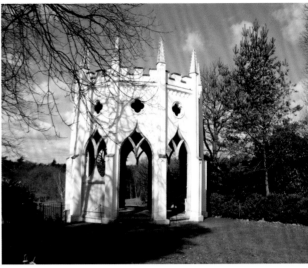

Bridge (Figure 10.7) in the fashionable (although sometimes confused) style represented the perceived 'naturalness' of Chinese gardens.

FIGURE 10.7. Chinese Bridge at Painshill.

The initial landscape was transformed in a relatively short six-year period from 1738 to 1744. By then, Hamilton had started work on the creation of part of the lake, the construction of some elevated areas and also a shelterbelt of trees around the outside. He then had to wait for the landscape to 'mature', before he started adding the built features. Between 1758 and 1762, he erected six key garden buildings, five of which were recently restored or replaced. The most iconic of these are the Gothic Temple (Figure 10.8), a ten-sided structure first mentioned in 1761 and the Turkish Tent (Figure 10.9), designed to provide a resting place for visitors and a key viewpoint. The Mausoleum, a ruined replica of a Roman triumphal arch and the Gothic Tower, built in imitation of a medieval watchtower, have also been restored. However the Temple of Bacchus, a classical building housing Hamilton's collection of Italian marbles and the rustic Hermitage have not survived the passage of time, although the latter has now been rebuilt. One of the most difficult parts of the restoration was the intricate Grotto (Figure 10.10), built sometime before 1770 and described as one of the best that was constructed (Symes 2010, 105). The last building was the Abbey (Figure 10.11), a gothic ruin, constructed in 1772, the year before Hamilton ran out of money and had to sell the estate.

FIGURE. 10.8 Gothic Temple at Painshill.

For Hamilton, the planting was as important as the overall structure and in many ways, this marks out the restoration at Painshill. Many of the key eighteenth century landscapes had become simplified either through the hand of Lancelot Brown and other improvers, or just by the passage of time. At Painshill, the great variety of plants including flowers and shrubs that Hamilton had used, provided an important impetus for researchers such as Symes (1983) and Mark Laird (2010) to start looking at the way plants, were used in this period. Hamilton was passionate about the new trees and shrubs that were arriving from abroad, particularly North America and experimented with these to great effect. The key area was the 'amphitheatre' (Figure 10.12) where he

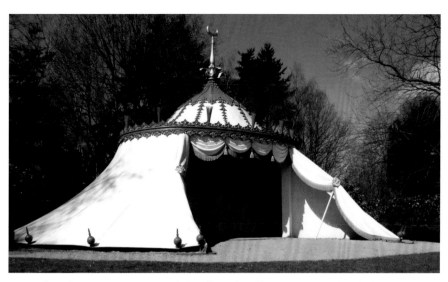

FIGURE. 10.9 Turkish
Tent at Painshill.

created with evergreens one of the first shrubberies, using the different shades
of green to create the effect. Painshill was a popular place to visit in its heyday
and the visitors, including eminent botanists such as Joseph Banks, gave useful
descriptions (Symes 2006, 34) of the plants used.

Hamilton's creation was sold to Benjamin Bond Hopkins who clearly
appreciated his purchase and continued with the development of the park,
particularly the plantings. The next owners throughout the nineteenth and the
start of the twentieth centuries, continued to look after this important landscape
and critically few alterations were made during this period. By the 1930s, though
in common with other estates, it was being to suffer from neglect, due to a lack
of funds for maintenance. The estate being requisitioned during the Second
World War did not help this. In 1948 a new owner split up the estate, selling it
off in lots, with large parts of the estate devoted to commercial forestry. In 1953,
in her book *Follies & Grottoes*, Barbara Jones described the sad state of Painshill
that seemingly was heading into terminal decline (Eyres 2010b, 10-11). However
within the newly formed Garden History Society, the Painshill Group was set
in 1969 to conduct research and more importantly lobby for the protection of
its buildings and designed landscape.

It was in protecting Painshill's remaining buildings that campaigners were
able to start the long slow process of restoration (Figure 10.13). The key was
the buildings' settings, by virtue of two Acts in the early 1970s. When historic
buildings were in an historic garden or landscape, grants could now be made
available both for them and the surrounding area (Batey 2010, 16). The problem
however lay in the definition of an 'historic garden'. This was resolved when
the Garden History Society undertook the enormous task of identification
that eventually became the Register of Parks and Gardens of Special Historic
Interest. While this was a step forward, it was the creation of the National
Heritage Memorial Fund, the successor to the National Land Fund (see Chapter
10) that was critical. It gave a grant to help the council buy Painshill. This was
the first grant it had given for a landscape. In the following thirty years, it and

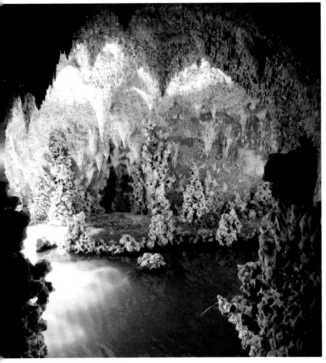

FIGURE. 10.10 Grotto at Painshill.

10.11. Abbey at Painshill.

10.12. Planting in the amphitheatre at Painshill.

10.13. The restored landscape at Painshill, looking towards the Gothic Temple.

its successor, the Heritage Lottery Fund, have helped numerous restoration projects at Britain's many historic parks and gardens, estimated to number over ten thousand.

Bibliography

Adams, W. H. (1979) *The French Garden 1500–1800*. London, Scolar Press.

Adams, W. H. (1991) *Nature Perfected: Gardens through History*. New York, Abbeville Press.

Adams, W. H. (1993) *Grounds for Change: Major Gardens of the Twentieth Century*. Boston, Little Brown and Company.

Alberti, L. B. (1988) *On the Art of Building in Ten Books*. Translated by Joseph Rykwert, Neil Leach, and Robert Tavernor. Cambridge MA, The MIT Press.

Alemi, M. (1997) The Royal Gardens of the Safavid Period: Types and Models. In Petruccioli, A. (ed.), *Gardens in the Time of the Great Muslim Empires: Theory and Design*. Leiden, New York, E.J. Brill.

Alemi, M. (2007) Princely Safavid Gardens: Stage for Rituals of Imperial Display and Political Legitimacy. In Conan, M. (ed.) *Middle East Garden Traditions: Unity and Diversity*. Washington, Dumbarton Oaks Research Library and Collection.

Amherst, A. (1895) *A History of Gardening in England*. London, B. Quaritch.

Anon. (n.d.) *Ryoan-ji Temple*. Fukui Asahido Co. Ltd, Kyoto.

Arnold, D. (2008) Plant Capitalism and Company Science: The Indian Career of Nathaniel Wallich. *Modern Asian Studies* 42(5), 899–928.

Asher, C. B. (1991) Babur and the Timurid Char Bagh. *Environmental Design* 1–2, 46–55.

Atasoy, N (2007) Matrakçi Nasuh and Evliya Çelebi: Perspectives on Ottoman Gardens (1534–1682). In Conan, M. (ed.) *Middle East Garden Traditions: Unity and Diversity*. Washington, Dumbarton Oaks Research Library and Collection.

Attlee, H. (2006) *Italian Gardens: A Cultural History*. London, Frances Lincoln.

Axelby, R. (2008) Calcutta Botanic Garden and the colonial re-ordering of the Indian environment. *Archives of Natural History* 35(1), 150–163.

Ball, V. (1889) *Travels in India by Jean Baptiste Tavernier Volume 1*. London, Macmillan.

Ballantyne, A. (1997) *Architecture, Landscape and Liberty: Richard Payne Knight and the Picturesque*. Cambridge, Cambridge University Press.

Ballard, P. (1985) John Claudius Loudon and the Birmingham Botanical and Horticultural Society's gardens at Edgbaston 1831–1845. *Garden History* 8(2), 66–74.

Barnatt, J. and Williamson, T. (2005) *Chatsworth: A Landscape History*. Oxford: Windgather Press.

Batey, M. (1995) *Regency Gardens*. Princes Risborough Shire Publications.

Batey, M. (2005) The Pleasures of the Imagination: Joseph Addison's Influence on Early Landscape Gardens. *Garden History* 33(2), 189–209.

Batey, M. (2010) Paradise Regained: The Garden History Society's Campaign to Save Painshill. *New Arcadian Journal* 67/68, 15–21.

Batey, M. and Lambert, D. (1990) *The English Garden Tour: A View into the Past*. London, John Murray.

Batey, M. *et al.* (1994) *Arcadian Thames: The River Landscape from Hampton to Kew*. London, Barn Elms Publishing.

Batey, M, Lambert, D. and Wilkie, K. (2000) *Indignation! The Campaign for Conservation*. London, Kit-Cat Books.

Bauman, J. (2002) Tradition and Transformation: The Pleasure Garden in Piero de' Crescenzi's *Liber ruralium commodorum*. *Studies in the History of Gardens and Designed Landscapes* 22(2), 99–141.

Bean, W. J. (1908) *The Royal Botanic Gardens, Kew: Historical and Descriptive*. London, Cassell.

Begley, W. (1996) The Garden of the Taj Mahal: A Case Study of Mughal Architectural Planning and Symbolism. In Wescoat, J. L. and Wolschke-Bulmahn, J. (eds), *Mughal Gardens: Sources, Places, Representations, and Prospects*. Washington, Dumbarton Oaks Research Library and Collection.

Beneš, M. (2001) Pastoralism in the Roman Baroque Villa and in Claude Lorrain: Myths and Realities of the Roman Campagna. In Beneš, M. and Harris, D. (eds) *Villas and Gardens in Early Modern Italy and France*. Cambridge, Cambridge University Press.

Berger, R. W. (1985) *In the Garden of the Sun King: Studies on the Park of Versailles under Louis XIV.* Washington DC, Dumbarton Oaks.

Berger, R. W. and Hedin, T. F. (2008) *Diplomatic Tours in the Gardens of Versailles under Louis XIV.* Philadelphia, University of Pennsylvania Press.

Bernier, F. (1891) *Travels in the Mogul Empire AD 1656–1668.* London, Archibald Constable.

Bevington, M. (2005a) Stowe before Viscount Cobham. In *Stowe Landscape Gardens.* London, National Trust.

Bevington, M. (2005b) Viscount Cobham. In *Stowe Landscape Gardens.* London, National Trust.

Blackmar, B. and Rosenzweig, R. (1992) *The Park and the People: History of Central Park.* New York, Cornell University Press.

Blomfield, R. (1892) *The Formal Garden in England.* London, Macmillan.

Bowe, P. (2004) *Gardens of the Roman World.* London, Frances Lincoln.

Brand, M. (1993) Orthodoxy, Innovation, and Revival: Considerations of the Past Imperial Mughal Tomb Architecture. *Muqarnas* 10, 323–334.

Bray, W. (ed.) (1901) *The Diary of John Evelyn.* New York and London, M. W. Dunne.

Brignoli, J.-D. (2007) The Royal Gardens of Farahābād and the Fall of Shāh Sultān Husayn Revisited. In Conan, M. (ed.) *Middle East Garden Traditions: Unity and Diversity.* Washington, Dumbarton Oaks Research Library and Collection.

Brockway, L. H. (2002) *Science and Colonial Expansion.* New Haven and London, Yale University Press.

Brown, D. (2001) Lancelot Brown and his Associates. *Garden History* 29(1), 2–9.

Brown, J. (1999) *The English Garden Through the 20th Century.* Woodbridge, Garden Art Press.

Brown, J. (2000) *The Modern Garden.* London, Thames and Hudson.

Bruce, C. (1910) *The Broad Stone of Empire, Volume II.* London, Macmillan.

Burke, E. (1757) *Philosophical Inquiry into the Origin of our Ideas of the Sublime and the Beautiful.* London, R. and J. Dodsley.

Butters, S. B. (2001) Pressed Labor and Pratolino: Social Imagery and Social Reality at a Medici Garden. In Beneš, M. and Harris, D. (eds), *Villas and Gardens in Early Modern Italy and France.* Cambridge, Cambridge University Press.

Cain, P. J. (1999) Economics: The Metropolitan Context. In Porter, A. (ed.), *The Nineteenth Century: The Oxford History of the British Empire Volume 3.* Oxford, Oxford University Press.

Çaliş, B. D. (2007) Gardens at the Kağithane Commons during the Tulip Period (1718–1730). In Conan, M. (ed.), *Middle East Garden Traditions: Unity and Diversity.* Washington, Dumbarton Oaks Research Library and Collection.

Campbell, M. (1996) Hard Times in Baroque Florence: the Boboli Garden and the Grand Ducal public works administration. In Hunt, J. D. (ed.) *The Italian Garden: Art, Design and Culture.* Cambridge, Cambridge University Press.

Campbell-Culver, M. (2004) *The Origin of Plants.* London, Eden Project Books.

Campbell-Culver, M. (2006) A *Passion for Trees.* London, Random House.

Canny, N. (1998) The Origins of Empire: An Introduction. In Canny, N. (ed.), *The Origins of Empire, The Oxford History of the British Empire Volume 1.* Oxford, Oxford University Press.

Carroll, M. (2003) *Earthly Paradises: Ancient Gardens in History and Archaeology.* London, The British Museum Press.

Carroll-Spillecke, M. (1992) The gardens of Greece from Homeric to Roman times. *Journal of Garden History* 12(2), 84–101.

Cavendish, S. C. (1874) *Fourth report of the Royal Commission on the scientific instruction and the advancement of science.* Parliamentary Papers, Command Papers; Reports of Commissioners 884, XXII, 1.

Cellauro, L. (2003) Iconographical aspects of the Renaissance villa and garden: Mount Parnassus, Pegasus and the Muses. *Studies in the History of Gardens and Designed Landscapes* 23(1), 42–56.

Chambers, D. (1999) The view from Wooburn Farm: looking out/looking in. *Studies in the History of Gardens and Designed Landscapes* 19(1), 62–73.

Chambers, W. (1772) *Dissertation on Oriental Gardening.* London, W. Griffin.

Charlesworth, M. (1986) The Wentworths: Family and Political Rivalry in the English Landscape Garden. *Garden History* 14(2), 120–137.

Charlesworth, M. (1991) Elevation and Succession: The representation of Jacobite and Hanoverian politics in the landscape gardens of Wentworth Castle and Wentworth Woodhouse. *New Arcadian Journal* 31/32, 18–29.

Chase, I. W. U. (1943) *Horace Walpole: Gardenist.* Princeton, Princeton University Press.

Clark, F. (1973) Nineteenth-Century Public Parks from 1830. *Garden History* 1(3), 31–41.

Clarke, G. (1973) Grecian Taste and Gothic Virtue: Lord Cobham's gardening programme and its iconography. *Apollo* 97, 566–571.

Colton, J. (1976) Merlin's Cave and Queen Caroline: Garden Art as Political Propaganda. *Eighteenth-Century Studies* 10(1), 1–20.

Comito, T. (1971) Renaissance Gardens and the Discovery of Paradise. *Journal of the History of Ideas* 32(4), 483–506.

Comito, T. (1991) The Humanist Garden. In Mosser, M. and Teyssot G. (eds), *The History of Garden Design: The Western Tradition from the Renaissance to the Present Day*. London, Thames and Hudson.

Conan, M. (ed.) (2007) *Middle East Garden Traditions: Unity and Diversity*, Washington. Dumbarton Oaks Research Library and Collection.

Conan, M. and Wangheng, C. (eds) (2008) *Gardens, City Life and Culture: A World Tour*. Washington DC, Harvard University Press.

Conlin, J. (2008) Vauxhall on the boulevard: pleasure gardens in London and Paris, 1764–1784. *Urban History* 35(1), 24–47.

Conway, H. (1996) *Public Parks*. Princes Risborough, Shire Publications.

Coombs, D. (1997) The Garden at Carlton House of Frederick Prince of Wales and Augusta Princes Dowager of Wales. *Garden History* 25(2), 153–177.

Cousins, M. (2007) Hagley Park, Worcestershire. *Garden History* 35, Supplement 1.

Coutu, J. (1997) Stowe: A Whig Training Ground. In Eyres, P. (ed) *The Political Temples of Stowe, New Arcadian Journal* 43/44, New Arcadian Press.

Crompton, J. L. (2007) The Role of the Proximate Principle in the Emergence of Urban Parks in the United Kingdom and in the United States. *Leisure Studies* 26(2), 213-234.

Crowe, S., Haywood, S., Jellicoe, S. and Patterson, G. (1972) *The Gardens of Mughal India*. London: Thames and Hudson.

Cumberland, G. (1996) *An Attempt to Describe Hafod*. Aberystwyth, Hafod Trust.

Dalley, S. (1993) Ancient Mesopotamian Gardens and the identification of the Hanging Gardens of Babylon resolved. *Garden History* 21, 1, 1–13.

Daniels, S. (1982) The Political Landscape: Early Patronage and Party Politics. In Carter, G., Goode, P. and Laurie, K. (eds) *Humphry Repton: Landscape Gardener 1752–1818*. Norwich, Sainsbury Centre for Visual Arts.

Daniels, S. (1988) The political iconography of woodland in later Georgian England. In Cosgrove, D and Daniels, S. *The Iconography of Landscape*. Cambridge, Cambridge University Press.

Daniels, S. (1999) *Humphry Repton: Landscape Gardening and the Geography of Georgian England*. London, Yale University Press.

de Jong, E. (1990) For Profit and Ornament: The Function and Meaning of Dutch Garden Art in the period of William and Mary. In Hunt, J. D. *The Dutch Garden in the Seventeenth Century*. Washington DC, Dumbarton Oaks.

Desmond, R. (1995) *Kew: The History of the Royal Botanic Gardens*. London, Harvill Press.

Dixon, D. M. (1969) The Transplantation of Punt Incense Trees in Egypt. *Journal of Egyptian Archaeology* 55, 55–65.

Dobson, A. (1906) *The Diary of John Evelyn*. New York, Macmillan.

Donner, F. M. (1999) Muhammad and the Caliphate. In Esposito, J. L. (ed) *The Oxford History of Islam*. Oxford, Oxford University Press.

Downing, S. J. (2009) *The English Pleasure Garden 1660–1860*. Princes Risborough, Bucks. Shire Publications.

Drayton, R. (1998) Knowledge and Empire. In Marshall, P. J. (ed.), *The Eighteenth Century, The Oxford History of the British Empire Volume 2*. Oxford, Oxford University Press.

Drayton, R. (2000) *Nature's Government: Science, Imperial Britain, and the 'Improvement' of the World*. New Haven, Yale University Press.

Eburne, A. (2003) Charles Bridgeman and the Gardens of the Robinocracy. *Garden History* 31(2), 193–208.

Ehrlich, T. (1989) The waterworks of Hadrian's Villa. *Journal of Garden History* 9(4), 161–176.

El Faïz, M. (2007) The Garden Strategy of the Almohad Sultans and Their Successors (1157–1900). In Conan, M. (ed.), *Middle East Garden Traditions: Unity and Diversity*. Washington, Dumbarton Oaks Research Library and Collection.

Ellingsen, E. (2005) Uncertain certainty: the nearness of the far. Vaux-le-Vicomte vs. Versailles. *Studies on the History of Gardens and Designed Landscapes* 25(3), 149–155.

Elliott, B. (2000) Historical Revivalism in the Twentieth Century: A Brief Introduction. *Garden History* 28(1), 17–23.

Ergun, N. and Iskender, O. (2003) Gardens of the Topkapi Palace: and example of Turkish garden

art. *Studies in the History of Gardens and Designed Landscapes* 23(1), 57–71.

Eyres, P. (1985a) Studeley Royal: Garden of Hercules and Venus. *New Arcadian Journal* 20, 4–29.

Eyres, P. (1985b) Hackfall: A Sublime Landscape. *New Arcadian Journal* 20, 30–38.

Eyres, P. (1990) Landscape as Political Manifesto. *New Arcadian Journal* 29/30, 32–65.

Eyres, P. (1991) A Patriotic Landscape, Wentworth Woodhouse: Landscape of Patriotic opposition and of Patriotic Husbandry. *New Arcadian Journal* 31/32, 77–128.

Eyres, P. (2001) Kew and Stowe, 1757–1779: the Polarised Agendas of Royal and Whig iconographies. *New Arcadian Journal 51/52*, 52–95.

Eyres, P. (2010a) Jacobite Patronage: Lord Stafford, James Gibbs, Wentworth Castle, and the Politics of Dissent. In Kellerman, S. and Lynch, K. (eds) *With Abundance and Variety: Yorkshire Gardens and Gardeners across five centuries.* York, Yorkshire Gardens Trust.

Eyres, P. (ed.) (2010b) *Painshill Park: The Pioneering Restoration.* New Arcadian Journal 67/68.

Farrar, L. (1998) *Ancient Roman Gardens.* Stroud, Gloucestershire, Sutton Publishing.

Feluś, K. (2010) Charles Hamilton's Buildings: Speculation on the Social Use of Painshill Park. *New Arcadian Journal 67/68*, 41–49.

ffolliot, S. (2001) Women in the Garden of Allegory: Catherine de Medicis and the locus of female rule. In Beneš, M. and Harris, D. (eds) *Villas and Gardens in Early Modern Italy and France.* Cambridge, Cambridge University Press.

Fortune, R. (1852) *A Journey to the Tea Countries of China.* London, John Murray.

Fry, C. (2003) Spanning the Political Divide: neo-Palladianism and the early eighteenth century landscape. *Garden History* 31(2), 180–192.

Fryer, H. (1994) Humphry Repton's Commissions in Herefordshire: Picturesque Landscape Aesthetics. *Garden History* 22(2), 162–174.

Garbari, F. (2006) The Botanical Gardens of the University of Pisa. *Sitelines* 2(1), 4–5.

Gelani, I. A. S. (1996) Quranic Concepts of Landscape Architecture: A Comparison with Shalamar Garden. In Hussain, M. *et al.* (1996) *The Mughal Garden: Interpretation, Conservation and Implications.* Lahore: Ferozsons Ltd.

Gilpin, W. (1808) *Observations on several parts of England, particularly the mountains and lakes of Cumberland and Westmoreland relative chiefly to picturesque beauty,*

made in the year 1772. Vol II. London, T. Cadell and W. Davies.

Gleason, K. L. (1994) *Porticus Pompeiana*: a new perspective on the first public park of ancient Rome. *Journal of Garden History* 14(1), 13–27.

Gohary, O. E. (1986) Symbolic Meanings of Garden in Mosque Architecture. *Environmental Design* 1, 32–33.

Golombek, L. (1995) The Gardens of Timur: New Perspectives. *Muqarnas* 12, 137–147.

Goodchild, P. (n.d.) *Humphry Repton: On the Spot at Mulgrave Castle.* Halifax, Stott Brothers.

Gore, A. and Carter, G. (eds) (2005) *Humphry Repton's Memoirs.* Norwich, Michael Russell.

Gorse, G. L. (1986) An Unpublished Description of the Villa Doria in Genoa during Charles V's Entry, 1533. *The Art Bulletin* 68(2), 319–322.

Gröning, G. (2000) Aspects of the Political and Social Context of the Garden Conservation Movement in Twentieth Century Germany. *Garden History* 28(1), 32–56.

Grove, R. (1995) *Green Imperialism: Colonial Expansion, Tropical Island Edens and the Origins of Environmentalism, 1600–1860.* Cambridge, Cambridge University Press.

Guilding, L. (1825) *An Account of the Botanic Garden in the Island of St. Vincent: From Its First Establishment to the Present Time.* Glasgow, Richard Griffin.

Hansard, House of Commons Debates.

Hansard, House of Lords Debates.

Harwood, E. (1987) Aislabie's garden at Hackfall. *Journal of Garden History* 7(4), 307–411.

Harwood, E. S. (1993) Personal identity and the eighteenth century English landscape garden. *Journal of Garden History* 13(1 and 2), 36–48.

Havell, E. B. (1904) *A Handbook to Agra and the Taj.* London, Longmans, Green and Co.

Henneberger, J. W. (2002) Origins of fully funded public parks. *The George Wright Forum* 19(2), 13–20.

Henrey, B., (1986) *No ordinary gardener: Thomas Knowlton 1691–1781.* London, British Museum (Natural History).

Herbert, E. W. (2005) The Taj and the Raj: garden imperialism in India. *Studies in the History of Designed Landscapes* 25(4), 250–272.

Heritage Lottery Fund (2006) *Understanding and Valuing Your Park.* London, HLF.

Herries, A. (2001) *Japanese Gardens in Britain.* Princes Risborough, Shire.

Hill, O. (1877) *Our Common Land (and other short essays).* London: Macmillan.

Hobhouse, P. (2003) *Gardens of Persia*. London, Cassell Illustrated.

Hooker, J. D. (1854) *Himalayan Journals*. London, John Murray.

House of Commons (1833) *Report from the Select Committee on Public Walks; with the minutes of evidence taken before them*, 448

House of Commons (1840) *Copy of the Report Made to the Committee Appointed by the Lords of the Treasury in January 1838 to Inquire into the Management, andc. of the Royal Gardens at Kew*, 292.

House of Commons (1983) *National Heritage Act 1983*, 47, 24, 1a.

Howard, E. (1902) *Garden Cities of Tomorrow*. London, Swann Sonnenschein.

Hunt, J. D. (1991) The Garden as Cultural Object. In Wrede, S. and Adams, W. H., *Denatured Visions – Landscape and Culture in the Twentieth Century*. New York, Harry N. Abrams.

Hunt, J. D. (1996a) Anglo-Dutch Garden Art: Style and Idea. In Hoak D. and Feingold, M. (eds) *The world of William and Mary: Anglo-Dutch perspectives on the Revolution of 1688–89*. Stanford, Stanford University Press.

Hunt, J. D. (1996b) Humphry Repton and garden history. *Journal of Garden History* 16(3), 215–224.

Hunt, J. D. (2000) *Greater Perfections: The Practice of Garden Theory*. London, Thames and Hudson.

Hunt, J. D. (2002) *The Picturesque Garden in Europe*. London, Thames and Hudson.

Hunt, J. D. and Jong, E. (1988) *The Anglo-Dutch garden in the age of William and Mary*. London, Taylor and Francis.

Hunt, J. D. and Willis, P. (1988) *The Genius of the Place: The English Landscape Garden 1620–1820*. Cambridge, The MIT Press.

Hussey, C. (1967) *The Picturesque: Studies in a Point of View*. London, Frank Cass and Co.

Hyde, E. (2005) *Cultivated Power: Flowers, Culture and Politics in the Reign of Louis XIV*. Philadelphia, University of Pennsylvania Press.

Jacobs, P. (2004) Learning from Saihô-ji: sustaining a garden tradition. *Studies in the History of Gardens and Designed Landscapes* 24(1), 1–20.

Jacques, D. (1983) *Georgian Gardens: The Reign of Nature*. Portland, Timber Press.

Jacques, D. (2000a) Modern Needs, Art and Instincts: Modernist Landscape Theory. *Garden History* 28(1), 88–101.

Jacques, D. (2000b) The Formal Garden. In Ridgway, C. and Williams, R. *Sir John Vanbrugh and Landscape Architecture in Baroque England 1690–1730*. Stroud, Sutton Publishing.

Jacques, D. and van der Horst, A. J. (1988) *The Gardens of William and Mary*. London, Christopher Helm.

Jashemski, W. F. and Ricotti, E. S. P. (1992) Preliminary Excavations in the Gardens of Hadrian's Villa: The Canopus Area and the Piazza d'Oro. *American Journal of Archaeology* 96, 579–597.

Jekyll, G. and Elgood, G. S. (1904) *Some English Gardens*. London, Longmans, Green and Co.

Jellicoe, G. and Jellicoe, S. (1995) *The Landscape of Man*. London, Thames and Hudson.

Jellicoe, G. and Shepherd J. C. (1925) *Italian Gardens of the Renaissance*. London, Ernest Benn.

Jennings, A. (2006) *Roman Gardens*. London, English Heritage.

Joffee, J. and Ruggles, D. F. (2007) Rajput Gardens and Landscapes. In Conan, M. (ed.), *Middle East Garden Traditions: Unity and Diversity*. Washington, Dumbarton Oaks.

Kanazawa Castle Park and Kenrokuen Garden Management Office (n.d.) *Kenrokuen Garden* leaflet.

Keane, M. P. (2009) *The Japanese Tea Garden*. Berkeley, Stone Bridge Press.

Keene, D. (2003) *Yoshimasa and the Silver Pavilion*. New York, Columbia University Press.

Kemp, E. (1858) *How to Lay Out a Garden*. New York, Wiley and Halstead.

Keswick, M. (2003) *The Chinese Garden*. Cambridge, Harvard University Press.

Ketchell, R. (2009) Gardens and the *Samurai. Shakkei, The Journal of the Japanese Garden Society* 16(1), 11–17.

Kew (1893) Early History of Buitenzorg Botanic Gardens. *Bulletin of Miscellaneous Information (Royal Gardens, Kew)* 79, 173–175.

Kew (2010) *Annual Report and Accounts 2009/10*. London, Royal Botanic Gardens Kew.

Khansari, M., Moghtader, M. R. and Yavari, M. (2004) *The Persian Garden: Echoes of Paradise*. Washington DC, Mage Publishers.

Kitz, N. and Kitz, B. (1984) *Painshill Park: Hamilton and his picturesque landscape*. Cobham, Norman Kitz.

Knight, R. P. (1794) *The Landscape*. London, W. Bulmer and Co.

Knight, R. P. (1795) *The Landscape*, 2nd edition. London, W. Bulmer and Co.

Koch, E. (1986) The Zahara Bagh (Bagh-i-Jahanara) at Agra. *Environmental Design* 2, 30–37.

Koch, E. (1997) Mughal Palace Gardens from Babur to Shah Jahan (1526–1648). *Muqarnas* 14, 143–165.

Koch, E. (2005) The Taj Mahal: Architecture, Symbolism, and Urban Significance. *Muqarnas* 23, 128–149.

Koch, E. (2007) My Garden is Hindustan: The Mughal Padshah's Realization of a Political Metaphor. In Conan, M. (ed.), *Middle East Garden Traditions: Unity and Diversity*. Washington, Dumbarton Oaks.

Kuck, L. (1968) *The World of the Japanese Garden*. New York, Weatherhill.

Kuitert, W. (2002) *Themes in the History of Japanese Garden Art*. Honolulu, University of Hawaii Press.

Kuitert, W. (2007) Cultural values and political change: cherry gardening in Ancient Japan. In Conan, M. and Kress, W. J. (eds), *Botanical Progress, Horticultural Innovations and Cultural Changes*. Washington DC, Dumbarton Oaks Research Library and Collection.

Kuttner, A. (1999) Looking outside inside: ancient Roman garden rooms. *Studies in the History of Gardens and Designed Landscapes* 19(1), 7–33.

Laird, M (2010) The Planting Restoration at Painshill. *New Arcadian Journal* 67/68, 64–69.

Lall J. and Dube, D. N. (1987) *Taj Mahal and the Glory of Mughal Agra*. New Delhi: Lustre Press.

Lambert, D. (2006) The History of the Country Park, 1966–2005: Towards a Renaissance? *Landscape Research* 31(1), 43–62.

Lambert, D. (2010) Wentworth Castle in the Welfare State. *Jacobites and Tories, Whigs and True Whigs: Political Gardening in Britain c.170–c.1760*, Wentworth Castle, 6–8 August 2010 Conference Paper.

Lapidus, I. M. (1999) Sultanates and Gunpowder Empires. In Esposito, J. L. (ed), *The Oxford History of Islam*. Oxford, Oxford University Press.

Lasdun, S. (1991) *The English Park*. London, Andre Deutsch.

Law, S. (2007) Liverpool/Calcutta Exchanges: William Roscoe's Reappraisal of the First Linnaean Order of Plants. *Garden History* 35(2), 180–196.

Layton-Jones, K. (2010) Misread landscapes: the Victorian public park as ideological battleground. *Conference of the European Association of Urban Historians*, Ghent, Belgium.

Layton-Jones, K and Lee, R. (2008) *Places of Health and Amusement: Liverpool's historic parks and gardens*. Swindon, English Heritage.

Lazzaro, C. (1990) *The Italian Renaissance Garden*. New Haven, Yale University Press.

Lazzaro-Bruno, C. (1977) The Villa Lante at Bagnaia: An Allegory of Art and Nature. *The Art Bulletin* 59(4), 553–560.

Lentz, T. W. and Lowry, G. D. (1989) *Timur and the Princely Vision: Persian Art and Culture in the Fifteenth Century*. Washington, Smithsonian Institution Press.

Lentz, Thomas W. (1996) 'Memory and Ideology in the Timurid Garden'. In Wescoat, J. and Wolschke-Bulmahn, J. (eds), *Mughal Gardens: Sources, Places, Representations, and Prospects*. Washington, Dumbarton Oaks Research Library and Collection.

Loudon, J. C. (1803) Hints Respecting the Manner of Laying Out the Grounds of the Public Squares in London, to the Utmost Picturesque Advantage. *Literary Journal*. London.

Loudon, J. C. (1804) *Observations on the Formation and Management of Useful and Ornamental Plantations; on the Theory and Practice of Landscape Gardening*. Edinburgh, Archibald Constable and Co.

Loudon, J. C. (1822) *An Encyclopaedia of Gardening*. London, Longman, Hurst, Rees, Orme, Brown and Green.

Loudon, J. C. (1829) *The Gardener's Magazine* 5

Loudon, J. C. (1835) *An Encyclopædia of Gardening*. London, Longman.

Loudon, J. C. (1840) *The Landscape Gardening and Landscape Architecture of the late Humphry Repton Esq.* London, Longman and Co.

Lowry, G. (1987) Humayun's Tomb: Form, Function, and Meaning in Early Mughal Architecture. In Grabar, O. (ed), *Muqarnas IV: An Annual on Islamic Art and Architecture*. Leiden, E.J. Brill.

Lynch, K. (2010) 'Extraordinary convulsions of nature': The Romantic Landscape of Plumpton Rocks. In Kellerman, S. and Lynch, K. (eds) *With Abundance and Variety: Yorkshire Gardens and Gardeners across five centuries*. York: Yorkshire Gardens Trust.

MacDougall, E. B. (1994) *Fountains, Statues, and Flowers: Studies in Italian Gardens of the Sixteenth and Seventeenth Centuries*. Washington, DC, Dumbarton Oaks Research Library and Collection.

Mackail, J. W. (1899) *The Life of William Morris Volume 1*. London, Longman, Greens and Co.

Magnani, L. (2002) The Rise and Fall of Gardens in the Republic of Genoa, 1528–1797. In Conan, M. (ed.) *Bourgeois and Aristocratic Cultural Encounters in Garden Art, 1550–1850*. Washington DC, Dumbarton Oaks Research Library and Collection.

Magnani, L. (2008) Genoese Gardens: Between Pleasure and Politics. In Conan, M. and Wangheng, C. (eds), *Gardens, City Life, and Culture: A World Tour*. Washington DC, Dumbarton Oaks Research Library and Collection.

Maiden, J. H. (1906) Sydney Botanic Gardens. *Bulletin of Miscellaneous Information (Royal Gardens, Kew)* 6, 205–218.

Malchow, H. L. (1985) Public Gardens and Social Action in Late Victorian London. *Victorian Studies* 29, 1, 97–124.

Marsden, J. (2005) Description of the Garden. In *Stowe Landscape Gardens*. London, National Trust

Marshall, P. J. (1998) *The Eighteenth Century, The Oxford History of the British Empire Volume 2*. Oxford, Oxford University Press.

Mason, G. (1768) *An Essay on Design in Gardening*. London, Benjamin White.

Mason, W. (1773) *An Heroic Epistle to Sir William Chambers*. London, J. Almon.

Mason, W. (1783) *The English Garden: A Poem in Four Books*. York, A. Ward.

McCracken, D. (1987) Durban Botanic Gardens, Natal: 1851–1913. *Garden History* 15(1), 64–73.

McCracken, D. P. (1997) *Gardens of Empire: Botanical Institutions of the Victorian British Empire*. London, Leicester University Press.

Moore, C. W., Mitchell, W. J. and Turnbull, W. (1988) *The Poetics of Gardens*. Cambridge, MA, MIT Press.

Morris, W. (1877) *Manifesto of the Society for the Protection of Ancient Buildings*. London: SPAB.

Morris, W. M. (1883) *Mr W. Morris' 'Utopia' and the way thither*. The Pall Mall Gazette 5622.

Morris, W. M. (1887) *How We Live and How We Might Live*, a lecture delivered to the Hammersmith Branch of the Socialist Democratic Federation (S.D.F.) at Kelmscott House on 30 November 1884. Commonweal.

Mowl, T. (2000) *Gentlemen and Players*. Stroud, Sutton Publishing.

Mowl, T. (2004) The Problem with Lord Shaftesbury. *Garden History* 32(1), 35–48.

Moynihan, E. B. (1980) *Paradise as a Garden in Persia and Mughal India*. London, Scolar Press.

Moynihan, E. B. (ed.) (2000) *The Moonlight Garden: New Discoveries at the Taj Mahal*. Seattle and London: University of Washington Press.

Mukerji, C. (1997) *Territorial Ambitions and the Gardens of Versailles*. Cambridge, Cambridge University Press.

Mukerji, C. (2001) Dress and Address: Garden Design and Material Identity in Seventeenth-Century France. In Beneš, M. and Harris, D. (eds) *Villas and Gardens in Early Modern Italy and France*. Cambridge, Cambridge University Press.

Mukerji, C. (2005) Dominion, Demonstration and Domination: Religious Doctrine, Territorial Politics and French Plant Collection. In Schiebinger, L. and Swan, C. (eds), *Colonial Botany: Science, Commerce, and Politics in the Early Modern World*. Philadelphia, University of Pennsylvania Press.

Musgrave, T. and Musgrave, W. (2000) *An Empire of Plants: People and Plants that Changed the World*. London, Cassell.

Necipoglu, G. (1997) The Suburban Landscape of Sixteenth-Century Istanbul as a Mirror of Classical Ottoman Garden Culture. In Petruccioli, A (ed.), *Gardens in the Time of the Great Muslim Empires: Theory and Design*. Leiden, New York, E. J. Brill.

Nitschke, G. (2007) *Japanese Gardens*. Köln, Taschen.

Offer, A. (1999) Costs and Benefits, 1870–1914. In Porter, A. (ed) *The Nineteenth Century: The Oxford History of the British Empire Volume 3*. Oxford, Oxford University Press.

Ohnuki-Tierney, E. (2003) *Kamikaze, Cherry Blossom and Nationalisms*. Chicago, University of Chicago Press.

Olmsted, F. L. (1852) *Walks and Talks of an American Farmer in England*. New York, George P. Putnam.

Orsenna, E. (2000) *André Le Nôtre: Gardener to the Sun King*. New York, Georges Braziller.

Osborn, R. F. (1964) *Valiant Harvest: The Founding of the South African Sugar Industry*. Durban, The South African Sugar Association.

Osborne, R. (1992) Classical Greek Gardens: Between Farm and Paradise. In Hunt J. D. (ed.), *Garden History: Issues, Approaches, Methods*. Washington DC, Dumbarton Oaks Research Library and Collection.

Pemberton, R. A. (1999) The Trinidad Botanic Gardens and Colonial Resource Development, 1818–1899. *Revista/Review Interamericana* 29, 1–4.

Percy, J. (2001) *In Pursuit of the Picturesque: William Gilpin's Surrey Excursion*. Surrey, Surrey Gardens Trust.

Pevsner, N. (1944) The genesis of the Picturesque. *Architectural Review* XCVI, 139–46.

Phibbs, J. (2003) The Englishness of Lancelot 'Capability' Brown. *Garden History* 31(2), 122–140.

Phibbs, J. (2010) Mingle, Mass and Muddle: the use of plants in Eighteenth Century Gardens. *Garden History* 38(1), 35–49.

Platt, C. (1894) *Italian Gardens*. New York, Harper and Brothers.

Ponte, A. (1991) Public Parks in Great Britain and the United States: From a 'Spirit of the Place' to a 'Spirit of Civilization'. In Mosser, M. and Teyssot, G. (eds)

The History of Garden Design: The Western Tradition from the Renaissance to the Present Day. London, Thames and Hudson.

Porter, A. (1999) *The Nineteenth Century: The Oxford History of the British Empire Volume 3*. Oxford, Oxford University Press.

Prest, J. (1981) *The Garden of Eden: The Botanic Garden and the Re-Creation of Paradise*. New Haven and London, Yale University Press.

Price, U. (1810a) *Essays on the Picturesque, Vol. I*. London, J. Mawman.

Price, U. (1810b) *Essays on the Picturesque, Vol. II*. London, J. Mawman.

Quaintance, R. (2001) Kew Gardens 1731–1778: Can We Look At Both Sides Now? *New Arcadian Journal* 51/52, 14–51.

Quaintance, R. E. (1979) Walpole's Whig Interpretation of Landscaping History. *Studies in 18th Century Culture* 9, 285–300.

Quest-Ritson, C. (2001) *The English Garden: A Social History*. London, Penguin Books.

Reade, J. (2000) Alexander the Great and the Hanging Gardens of Babylon. *Iraq* 62, 195–217.

Repton, H. (1795) *Sketches and Hints on Landscape Gardening*. London, W. Bulmer and Co.

Repton, H. (1803) *Observations on the Theory and Practice of Landscape Gardening*. London, J. Taylor.

Repton, H. (1804) *Odd Whims and Miscellanies*, Vol. 1. London, William Miller.

Repton, H. (1816) *Fragments on the Theory and Practice of Landscape Gardening*. London, T. Bensley and Son.

Richards, J. F. (1996) The Historiography of Mughal Gardens. In Wescoat, J. L. and Wolschke-Bulmahn, J. (eds), *Mughal Gardens: Sources, Places, Representations, and Prospects*. Washington, Dumbarton Oaks Research Library and Collection.

Richardson, T. (2008) *The Arcadian Friends*. London, Bantam Press.

Robinson, J. M. (1990) *Temples of Delight: Stowe Landscape Garden*. London, National Trust/Pitkin.

Robinson, W. (1869) *The parks, promenades, and gardens of Paris: described and considered in relation to the wants of our own cities, and the public and private gardens*. London, John Murray.

Rorschach, K. (1983) *The Early Georgian Landscape Garden*. New Haven, Connecticut: Yale Center for British Art.

Roscoe, I. (1997) Peter Scheemakers and the Stowe Commission. In Eyres, P. (ed) *The Political Temples of Stowe*, New Arcadian Journal 43/44, New Arcadian Press.

Ruggles, D. F. (1997) Humayun's Tomb and Garden: Typologies and Visual Order. In Petruccioli, A. (ed), *Gardens in the Time of the Great Muslim Empires: Theory and Design*. Leiden, New York, E. J. Brill.

Ruggles, D. F. (2000) *Gardens, Landscape, and Vision in the Palaces of Islamic Spain*. Philadelphia, The Pennsylvania State University Press.

Ruggles, D. F. (2008) *Islamic Gardens and Landscapes*. Philadelphia, University of Pennsylvania Press.

Samson, J. (ed.) (2001) *The British Empire*. Oxford, Oxford University Press.

Schama, S. (2002) *A History of Britain 3: 1776–2000. The Fate of Empire*. London, BBC Books.

Schiebinger, L. and Swan, C. (eds) (2005) *Colonial Botany: Science, Commerce, and Politics in the Early Modern World*. Philadelphia, University of Pennsylvania Press.

Sheeran, G. (2006) Patriotic Views: Aristocratic Ideology and the Eighteenth-Century Landscape. *Landscapes* 2, 1–23.

Simo, M. L. (1981) John Claudius Loudon: On Planning and Design for the Garden Metropolis. *Garden History* 9(2), 184–201.

Slaney, R. A. (1824) *Essay on the Beneficial Direction of Rural Expenditure*. London, Longman, Hurst, Rees, Orme, Brown and Green.

Slawson, D. A. (1991) *Secret Teachings in the Art of Japanese Gardens*. Tokyo, Kodansha International.

Smith, A. (1776) *An Inquiry Into The Nature And Causes Of The Wealth Of Nations*. London, W. Strahan and T. Cadell.

Smith, N. (1997) Walpole, Whigs and William III. In Patrick Eyres (ed) *The Political Temples of Stowe*, New Arcadian Journal 43/44, New Arcadian Press.

Smith, W. (1961) Pratolino. *The Journal of the Society of Architectural Historians* 20(4), 155–168.

Spellman, W. M. (2001) *Monarchies 1000–2000*. London, Reaktion Books.

Spens, M. (1992) *Gardens of the Mind: The Genius of Geoffrey Jellicoe*. Woodbridge, Antique Collectors Club.

Stackelberg, K. T. von (2009) *The Roman Garden: Space, Sense and Society*. London, Routledge.

Strika, V. (1986) The Umayyad Garden: Its Origin and Development. *Environmental Design* 1, 72–75.

Stronach, D. (1990) The Garden as a Political Statement: Some Case Studies from the Near East in the first Millennium BC. *Bulletin of the Asia Institute* 4, 171–180.

Stronach, D. (1994) Parterres and stone watercourses at Pasargadae: notes on the Achaemenid contribution of

garden design. *Journal of Garden History* 14(1), 3–12

Strong, R. (1998) *The Renaissance Garden in England*. London, Thames and Hudson.

Stroud, D. (1950) *Capability Brown*. London, Country Life.

Stuart, D. (1988) *The Garden Triumphant: A Victorian Legacy*. New York, Harper and Row.

Symes, M. (1983) Charles Hamilton's Plantings at Painshill. *Garden History* 11(2), 112–124

Symes, M. (1996), William Pitt the Elder: The Gran Mago of Landscape Gardening. *Garden History* 24, 1, 126–136.

Symes, M. (2005) Flintwork, Freedom and Fantasy: the landscape at West Wycombe Park, Buckinghamshire. *Garden History* 33(1), 1–30.

Symes, M. (2006) *Fresh Woods and Pastures New: The Plantings at Painshill*. Croydon: Cherrill Print.

Symes, M. (2010) *Mr Hamilton's Elysium: The Gardens of Painshill*. London, Frances Lincoln.

Takei, J. and Keane, M. P. (2008) *Sakuteiki: Visions of the Japanese Garden*. North Clarendon, Tuttle Publishing.

Taylor, H. A. (1995) Urban Public Parks, 1840–1900: Design and Meaning. *Garden History* 23(2), 201–221.

Thackston, W. (2002) *The Baburnama: Memoirs of Babur, Prince and Emperor*. New York, The Modern Library.

Theokas, A. (2004) *Grounds for Review: The Garden Festival in Urban Planning and Design*. Liverpool, Liverpool University Press.

Thomas, A. P. (2006) The Establishment of Calcutta Botanic Garden: Plant Transfer, Science and the East India Company 1786–1806. *Journal of the Royal Asiatic Society* Series 3, 16(2), 165–177.

Thompson, I. (2006) *The Sun King's Garden*. London, Bloomsbury.

Tokyo Metropolitan Park Association (n.d.) *Koishikawa Korakuen Garden* leaflet.

Tokyo Metropolitan Park Association (n.d.) *Rikugien Garden* leaflet.

Tomasi, L. T. (2005) The origins, function and role of the botanical garden in sixteenth- and seventeenth-century Italy. *Studies in the History of Gardens and Designed Landscapes*. 25(2), 103–115.

Treib, M. and Herman, R. (2003) *A Guide to the Gardens of Kyoto*. Tokyo, Kodansha International.

Tschumi, C. (2007) *Mirei Shigemori – Rebel in the Garden*. Basel, Birkhauser.

Tunnard, C. (1938) *Gardens in the Modern Landscape*. London, Architectural Press.

Turner, R. (1999) *Capability Brown and the Eighteenth-*

Century English Landscape. Chichester, Phillimore and Co.

Turner, T. (2011) *Asian Gardens: History, Beliefs and Design*. Abingdon, Routledge.

Turner, T. H. D. (1982) John Claudius Loudon and the Public Park. *Landscape Design* November, 33–35.

Uffelen, G. van (2006) Hortus Botanicus Leiden. *Sitelines* 2(1), 6–7.

Van Tonder, G. J., Lyons M. J. and Ejima Y. (September 23 2002) Perception psychology: Visual structure of a Japanese Zen garden. *Nature* 416, 359–360.

Vasari, G. (1851) *Lives of the Most Eminent Painters, Sculptors and Architects Volume 4*. London, Henry G. Bohn.

Vaughan, P. (2000) India: From Sultanate to Mughal Empire. In Hattstein M. and Delius, P. *Islam: Art and Architecture*. Cologne, Könemann.

Vitruvius (1914) *The Ten Books on Architecture, translated by M. H. Morgan*. Cambridge, Harvard University Press.

Walpole, H. (1995) *The History of the Modern Taste in Gardening*. New York, Ursus Press.

Watkins, J. and Wright, T. (2007) *The Management and Maintenance of Historic Parks, Gardens and Landscapes*. London, Frances Lincoln.

Waymark, J. (2009) *Thomas Mawson: Life, gardens and landscape*. London, Frances Lincoln.

Weiss, A. S. (1995) *Mirrors of Infinity: The French Formal Garden and 17th Century Metaphysics*. New York, Princeton Architectural Press.

Welch, A. (1996) Gardens that Babur did not like.In Wescoat, J. and Wolschke-Bulmahn, J. (eds). *Mughal Gardens: Sources, Places, Representations, and Prospects*. Washington, Dumbarton Oaks Research Library and Collection.

Wescoat, J. L. (1986) The Islamic Garden: Issues for Landscape Research. *Environmental Design* 1, 10–19.

Wescoat, J. L. (1989) Picturing an Early Mughal Garden. *Asian Art* 2, 59–79.

Wescoat, J. L. (1990) Gardens of invention and exile: the precarious context of Mughal garden design during the reign of Humayun (1530–1556). *Journal of Garden History* 10(2), 106–116.

Wescoat, J. L. (2007) Questions about the Political Significance of Mughal Waterworks. In Conan, M. (ed.) *Middle East Garden Traditions: Unity and Diversity*. Washington, Dumbarton Oaks Research Library and Collection.

Wharton, E. (1904) *Italian Villas and their Gardens*. New York, The Century Co.

Whately, T. (1770) *Observations on Modern Gardening*. London, T Payne.

Wheeler, R. (2006) Prince Frederick and Liberty: the gardens of Hartwell House, Buckinghamshire in the mid-eighteenth century. *Garden History* 34(1), 80–91.

Wilber, D. N. (1979) *Persian Gardens and Garden Pavilions*. Washington: Dumbarton Oaks Research Library and Collection.

Wilkinson, A. (1990) Gardens in ancient Egypt: their locations and symbolism. *Journal of Garden History* 10(4), 199–208.

Wilkinson, A. (1994) Symbolism and design in ancient Egyptian Gardens. *Garden History* 22(1), 1–17.

Wilkinson, A. (1998) *The Garden in Ancient Egypt*. London, The Rubicon Press.

Williamson, T. (1995) *Polite Landscapes*. Stroud, Sutton Publishing.

Wiseman, D. J. (1983) Mesopotamian Gardens. *Anatolian Studies* 33, 137–144.

Woodbridge, K. (1976) Bolingbroke's Château of La Source. *Garden History* 4(3), 50–64.

Woodbridge, K. (1986) *Princely Gardens: The origins and development of the French formal style*. London, Thames and Hudson.

Woodbridge, K. (1991) The Architectural Adornment of Cardinal Richelieu's Garden at Rueil. In Mosser, M. and Teyssot, G. (eds), *The History of Garden Design: the Western Tradition from the Renaissance to the Present Day*. London, Thames and Hudson.

Woudstra, J. (2000) The Corbusian Landscape. *Garden History* 28(1), 135–151.

Wright, D. R. E. (1975) The Iconography of the Medici Garden at Castello. *Journal of the Society of Architectural Historians* 34(4), 314.

Yeomans, R. (1999) *The Story of Islamic Architecture*. Reading: Garnet Publishing.

Zangheri, L. (1991) Curiosities and Marvels of the Sixteenth-Century Garden. In Mosser, M. and Teyssot, G. (eds), *The History of Garden Design: The Western Tradition from the Renaissance to the Present Day*. London, Thames and Hudson.

Index

Figures in italics refer to illustrations